Reading
Medieval
Images

Reading Medieval Images

THE ART HISTORIAN AND THE OBJECT

Edited by Elizabeth Sears and Thelma K. Thomas

The University of Michigan Press

2005 2004 2003 2002 4 3 2 1

A CIP catalog record for this book is available from the
British Library.

Library of Congress Cataloging-in-Publication Data

Reading medieval images : the art historian and the object /
edited by Elizabeth Sears and Thelma K. Thomas.
 p. cm.
 Dedicated to medievalist Ilene Forsyth.
 ISBN 0-472-09751-2 (cloth : alk. paper) —
ISBN 0-472-06751-6 (pbk. : alk. paper)
 1. Art, Medieval. 2. Symbolism in art. I. Sears, Elizabeth,
1952– II. Thomas, Thelma K. III. Forsyth, Ilene H.

N5975.R425 2002
704.9'46'0902–dc21
 2002072459

Contents

Preface and Acknowledgments

This volume was conceived from the outset as a tribute to the accomplishments of a distinguished medievalist, Ilene H. Forsyth, Professor Emerita at the University of Michigan. Yet it was never intended to be a conventional Festschrift. Admiring the intensity that Forsyth has consistently brought to bear on the scrutiny of images and objects and recognizing that her subtle readings of medieval works of art constitute ruminations on art-historical practice, we determined to compile an anthology that would seek to demonstrate just what it is art historians do when they confront the art object.

Accordingly we invited a group of prominent medievalists, who count among Forsyth's colleagues, students, collaborators, and friends, to choose an image or an object and to prepare an analysis of it. We received back, in due course, a set of carefully crafted essays, accessible to the non-specialist, representing a wide variety of methodologies and approaches. The authors, as we had hoped, treated works in many media—mosaics, sculpture in stone, carved ivories, cast bronze, enamels, textiles, illuminated manuscripts, painted panels, architectural drawings—extending from large-scale compositions made for public viewing to small-scale objects intended for private use. Moreover, they chose for consideration products not only of the Latin-speaking West but also of the Greek-speaking Byzantine East and the Arabic-speaking Islamic realm. The collected essays seemed to offer something of a conspectus of current practice in the medieval field. We decided then to provide, in introductory essays and interpolated excursuses, commentary on various of the trends and positions represented in the volume.

Our governing premise has been that medieval culture—at once foreign and familiar, remote yet linked to our present by infinite threads—offers a particularly powerful vantage point from which to reflect upon art history's tasks. For when we undertake to interpret medieval works of art, we can take nothing for granted about the functions of images, the economic bases of art-making, the status of artists, and the visual skills of viewers. To analyze a work made in the medieval past is to review basic disciplinary assumptions and to engage in demanding tasks of historical re-creation.

∾

Many individuals contributed to the making of this book. We wish first of all to thank those who provided invaluable practical assistance: Anne Adams, Adam Hyatt, Veronica Kalas, and, most particularly, Anne Duroe, who worked closely with us in the editorial phase of the project. We are also grateful to Kirk Ambrose, Lisa Bessette, Jeffrey Hamburger, Melanie Holcomb, Leila Kinney, Gloria Kury, John Lowden, Robert Maxwell, Molly Nesbit, and Robert S. Nelson, as well as to contributors to the volume, for useful commentary on individual parts of the book. Ellen Bauerle, Colin Day, and Collin Ganio at the University of Michigan Press provided helpful advice and encouragement. We wish, too, to thank our copy editor, Margaret Lourie, and our designer, Mike Savitski of Savitski Design, Ann Arbor, for contributing their expertise. Funding for the project came from various sources. A grant from the Office of the Vice President for Research at the University of Michigan and generous gifts from anonymous donors enabled us to meet the costs of production and design. Individually we would like to express our debt to several institutions that offered indispensable support. The Horace H. Rackham School of Graduate Studies and The Kelsey Museum of Archaeology at the University of Michigan underwrote research assistance for Thelma K. Thomas. Elizabeth Sears was able to pursue the project while holding fellowships at the Institute for the Humanities at the University of Michigan and at the Getty Research Institute in Los Angeles.

E. S. and T. K. T.

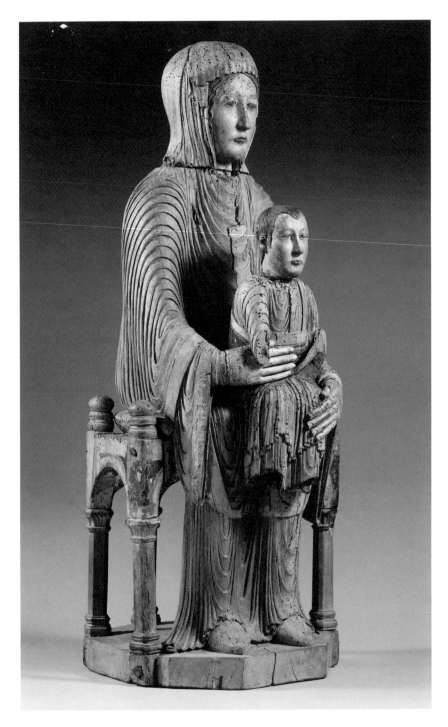

I. Madonna in Majesty. New York, The Metropolitan Museum of Art, Gift of J. Pierpont Morgan, 1916 (16.32.194). Photo: The Metropolitan Museum of Art.

Dedication: Ilene H. Forsyth

Elizabeth Sears

Though all art historians deal with things seen, not all see with equal perspicacity. Over the course of a distinguished professional career, Ilene H. Forsyth has produced a body of scholarship exemplary for its intelligent engagement with the object. What follows is a brief profile of a perceptive reader of medieval images.

Forsyth's conversion to art history came about during a *Wanderjahr* in Europe that followed upon her graduation from the University of Michigan with a degree in English literature.[1] It was in the north Italian city of Ravenna, in its sixth-century churches, as she experienced the impact of glittering expanses of mosaic decoration and sumptuous marble fittings, that she first thought about entering the art-historical discipline. Princeton was then the logical place to undertake graduate study in medieval art, especially Byzantine, but in 1952 (as she was informed) women were not permitted to apply. Forsyth matriculated at Columbia University, a fortuitous decision, for the outstanding faculty included Meyer Schapiro in its ranks.[2] She attended several classes given by this towering intellect, renowned for his powers of visual analysis, but a seminar on Romanesque sculpture had particularly far-reaching consequences. Twelfth-century French sculpture would become Forsyth's principal area of interest and expertise, while Schapiro's casual suggestion that she look into the issue of "narrative" would lead to a lifetime's involvement with twelfth-century visual semiotics.

Forsyth completed an M.A. thesis, "Narrative Order in Romanesque Sculpture," in 1955. Well before narratology had taken hold as a subfield within the humanistic disciplines, she began studying the intricacies of Romanesque story-telling in a systematic way. Traveling through France, Germany, Italy, and Spain laden with photographic equipment, she built up a personal photographic archive. A specific focus emerged as she sketched and photographed each face of the capitals in the cloisters at Moissac, La Daurade I and II, and St.-Étienne, Toulouse, for she discovered that often, rather than wrapping episodes around the capital, sculptors would disrupt the expected sequence for dramatic and expressive ends—a fundamental insight that would later bear fruit.

For her doctoral dissertation Forsyth shifted from stone to wood, from fixed to portable sculpture. Her topic emerged from teaching. As an instructor at Barnard College, she regularly held discussion classes at the Metropolitan Museum of Art. Becoming intrigued by three imposing Romanesque statues of the Virgin and Child (Fig. I), she set out to learn about the origins of the statue type and more particularly about its functions, especially in its "cultish" aspects—again a forward-

looking notion. She broached the idea with Schapiro, who said, "That's fine," and left her to her own devices. The dissertation was completed in 1960. Reworked and expanded, it was published by the Princeton University Press in 1972 as *The Throne of Wisdom: Wood Sculptures of the Madonna in Romanesque France.*

Forsyth, in this prize-winning book, presents the statues as crafted objects, bringing their materiality to the fore in vivid descriptions. Demonstrating that style and form respond to both symbolic and functional requirements, she shows that these sculptures embodied the theology of the Incarnation. The enthroned Mother of God, the Seat of Wisdom, is herself a throne for Christ—the Word made flesh: "The majestic connotation thus imposed a rectilinear rather than a free form upon the composition of the work and a hieratic rather than a human character upon its expression. Attributes, costume and gesture followed accordingly."[3] Forsyth assembles evidence of use, showing that the statues could serve as proxies for the Virgin and Child and even function as sacred props in liturgical drama.[4] It is precisely this concern with audience engagement—the affective power and performative functions of the medieval image—that has ensured the book's continuing resonance.

By the time *The Throne of Wisdom* went to press, Forsyth was on the faculty of History of Art at the University of Michigan, having relinquished a position at Columbia University a year after her marriage to the architectural historian George Forsyth.[5] She would give much to teaching, emerging as a highly effective lecturer and seminar leader, brilliantly adept at devising means to make students undertake the kind of rigorous looking that generates ideas. Seminars were conducted around a table covered with black-and-white photographs, and students learned to test published interpretations against the evidence of the object.[6] Dissertations that Forsyth supervised typically took as their point of departure a single monument or theme and involved meticulous visual analysis.[7]

Forsyth's next major project, after *The Throne of Wisdom*, centered on a monument. In the early 70s, in search of a topic, she had traveled to France to reexamine Romanesque works *in situ*, certain only that she would return to sculpture in stone, a medium for which she felt a particular affinity. The narrative sculpture in the twelfth-century church of Saint-Andoche in the village of Saulieu—lying halfway between Vézelay and Autun—caught her attention, and she decided that a monographic treatment of the church was wanted. One necessary task was to reconstruct, on the basis of archival documentation, the original appearance of the church's main façade—burned and then disastrously restored in the nineteenth century.[8] But she simultaneously began her scrutiny of individual capitals, focusing on those with historiation. Forsyth's investigations into themes in Burgundian sculpture would set her research on a new trajectory. A series of provocative articles she wrote would greatly enliven the study of Romanesque sculpture.

One of the Saulieu capitals shows a cockfight, more dramatic than its ana-

logues at Autun and Beaune: the violent emotions expressed by the winning and losing bird are echoed in the joy and despair of the boys who have set them to fighting. Forsyth's article, "The Theme of Cockfighting in Burgundian Romanesque Sculpture," appeared in 1978,[9] at just the time when Clifford Geertz' study, "Deep Play: Notes on the Balinese Cockfight," was focusing scholarly attention on the institution of the cockfight—an event, in Geertz' words, that "taken as a fact of nature, is rage untrammeled and, taken as a fact of culture, is form perfected."[10] Forsyth, by choosing to take a playful subject seriously, was positioning herself in relation to previous scholarship. She was, on the one hand, taking issue with Schapiro's notion that secular intrusions in Romanesque ecclesiastical contexts can be viewed as spontaneous expressions of individual artistic fantasy.[11] But she was also separating herself from that iconographical approach which would regard depictions of the theme—found earlier in Greek, Roman, and Early Christian art— as vacant appropriations from the past.[12] The cockfight, she demonstrated, was a living institution in the twelfth century: at Carnival, for example, schoolboys would bring fighting cocks to their masters. But even so, she argued, lived experience of the event cannot explain its representation in churches. Forsyth reconstructed the web of symbolic associations surrounding the animal in medieval writings, even while maintaining that a moral reading does not exhaust the capitals' meaning. We must be prepared to embrace ambiguity: "To see only the human and profane side of the work is to be ignorant of its deep seriousness, whereas to see only the spiritual, moralizing implications is to miss its essential *joie de vivre*."[13]

The boldest, and possibly most celebrated, of her studies in these years was "The Ganymede Capital at Vézelay."[14] Here again she demonstrated that a classical theme could function in its medieval context as more than a "hollow quotation" from antiquity. Precisely because of its erotic implications, the tale of the abduction of a beautiful young boy by Zeus in the form of an eagle had particular resonance in a monastic context. Concern over pederasty and homosexuality was great in a situation where men and boys (oblates) lived communally. Through the contrasting analyses of a Greek statue of the fifth century BCE and the twelfth-century capital (Fig. II), Forsyth conveys a world of cultural difference. Her technique is to weave charged narratives from visual observations, so as to move closer to defining viewer response.

> In the Olympian sculpture a boyish prettiness pervades the slight, nude form of Ganymede's body. He yields easily to the firm embrace of Zeus and places his right hand very trustingly—the fingers are still visible—on the powerful arm which grasps him.... The play between the mature assertiveness of the adult and the innocent submission of the boy, evoked by incipient versus developed masculine shapes, conveys the essence of the relationship.

In our Vézelay sculpture, this emphasis upon splendid nude bodies and a close physical relationship is totally eclipsed by the terrifying interpretation given the event.... At Vézelay the wings of the vulturous bird are harshly vertical, his pose rapacious, tensed for attack; enormous talons clutch at the young hunter's snarling dog, and the beak of the bird, like that of a falcon, has a cruel sharpness as it snatches and crushes the child. The scene becomes an image of childhood terror. Vainly pleading and lamenting, the frantic parents rush toward the boy from the left. The fear of the child is graphically conveyed: he presses his hands together desperately as if in prayer; his eyes bulge in panic; his hair literally stands on end, and his mouth opens to utter a hideous scream as the twisted, slight body disappears above. An hysterical family watching its innocent child snatched from them by the attack of a brutish, aggressive monster instigated by a demon becomes a tragedy as horrible as the attacks of birds of prey upon small, helpless creatures in open fields. Here Ganymede, the young hunter of the Classical myth, is himself the hunted one.[15]

The child is thus presented as the terrified victim of an act undertaken at the urging of the devil. It is no accident, Forsyth suggests, that the fiend was prominently situated on the right side of the capital, able to "glare and gesture obscenely at the monks as they left the church through the south aisle"—and thus to act as a perpetual warning to resist illicit temptations. In subsequent studies Forsyth would explore other aspects of monastic mentalities: in an article concerning Burgundian renderings of Balaam's talking she-ass, she broached the subject of monastic humor.[16]

II. The Abduction of Ganymede. Vézelay, Abbey
 Church. Photo: Foto Marburg/Art Resource, NY.

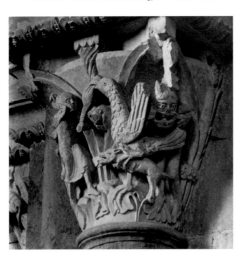

These focused studies prepared the way for increasingly broad inquiries into the links between aspects of twelfth-century monastic spirituality and the themes and forms of monastic sculpture. Again Forsyth anticipated trends in the field. Noting the frequency with which apostolic iconography appeared in cloisters—images of the entire college of the apostles or scenes showing intimate interactions between the apostles and their Lord—she suggested that such sculpture corresponded to the aims of a particular monastic ideal: monks were to live in poverty and

Reading Medieval Images

pray in community, modeling themselves on the original followers of Christ, imitating the *vita apostolica*.[17] Increasingly, both in her teaching and in her research, Forsyth made the cloister and cloistral sculpture a focus of inquiry. The site, she felt, provided an ideal laboratory for the art historian: "[the cloister] was where the commissioners of a work of art and the consumers of that art were most clearly identical, and where we can be sure these two groups were not offhand or casual in their interest but keenly engaged by the art around them."[18] The most effective way to approach monastic sculpture, Forsyth came to feel, was through notions of emulation and empathy. What monks and canons needed was not didactic imagery instructing them in points of doctrine but imagery that would stimulate and guide pious meditation.[19]

A new project enabled her to explore these issues on a different footing. Becoming interested in widely scattered pieces of mid-twelfth-century sculpture from the Rhône Valley, Forsyth undertook the detective work required to draw them together—even submitting stone samples for neutron-activation analysis, which "fingerprints" limestone. She succeeded in locating numerous pieces to the abbey of Saint-Martin in Savigny, a wealthy monastery demolished in the aftermath of the French Revolution.[20] In an article of 1994, "Permutations of Cluny–Paradigms at Savigny,"[21] she studied the way that Rhône Valley sculptors adapted motifs from Burgundian sources, playing with received visual ideas, decomposing and recomposing their models. In this way, she argued, they altered the syntactical organization so as to engage the viewer in new ways. In a study of the Samson monolith in the Duke University Art Museum, she showed how a choice of scenes from Samson's life, dramatically rendered, presented out of chronological order, offered a model of faith for the monks' emulation.[22] Problems of Romanesque narrative that had long concerned her find sophisticated resolution in this piece.

In all her studies Forsyth has been alert to the relations among artisans, patrons, and viewers.[23] She has revealed the power of images to shape perception, and she has investigated the ideological bases of artistic re-presentation of visual material borrowed from the past.[24] Her subtle readings of images—Byzantine, Ottonian, Carolingian, and Hiberno-Saxon as well as Romanesque—show how thematic meaning inheres in form. In every carefully chosen descriptive and analytical term, she reveals serious efforts to comprehend medieval works of art in all their complexity. It is fitting that *Reading Medieval Images: The Art Historian and the Object* be dedicated to her.

1 This essay draws upon interviews conducted by the author on February 14, 1998, April 10, 1999, and July 21, 1999.

2 Other faculty members with whom Forsyth worked include Julius Held, who taught techniques of formal analysis, Hans Tietze, Erika Tietze-Conrat, Charles de Tolnay, Rudolf Wittkower, and William Dinsmoor.

3 *Throne of Wisdom*, 8. The book received the Charles Rufus Morey Prize from the College Art Association.

4 In the book's third chapter Forsyth explored the relation between the cult of relics and the rebirth of free-standing sculpture in the early Middle Ages; this chapter was reprinted in the proceedings of a conference held at the University of Heidelberg: *Kolloquium über spätantike und frühmittelalterliche Skulptur*, 3 vols. (Mainz, 1974), 3:67–91. Forsyth first published her suggestion that the sculptures figured in Epiphany plays in "Magi and Majesty: A Study of Romanesque Sculpture and Liturgical Drama," *Art Bulletin* 50 (1968), 215–22.

5 Forsyth's teaching career began with a lectureship at Barnard College and an instructorship at Columbia University. In 1960 she married George H. Forsyth, Jr., then chairing the Department of the History of Art at the University of Michigan. A year later he left the department to become director of the Kelsey Museum of Archaeology, and she left Columbia to join the faculty at Michigan. Here she would conduct her scholarly career, rising through the professorial ranks, awarded an Arthur F. Thurnau Professorship in 1984. In an era when women were but poorly represented in the professoriate, Forsyth did more than her share of work behind the scenes. She has served a great many national and international organizations, their acronyms familiar to those in the field—ICMA, CAA, MAHS, BSC, CIHA, NEH, CASVA, the Académie des Arts, Sciences et Belles-Lettres de Dijon, the Medieval Academy of America, the American Academy in Rome, the Getty Research Institute—and she has been the recipient of numerous fellowships and visiting professorships, e.g., Institute for Advanced Study, Princeton (1977), Harvard University (1980), the University of Pittsburgh (1981), the University of California, Berkeley (1996), CASVA (1998).

6 For teaching purposes, Forsyth amassed a Romanesque Archive, containing at the time of her retirement more than 5,000 photographs of Romanesque sculpture.

7 Michigan dissertations chaired or co-chaired by Forsyth include: Margret Pond Rothman, "The Arch of Galerius: A Sculptural Record of the Age of the Tetrarchies" (1970); Lois Drewer, "The Carved Wood Beams of the Church of Justinian, Monastery of St. Catherine, Mount Sinai" (1971); Annemarie Weyl Carr, "The Rockefeller McCormick New Testament: Studies toward the Reattribution of Chicago, University Library, MS. 965" (1973); Kathryn Horste, "The Capitals of the Second Workshop from the Romanesque Cloister of La Daurade, Toulouse" (1978); Marjorie Hall Panadero, "The Labors of the Months and the Signs of the Zodiac

in Twelfth-Century French Façades" (1984); Carolyn M. Carty, "Dreams in Early Medieval Art" (1991); Jean Ann Dabb, "The Church of Saint-Nicholas at Civray: The Façade and Its Sculptural Decoration" (1992); Masuyo Tokita Darling, "The Romanesque Architecture and Sculpture of Perrecy-les-Forges" (1994); Leslie Cavell, "Social and Symbolic Functions of the Romanesque Façade: The Example of Macon's Last Judgment Galilee" (1997); Rebecca Price-Wilkin, "The Late Gothic Abbey Church of St. Riquier: An Investigation of Historical Consciousness" (1997); Kirk Ambrose, "Romanesque Vézelay: The Arts of Monastic Contemplation" (1999); Melanie Holcomb, "The Function and Status of Carved Ivory in Carolingian Culture" (1999).

8 "The Romanesque Portal of the Church of Saint-Andoche, Saulieu (Côte-d'Or)," *Gesta* 19 (1980), 83–94.

9 *Speculum* 53 (1978), 252–82.

10 The article, first published in 1972, was disseminated in Geertz, *The Interpretation of Cultures: Selected Essays* (New York, 1973), 412–53; citation at 424. In a note at the end of the paper Forsyth calls attention to Geertz' "penetrating study of the social expression and moral impact of cockfighting in Bali."

11 See especially Schapiro, "On the Aesthetic Attitude in Romanesque Art" (1947), rpt. in his *Romanesque Art* (New York, 1977), 1–27.

12 "...the theory of an ancient sculpture as a model is complicated by the gap of eight centuries, by the profound changes in values and beliefs wrought by those intervening years, and by the apparent indifference of Romanesque carvers to Roman carvings. "Cockfighting," 266.

13 Ibid., 282.

14 *Gesta* 15 (1976), 241–46. V. A. Kolve recently returned to the theme in "Ganymede / Son of Getron: Medieval Monasticism and the Drama of Same-Sex Desire," *Speculum* 73 (1998), 1014–67, taking Forsyth's interpretation of the Vézelay capital as his point of departure.

15 Forsyth's work on the child Ganymede was preceded by research into medieval images of children. Philippe Ariès, in an influential study translated as *Centuries of Childhood: A Social History of Family Life* (New York, 1962), had made the provocative claim: "Medieval art until about the twelfth century did not know childhood or did not attempt to portray it" (33). Asking that "we not confuse artistic style with the overall content of a work of art," Forsyth composed a polemical piece for non-specialists collecting images of childhood in its various phases: "Children in Early Medieval Art: Ninth through Twelfth Centuries," *History of Childhood Quarterly: The Journal of Psychohistory* 4 (1976), 31–70.

16 "L'âne parlante: The Ass of Balaam in Burgundian Romanesque Sculpture," *Gesta* 20 (1981), 59–65.

17 "The *Vita Apostolica* and Romanesque Sculpture: Some Preliminary Observations," *Gesta* 25 (1986), 75–82. Forsyth drew gratefully upon the work of Léon Pressouyre, notably his "St. Bernard to St. Francis: Monastic Ideals and Iconographic Programs in the Cloister," *Gesta* 12 (1973), 71–92.

18 "The Monumental Arts of the Romanesque Period: Recent Research. The Romanesque Cloister," in *The Cloisters: Studies in Honor of the Fiftieth Anniversary*, ed. Elizabeth C. Parker (New York, 1992), 3–25, at 5. Forsyth earlier edited a volume, *Current Studies on Cluny = Gesta* 27/1–2 (1988).

19 "Metaleptic historiation" was the phrase Forsyth adopted to describe that identification with the sculpted subject which would induce "a spiritual synergy tran-scending time." See *Vita Apostolica*," 75; "Permutations of Cluny–Paradigms at Savigny: Problems of Historiation in Rhône Valley Sculpture," in *Studien zur Geschichte der europäischen Skulptur im 12./13. Jahrhundert*, ed. Herbert Beck and Kerstin Hengevoss-Dürkop (Frankfurt am Main, 1994), 335–49, at 335.

20 "Five Sculptures from a Single Limestone Formation: The Case of Savigny," *Gesta* 33 (1994), 47–52. See also Forsyth's analyses of two Savigny pieces: "The Samson Monolith," in *The Brummer Collection of Medieval Art*, ed. Caroline Bruzelius with Jill Meredith (Durham, NC, 1991), 21–55, and "Relief Panel with the *Agnus Dei*," in *Catalogue of the Sculpture in the Dumbarton Oaks Collection*, ed. Gary Vikan (Washington, DC, 1995), 115–23.

21 As n. 19.

22 As n. 20. Forsyth ("Permutations of Cluny–Paradigms," 337) concluded that a significant shift took place from about the second quarter of the twelfth cen-tury. This was "the sculptor's discovery that the capital's surface can be conceived as a stage for a drama which can engage the observer in a new way and the artist's exploitation of that knowledge regarding a new relation-ship between viewer and viewed."

23 In *The Uses of Art: Medieval Metaphor in the Michigan Law Quadrangle*, a gift to her *alma mater*, published by the University of Michigan Press in 1993, Forsyth sifted through the extensive documentation surviving on the design and construction of the Law Quad—an architectural complex in the Collegiate Gothic style built in the 1920s—to present a picture of the intellectual climate and ideological ambitions that informed artistic choices.

24 See, most recently, her "Art with History: The Role of Spolia in the Cumulative Work of Art," in *Byzantine East, Latin West: Art-Historical Studies in Honor of Kurt Weitzmann* (Princeton, 1995), 153–58.

"Reading" Images

Elizabeth Sears

The metaphor of reading has become a commonplace in art-historical writing of late, so much so that art historians who claim to be "reading" their objects of study—whether images, paintings, drawings, portraits, landscapes, spaces, buildings, cities, or other entities[1]—rarely feel the need to define or defend the practice denoted. Sometimes critics will take issue with the term, normally on the grounds that it promotes a word-based ("logocentric" or "verbocentrist") analytical model: by thinking of ourselves as reading, we direct our attention to those aspects of visual images most closely analogous to verbal texts, thereby blurring distinctions between verbal and visual modes of communication and skewing the interpretive process.[2] Occasionally the term is defended, but then necessarily with a distinction drawn between proper and improper modes of reading.[3]

The notion of reading images has a long history: the metaphor was utilized throughout the Middle Ages, especially in the Latin West, where pictorial cycles in churches were defended on the grounds that they were the books of the illiterate.[4] But it owes its current prominence to interdisciplinary exchanges that have taken place in recent decades. In the wake of semiotic and structuralist analysis, non-verbal signifying systems came to be viewed in terms of language, and objects of study became "texts." The influential cultural anthropologist Clifford Geertz could write: "cultural forms can be treated as texts, as imaginative works built of social materials" and "[t]he culture of a people is an ensemble of texts…which the anthropologist strains to read over the shoulders of those to whom they properly belong."[5] Naturalized within the art-historical discipline, the metaphor has come to suggest a set of practices. It is useful, therefore, to try to define, at least provisionally, what kinds of intellectual work "reading" an image implies.

To read a work is to submit it to close visual analysis, informed by a knowledge of the specific historical context in which the work functioned, a familiarity with relevant pictorial conventions and their associations, and a grasp of visual genres. The most common synonym for "read" is "interpret," though "read" has the advantage that it stresses the use of the eye in conjunction with the mind. The word carries a range of nuance: sometimes it is employed to mean simply "decipher," "decode," "comprehend"; other times it calls attention to the interpretive act, suggesting something like "make intelligible," "reveal the internal logic of," or, quite commonly, "develop a take in relation to." A reading is an interpretation from a position—a story told from a vantage point—and often the specific object of study has been chosen because it enables the interpreter to broach an issue of

broader significance for the study of visual materials.

There are things a "reading" is not. The term is not used synonymously with "stylistic analysis" or "formal analysis," interrelated practices that have traditionally been the goal of much art-historical training. Both involve consideration of features of form (line, color, composition, handling, etc.), often in comparison to related works, apart from subject matter and without necessary reference to a work's function. The analytical skills gained therefrom serve multiple functions, whether dating a work or localizing it, identifying artists' hands, constructing a chronology of stylistic development, or assessing quality. None of these purposes is eclipsed, of course, in current art-historical practice. To read an image is to be highly attentive to minutiae of form.

Nor is "reading" synonymous with "iconographical analysis." The latter has come to imply a search for meaning, narrowly defined, through a process of deciphering pictorial conventions, that is, recognizing what is represented (e.g., a biblical story, a mythical or allegorical figure), usually with reference to a written text or to an orally transmitted story. Part of this process involves constructing prior histories of visual motifs and charting the ways that given figures and concepts were represented over time. Accurate identification of subjects and awareness of long-standing traditions of use, of course, remain crucial in current art-historical practice. To read an image is to be highly attentive to questions of content, on many levels.

But shifts have occurred. In 1985 Svetlana Alpers could write, polemically: "In the past decade questions of style and questions of meaning—those traditional compartments into which art historians have tended to divide their field—have either been retired or tilted in the direction of circumstance."[6] Reading images might be called a process of analyzing form and content in their interaction, in relation to the reconstructed circumstances of an artifact's making and viewing. The reader of images studies period attitudes toward image-making and assembles possible connotations of styles, themes, and media for initial and subsequent audiences. It is recognized that visual skills vary among cultures (and among groups within cultures) and that past viewers were compelled by culture and language to be more attentive to certain visual features than others.[7] In a book entitled *Reading Images*, Suzanne Lewis endeavors to find her way into the "visual culture" of illustrated medieval apocalypse manuscripts "by picking up the broken threads of philosophy, optics, theology, and psychology that might help reconnect us to an almost lost and distant experience of reading images."[8] Interpreters remain alert to the effect that such factors as religious affiliation, education, gender, class, and ethnicity might have had on the reception of images, and they pay particular attention to the specific physical context in which a work functioned—who had access to it and what social and religious practices governed its use. Images and objects are seen to open

themselves up, at all times, to multiple readings that are not mutually exclusive. Yet it is a premise that not all interpretations of past works of art are equally plausible, equally powerful. Research is undertaken in the awareness that the works themselves anticipate and guide response.[9]

These practices and attitudes, individually, are by no means new to our time. The art historian whom medievalists, if polled, would likely name as the most perspicacious "reader" of medieval images, in the sense outlined above, is Meyer Schapiro.[10] It was in the 1930s that he prepared his revered analyses of Romanesque sculpture and manuscript illumination, and in the late 1960s that he began publishing his still-consulted semiotic studies.[11] Schapiro himself only rarely used the term "reading" in relation to images but did so in a way consonant with current usage. He plays on the connection to and contrast with the reading of words: "we are asked to view the figures in a sequence in time as well as space, and to read them as we read the text they illustrate."[12] But he applies the term equally to non-narrative aspects of images: "such an account, however justified as a reading of the linear equilibrium of the work, would overlook the expressive character of the whole."[13] And Schapiro drew the link between "reading" and rhetoric: "The reading of the separate parts in succession does violence to the simultaneous coherence of the object, but it enables us to follow the design of the work more easily."[14]

A full history of art-historical use of the metaphor of reading might well illuminate broader currents in the field. Schapiro's contemporaries employed the term variously. E. H. Gombrich, when discussing "what is actually involved in the process of image making and image reading," referred to the ability of the human brain to determine that a drawn or painted configuration of line and mass is a rendering of three-dimensional form.[15] Edgar Wind stressed the role of knowledge in the comprehension and aesthetic appreciation of images: "The eye focuses differently when it is intellectually guided," yet better expressed in his dictum: "Our eye sees as our mind reads."[16]

~

Words, it is acknowledged, are scarcely adequate to the task of communicating the results of visual analysis: art historians must forever wrestle with the problem inherent in "matching language with the visual interest of works of art," to quote Michael Baxandall.[17] Nonetheless verbal mediation performs—and has always performed—a crucial role in guiding viewers' experiences of visual representations.[18] The discipline's most effective practitioners are consummate wordsmiths, who construct deft verbal arguments with, about, and around objects. Art history shares much with cognate disciplines, having engaged steadily in cross-disciplinary exchange since it emerged as an academic discipline in the early nineteenth century. Yet art-historical writing has stood apart in using extensively analyzed images to sustain and even clinch arguments. The reader or listener is ideally brought,

through words, to agree with the art historian who might suggest, for example, that given features of two images are significantly like or unlike one another, or that an image in its structure is analogous to a philosophical concept. But if that reader or listener *sees* things differently, the argument loses force.

The great orators of art history persuade audiences to see with them. Heinrich Wölfflin, one of the most powerful analyzers of pictorial form the discipline has produced, entranced university audiences in Basel, Berlin, Munich, and Zürich with his commentaries on works of art. Eyewitness accounts survive. One student remembers that Wölfflin would forego the lit lectern and stand in the dark with his audience, with them directing his eye toward the projected image, seeming to articulate the common experience:

> For a while Wölfflin lets the work have its effect in the stillness. He makes his approach, following Schopenhauer's advice, as if to a prince, waiting until the work speaks to him. Then the sentences come forth slowly, almost hesitatingly.... Wölfflin's speech never gives the impression of being something prepared, something finished, flung at the artwork, but rather as something first engendered by the work at that moment. Through this, the artwork retains its preeminent position. The words do not overwhelm it; they sit like pearls upon it.[19]

Wölfflin's disquisitions seemed unrehearsed, unrhetorical. "The overfilled lecture hall," another student recalls, "was like the space of a solitary dialogue between him and the picture before which he stood. How did it happen that sparks flew and ignited, that he could excite without himself betraying excitement?"[20] Wölfflin spoke with a still force: "one had to see with his eyes and learned to see."[21]

The art historian brings the reader or listener to look at things with heightened attention, in new ways, so as to concede an argument. But how, through language, is this effected? What is it that we do when we "describe" works of art? The ruminations of Michael Baxandall prove useful. Struck by the relative impoverishment of the language available for seizing many visual effects—noticing, for example, that we have a finer and more extensive vocabulary for Euclidian forms than for surface textures—he surveyed ways we compensate for the lack. Writers about art, he concluded, proceed indirectly, in at least three ways, and he classified art-critical terms as follows:

I. comparative or metaphorical words

I *bis*. comparative or metaphorical words applied as if the things or persons represented were actual

<table>
<tr><td>II.</td><td>causal or inferential words (descriptive in terms of the producing action or agent)</td></tr>
<tr><td>III.</td><td>subject or ego words (descriptive in terms of the work's action on the beholder or the beholder's reaction to it).[22]</td></tr>
</table>

Baxandall drew his examples from Wölfflin's study *Classic Art*, set in Renaissance Italy. We might more fittingly turn for verbal material to Meyer Schapiro's classic investigations of Romanesque sculpture. And first it may be observed how greatly Schapiro does rely on the precisions of geometrical language, if he masterfully shades into metaphor: "The folds are rendered as if permanent attributes of the dress, as purely decorative lines, though once suggested by a bodily conformation. They are spun to and fro across the body in regular, concentric, and parallel lines produced by a single incision, or by a double incision which creates a slight ridge, by polygonal patterns of fixed form, and by long vertical moldings parallel to the legs."[23] All of Baxandall's categories are represented in his writings, often in combination:

<table>
<tr><td>I.</td><td>"the flow of facial surface," "meandering edges," "tense and vehement combination," "dynamic, accelerating whole"</td></tr>
<tr><td>I *bis*.</td><td>"a body otherwise soft and submissive," "impassive faces," "unstable, pirouetting posture," "flying drapery"</td></tr>
<tr><td>II.</td><td>"energetically contrasted lines," "intricate juggling of symmetrical schemes," "cut with an obvious decisiveness"</td></tr>
<tr><td>III.</td><td>"exciting zigzag," "elegant contrast," "seemingly confused or arbitrary space"</td></tr>
</table>

The reader of images works especially within Category I *bis*. It is by treating persons and things as if actual that the discussion lifts out of formal analysis. The analyzer undertakes to reveal the formal logic of the presentation of subject matter, as in this passage from Schapiro's analysis of the sculptures of Souillac: "The two scenes produce a chiasmic symmetry, with Theophilus and the devil back to back in the center of the field, and the devil and Theophilus face to face at the sides of the field.... With a passionate feeling for the expressive pantomime, the sculptor has varied the two pairs according to the meanings of the episodes, the left showing a more relaxed and compact confrontation of the figures...and the right, a more tense and vehement combination."[24]

A reading is the endpoint of a process. As Schapiro builds his argument, the

order in which insights actually occurred is immaterial: he describes the assemblage of sculpture at Souillac so as to prefigure a thesis. Casting his analysis as an exploration of defied expectations, he seeks to demonstrate that "the apparently 'accidental' design is a deeply coherent arrangement, even systematic in a sense."[25] Lack of correspondence between frame and composition, disjunct axes, repetitions and inversions all contribute to a tension-filled rendering of three episodes drawn from the story of Theophilus: the cleric who made a pact with the devil and was saved by the Virgin is presented as an individual who entered into a wrongful feudal agreement and was rescued by the body of the church. Schapiro can thus place the rendering in the context of contemporary struggles between temporal and religious powers and can show that the imagery participates in a new spiritual orientation stressing the moral conflicts that determine individual fate. He delivers broad religio-political conclusions as developing directly out of visual analysis. Like all powerful readings, Schapiro's activates eye and mind, enabling the viewer to see afresh, to meet familiar works with the force of discovery.

1 These range from Suzanne Lewis's theory-rich *Reading Images: Narrative Discourse and Reception in the Thirteenth-Century Apocalypse Manuscripts* (Cambridge, 1995) to James Morganstern's archaeologically based "Reading Medieval Buildings: The Question of Diaphragm Arches at Notre-Dame de Jumièges," in *Architectural Studies in Memory of Richard Krautheimer* (Mainz, 1996), 123–25—where a "close reading" of scars left in nave walls after remodeling is undertaken. A search of the website of the Bibliography of the History of Art brings home the ubiquity of the term.

2 For a critique of recourse to the *logos* in art-historical analysis, see, among others, Georges Didi-Hubermann, *Devant l'image* (Paris, 1990), 145–53; Michael Camille, "Mouths and Meanings: Towards an Anti-Iconography of Medieval Art," in *Iconography at the Crossroads*, ed. Brendan Cassidy (Princeton, 1993), 43–54. On the impact of linguistic models, see, for example, Wayne R. Dynes, "Art, Language, and Romanesque," *Gesta* 28 (1989), 3–10; Horst Bredekamp, "Words, Images, Ellipses," in *Meaning in the Visual Arts: Views from the Outside. A Centennial Commemoration of Erwin Panofsky (1892–1968)*, ed. Irving Lavin (Princeton, 1995), 363–71.

3 Louis Marin's reflective analysis is important: "Toward a Theory of Reading in the Visual Arts: Poussin's *The Arcadian Shepherds*," in *The Reader in the Text: Essays on Audience and Interpretation*, ed. Susan Suleiman and Inge Crosman (Princeton, 1980), 293–324. Mieke Bal submits the term to analysis in "Reading Art?," in *Generations and Geographies in the Visual Arts: Feminist Readings*, ed. Griselda Pollock (London, 1996), 25–41. John Shearman provides a historicizing defense in *Only Connect . . . : Art and the Spectator in the Italian Renaissance* (Princeton, 1992), 5: "There seems to be no other word which adequately describes a kind of looking which, like reading, follows through. Now the reading of works of art is an activity which ought to be susceptible to historical discrimination. There is, I think, a *style* of reading visually in the Renaissance which might be called Neo-Plinian."

4 Statements by Pope Gregory the Great (d. 604) were quoted in the Latin West throughout the Middle Ages: "For what writing offers to those who read it, a picture offers to the ignorant who look at it, since in it the ignorant see what they ought to follow, *in it they read who do not know letters*; whence especially for gentiles a picture stands in place of reading." See Celia M. Chazelle, "Pictures, Books, and the Illiterate: Pope Gregory I's

Reading Medieval Images

Letters to Serenus of Marseilles," *Word & Image* 6 (1990), 138–53, at 139. See also Lawrence G. Duggan, "Was Art Really the 'Book of the Illiterate'?," *Word & Image* 5 (1989), 227–51; Celia Chazelle, "Memory, Instruction, Worship: 'Gregory's' Influence on Early Medieval Doctrines of the Artistic Image," in *Gregory the Great: A Symposium*, ed. John C. Cavadini (Notre Dame, 1995), 181–215.

5 Clifford Geertz, "Deep Play: Notes on the Balinese Cockfight" (1972), rpt. in *The Interpretation of Cultures* (New York, 1973), 412–53, at 449, 452.

6 Svetlana Alpers, "Art or Society: Must We Choose?," *Representations* 12 (1985), 1.

7 From *Giotto and the Orators* (Oxford, 1971) to *Painting and Experience in Fifteenth Century Italy* (Oxford, 1972) to *The Limewood Sculptors of Renaissance Germany* (New Haven, 1980), Baxandall's work has had a powerful effect on the practice of reading images, extending far beyond the early modern field.

8 Lewis (as n. 1), 2.

9 In Thomas Crow's words (*The Intelligence of Art* [Chapel Hill, 1998], 5): "the object invites and prefigures its analysis; half the genius of the interpreter lies in recognizing that invitation." Or Mieke Bal's: "The text does not speak for itself, but it does speak back" (*The Practice of Cultural Analysis: Exposing Interdisciplinary Interpretation*, ed. Bal [Stanford, 1999], 138).

10 Some encomia: Hubert Damisch, in *Social Research* 45 (1978), 2: "one cannot read him without feeling 'better,' by which I mean more intelligent"; Wayne Dynes, in *Journal of the History of Ideas* 42 (1981), 163: "the health of our discipline would be enhanced were his influence more active"; Michael Camille, in *Oxford Art Journal* 17 (1994), 68: "The emphasis in the Souillac essay upon the opposite of geometrical order, indeterminacy, process, performance and chiasmic conflict in image-making, provides some crucial pointers towards a possible future formalism."

11 These include: "On Some Problems in the Semiotics of Visual Art: Field and Vehicle in Image-Signs," *Semiotica* 1 (1969), 223–42; *Words and Pictures: On the Literal and the Symbolic in the Illustration of a Text* (The Hague, 1973).

12 "The Romanesque Sculpture of Moissac" (1931), rpt. in *Selected Papers*, vol. 1. *Romanesque Art* (New York, 1977), 156.

13 "From Mozarabic to Romanesque in Silos" (1939), ibid., 56.

14 "The Romanesque Sculpture of Moissac," 151.

15 *Art and Illusion* (Princeton, 1960; 2d ed., 1961), 25.

16 *Art and Anarchy* (London, 1963; 3d ed., 1985), 60.

17 "The Language of Art History," *New Literary History* 10 (1979), 453–65, at 455; the essay is reprinted with revisions in *The Language of Art History*, ed. Salim Kemal and Ivan Gaskell (Cambridge, 1991). For comment see Allan Langdale, "Art History & Intellectual History: Michael Baxandall's Work between 1963 and 1985," Ph.D. dissertation (University of California, Santa Barbara, 1995), 215–25.

18 Works on art writing include: David Summers, "Intentions in the History of Art," *New Literary History* 17 (1986), 305–21; David Carrier, "Ekphrasis and Interpretation: Two Modes of Art History Writing," *British Journal of Aesthetics* 27 (1987), 20–31; W. J. T. Mitchell, *Picture Theory* (Chicago, 1994), esp. ch. 5, "Ekphrasis and the Other," 151–81; James Elkins, *On Pictures and the Words that Fail Them* (Cambridge, 1998); James A. W. Heffernan, "Speaking for Pictures: The Rhetoric of Art Criticism," *Word & Image* 15/1 (1999), 19–33.

19 Franz Landsberger, *Heinrich Wölfflin* (Berlin, 1924), 94. Projected slides had been in use since the last decades of the nineteenth century. For analysis of the techniques of oral art history, see Heinrich Dilly, "Lichtbildprojektion–Prothese der Kunstbetrachtung," in *Kunstwissenschaft und Kunstvermittlung*, ed. Irene Below (Giessen, 1975), 153–72; Robert S. Nelson, "The Slide Lecture, or the Work of Art *History* in the Age of Mechanical Reproduction," *Critical Inquiry* 26 (2000), 414–34.

20 Fritz Strich, *Zu Heinrich Wölfflins Gedächtnis: Rede an der Basler Feier seines zehnten Todestages* (Bern, 1956), 6.

21 Ibid., 9.

22 Heffernan, "Speaking for Pictures," 21, re-presents the scheme as "comparison," "cause," and "effect" words.

23 Of Schapiro's visual descriptions, Wayne Dynes goes so far as to claim: "in some instances he has pushed the capturing of idiographic detail to such a fine pitch that we seem to stand on the threshold of realizing the utopian program of the phenomenologists for a truly complete account of some segment of perceived reality." See "The Work of Meyer Schapiro: Distinction and Distance," *Journal of the History of Ideas* 42 (1981), 163–72, at 164.

24 "The Sculptures of Souillac" (1939), rpt. in Schapiro's *Romanesque Art*, 109–10.

25 Ibid., 102.

Understanding Objects

Thelma K. Thomas

Not so long ago, even as late as the mid-1980s, to characterize a project or, worse, an art historian, as "object-oriented" was to affix a derogatory label implying adherence to the values of connoisseurship or antiquarianism and resistance to then current forms of engagement with theory. It is true that to look at an art work as an object is to emphasize the quantifiable, to foreground material and medium, to view the product as the result of the directed labor of human muscles. But that is only the beginning. In a full and precisely apt object study, the art work and its material qualities are also assessed historically, and available archaeological evidence and documentary sources are analyzed in order to determine the circumstances in which a given artifact was used and experienced. Nowadays, object study undertaken in the context of studies of museums, collections, and collecting adapts approaches from a range of other disciplines and fields, including semiotics and structural linguistics, anthropology, sociology and cultural studies, and theoretical archaeology.[1] In response to increasingly sophisticated theories of objects, which address such issues as the implications of diachronicity and changing conceptions of materiality, the status of object study is rising.

Reading an object as a *realion* typically begins with the informed assessment of physical clues about materials, dimensions, condition, format, composition (and subject matter), techniques, and craftsmanship.[2] Thus, a preliminary description of a given Byzantine ivory plaque might include the information that it measures 14.5 by 9.8 centimeters, is abraded at the edges and especially at the lower edges, has a six-part composition of three superimposed registers of pairs of rectangular frames (containing six scenes from the life of Christ), and is carved in high relief.[3] The categories and terms of this terse portrayal owe a debt to museum cataloguing, which, based upon routinized physical and formal analysis, classifies objects within established taxonomies and according to medium and functional type (portable ivory icon for personal devotional use) or by style, with developed systems for enabling objects to be dated (Middle Byzantine period) and localized (Constantinople).[4] Object descriptions in museum catalogues are further augmented by information on provenance and publication history. Archaeological cataloguing, distinguished from museum cataloguing, among other things, by its greater insistence on recording information about the locus of discovery, has been influential as well, owing to the importance of fieldwork for the recovery of medieval monuments.[5] The depth of this classificatory current in medieval art history is due, in part, to the work of

several generations of influential historians of medieval art and architecture who undertook massive cataloguing projects.[6]

For certain scholars today the fact that the museum is the most common site of encounters with medieval objects is an issue of some concern, and the museum setting has become emblematic of the artifact's loss of original context. Herbert Kessler has pointed out the limitations of museum displays for providing the "circumstantial unity" of medieval art. He refers in particular to the loss of the original functioning contexts of medieval objects, as when icons are isolated in vitrines or inserted into simulations of church environments, where they are viewed without faith or attendant ritual.[7] Yet losses—contextual and, consequently, conceptual—are inevitable even when a work is preserved at the location of its first use.[8] Say an icon is removed from the screen for which it was made and then placed nearby in the church treasury.[9] The physical traces of even such a small change in location may well be revealed through close physical analysis of the icon and archaeological exploration of the architectural setting. But conceptual alterations must be addressed as carefully as changes that are strictly physical.[10] Say a new icon is added to the screen and the altered whole is then repainted, further decorated, and repaired. Again, close physical analysis may determine phases in the object's existence; however, only historical research will reveal how, under new circumstances, new attitudes and responses come to replace those that once prevailed. The removal of the first icon from display on the iconostasis might mean the end of its use in the public liturgy of the faithful, but its placement on a shelf alongside other items serving ritual devotion or made of similar materials might reestablish its value in different terms. Subsequent removal from the church treasury, while it might devalue the icon's "original" ecclesiastical frame of reference, would promote values particular to the icon's new setting.[11] Such translations might occur throughout the life of an object extending to the present: Susan Pearce has called attention to the re-creation of the artifact as a "museum object" by the act of collecting.[12] Museum display brings about comparable transformations: Robert Nelson has noted the distancing effect or "objectifying" of the artifact wrought by its placement in a display case.[13] Indeed, the disciplinary frames of reference underlying museum installations have prompted Kessler to write that "separately displayed objects stand for their age in the implied narrative of a universal art history."[14] Similarly, Nelson considers museum systems of classification to be but one of several postmodern systems of communication through which the object continues to acquire meaning.[15]

Physical analysis and the determination of factors affecting an object's preservation provide evidence for that object's use and associated meanings. Anthony Cutler has shown, for example, that the abrasion of surface features of Byzantine icons in ivory can be interpreted in light of devotional practices centered on small-scale portable icons in other materials: written accounts and visual representations reveal that these icons were held, rubbed, and kissed during ritual devo-

tions imbued with intense emotion.[16] Inquiry into the period connotations and use of given materials reveals the culturally specific rationale for attributing values to them. Cutler, again, has shown that diminished trade opportunities and the resulting rarity of ivory during and after the Middle Byzantine period (ninth to twelfth centuries) contributed to its effectiveness as a marker of great wealth and high social status and its association with the Byzantine court.[17]

Whereas in a given cultural milieu details of monetary worth—such as the extra cost for a more highly skilled craftsman—might be recorded in an inventory or bill of sale, the relation between execution and aesthetic value is not so easily quantifiable. The appreciation of craft may be assessed approximately by comparing a given work to similar works in the same material, other materials, and other media, and to like objects found in the same milieu. Extant ivory plaques with backgrounds so thin and translucent that the flickering of light shining behind them makes carved figures appear to move[18] can, for example, be compared to other marvels produced within the sphere of Byzantine (and Islamic) court arts, including mechanical marvels. These were automata produced in the ancient tradition of "fine technology," which, as James Trilling points out, participated in an aesthetic of luxury heightened by the conspicuous virtuosic handling of sumptuous materials.[19] Precisely engineered, requiring skill to operate and maintain, and often made of costly metals that could be melted down for conversion to coin, these machines do not survive today. We know of them only from written descriptions, such as Liutprand of Cremona's well-known account of his visit to the throne room of the Byzantine emperor Constantine Porphyrogennetos in 968–69:

> The throne itself was so marvelously fashioned that at one moment it seemed a low structure, and at another it rose high into the air. It was of immense size and was guarded by lions, made either of bronze or of wood covered with gold, who beat the ground with their tails and gave a dreadful roar with open mouth and quivering tongue.... At my approach the lions began to roar and the birds to cry out, each according to its kind; but I was neither terrified nor surprised, for I had previously made enquiry about all these things from people who were well acquainted with them. So after I had three times made obeisance to the emperor with my face upon the ground, I lifted my head and behold! The man whom just before I had seen sitting on a moderately elevated seat had now changed his raiment and was sitting on the level of the ceiling. How it was done I could not imagine, unless perhaps he was lifted up by some such sort of device as we use for raising the timbers of a wine press.[20]

Here, craftsmanship is seen to enhance the symbolic value of materials, grounding a network of meanings and associations in a spectacularly dynamic programmatic

composition, the effect of which was further intensified by ritual behavior.[21]

Liutprand's description of this lost machine also provides otherwise unobtainable information about the anticipated viewer response (he rather ineffectually denies his amazement and surprise), the engagement of the viewer's sense of hearing, the potential importance of motion (Liutprand's and the throne's) during the viewing process,[22] as well as the character and functions of non-religious medieval art, especially court art displayed in the service of imperial ideology. Medieval writings dealing directly with aesthetic expectations are all too rare, and so the art historian must read between the lines of other sorts of written sources—in this case Liutprand's bitterly sarcastic report to Otto I on his failed diplomatic mission—in order to reconstruct the circumstances of viewing.

Medieval perceptions of art works, as Liutprand's description suggests, were not limited to sight.[23] In the case of sacred objects, a powerful material object was approached in the understanding that it was animated by a spiritual presence. The medieval objects best known for their explicit linkage of the qualities of physical matter with spiritual power are relics. Vestiges of the living and the dead and those soon to die, "relics," in the words of Patricia Cox Miller, "occupied a signifying field that mediated between matter and spirit and so subdued the potential dichotomy between them."[24] Reliquaries and images of relics took advantage of the charged space of this signifying field to contain, represent, and otherwise manipulate sacred energies, and they provided the devout medieval viewer with access by sight or touch, sound, smell, or even taste and ingestion. Among several compelling examples, Miller cites Prudentius' ekphrasis of the painting of the martyrdom of Hippolytus in the decorated shrine containing Hippolytus' relics as an example of this kind of elaborate synaesthetic interplay between relic, chosen materials, and their crafting, and the devotee's own mimetic spiritual experience. One passage cited by Miller describes a fresco above the tomb:

> The wall holds a painted representation of the crime, on which pigments of many colors set out the whole outrage. Above the tomb a likeness is depicted, powerful in its clear images, delineating the bleeding limbs of the man dragged to his death. The jagged rock tips dripped blood. . . . I saw them, and read the crimson signs imprinted on the bushes. A hand skilled in imitating green vegetation had also portrayed the red blood with vermilion dye. You could see the torn frame and limbs scattered and lying randomly in unpredictable locations. Later, the artist added the loyal friends following with tearful footsteps where his erratic course traced its fractured path. Stunned with sorrow, they went along with searching eyes, filling the folds of their tunics with his ravaged guts.[25]

Other passages describing the mirrored silver shrine, the altar nearby, and the worshippers' actions combine to reproduce verbally a deliberately sensuous, keenly emotional aesthetic interaction.

These excerpts from Liutprand's account and Prudentius' vivid and moving description underscore the extent to which reading medieval art works may involve coming to terms with physically complex assemblages in which materiality plays especially allusive and symbolic roles. In some texts, however, materials were characterized as lifeless, lacking animation and true vitality—qualities that could be instilled not by a craftsman's artifice but only through adoption of a fittingly reverent attitude toward an object's manufacture and use.[26] Medieval texts can thus offer crucial information about how materiality acquired meaning and how the real presence of an object had aesthetic ramifications, how medieval viewers encountered objects, became culturally attuned to particular types of objects, and learned to perceive differences within classes of objects.

≈

Understanding objects involves reading their material clues, reconstructing experiences of them at various moments in the entire span of their existence, and recognizing that our own disciplinary expectations are historically contingent, based upon available knowledge, training, and practices, and further shaped by the places and modes of our encounters with the objects.

1 Susan M. Pearce, ed., *Interpreting Objects and Collections* (London, 1994), provides an overview of approaches to and theorizations of objects. Pearce's essay, "Thinking about Things," 125–32, offers an especially interesting demonstration of a semiotic approach to object analysis within the museum context. For a similarly wide-ranging overview, see John Elsner and Roger Cardinal, eds., *The Cultures of Collecting* (Cambridge, MA, 1994). Post-processual archaeology attempts to treat material culture as a text, thus "reading" objects. For a post-processual definition of objects and object analysis, see Ian Hodder, "The Contextual Analysis of Symbolic Meanings," in *The Archaeology of Contextual Meanings*, ed. Hodder (Cambridge, 1987), esp. 1; idem, *Reading the Past: Current Approaches to Interpretation in Archaeology* (Cambridge, 1986). Against reading objects as texts, see David Summers, "On the Histories of Artifacts," *Art Bulletin* 86 (1994), 590–92, part of "A Range of Critical Perspectives: The Subject in/of Art History," 570–95.

2 W. McAllister Johnson, *Art History: Its Use and Abuse* (Toronto, 1988), 228: "Objects are the focal point of any collecting or cataloguing effort. In the most literal acception of the word *Realia*, these material realizations alone are transmissible from generation to generation, place to place. They come to be known quite removed from their original context."

3 The ivory plaque described is in the Hermitage in St. Petersburg. For further discussion and a reproduction, see Anthony Cutler, *The Hand of the Master: Craftsmanship, Ivory, and Society in Byzantium* (Princeton, 1994), 22–24, and fig. 20.

4 Johnson, *Art History*, ch. 5, "Cataloguing Theory," 227–76, and ch. 6, "Cataloguing Practice," 277–322. Early concern with scientific analysis of artifacts and accurate cataloguing is discussed in Elizabeth Blakewell, William O. Beeman, and Carol McMichael Rees, *Object, Image, Inquiry: The Art Historian at Work*,

Report on a Collaborative Study by the Getty Art History Information Program (AHIP) and the Institute for Research in Information and Scholarship (IRIS), Brown University (Santa Monica, 1988), e.g., 11.

5 For a survey of archaeological cataloguing, see Brian M. Fagan, *Archaeology: A Brief Introduction* (New York, 1994), esp. ch. 8, "Ordering the Past," 133–51.

6 Foundational corpora of monuments include such works as: Adolph Goldschmidt, *Die Elfenbeinskulpturen*, 4 vols. (Berlin, 1914–26) and Goldschmidt and Kurt Weitzmann, *Die byzantinischen Elfenbeinskulpturen des X.–XIII. Jahrhunderts*, 2 vols. (Berlin, 1930–34); Josef Wilpert, *I sarcofagi cristiani antichi*, 3 vols. (Rome, 1929–36); and Richard Krautheimer, *Corpus Basilicarum Christianarum Romae*, 5 vols. (Rome and Vatican City, 1937–76). These object-oriented research projects were paralleled by thematic, interpretive undertakings that also yielded corpora, e.g., André Grabar, *Martyrium: Recherches sur le culte des reliques et l'art chrétien antique*, 2 vols. (Paris, 1943–46). Such projects provide a context for charting the development of agendas for the research, acquisition, and display of medieval art in the United States. For Byzantine studies, see Kurt Weitzmann, "Byzantine Art and Scholarship in America," *American Journal of Archaeology* 51 (1947), 398–418; and Milton V. Anastos, "Dumbarton Oaks and Byzantine Studies, a Personal Account," in Henry Maguire and Angeliki E. Laiou, eds., *Byzantium: A World Civilization* (Washington, DC, 1992), 5–18. For Islamic art, see Linda Komaroff, ed., *Exhibiting the Middle East: Collections and Perceptions of Islamic Art =Ars Orientalis* 30 (2000). For a broader view of American trends with an emphasis on medieval art history at Princeton, see Craig Hugh Smyth and Peter Lukeharts, eds., *The Early Years of Art History in the United States: Notes on Departments, Teaching, and Scholars* (Princeton, 1993). For framing discussions of European, especially German, trends, see Kathryn Brush, *The Shaping of Art History, Wilhelm Vöge, Adolph Goldschmidt, and the Study of Medieval Art* (Cambridge, 1996), esp. 11–23.

7 Herbert L. Kessler, "On the State of Medieval Art History," *Art Bulletin* 70 (1988), 166–87, at 179. The well-known essay by Jean Baudrillard, "The System of Collecting," rpt. in John Elsner and Roger Cardinal, *The Cultures of Collecting* (Cambridge, MA, 1994), 6–24, although primarily responding to the 1960s culture of consumerism, makes the generally applicable comment that an object collected is an "object divested of its function" (7).

8 Provocative discussions of the historical dimensions of peoples, things, and ideas, and the scholars who study them, may be found in Johannes Fabian, *Time and the Other: How Anthropology Makes Its Object* (New York, 1983).

9 In contrast to North America, where medieval objects are usually found within art museums, in Europe and the Middle East medieval objects are frequently found, for example, in treasuries of mosques, churches, and palaces, as well as in museums celebrating regional and cultural heritage. The touristic setting is especially relevant for architectural monuments, which, if intact, rarely enjoy a tradition of continuous, uninterrupted use, although many churches, temples, and mosques have been preserved over time for their continued relevance to the communities in which they are located. Increasingly, in addition to religious structures, domestic and commercial structures, entire town-sites, and landscapes are preserved for their historical worth and their enormous economic potential. For a consideration of tourism at archaeological sites and museums, see Susan M. Pearce, *Archaeological Curatorship* (Washington, DC, 1990), esp. part 3, "Museums, the Public and the Past," 133–203.

10 "The first problem that an art historian must consider is the identity of the artwork as artifact," says David Carrier, *Principles of Art History Writing* (University Park, PA, 1991), 13, stressing the need for careful, historically sensitive interpretations of the physical reality of the work of art and comparing the task of the art historian to that of the restorer. For example, art historians can investigate the consequences of looking at medieval art through the inherited lens of modernism. On modernism and the reception and study of western medieval architecture, see Maija R. Bismanis, "The Necessity of Discovery," *Gesta* 28 (1989), 115–20; on modernist aesthetics and the modern appreciation of Byzantine art, see Henry Maguire, "Byzantine Art History in the Second Half of the Twentieth Century," in Maguire and Laiou, *Byzantium*, 119–55.

11 Seen in this light, provenance—the route from iconostasis to church treasury to museum collection—has profound implications for interpretation. Arjun Appadurai, ed., *The Social Life of Things: Commodities in Cultural Perspective* (Cambridge, 1983), provides insights into the notion of provenance.

12 Susan M. Pearce, *Museums, Objects, and Collections: A Cultural Study* (Washington, DC, 1992), 7.

13 Robert S. Nelson, "The Discourse of Icons, Then and Now," *Art History* 12 (1989), 144–57, at 154.

14 Kessler, "On the State of Medieval Art History," 179, includes printed reproductions in his critique. For further discussion of the transformation of objects by their graphic presentation, see Brian Leigh Molyneaux, ed., *The Cultural Life of Images: Visual Representation in Archaeology* (London, 1997), esp. "Introduction: The Cultural Life of Images," 1–10; and the essays in "Digital Culture and the Practices of Art and Art History," *Art Bulletin* 79 (1997), 187–216. In an article charting the development of a modern master narrative based on style, "From Stilus to Style: Reflections on the Fate of a Notion," *Art History* 6 (1983), 253–50, Willibald Sauerländer takes uncritical readings of style in objects to task.

15 Important discussions of encounters with objects within the museum setting are Eilean Hooper-Greenhill, *Museums and the Shaping of Knowledge* (London, 1992), and Carol Duncan, *Civilizing Rituals: Inside Public Art Museums* (London, 1995). Duncan's important analysis of the ritualistic behavior of museum visitors might be extended profitably to examination of the habitual practices of art historians at work within the museum and in the field and of the way the descriptive act is organized to suit existing taxonomies. On the development of museums' taxonomic ordering of objects, see Andrew McClellan, *Inventing the Louvre: Art, Politics, and the Origins of the Modern Museum in Eighteenth-Century Paris* (Cambridge, 1994), 4ff.; and more broadly, Tony Bennett, *The Birth of the Museum: History, Theory, Politics* (London, 1995), "Part I: History and Theory," 17–105.

16 Cutler, *The Hand of the Master*, 23–26, and 22 (for Western medieval "delight in touching" statuary).

17 Anthony Cutler, *The Craft of Ivory* (Washington, DC, 1985), esp. 51–54, and Peter Barnet, ed., *Images in Ivory: Precious Objects of the Gothic Age* (Princeton, 1997). The ready availability of ivory in late antiquity allowed its use for a wide range of objects, including items of personal adornment, furnishings, and even toys. Ivory was rare in the early medieval West (seventh to twelfth centuries), but new access to the ivory trade during the Gothic period (1250–1350) resulted in the availability of relatively great quantities of ivory. It became the predominant luxury material in Europe, where it was used for devotional arts, musical instruments, game pieces, mirror cases, combs, etc.

18 Cutler, *Hand of the Master*, 19–29, and pl. V. Additional examples of this level of craftsmanship in ivory and other media can be found in *The Glory of Byzantium*, exh. cat., ed. Helen C. Evans and William D. Wixom (New York, 1997), esp. the section "Luxury Objects," 218–53.

19 For a recent discussion of automata, unattested in the West before the thirteenth century, see James Trilling, "Daedalus and the Nightingale: Art and Technology in the Myth of the Byzantine Court," in *Byzantine Court Culture from 829 to 1204*, ed. Henry Maguire (Washington, DC, 1997), 217–30.

20 Ibid., 228.

21 For perceptions of the symbolic values inherent in ivory, see, for example, Cutler, *Hand of the Master*, 22–23, 248. See also Ioli Kalavrezou's study *Byzantine Icons in Steatite* (Vienna, 1985), in which she draws upon Byzantine poetic descriptions explicitly assigning meaning to the substance of steatite. Dominic Janes, in *God and Gold in Late Antiquity* (Cambridge, 1998), offers an intriguing consideration of the late antique background for medieval notions of the signifying capacities of materials used in church art.

22 See, e.g., Cutler, *Hand of the Master*, 249, on the effects of movement and lighting and the sense of touch in devotion to icons.

23 On culturally inflected visualities, see Robert S. Nelson, "Descartes' Cow and Other Domestications of the Visual," in *Visuality before and beyond the Renaissance: Seeing as Others Saw*, ed. Nelson (Cambridge, 2000), 1–22.

24 Patricia Cox Miller, "'The Little Blue Flower is Red': Relics and the Poetizing of the Body," *Journal of Early Christian Studies* 8 (2000), 213–36, at 214–15.

25 Ibid., 223.

26 This recurring theme in both icon theory and Byzantine magic may be illustrated by reference to a story from the life of St. Andrew the Fool, in which a woman dreams "that all her icons had been smeared from bottom to top with human excrement" because she had practiced magic in their vicinity. Therefore "the grace of God had departed from the icons, leaving them only as empty matter—that is, color and wood—where now was found the stench and turpitude of demons." This story is recounted by Henry Maguire in "Magic and the Christian Image," in *Byzantine Magic*, ed. Maguire (Washington, DC, 1995), 51–71, at 51.

Medieval Sign Theory

"A sign," said Augustine (354–430), "is a thing which of itself makes some other thing come to mind, besides the impression that it presents to the senses."[1] Whereas *things*, strictly speaking, signify nothing but themselves, *signs*—including the whole category of words—signify something else. They serve to transmit what is in the mind of one to the mind of another, but only if the other agrees with the convention in use. A sign, for Augustine, is thus a triadic construct: it is a thing that signifies something to someone.[2]

Medieval sign theory in the Latin West owed much to Augustine's reflections, especially as found in his *On Christian Teaching* (*De doctrina christiana*).[3] This tract, providing rules for the interpretation of sacred scripture, was intended for anyone who desired to penetrate the obscurities in the Old and New Testaments. Augustine, accordingly, was concerned with the signifying capacity of words rather than pictures. He did speak of signs communicated to the eye rather than to the ear, "visible words" (*verba visibilia*), which included nodding and gesturing and, in a military context, raising flags or standards (*DDC* 2.5). And elsewhere he included pictorial representations among the non-verbal signs that could help establish the meaning of words.[4] But it is clear that he doubted the capacity of images to communicate complex ideas; those who seek Christ and the apostles on painted walls rather than in the sacred books, he remarked in one context, deservedly fall into total error.[5] Living in late antiquity, Augustine could hardly have envisioned images like those treated in the following two essays—a twelfth-century depiction of Christ embracing his bejeweled beloved at the center of a complex mystical program and a Carolingian crucifixion scene that incorporates motifs derived from his own spiritual interpretation of the gospel story. Transferred from verbal to visual signs, Augustine's hermeneutical distinctions help to clarify the process of deciphering pictorial imagery that visualizes, interprets, or alludes to biblical words.

The reader of scripture, according to Augustine, can be led astray in two ways (*DDC* 2.32). He may come upon unknown signs (*ignota signa*) or encounter ambiguous signs (*ambigua signa*). Knowledge is the remedy for the former ill, and Augustine describes a range of learning useful for the Christian exegete.[6] But ambiguous signs are trickier. First it must be determined whether the sign is to be read literally or figuratively (*DDC* 3.20); then the interpreter must examine context, for it is in the nature of ambiguous signs to signify contradictory or diverse things in different places. Take the case of the serpent, one of Augustine's own examples. To proceed, the exegete must know something about natural history: "a knowledge of the habits of the snake clarifies the many analogies involving the animal regularly given in scripture" (*DDC* 2.60). But he must be prepared to weigh alternatives, since the snake is an ambiguous sign:

"'serpent' is used in a good sense in the passage 'be wise as serpents' (Matthew 10:16) but in a bad sense in 'the serpent seduced Eve by its cunning'" (2 Corinthians 11:3) (*DDC* 3.80). As a pictorial motif, the serpent turns up in three essays in this volume—those by Chazelle, Sears, and Camille—and in each case the author deals with slippery questions of connotations in context.

Augustine allows that meanings not intended by the human authors of inspired scripture, even multiple meanings, are valid so long as they are congruent with other passages of scripture (*DDC* 3.84). His is a circular model—the interpreter of the Bible uses "the more obvious parts to illuminate obscure passages" (*DDC* 2.31)—but it does not restrain the imagination. And this may help us to imagine the medieval approach to images depicting the things and signs of the Bible. Dale Kinney and Celia Chazelle, in the essays that follow, identify unknown signs and explore the range in meaning of ambiguous signs, taking into consideration the perspective of the period viewer—that is, the interpreter for whom the signs signified. Both of the compositions under analysis contain obscurities challenging and therefore stimulating to viewers, then and now. As Augustine said: "No one disputes that it is much more pleasant to learn lessons presented through imagery (*similitudines*) and much more rewarding to discover meanings that are won only with difficulty" (*DDC* 2.13).[7]

<div align="right">E. S.</div>

1 *De doctrina christiana*, 2.1. All citations are from the edition and translation of the text by R. P. H. Green (Oxford, 1995).

2 R. A. Markus, "St. Augustine on Signs," *Phronesis* 2 (1957), 60–83, at 72; rpt. in *Augustine: A Collection of Critical Essays*, ed. R. A. Markus (Garden City, NY, 1972), 61–91, at 74. See also his "Signs, Communication and Communities in Augustine's *De doctrina christiana*," in *De doctrina christiana: A Classic of Western Culture*, ed. Duane W. H. Arnold and Pamela Bright (Notre Dame, 1995), 97–108. Parallels to the work of C. S. Peirce have been drawn.

3 On the impact of the tract, see the essays in *Reading and Wisdom: The De doctrina christiana of Augustine in the Middle Ages*, ed. Edward D. English (Notre Dame, 1998). Jan Pinborg describes a thirteenth-century response in "Roger Bacon on Signs: A Newly Recovered Part of the *Opus Maius*," in *Sprache und Erkenntnis im Mittelalter*, Miscellanea Mediaevalia, vol. 13/1 (Berlin, 1981), 403–12.

4 *De magistro*, 10.33–35. Brian Stock, *Augustine the Reader: Meditation, Self-Knowledge, and the Ethics of Interpretation* (Cambridge, MA, 1996), 152–57.

5 *De consensu evangelistarum*, 1.10.16, discussing Roman images of Peter and Paul in the company of Christ.

6 This included a knowledge of Hebrew names, animals, stones, plants, numbers, music, history, topography, astronomy, crafts, and logic.

7 See Jean Pépin, "Saint Augustin et la fonction protreptique de l'allégorie," *Recherches augustiniennes* 1 (1958), 243–86.

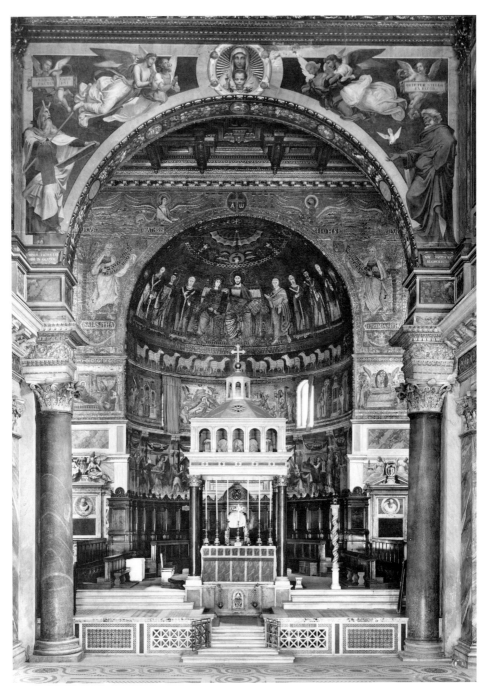

1.1 Rome, Santa Maria in Trastevere, view of apse from nave. Photo: Alinari/Art Resource, NY.

1

The Apse Mosaic of Santa Maria in Trastevere

Dale Kinney

The central image in the apse of Santa Maria in Trastevere (Fig. 1.2) resembles in one important respect the class of objects made prominent in art history by Ilene Forsyth, the portable wooden statuettes called Thrones of Wisdom.[1] Both are figurative as well as figural works of art. To use a linguistic analogy, the figural references are denotational: the Virgin Mary enthroned with the infant Jesus in the statuettes, Mary enthroned with her adult son in the mosaic. The figurative aspects are connotational: the array of theological, doctrinal, and other associations evoked by these nominal subjects. Visual analysis can point to the existence of these semiotic modalities, but it cannot fully decode either system. To understand artworks of this kind, visual analysis must always be supplemented by other interpretive equipment.

Their one fundamental similarity aside, the Throne of Wisdom statuettes and the apse mosaic are unlike. The mosaic is fixed rather than portable, pictorial rather than sculptural, and inscribed rather than wordless. Its iconography is unusual, for it shows not exactly a Coronation of the Virgin but a co-enthronement in which Christ embraces his already coronated mother. Its patronage is also exceptional: as part of the new construction that replaced the ancient church of Santa Maria in Trastevere under the sponsorship of Pope Innocent II (1130–43), it is the only example of direct papal patronage of monumental imagery surviving from the twelfth century.

The most obvious consequence of the mosaic's fixedness is that it can be viewed in only one place, inside the twelfth-century basilica across the Tiber from Rome (Fig. 1.1). Physically this is a limiting condition: one sees the mosaic in the light, at the times, from the distances imposed by the basilica. Liturgical barriers discourage close examination, and the mosaic's design suggests an ideal viewpoint from somewhere in the nave. Standing between the eighth and ninth columns of the flanking colonnades—at a point that, in the Middle Ages, was inside the privileged space of the canons' choir (*schola cantorum*)—the viewer can see the entire mosaic, including the figures on the transept wall around the conch, but not the awkward caesura over the windows, where the mosaic abruptly breaks off in favor of less expensive forms of decoration.

From wherever it is viewed, the conch of the apse retreats in shadow.

1

It must have received more light originally, as the twelfth-century builders included windows in all of the transept walls. Some of them have since been blocked, but the windows in the east wall survive and have even been enlarged. As the apse projects westward, these windows should illuminate it with the morning sunlight, yet at 9 a.m. on a winter day the conch is dark. Even at noon it is dull, nearly colorless except for the gold, which glimmers fitfully, creating a textured atmosphere around the figures. Its visual quiescence is disrupted when a tourist drops some coins into a light box, and suddenly the apse explodes in color: turquoise, cobalt, sapphire, green, red, white, and gleaming gold. Excited eyes race over the newly patterned surface, trying to take it all in. With a click the purchased time elapses, the apse falls dark again, and the eye's delight is over. The visual experience was thrilling, and completely anachronistic. No one before the twentieth century could have seen the apse in the brilliant totality of electric light. Its joyful fields of color were often obscured, always subdued, apprehensible in patches of tesserae rather than in continuous flat expanses, as in a painting.

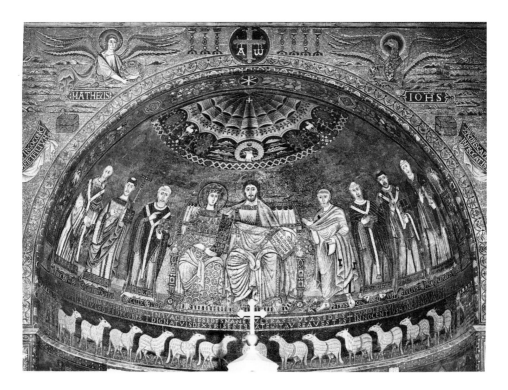

1.2. Rome, Santa Maria in Trastevere, apse mosaic. Photo: Alinari/Art Resource, NY.

1

Reading Medieval Images

To viewers unaccustomed to the active, searching mode of seeing demanded by premodern levels of interior illumination, electricity makes the mosaic more enjoyable, but it also creates unpleasant side effects. Strong light flattens the standing figures against the surface like bright band-aids, pressing them against the curve of the conch and deflating their fictional corporeality. The electrically illuminated surface becomes an unyielding absolute, smooth and glossy, whereas without the light the gold is darkly changeable, irregular and atmospheric, a medium in which the figures palpably assert themselves. In natural light, the shapes in the mosaic are sharply and linearly defined, but the viewer's relation to them is impressionistic, softly focused and subject to continual ambient variation. One can only imagine the same effects intensified by the warm, erratic light of candles or lamps.

Mosaic is a visually volatile medium that cannot be analyzed art historically simply by looking at the object as it was made to be seen. The object is too unstable. Analysis requires a continuous visual availability, which is possible for a monumental mosaic only through technological enhancement (the electric lamps) or by fixing it in reproduction. To study its style one must climb upon a scaffold or—since that privilege is denied to most of us—work from the surrogate view of photographs.

On the scaffold, the art historian recaptures the viewpoint of the craftsman, and analysis proceeds in those terms. The viewpoint is microscopic, revealing the colors, shapes, and alignments of single tesserae, but it is too close to see the composition or even entire figures. The tesserae in the apse mosaic at Santa Maria in Trastevere are mostly glass, with visible surfaces about one centimeter square. Some are spolia, including a few inscribed fragments that look as if they came from early Christian medallions or vessels.[2] They are set in dense rows, following the contours of the forms they are describing: straight noses, concentric eyelids and brows, half-disks for lower lips. Draperies fall flatly, with long parallel or converging folds marked by lines of darker colors. Precise in its own terms, in comparison to contemporary Byzantine mosaics the texture in Santa Maria in Trastevere looks loose and extemporaneous.[3] Forms are large, simple, static, slightly bland, enlivened by spots or lines of red rather than by contouring highlights in white or gold. From the scaffold one also can see where the surface has been altered by restoration. Such changes are remarkably few, but the head second from the right in the conch (Fig. 1.2) was completely remade by a nineteenth-century mosaicist, and half of the portrait at the far left was carelessly reset with old tesserae, deforming it "as if by a serious disease."[4]

From the ground the problem of analysis is completely different. The macroscopic view takes in more than the mosaic, nearly losing it in a complex environment of decorative accretions (Fig. 1.1). Entities that art history keeps apart jostle one another for attention: garish nineteenth-century paintings on the triumphal

1

arch, a strip of narrative mosaic added near 1300 by Pietro Cavallini, the tall nineteenth-century ciborium, a brightly colored pseudo-Cosmati floor, and more. Selecting another photograph allows us to focus on the twelfth-century object (Fig. 1.2), but merely excluding anachronistic competition does not solve the problem of priorities. The viewer is still bewildered by a kaleidoscope of meaningful configurations: human shapes, animals, fantastic creatures, inanimate objects, lettering, foliage, geometric constructions. Where to begin the analysis of such a smorgasbord of representation?

In a famous introduction to iconographic interpretation, Erwin Panofsky proposed three levels of meaning in representational imagery and three corresponding stages of decipherment: natural, conventional, and intrinsic.[5] Natural meaning is deciphered by practical experience; on this level we recognize women, sheep, flowers, and so forth. At the next level we decipher standard cultural or artistic symbols; thus a male figure with a cross and halo is Jesus Christ, and a human with wings is an angel. On the third level, the work of art can be decoded as a sign of something that produced it, for example the personality of the artist or the mindset of an entire culture.

Devised with reference to the naturalistic, "humanistic" painting of the fifteenth and sixteenth centuries, Panofsky's schema points up the differences between that sort of imagery and representations like the mosaic in Santa Maria in Trastevere. The mosaic has no foundation in nature; very little in it corresponds to the viewer's practical experience, except for his or her experience of other images. Its forms are purely symbolic. Any attempt to describe it naturalistically makes it absurd ("a man and a woman seated over a strip of letters and two files of sheep") and introduces false priorities. Naturalism encourages us to look first at the human figures, and to analyze representation in terms of experiential notions of how such figures exist in time and space. For images like this mosaic, the experiential frame of reference is nearly useless. Rather, what counts is the ability to decipher symbols and to transcode what are, for us, two fundamentally different symbol systems: verbal and iconographic. This returns us to the question of priorities. Where should the viewer start "reading" this mosaic? Literally, with the inscriptions? In the center? From the bottom? From the top?

Structure, both physical and pictorial, provides an intrinsic hierarchy and with it, a place to begin. Physically, the mosaic surface comprises a half-dome and the arcuated wall around it; the dome is central, and the wall is its frame. Pictorially, the surface is organized by two complementary principles: axiality, and mirror symmetry around the axis. The axis is marked by a vertical succession of motifs in the mosaic and also by elements outside it: the central window and, at ground level, the marble papal chair (*cathedra*) behind the altar. Nearly all of the axial elements refer to Christ (Fig. 1.2): at the apex of the framing arch, a gold cross

1

Reading Medieval Images

with pendant alpha and omega; in the soffit of the conch, the christogram, combining the first two letters of *Christos* (chi, rho); just below the christogram, a tiny cross; in the center of the conch, the bulky male figure wrapped in a gleaming gold mantle; and at the bottom, the cross-nimbed lamb, which is obscured by the finial of the obtrusive ciborium. The features outside the mosaic allude to Christ as well. The window below the conch is light, and Christ is "the light of the world" (John 8:12); and the axial chair is reserved for the "vicar of Christ." The only other referents on the axis are God the Father, whose hand holds a wreath above Christ's head, and the Holy Spirit, represented by the dark ray above God's hand. Together with the tiny cross above them, the ray and the hand symbolize the Christian Trinity, one God in three.

The vertical axis is intersected horizontally by a row of monumental figures: the Virgin Mary, seated with Christ on the throne, and seven standing males. Except for Mary these figures are all labeled, but before reading the labels one can identify them categorically, by costume. The man next to Christ wears an ancient Roman toga and must be an apostle. Four men wear the Y-shaped scarf (*pallium*) reserved to bishops; another is in the wide-sleeved tunic (*dalmatica*) of a deacon. The seventh figure wears a priest's *stola*, the two ends of which hang to his knees underneath his chasuble. Turning to the labels, one finds that the bishops all are popes: Pope Innocent II (INNOCEN[tius]), holding a diminutive basilica that symbolizes his gift as donor of the building; Pope Callixtus I (218–22, CALIXTVS), Pope Cornelius (251–53, CORNELIVS), and Pope Julius I (337–52, IVLIVS). The deacon is St. Lawrence (LAVRENTIVS), the apostle is St. Peter (PETRVS), and the priest at the far right is Calepodius.

This strong horizontal is echoed by two parallels. A frieze of striding lambs, symbolizing the twelve apostles, runs below the figures, and a row of apocalyptic symbols tops the wall above the arch: the four winged creatures (Apoc. 4:6–8), identified with the four evangelists, and seven lampstands (Apoc. 4:5). Below the winged creatures, two large males in ancient Roman dress are identified as the prophets Isaiah and Jeremiah by labels (ISAIAS P[ro]PH[et]A, HIEREMIAS P[ro]PH[et]A) and by quotations on unfurled scrolls: "Behold a virgin shall conceive, and bear a son" (Isaiah 7:14), and "Christ the Lord is taken in our sins" (Lamentations 4:20).[6] The prophets extend the figural axis of the conch. The two dominant axes form a cross, intersecting in the figure of Christ, and the arms of the cross bind all of the symbolic forms together. The vertical axis extends outside the mosaic and claims the liturgical space below it as part of the realm of representation. There the pope in the *cathedra* acts for Christ on earth, and priests perform rituals that symbolize Christ's sacrifice, mercy, and incomprehensible love of mankind.

Read as a unit, the arch around the apse seems to be about time, or rather

1

time's erasure in the divinity of Jesus Christ. The prophets belong to a time before Christ, their visions to his lifetime, and the Apocalypse to the as yet unrealized future. The collapse or transcendence of all of these times is symbolized by the Greek letters hanging from the central cross: "I am Alpha and Omega . . . who is, and who was, and who is to come, the Almighty" (Apoc. 1:8). With the guide of the frame we can see a similar implosion of temporality in the conch. The portraits of historical persons collapse the past into one prospective moment, when these mortals will be chosen to rise and share the glory of the Lord, as the apostles (symbolized by the lambs) shared Jesus' existence on earth. The Virgin Mary, already seated in the Lord's throne, has preceded other mortals to his presence and partakes of his divinity in a uniquely intimate way.

On a more detailed level, gestures are as varied and significant as the costumes already discussed. Except for Pope Innocent II, whose hands are occupied with his miniature basilica, and Pope Cornelius, all of the figures in the conch make signifying gestures. St. Peter extends his open right hand toward the seated Christ, and St. Lawrence displays his hand similarly but in front of his body. Both gestures denoted respect or, more strongly, awe and adoration. The other popes and Calepodius hold up their right hands with two fingers curled and two extended as if pointing. Often called the "Latin blessing," this gesture descended from an ancient Roman sign for speech or teaching. The Virgin Mary makes the same gesture as she unfurls her scroll, as if she were speaking to her son. Christ's own gesture is much more unusual, and startling, in this context: his right arm wraps behind the Virgin to embrace her, his fingers closing on her shoulder. Characteristic of lovers, this motion was often depicted in illustrations of Old Testament couples but is rarely seen in New Testament iconography and never in apse mosaics.[7]

The couple displays inscriptions. "His left hand is under my head, and his right hand shall embrace me" is on the Virgin's scroll, and "Come my chosen one, and I will place in you my throne" is written on the pages of Christ's book.[8] The Virgin's words come directly from the Bible (Song of Songs 2:6, 8:3), and Christ's are from the liturgy for the feast of the Virgin's Assumption (August 15). The inscriptions expose the error of any literal (or "natural") interpretation of the central image. This is not—cannot be—the representation of a carnal love affair but an allegory rooted in sacred metaphor, a visualization of mysteries heard in the Bible and in holy chant. The inscriptions also refer the visual image to its origin in verbal expression. Although the Assumption of the Virgin was not shown in art as an enthronement or coronation before the later Middle Ages, it was commonly described that way as early as the Carolingian period, e.g., "This is the day on which the unstained mother and virgin . . . [was] raised to the throne of the king, and sat glorious with Christ."[9]

Another inscription, at the bottom of the mosaic between the frieze of

monumental figures and the lambs, offers the same mix of past, present, and visionary future as the mosaic decoration as a whole: "In your honor, shining Mother, this palace of godly honor glows with the brightness of beauty. / Where you sit, Christ, will be a seat beyond time; worthy of your right hand is she enveloped by the golden robe. / As the old building was threatening ruin, Pope Innocent the second, from here arisen, renewed it."[10] The first couplet affirms that the principal subject of the mosaic *is* the Virgin Mary; the third affirms that the sponsor of her new church, which *was* ruinous, is Pope Innocent II. The middle pair of verses paraphrases the forty-fourth psalm to describe what *will be*. This complicated bit of poetry both reinforces and destabilizes the commonsensical identification of the enthroned queen as Mary. Costume also calls this identification into question, as the female figure does not wear the standard blue maphorion of the Virgin but a gold dress with multi-colored patterns. Although there were Roman images of an iconographic type called "Maria Regina," this figure too was usually dressed in blue or purple. The garment of the woman in the apse mosaic seems to be another allusion to Psalm 44: "Thy throne, O God, is for ever ... The queen stood on thy right hand, in gilded clothing, surrounded with variety."[11] The queen of the psalm is a bride, like the lover of the Song of Songs. Returned to its source in verbal metaphor, the mosaic's central image reads as the bride of Christ at the moment of her union with the king. This subject cannot be understood in strictly Marian terms. To grasp its spiritual significance, it is necessary to delve further into the world of words, into scripture and its exegesis, especially the numerous interpretations of the Song of Songs.

From the floor of the basilica, the inscriptions containing the keys to the allegory in Santa Maria in Trastevere are hard to make out, especially the quotation from the Song of Songs, whose gold letters shimmer in and out of focus against the deep blue of the Virgin's scroll. It takes desire and effort to read them, a physical premonition of the intellectual exertion that will be required to penetrate the allegory once it is perceived. To the art historian, this is a signal that visual analysis has done its work, and it is time to move on to the library.[12]

1
———

1 Ilene H. Forsyth, *The Throne of Wisdom: Wood Sculptures of the Madonna in Romanesque France* (Princeton, 1972). I often assign this monograph to students. It is a model of objective art-historical analysis, patiently teasing out the statues' secrets by observation through the multiple lenses of facture, function, style, iconography, and evolution of the genre. *The Throne of Wisdom* is one of the increasingly rare publications that endure as required reading long after they first appear in print.

2 Vitaliano Tiberia, *I mosaici del XII secolo e di Pietro Cavallini in Santa Maria in Trastevere. Restauri e nuove ipotesi* (Todi, 1996), 183, figs. 70, 71.

3 Compare the photographs published by Tiberia with those in Ernst Kitzinger, *The Mosaics of St. Mary's of the Admiral in Palermo* (Bologna, 1990); e.g., Tiberia, pl. XVII, and Kitzinger, fig. 7 (the heads of Christ).

4 Tiberia, *Mosaici*, 194; cf. 190, fig. 83; 192, fig. 84.

5 Erwin Panofsky, *Studies in Iconology: Humanistic Themes in the Art of the Renaissance* (New York, 1939), 3–17.

6 ECCE VIRGO CONCIPIET ET PARIET FILIVM; XPS D[omi]N[u]S CAPTVS E[st] IN PECCATIS N[ost]RIS.

7 For example, Ahasuerus embracing Esther in the eleventh-century Roda Bible: Walter Cahn, *Romanesque Bible Illumination* (Ithaca, 1982), 78, fig. 48.

8 LEVA EIVS SVB CAPITE MEO ET DEXTERA ILLIVS AMPLESABIT[ur] ME; VENI ELECTA MEA ET PONAM IN TE THRONVM MEVM.

9 "Haec est, inquam, dies, in qua usque ad throni celsitudinem intemerata mater et virgo processit, atque in regni solio sublimata, post Christum gloriosa resedit." Pseudo-Jerome [Pascasius Radbertus (?)], *Epistola 9, Ad Paulam et Eustochium, De assumptione beatae Mariae Virginis*, 7 (PL 30, 128), cited by Adolf Katzenellenbogen, *The Sculptural Programs of Chartres Cathedral: Christ, Mary, Ecclesia* (Baltimore, 1959), 58, 126 n. 14.

10 HEC IN HONORE TVO PREFVLGIDA MATER HONORIS
REGIA DIVINI RVTILAT FVLGORE DECORIS
IN QVA CRISTE SEDES MANET VLTRA SECVLA SEDES
DIGNA TVIS DEXTRIS EST QVA[m] TEGIT AVREA VESTIS
CVM MOLES RVITVRA VETVS FORET HINC ORIVNDVS
INNOCENTIVS HANC RENOVAVIT PAPA SECVNDVS.

Calvin Kendall and my colleague Julia Haig Gaisser kindly lent their expertise to the interpretation of this inscription.

11 "Sedes tua, Deus, in saeculum saeculi"; "Astitit regina a dextris tuis / In vestitu deaurato, circumdata varietate" (Psalm 44:7, 10).

12 For explication of the further complexities of this apse mosaic, see: Carlo Cecchelli, *Mater Christi*, 1. *Il "Logos" e Maria* (Rome, 1946), 91–98; G. A. Wellen, "Sponsa Christi: Het Absismozaïek van de Santa Maria in Trastevere te Rome en het Hooglied," in *Feestbundel F. van der Meer* (Amsterdam, 1969), 148–59; Gerhart B. Ladner, *Die Papstbildnisse des Altertums und des Mittelalters*, 2. *Von Innozenz II. zu Benedikt XI.* (Rome, 1970), 9–16; Ernst Kitzinger, "A Virgin's Face: Antiquarianism in Twelfth-Century Art," *Art Bulletin* 62 (1980), 6–19; Philippe Verdier, *Le Couronnement de la Vierge: Les origines et les premiers développements d'un thème iconographique* (Montréal, 1980), 40–47; Ursula Nilgen, "Maria Regina—ein politischer Kultbildtypus?" *Römisches Jahrbuch für Kunstgeschichte* 19 (1981), 3–33; Marie-Louise Thérel, *A l'origine du décor du portail occidental de Notre-Dame de Senlis: Le triomphe de la Vierge-Église. Sources historiques, littéraires et iconographiques* (Paris, 1984), 194–202; Penny Schine Gold, *The Lady and the Virgin: Image, Attitude and Experience in Twelfth-Century France* (Chicago, 1985), 51–61; Kunibert Bering, "Zeichen-System-Bedeutung: S. Maria in Trastevere als paradigmatischer Fall," *Zeitschrift für Ästhetik und allgemeine Kunstwissenschaft* 33 (1988), 200–214; William Tronzo, "Apse Decoration, the Liturgy and the Perception of Art in Medieval Rome: S. Maria in Trastevere and S. Maria Maggiore," in *Italian Church Decoration of the Middle Ages and Early Renaissance*, ed. Tronzo, Villa Spelman Colloquia, vol. 1 (Bologna, 1989), 167–93; Joan E. Barclay Lloyd, "Das goldene Gewand der Muttergottes in der Bildersprache mittelalterlicher und frühchristlicher Mosaiken in Rom," *Römische Quartalschrift* 85 (1990), 66–85; Mary Stroll, *Symbols as Power: The Papacy following the Investiture Contest* (Leiden, 1991), 162–79; Ursula Nilgen, "Texte et image dans les absides des XIe–XIIe siècles en Italie," in *Épigraphie et iconographie. Actes du Colloque tenu à Poitiers les 5–8 octobre 1995* (1996), 153–65; Tiberia, *Mosaici*.

1

An *Exemplum* of Humility: The Crucifixion Image in the Drogo Sacramentary

Celia Chazelle

One of the most beautiful and enigmatic of Carolingian crucifixion images occurs in the Drogo Sacramentary (Fig. 2.1), a manuscript made for Drogo, bishop of Metz, probably in the decade before his death in 855.[1] The miniature is set within the tiny initial O of a Palm Sunday prayer: "Almighty eternal God, who, as an example of humility for the human race to imitate, made our savior both assume flesh and undergo the cross, grant quickly that we may deserve to have proofs of his patience [suffering] and be partners of his resurrection."[2]

At the center of the O, a nimbed Christ is fixed to a cross with a large serpent coiled at its base, his feet on a suppedaneum. Christ's eyes are apparently still open, but his body twists at the hips, blood spurting from his pierced side, and his head drops onto his right shoulder. The position of his head possibly indicates that he is looking at the woman standing at the far left of the image, but it also evokes the moment of his death, when, according to John 19:30, Jesus bowed his head as he gave up the spirit. The other figures in the scene all look toward Christ, drawing the viewer's attention into the center of the O. Two tiny figures rise from open coffins to the lower left and right of Christ, lifting their arms toward the crucifix above them. A wreath hangs from the upper rim of the O directly above the cross; it is flanked by personifications of the sun and the moon and two half-figures of angels, who look down on Christ and extend their hands in acclamation. Scholars generally agree that the nimbed woman at the far left of the scene is the Virgin Mary; John the Evangelist stands to the far right, also nimbed and holding a book. Both face Christ from hillocks that bring their heads level with his, lifting their hands to their faces in gestures of grief. Between Christ's cross and Mary, lower than Mary because of the undulating ground, stands a smaller, nimbed female figure, who holds a triumphal banner and raises a chalice to catch the blood from Christ's side wound. Again, scholars for the most part agree that this is Ecclesia, a personification of the Church.

Although there is little scholarly disagreement over the identification of the pictorial details just noted, there is virtually no consensus regarding the one remaining

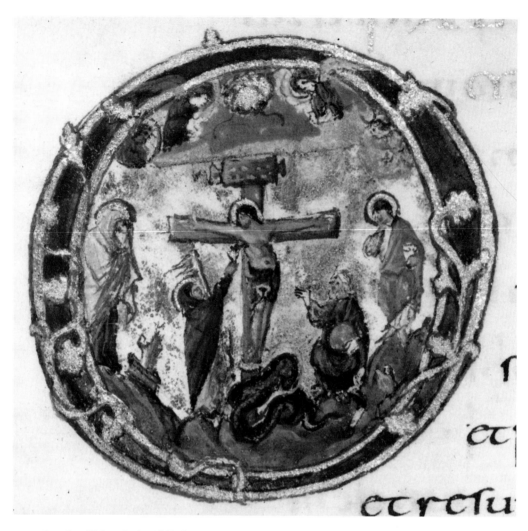

2.1 Crucifixion. Paris, Bibliothèque nationale de France, MS lat. 9428 (Drogo Sacramentary), fol. 43v. Photo: Bibliothèque nationale de France.

human figure in the miniature: the seated man with white hair and beard, without nimbus, who looks at Christ and lifts a hand toward the cross in a gesture of acclamation. Nor is there agreement about the nature of the object in his lap.[3] I cannot in the next few pages provide an exhaustive analysis of the signification of these features of the illumination or of the image as a whole, which likely suggested to the miniature's Carolingian viewers levels of meaning beyond those I will propose here. But I hope that my comments will at least clarify the basic elements of the picture's iconography and their main sources, including those of the disputed details, and thus provide a firmer basis for assessing its relation to other Carolingian crucifixion images.

The best explanation of the scene represented here has its starting point in the scriptural readings of the ninth-century Carolingian liturgy for Good Friday, the culminating ceremonies of the Holy Week observances that began on Palm Sunday. That the sacramentary's one crucifixion image is situated alongside orations for Palm Sunday rather than Good Friday, as might seem more logical, indicates its designer's intention that the book's users keep the crucified Christ in their thoughts throughout the rites of Holy Week. Thus they would remain mindful of the crucifixion's position as the climax to the progressive stages of Jesus' self-abasement after the entry into Jerusalem, commemorated on Palm Sunday, and they would preserve the solemn atmosphere appropriate to the entire final week of Lent; for during all those days, as the Palm Sunday prayer next to the illumination confirms, Christians remember and imitate their redeemer's passion by humbly repenting their sins.

Of principal importance in interpreting the miniature is the passion narrative in John 19, which Carolingian *ordines* indicate was the gospel lection for the main service on Good Friday.[4] It is in John 19:26–27 that the crucified Christ identifies the Virgin and John as mother and son, the primary scriptural foundation for the tradition widely found in medieval art of depicting Mary and John beside the crucifix. Their preeminence among witnesses to the crucifixion lies behind their portrayal in this miniature as standing on hillocks, above Ecclesia, the seated man, and the resurrected dead, so that their gaze is level with Christ's head. More significantly for our purposes, John 19 suggests a plausible interpretation of the old man in the image. As Knut Berg earlier proposed,[5] he is most likely Nicodemus, who, according to John 19:39–40, appeared after Christ had died to help Joseph of Arimathea prepare the body for burial. John 19:39 describes Nicodemus as "he who at the first came to Jesus by night."[6] This passage refers back to John 3, where it is recounted how Nicodemus, a Pharisee and "ruler of the Jews," sought out Christ as his rabbi, posing him questions that led Jesus to compare his future crucifixion to the story of the brazen serpent and identify himself as the light overcoming darkness. Similarly, the Drogo Sacramentary painting combines its

2

crucifixion scene with reminders of John 3. Nicodemus, seated on the ground—thus resembling scholarly men in certain drawings of the contemporary Utrecht Psalter[7]—waits for the body on the cross, hand raised to acclaim his lord, teacher, and master. His posture underscores the irony of their relationship: the old man who still lives seeks instruction from the young crucified savior, the scholar of the old law from the provider of the new, the "ruler of the Jews" from the king on the cross. The small, oblong object on the ground beside Nicodemus is probably an extinguished torch. Still smoldering, it recalls the light restored through Christ's passion, as expressed in John 3:19–21, a light that overwhelms the shadows of sin and death and renders this symbol of darkness unnecessary. Nicodemus, who came to Jesus "by night" (John 3:2) and who therefore sits on the moon or dark side of the cross, gazes upon the light of revelation. Near his and Mary's feet, the resurrected dead recall both the crucifixion scene in Matthew 27:52 and Christ's promise, in John 3:15, that all who believe in the crucified Son of Man will have eternal life.[8] Possibly as well they are reminders of the two resurrected sons of Symeon described in the Gospel of Nicodemus (17:1–3), a text preserved in several ninth-century Carolingian manuscripts. As in that gospel, so in the sacramentary miniature Nicodemus witnesses to Christ's passion.[9]

To connect the crucifixion image in the Drogo Sacramentary with John 3 assists our understanding of the serpent beneath the crucifix. This pictorial motif—which first occurs in Carolingian crucifixion images of the second quarter to second half of the ninth century and perhaps has its earliest appearance in our miniature[10]—may have been partly inspired by two biblical passages heard before the passion narrative during the main service on Good Friday: namely, a portion of the Old Testament prayer of Habacuc, including the verse, "Death shall go before his face. And the devil shall go before his feet" (Habacuc 3:5), and Psalm 139.[11] The psalm compares the evil men besetting David to snakes; although his enemies "have sharpened their tongues like a serpent" and have the "venom of asps" under their lips, the "labor of their lips" will overwhelm them and the lord will cast them down.[12] Augustine, whose exegesis of this text possibly influenced the new iconography, identifies the evil men having serpent-like tongues with the body of the devil, just as the good constitute Christ's body.[13] In the Drogo Sacramentary miniature, and in other contemporary Carolingian crucifixion images, the vanquished serpent beneath the crucifix may have been understood to evoke these texts. The lord for whom death goes "before his face" defeats the devil and his forces, represented by the venomous serpent that now goes "before his feet."

The analogy drawn in John 3 between the crucified Son of Man and the brazen serpent, however, sheds additional light on the motif. The bronze snake Moses raised in the wilderness, at God's command, healed all who looked on it of the snake bites inflicted on the Israelites for their sinfulness (Numbers 21:9). In con-

2

formity with John 3:14–15, where Jesus recalls this story for Nicodemus, the Son of Man, who is lifted on the cross in the sacramentary illumination, overcomes the devil, the great serpent of sin, just as the brazen serpent defeated the snakes besetting the sinful Israelites. Christ's crucified body, gently twisted on the cross in a subdued version of the dramatic coils beneath his feet, is the new brazen serpent. He is the one on whom Nicodemus and all desiring salvation—among them Mary, John, Ecclesia, and the miniature's viewers, who behold the scene through the oculus-like O—must gaze in faith, in order to be healed of sin.[14]

Augustine's tractates on John suggest further connections between Christ in this painting and the brazen serpent. In discussing John 3:14–15 Augustine interweaves the themes of death and sin, symbolized by the snake, and Christ as the new brazen serpent, dying on the cross to liberate mortals from the same evils. The crucial link between Christ and the bronze serpent, for Augustine, is Jesus' death. The serpent raised by Moses *is*, symbolically, "the death of the lord on the cross," a death that conquered the death from sin that is itself represented by the "image of the serpent." As the miniature in the Drogo Sacramentary seems to convey, it is precisely Christ's dying that brings life, by defeating the serpent of sin and death. Hence those who desire to be healed of sin, according to Augustine, must "set their gaze upon the serpent that the serpent may have no power." While temporal life was restored to the Israelites who beheld the brazen serpent, Christians who "look with faith upon the death of Christ," as do the figures surrounding the cross in the miniature, may hope to receive eternal life.[15]

Augustine's tractates elucidate other features of the sacramentary miniature, as well—features that cannot be directly linked with the Good Friday liturgy or the gospel of John. One is probably the depiction of Mary. Whereas in other Carolingian crucifixion images she is usually the same height as John,[16] in this scene she and Christ are the two largest figures. Her size is partly clarified by Augustine's analysis of Jesus' interview with Nicodemus in John 3. In discussing the contrast Jesus draws between physical and spiritual birth in John 3:3–8, Augustine points to the example of the incarnation. While Christ's "birth" from God corresponds to the first creation, his human yet miraculous birth from Mary enables mortals to be reborn "through the spirit."[17] Mary, the mother of the crucified savior, who brought light back into the world, is the spiritual mother of other figures in the sacramentary image and of all the faithful whom Christ's death redeems. Her uniqueness among mortals is further discussed in Augustine's commentary on John 19, where Christ's words from the cross are used to highlight the respect children owe their parents and, especially, the mother of the creator, to whom Jesus gave another son in John.[18]

A second feature is the personification of Ecclesia holding the chalice, an iconographic form that first appears in ninth-century Carolingian crucifixion

2

images. On one level, the motif reflects the growing power of the western church at this time and the increased concern evinced in contemporary writings with the sacraments as channels of that power. The depiction of the crucified Christ's blood flowing directly into a chalice, here and in a number of other crucifixion images,[19] may also be connected with the doctrine expressed in a few Carolingian texts dating from the 830s to the 860s that the eucharistic bread and wine are identical with Christ's crucified body and blood.[20] A further likely influence on the image of Ecclesia with the cup, however, is Augustine's commentary on John 19:34. For Augustine, the blood and water issuing from the wound in Christ's side were the source of the eucharistic cup and, for this reason, the origin of the church, born from that wound to be Christ's spouse, just as Eve came from the side of the sleeping Adam.[21] In the sacramentary miniature, Ecclesia, bride of Christ and symbol of Carolingian ecclesiastical authority, stands before her dying lord to continue his saving work on earth, receiving in her cup the blood and water fundamental to salvation and hence to her very existence.[22]

A final motif in the sacramentary miniature that requires identification is the object in Nicodemus' lap. It has sometimes been argued that this is a paten,[23] but it is more probably an orb or disk designating the earth—a symbol traceable to antique iconography that is also held by certain figures, among them *Terra* herself, in drawings of the Utrecht Psalter.[24] When associated with Nicodemus, it is likely emblematic of the old man's worldliness and his inability to understand the spiritual sense of Jesus' words despite the faith that brought him to turn to the "rabbi"—an interpretation in accord with Augustine's exegesis of John 3.[25] Augustine's analysis and the Holy Week liturgy together suggest that Nicodemus' presence beneath the cross may have carried another level of meaning for Carolingian viewers. According to Augustine, Nicodemus' relationship with Christ in John 3—one of faith without full understanding—symbolizes the state of catechumens, who must wait to receive the eucharist until they are baptized. This was a ceremony that in Augustine's time and in the Carolingian liturgy—despite concern to allow for infant baptism throughout the year—was conducted at the Easter vigil.[26] Although catechumens already believe in Christ, Augustine declares, they, like Nicodemus, do not yet fully belong to the church, since Jesus does not yet "give his trust to them"; this lack of trust is perhaps suggested in the sacramentary miniature by Christ's leaning away from Nicodemus and toward Ecclesia, symbol of the baptized faithful. True membership in the church, according to Augustine, will not be achieved until, through a humility imitating Christ's humility, manifested in baptism, the catechumen is able to distinguish earthly from spiritual things. Only then will he or she be given the eucharist that Ecclesia already receives.[27]

Seated on the ground—conceivably in this context another indication of his earthliness—Nicodemus draws the viewer's attention, with uplifted hand, to the

2

crucifix that rises above him. He waits for the body of Christ like the catechumen who waits to be a full member of the church, granted access to Christ's body in the eucharist. Nicodemus is thus a reminder of the situation that, according to Amalarius of Metz and other Carolingian liturgical exegetes, all Christians occupy during Holy Week: not only catechumens but all laity, monks, and even the clergy together wait, in the last days of Lenten penitence and fasting, for the new eucharistic body and blood of Easter. Both the prayer that the sacramentary miniature accompanies and ninth-century Carolingian writings affirm that the supreme model of humility every Christian should emulate is Christ's passion. For Amalarius and contemporary theologians, a primary occasion for such imitation of the crucified Christ was the Holy Week liturgy, a series of rituals that offered commemorative representations of the events leading up to Jesus' death and, it was believed, incited the faithful to the "second baptism" of repentance of their sins, even as they looked forward to Easter.[28] The climax to this week, every viewer of the miniature would have realized, came in the *Adoratio crucis*, when Carolingian Christians beheld the image or relic of the cross and prostrated themselves to kiss it, as if, according to interpreters such as Amalarius, they saw Christ hanging there.[29] By the faithful witness to the crucifixion that the Drogo Sacramentary miniature invites on Palm Sunday, penitent Christians may engage in remembrance of the crucified savior's "patience" and in emulation of the "example of humility" given "for the human race to imitate," following the words of the accompanying prayer, in the hope that they may be "partners of his resurrection," celebrated the following Sunday.

His eyes turned toward Christ but his body toward the viewer, Nicodemus invites those who behold the sacramentary miniature—among them perhaps Drogo—to contemplate these truths with him as they participate in the Palm Sunday mass and begin their observances of the final days of Lent.

Research for this article was made possible by the FIRSL program of The College of New Jersey. I am grateful to the American Catholic Historical Association, the American Academy of Religion, Princeton University, and the International Congress on Medieval Studies, Western Michigan University, for opportunities to present my findings in public and to members of those audiences for their suggested revisions. My thanks, too, to anonymous readers of an earlier draft of this article and to Elizabeth Sears and Thelma Thomas for their patience in including last minute changes.

1 Paris, Bibliothèque Nationale de France, MS lat. 9428, fol. 43v; reproduced in facsimile in Codices selecti, vols. 49–49*, ed. Florentine Mütherich, commentary by Wilhelm Köhler (Graz, 1974). This is the dating of most scholars: Köhler, 13; Elizabeth Leesti, "The Pentecost Illustration in the Drogo Sacramentary," Gesta 28 (1989), 205. Franz Unterkircher, Zur Ikonographie und Liturgie des Drogo-Sakramentars (Graz, 1977), 9–11, 18–19, citing earlier scholars, favors a date before 840 but based on an erroneous (to my mind) interpretation of the seated figure in the crucifixion miniature.

2 "Die Dominica in Ramis Palmarum ad Sanctum Iohannem: Omnipotens sempiterne Deus, qui humano generi ad imitandum humilitatis exemplum salvatorem nostrum et carnem sumere et crucem subire fecisti, concede propitius ut et patientiae ipsius habere documenta et resurrectionis consortia mereamur." "Ad sanctum Iohannem" refers to St. John Lateran, Rome's stational church for Palm Sunday: Mario Righetti, Manuale di storia liturgica, vol. 2. L'anno liturgico, 3d ed. (Milan, 1969), 188.

3 Sonia Simon, "Studies in the Drogo Sacramentary: Eschatology and the Priest-King" (Ph.D. diss., Brown University, 1975), 69–90, esp. 77–90 (the figure is simultaneously Melchisedek and Drogo, holding a paten); Unterkircher, Zur Ikonographie und Liturgie, 18–19 (the figure is the Prophet Hosea, with the orbis terrarum). Simon cites earlier literature that variously identifies the figure as Synagogue, Moses, a symbol of the Old Law, the defeated prince of the world; he holds a tambourine, a shield, a symbol of the world.

4 For example Ordines, 23, 24, 27–29, 30B–32; ed. Michel Andrieu, Les "Ordines Romani" du haut moyen âge, 3 vols. (Louvain, 1951), 3:271–519. Cf. Gerhard Römer, "Die Liturgie des Karfreitags," Zeitschrift für katholische Theologie 77 (1955), 39–93, esp. 62.

5 Knut Berg, "Une iconographie peu connue du crucifiement," Cahiers archéologiques 9 (1957), 319–28, at 326. Later medieval images of Nicodemus as witness to the crucified Christ also exist; see, e.g., Jennifer Sheppard, "A Devotional Diptych of the Resurrection: Oxford, Corpus Christi College MS 2," in English Manuscript Studies, 1100–1700, ed. Peter Beal and Jeremy Griffiths (Oxford, 1990), 231–56.

6 Biblical references are to the Douay-Rheims Version.

7 Utrecht, Bibliotheek der Rijksuniversiteit, MS 32, fols. 6r (Psalm 10), 13r (Psalm 22; the seated man is David). I have recently argued that the Utrecht Psalter may date ca. 850. See "Archbishops Ebo and Hincmar of Reims and the Utrecht Psalter," Speculum 72 (1997), 1055–77, esp. 1071–73.

8 See also Hosea 6:2, the first scriptural reading of Good Friday: Römer, "Die Liturgie des Karfreitags," 54–55.

9 Zbigniew Izydorczyk, ed., The Medieval Gospel of Nicodemus: Texts, Intertexts, and Contexts in Western Europe (Tempe, AZ, 1997), 4; idem, Manuscripts of the Evangelium Nicodemi: A Census (Toronto, 1993), 234. See Nicodemus 5, 7.1, 12.1.

10 For other examples, Genevra Kornbluth, Engraved Gems of the Carolingian Empire (University Park, PA, 1995), frontispiece, figs. 14–16, 18, 19, 43, 48; Danielle Gaborit-Chopin, Ivoires du moyen âge (Fribourg, 1978), figs. 77, 86; J. Hubert, J. Porcher, and W. F. Volbach, The Carolingian Renaissance (New York, 1970), fig. 152.

11 The Roman Good Friday liturgy called for the reading of Psalm 90. However, while later Carolingian churches followed Roman practice for certain aspects of their ceremony, the practice of replacing Psalm 90 with Psalm 139 spread during the ninth century. See Römer, "Die Liturgie des Karfreitags," 58–59 and n. 15.

12 Psalm 139:4, 10–11.

13 Augustine, Enarratio in Psalmum 139, 6–7; ed. E. Dekkers and J. Fraipont, CCSL 40 (Turnhout, 1956), 2015–16.

14 John 3:15. Cf. Stanley Ferber, "Crucifixion Iconography in a Group of Carolingian Ivory Plaques," Art Bulletin 48 (1966), 324. The connection between faith and an interior "seeing" of the crucified Christ is a pronounced theme in later Carolingian literature. As certain texts, including those cited below in n. 29, make clear, the inner vision is aided by access to material reminders of the passion, though most authors seem to have crosses rather than crucifixes in mind. I discuss these themes at greater length in The Crucified God in the Carolingian Era: Theology and Art of Christ's Passion (Cambridge, 2001), esp. 127, 219, 263, 276–77, 296–98.

15 Augustine, Tractatus in Iohannis evangelium, 12.11; ed. R. Willems, CCSL 36 (Turnhout, 1954), 126–27. Cf. Simon, "Studies in the Drogo Sacramentary," 73.

2

16 For example, Kornbluth, *Engraved Gems*, frontispiece, figs. 3, 4, 7, 14, 18; Gaborit-Chopin, *Ivoires*, figs. 61, 78, 86; Ernst T. Dewald, *The Illustrations of the Utrecht Psalter* (Princeton, 1931), pls. 105, 142.

17 Augustine, *Tractatus*, 11.6–12.8 (CCSL 36, 113–25), esp. *Tractatus*, 12.8.

18 Augustine, *Tractatus*, 119.1–3 (CCSL 36, 658–59).

19 Kornbluth, *Engraved Gems*, fig. 43; Gaborit-Chopin, *Ivoires*, figs. 77, 86; Adolph Goldschmidt, *Die Elfenbeinskulpturen*, vol. 1 (Berlin, 1914), figs. 85, 86, 88, 89, 96; Dewald, *Illustrations of the Utrecht Psalter*, pl. 105.

20 Such as Pascasius Radbertus, *De corpore et sanguine Domini*; ed. Beda Paulus, CCCM 16 (Turnhout, 1969) [831–33, revised ca. 843]; idem, *Expositio in Matheo*, 12.26; ed. Beda Paulus, CCCM 56B (Turnhout, 1984), 1288–89 [after 851]; Hincmar, *De cavendis vitiis et virtutibus exercendis*, 3; ed. Doris Nachtmann, MGH, Quellen zur Geistesgeschichte des Mittelalters, vol. 16 (Munich, 1998) [860s–early 870s]. These texts are also indicative of the strong sense of clerical authority in the later Carolingian church. See Celia Chazelle, "Figure, Character, and the Glorified Body in the Carolingian Eucharistic Controversy," *Traditio* 47 (1992), 9–19; eadem, *Crucified God*, 215–27.

21 Augustine, *Tractatus*, 120.2 (CCSL 36, 661).

22 See Ferber, "Crucifixion Iconography," 325.

23 Berg, "Une iconographie peu connue," 326; Simon, "Studies in the Drogo Sacramentary," 77–90.

24 See Dewald, *Illustrations of the Utrecht Psalter*, pl. 16, 46, 83.

25 Augustine, *Tractatus*, 11.3–6 (CCSL 36, 111–14).

26 Augustine was himself baptized at Easter 387: Peter Brown, *Augustine of Hippo* (Berkeley, 1967), 124. For baptism in the Carolingian Easter liturgy, Amalarius, *Liber Officialis* (= LO), 1.18–1.29; ed. J. M. Hanssens, *Amalarii episcopi opera liturgica omnia*, 3 vols. (Vatican City, 1948), 2:111–56; *Ordines*, 23, 24, 27–32 (Andrieu, 3:273–523). Cf. Peter Cramer, *Baptism and Change in the Early Middle Ages, c. 200–c. 1150* (Cambridge, 1993), 137–38.

27 Augustine, *Tractatus*, 11.3–6, 12.5–6 (CCSL 36, 111–14, 122–24).

28 Amalarius, *LO*, 1.10–1.16 (Hanssens, 2:58–108); cf. *LO*, 1.29.6 (2:154). Also, among others, Rabanus Maurus, *De institutione clericorum libri tres*, 2.35–37; ed. D. Zimpel (Frankfurt am Main, 1996), 383–88; Candidus, *De passione domini* (PL 106, 57–104). Cf. Robert Deshman, "The Exalted Servant: The Ruler Theology of the Prayerbook of Charles the Bald," *Viator* 11 (1980), 385–417, esp. 391–93.

29 Amalarius, *LO*, 1.14 (Hanssens, 2:101); Einhard, *Quaestio de adoranda cruce*; ed. Karl Hampe, MGH, Epistolae, vol. 5 (Berlin, 1899), 146–49. See also Jonas, *De cultu imaginum*, 2 (PL 106, 342C).

2

Visual Rhetoric

Mastering the art of eloquent and persuasive speech was a fundamental goal of education in antiquity, and rhetoric retained its prestige throughout the Middle Ages, especially in Byzantium. Rhetorical theory was studied in the medieval schools, east and west, as part of an education in the liberal arts. The reading of ancient rhetorical manuals, Greek and Latin, had consequences that went beyond preparing orators to declaim or sermon writers to preach. The educated elite absorbed knowledge of the principles of argument, the concept of styles, and the nature of verbal ornament, whether in the form of figures of speech, including hyperbole, metaphor, and allegory, or figures of thought, including antithesis, simile, and personification. Art theory was transmitted implicitly in these discussions, but also explicitly. Rhetoricians frequently drew parallels between writing and painting (e.g., Cicero, *De oratore*, 19.65: "[the Sophists] arrange their words as painters do their variety of colors"), and they made use of the device of *ekphrasis*, or description so vivid that it could bring absent things—including paintings, sculpture, and buildings—before the mind's eye.

Art historians have been increasingly aware of the relevance of rhetorical theory and practice to the analysis of medieval imagery, as many essays in this volume, including the following four, demonstrate.[1] Thelma K. Thomas, in her reading of a sumptuous late antique textile showing a bejeweled pagan goddess, draws upon Michael Roberts' suggestion that a "jeweled style" pervaded late antique poetry and visual arts alike. She demonstrates that makers of textiles consciously imitated the brilliant effects achieved in other media, and she utilizes pagan and Christian *ekphraseis* of splendid cloths and clothing to recreate now foreign aesthetic values and conditions of viewing. Walter B. Cahn, in his study of a twelfth-century "portrait" of Muhammad, demonstrates how the tiny sketch participated in anti-Islamic polemic. The prophet—a heretic from the Christian point of view—is portrayed as a fantastic hybrid, half-man, half-fish, with a curious mark at his shoulders. Cahn uncovers multiple dimensions of meaning through the study of medieval apocalypticism and bestiary lore, but his starting point is necessarily the famous opening passage of Horace's *Art of Poetry*, an ancient guide to good literary style, where verbal incoherence is ridiculed through analogy to hypothetical couplings of human and animal parts by painters.

Rhetoric, as taught in the schools of northern Europe, was one of the three arts comprised in the trivium. Grammar, the most fundamental of the three, "the key to everything written,"[2] taught not only correct speech and writing but also literary criticism through the study of the ancient authors; in a Christian context it prepared the mind for the understanding of scripture. Dialectic, in turn, inculcated skills in logical

thinking and in separating truth from falsehood. In the twelfth century, the status of the trivium was a burning issue, and the relation of the three arts was in flux. Rhetoric was easily allied with pedagogical grammar since both were concerned with literary style; but speculative grammar and dialectic had common linguistic concerns. Moreover rhetoric, as belonging to the theory of argument, could be coupled with dialectic and viewed as a species of logic, which was coming to reign supreme in the wake of the recovery of Aristotle's logical works.[3]

Elizabeth Sears and Michael Camille turn respectively to the spheres of grammar and dialectic in their analyses of twelfth-century images. Sears examines a double author portrait in a south German manuscript that shows an inspired author with his commentator. Camille looks at a carved tympanum from a house in Reims that shows two schoolmen disputing above a boy struggling with a serpent and lovers kissing. The manuscript image was intended for the gaze of monks, who would have received a traditional schooling based on the close reading of set texts by standard authors. The tympanum was placed to be seen by canons, students, and others of an urban populace in a cathedral town with an important school; here controversies about the old and the new learning raged, and the claims of dialectic, now coming to control verbal discourse, were challenged by those loyal to the study of the authors. In both essays the attempt is made to correlate medieval reading practices with the modern "reading" of medieval imagery.

E. S.

1 See, for example, the several studies of Henry Maguire listed in the bibliography, including *Art and Eloquence in Byzantium* (Princeton, 1981). Also Liz James and Ruth Webb, "'To Understand Ultimate Things and Enter Secret Places': Ekphrasis and Art in Byzantium," *Art History* 14 (1991), 1–17; and Robert S. Nelson, "To Say and to See: Ekphrasis and Vision in Byzantium," in *Visuality before and beyond the Renaissance: Seeing as Others Saw*, ed. Nelson (Cambridge, 2000), 143–68.

2 John of Salisbury, *Metalogicon*, 1.21.

3 On issues surrounding the status of the trivium in the twelfth century, see *The Seven Liberal Arts in the Middle Ages*, ed. David L. Wagner (Bloomington, 1983); Jan Ziolkowski, *Alan of Lille's Grammar of Sex: The Meaning of Grammar to a Twelfth-Century Intellectual* (Cambridge, MA, 1985); and relevant essays in *A History of Twelfth-Century Western Philosophy*, ed. Peter Dronke (Cambridge, 1988).

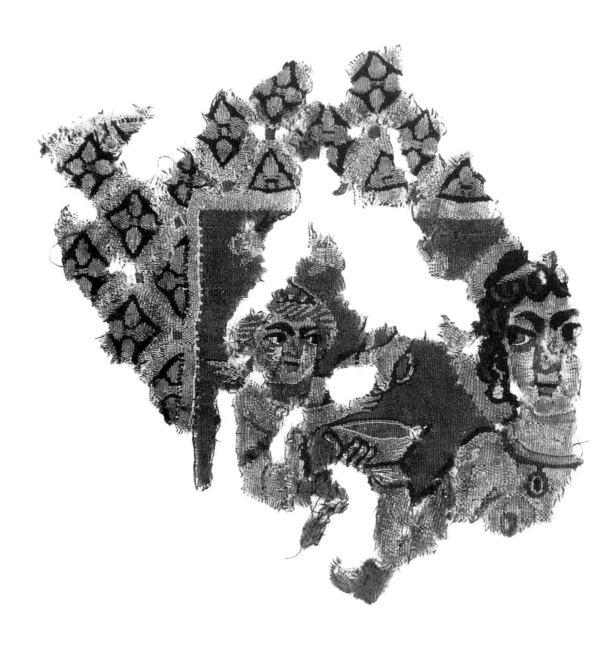

3.1. Tapestry-woven woolen fragment. Ann Arbor, University of Michigan, Kelsey Museum of Archaeology (22710). Photo: Kelsey Museum of Archaeology.

3

The Medium Matters: Reading the Remains of a Late Antique Textile

Thelma K. Thomas

Late antiquity may be characterized as a period that witnessed the transformation of media. This was a time of profound and innovative change in the visual landscape: the terrain of the known world became dotted with Christian *loca sancta* that vied with pagan shrines for a "makeover" of cosmic significance;[1] on a smaller scale, the cityscape was modified to correspond with evolving Christian imperial ideals and infrastructures.[2] Even in decorations within individual buildings, there was conspicuous concern with developing startling visual effects. Metamorphosis in the medium of mosaics, as tesserae crept up from their accustomed place on floors to cover walls and ceilings in envelopes of scintillating points of color, provides but one example of an increasingly playful spatial and coloristic aesthetic.[3] This "jeweled style," known in both the visual and the literary arts,[4] is an aesthetic of adornment that revels in polychromatic juxtapositions and contrasts which seek to outdo as much as to replicate effects seen in the natural world. A striking development of the aesthetic, one less well known than the transformation in mosaic decoration, took place within the realm of woven fabrics, as ornamental patterns grew in scale and compositional complexity.[5] The textile fragment in the Kelsey Museum discussed here (Fig. 3.1; Color Plate 1) is one example of the new style of pattern-weaving and will be read—via analysis of technique and iconography—in light of late antique documents alluding to this new style.

A skillfully made piece of cloth depicting pagan divinities, the Kelsey fragment was originally part of a much larger, intensely colorful rectangular composition.[6] It has suffered a great deal of damage since it was made in the fifth or sixth century: abrasion, tears and holes, stains and fading have reduced it to a ragged array of motley scraps. The small size of this piece (roughly 20 x 20 cm), however, facilitates close scrutiny of minute details of extremely delicate craftsmanship. Subtlety of coloring is most visible under a microscope, where it is revealed that pre-dyed wool fibers of various colors were spun together to create slender threads of heathered tones. Yet the means by which the striking effects were achieved can be discerned even by the naked eye. The underlying longitudinal threads of the warp

3

that were attached to the loom are of a very dark, perhaps mostly black, wool. Within the structure of the fabric this dark warp element is nearly invisible because the hand-carried shuttle overlaid it with horizontal weft threads in wools of deep and vibrant colors—blacks, reds, blues, browns, greens, pinks, yellows, and golds—along with whitish accents of undyed linen. These horizontal threads create a weft-faced design in tapestry-weaving technique in which large areas of color are woven as a unit (and only the longer slits resulting from this process are joined).[7] Juxtapositions of these swaths of color are sometimes outlined and sometimes gradually modulated by the heathered threads and by the underlying dark warp, which adds polychromatic depth to the entire composition but especially to the background.

Textile patterning in this period transfigured furnishings and clothing alike. New-style fabrics like these were, in a word, sensational. So we find, for example, in Paulus Silentiarius' mid-sixth-century ekphrasis of the newly built and furnished church of Hagia Sophia in Constantinople, a short passage on its silk tapestry-woven altarcloth:

> Whither am I carried? Whither tends my unbridled speech? Let my bold voice be restrained with silent lip lest I lay bare what the eyes are not permitted to see. But ye priests, as the sacred laws command you, spread out with your hands the veil dipped in the purple dye of the Sidonian shell and cover the top of the table. Unfold the cover along its four sides and show to the countless crowd the gold and the bright designs of skilful handiwork. One side is adorned with Christ's venerable form. *This has been fashioned not by artists' skilful hands plying the knife, nor by the needle driven through cloth, but by the web,*[8] the produce of the foreign [silk]worm, changing its colored threads of many shades. Upon the divine legs is a garment reflecting a golden glow under the rays of rosy-fingered Dawn, and a chiton, dyed purple by the Tyrian seashell, covers the right shoulder beneath its well-woven fabric.... Thus is everything clothed in beauty; everything fills the eye with wonder.[9]

The Silentiary's Homeric language may be heavy-handed in its emphasis on wonderment, but it is also rather subtle in its play on the contrasting actions of veiling and unveiling and in its use of nested imagery calling attention to woven representations of woven garments.[10] Such literary conceits will be shown to be relevant to an informed reading of the tapestry-woven woolen fragment in the Kelsey Museum, as will the Silentiary's praise of silk, imported from the eastern lands of China and Persia, renowned for its luster, the fineness of its threads, and its ability to accept dyes of brilliant hue.

3

————

Reading Medieval Images

As noted above, this artifact is just one small portion of an originally much larger composition, perhaps a hanging: only a corner of the border and main field survive. Enough of the repeating pattern of golden border motifs is preserved to reveal that it imitates, at least in part, metalworking designs.[11] More important for reconstruction efforts is the extreme breadth of this border relative to the surviving portion of the main field: the scene within must have been fairly large so as to command the overall design. The main field consists of a red background (more appropriately described as "reddish" due to the suggestion of depth provided by the dark warp) against which is represented the form of a winged child resembling Eros, the attendant of Aphrodite—dressed only in a cloak, cap, and strap for his (empty?) quiver—who raises a bottle over a cup of wine held by a beautiful nude young woman.[12] She is haloed, an indication of her divinity, and adorned with a diadem, drop earrings, and a gold necklace with jeweled pendant. The scene is calm, and the figures are in repose but animated by their side-long glances into each other's eyes. Although it is impossible to reconstruct the rest of the composition from the few preserved motifs, the red background, with no hint of landscape or architecture, suggests that this scene takes place not in the real world but in a sort of paradise of luxury and serenity, where chubby toddlers have the competent dexterity of trained servants, and the breeze lofting an as yet unidentified (unfortunately very damaged) motif does not disarrange one lock of the goddess' artfully curled ringlets. The Silentiary's learned, lyrical, and metaphorical description of the altarcloth at Hagia Sophia as clothing for furniture finds a secular parallel here, I suggest, in the sensitively modeled flesh—rose pink fingertips, cheeks, and breasts—that would have "clothed" the walls "in beauty," here, paradoxically, clothing with depictions of nudity.[13]

This kind of deliberate poetic transgression of the boundaries traditionally limiting media and subject matter is characteristic of late antique aesthetics. Metaphors drawing links between the expected visual effects of various media are constant tropes, and echoes across media are common. Patterned textiles, for example, sometimes imitated mosaic designs.[14] This may well reflect the fact that graphic renditions in the two media are, by necessity, similarly pointillist—even the subtlest shadings in tapestry-weaving retain distinct color juxtapositions that are psychedelically obvious at close range—forcing the artisans to work with dots and blocks of color.

Close viewing of large-scale fabric compositions would often have been hindered by the ways the pieces were hung on walls or in doorways, but a more distant perspective had advantages. Figured hangings were probably positioned so as to display fully their compositions; presumably if curtains were to be twisted and looped, more purely decorative and simpler designs that could not be dis-oriented by folds would have been preferred, with larger expanses of plain-weave that could

3
———

not be damaged by daily manipulations.[15] The more distant perspective on large-scale cloth furnishings would have had the additional side effect of bringing other furnishings into the late antique viewer's line of sight. When complete and in its original context, the Kelsey textile—whether a hanging or a covering—would have been read in association with other domestic furnishings.[16]

Excavated late antique interiors do not usually preserve fragile textiles intact and *in situ*.[17] But late antique visual documents depicting fabric furnishings suggest how textiles generated meaning within their architectural contexts. While illusionistic representations of interiors are rare (as are illusionistic representations of landscapes), fabric furnishings were often used to indicate interior spaces; curtains, hangings, covers, and veils were also employed as framing devices for figures. Representations of textiles thus functioned emblematically as signifiers of interior spaces and as hierarchical indicators of honor.[18] Actual textiles may well have served similar purposes.

Written documents provide information about how the meanings of fabrics and figured compositions were received by a range of late antique audiences. Compare, for example, the Silentiary's admiring description of the altarcloth in Hagia Sophia to the following oft-cited passage, illustrating that the contribution of textiles to the late antique aesthetic of ostentatious, hyper-refined display was not universally appreciated. The fourth-century Cappadocian bishop, Asterius of Amaseia, decried the new kind of weaving as unnecessary, therefore unspiritual, saying of those who commissioned these works:

> …they seek out new and superfluous forms of weaving,[19] which, through the way the warp is intertwined with the weft, imitate the force of the graphic arts…not only to adorn their walls and houses, but even their cloaks and clothing.[20]

Asterius, it is clear, regards those who wear these new-style fabrics as victims of fashion, rightly ridiculed *because* they have transgressed the proper boundaries of materials and media:

> When they come out in public dressed in this fashion, they appear like painted walls to those they meet. They are surrounded by children who laugh among themselves and point their fingers at the pictures on the garments. [21]

Asterius, who would have preferred plain clothes and plain walls to extravagant adornment, introduces his condemnation in a plain-spoken sermon on the gospel parable of "Lazarus and the Rich Man," portraying these sumptuous fabrics

as examples of the neglect of eternal health of the soul in favor of superficial cosmetics.[22] In a less well-known passage from the same sermon, Asterius speaks especially to the wealthiest members of his congregation, those who could have afforded these labor-intensive productions in the most expensive fabric: silk.

> ...if you abandon the sheep and the wool, and the indispensable provisions of the Creator of all, leading yourself astray by vain notions and capricious desires, and seek after silk, and join together the threads of the Persian worms, you will weave the windy web of a spider. And then you come to the dyer of bright colors, and pay hefty sums to have the shellfish drawn out from the sea, and anoint the garment with the blood of the animal. This is the deed of a wanton man, who abuses his property for want of a place to expend its superfluity. And for this reason such a one is attacked, accused by the Gospel as an effeminate idiot, adorning himself with the adornments of wretched little girls.[23]

Wealthy, status-conscious men and women paid lavish sums for pattern-woven woolen textiles, but, as Asterius implies, they paid even more for resplendently colored silks—especially imperial purple silks and cloths woven with golden threads. Although proscribed by sumptuary laws and legally produced only by imperially controlled craftsmen, these textiles were nonetheless still illegally commissioned and acquired;[24] they were also widely imitated.[25] Asterius may have intentionally discussed pattern-weaving of wools and silks together in the same sermon because he was aware that some finely figured wools deliberately imitated more prestigious silks.

Wool lends itself to the imitation of silk much more readily than other fibers: unlike linen and other cellulose fibers, it dyes easily; written sources frequently attest to cheaper dyes being used on wool to imitate the more costly dyes used on silk.[26] The lustrous effect produced by the colored warp in textiles like the Kelsey fragment appears to mimic the sheen of silk. And, as is evident in this piece, finely spun wool threads resulted in a cloth of light weight, as was possible in silk (and the highest grades of linen). In addition to imitating the brilliant colors, luster, and heft of silk, the fragment's woolen warp has been closely associated with textiles of Eastern, perhaps Syrian manufacture.[27] The red background, for example, recalls wall-hangings of Eastern, perhaps Persian origin, some of which are similar in composition if not in style. Thus, the fact that this piece was found in Egypt has interesting implications for its patronage. The owner may have purchased an imported trade good or bought or commissioned an Egyptian version of an exotic product. In either case, the purchaser, in displaying the textile, would have advertised an expensive, cosmopolitan taste.[28]

3

Iconographic motifs, of course, seem to offer more direct clues to the hanging's intended message. Erotes offering libations and gifts, and beautiful nude female divinities set against red backgrounds, are found in various combinations on a group of late antique hangings,[29] so this is not an entirely unique composition. In all cases, commonplace motifs, variously arranged, do not illustrate a distinct narrative event but speak to the fundamental theme of erotic love, as encountered in many antique texts. The identifiable motifs on the Kelsey fragment—the erote, nude beauty, wine, the sly glance, even the colors red and gold—are found in numerous epigrammatic commentaries on lust. These poems were written by men, and so seem to suggest that the pictorial motifs were chosen to anticipate or elicit arousal from a man, or men, although we have no evidence for the gender of the audience beyond the work itself. In any event, as is shown in the following quotations, each motif has multiple conventional poetic associations for passion. Aphrodite's Eros, or Love, shoots his arrows to wound with inflaming desire. The erote in this composition seems to have exhausted his arsenal, as he has in this poem by Irenaeus Referendarius, who speaks to his new-won lover, Rhodope:

> O haughty Rhodope, now yielding to the arrows of Cypris, and foreswearing your insufferable pride, you hold me in your arms by your bed, and I lie, it seems, in chains with no desire for liberty. Thus do souls and languid bodies meet, mingled by the streams of love.[30]

Eros also wounds when he offers wine that intoxicates, heightens sensual pleasure, and loosens inhibitions. The sixth-century Egyptian poet Agathias Scholasticus wrote of wine offered by a lover:

> I care not for wine, but if you would make me drunk, taste the cup first and I will receive it when you offer it. For, once you will touch it with your lips, it is no longer easy to abstain or to fly from the sweet cup-bearer. The cup ferries your kiss to me, and tells me what joy it tasted.[31]

Red suggests wine, dusk and dawn, flushed skin and passions' fires. Again, Paul the Silentiary:

> How long, O eyes, quaffing boldly beauty's untempered wine, will you drain the nectar of the Loves! Let us flee far away, far as we have the strength, and in the calm to a milder Cypris I will pour a sober offering. But if even there the fury possesses me, I will bid you be wet with icy tears, and suffer for ever the pain you deserve; for it was you, alas! who cast me into such a fiery furnace.[32]

Gold is expensive, precious, and serves as payment, even for love. The sixth-century Egyptian consul Macedonius writes:

> I pursue Love with gold; for bees do not work with spade or plough, but with the fresh flowers of spring. Gold, however, is the resourceful toiler that wins Aphrodite's honey.[33]

Beauty appeals and nudity arouses. Again, Macedonius the Consul:

> Your mouth blossoms with grace and your cheeks bloom with flowers, your eyes are bright with Love, and your hands aglow with music. You take captive eyes with eyes and ears with song; and with your every part you trap unhappy young men.[34]

As was traditional for wall-paintings and other furnishings, choice of subject matter could echo the activities occurring in the rooms in which they were placed, and mythological erotic themes were conventional choices for bedrooms.[35] A second-century sermon by Clement of Alexandria describes this practice, quoting Homeric verses on divine dalliances only to denounce their use as erotic decorative themes:

> Cease the song Homer. There is no beauty in that; it teaches adultery. We have declined to lend even our ears to fornication.
>
> But most men are not of this mind. Casting off shame and fear, they have their homes decorated with pictures representing the unnatural lust of the daemons. In the lewdness to which their thoughts are given, they adorn their chambers with painted tablets hung on high like votive offerings, regarding licentiousness as piety; and, when lying upon the bed, while still in the midst of their own embraces, they fix their gaze upon that naked Aphrodite, who lies bound in her adultery.[36]

The Kelsey textile seems to present just such themes. Other decorative objects within the room, as well as music, scent, and intentionally graceful dance-like postures, would have further enhanced the hanging's capacity to inspire poetic associations in ekphrastic love-talk.[37] Dark, lamplit atmospheres and perhaps even gentle breezes moving the lightweight cloth would have completed the visual effect to promote fleeting, ephemeral, changeable impressions.

The piece under discussion is one among thousands of examples of late antique pattern-woven textiles in museum collections worldwide. Most, like the Kelsey Museum fragment, were purchased on the art market and thus lack the archaeological documentation necessary for precise dating or contextualizations

3

specific to particular sites and patrons. Nonetheless, other interpretive efforts are well served by the surviving material evidence because, for these pattern-woven textiles, the medium is an important part of the message. Close analyses of pattern-woven furnishings and clothing elicit a wealth of information about technical innovations important for the "jeweled style" in late antiquity. Comparisons yield a wide range of societal conventions for expression as, throughout the period, media continued to evolve within an aesthetic milieu in which viewers were deeply sensitized to vividly sensational effects at the expense of merely realistic representation. Nevertheless, the fragmentary condition of these textiles reminds us that interpretations should rely on more than the artifacts themselves. Literary sources establish that this popular aesthetic of adornment was pervasive in the private and public spheres, in religious and secular settings, and that it was adapted by both institutions and individuals. The Silentiary's description of the altarcloth at Hagia Sophia presents an example of a pattern-woven textile in the most precious of materials intended for public viewing in the grandest religious monument of the empire, whereas it is likely that the far more modest fragment in the Kelsey Museum collection would have been used in a domestic setting. The fragment, interpreted in this way, attests to a personal commitment to sensuality, luxury, and cosmopolitan currents in fashion (if only in imitation) and may in addition offer a glimpse into one individual's pretensions to godlike seduction.

1 André Grabar, *Martyrium*, 2 vols. (Paris, 1943–46) offers the classic presentation of this phenomenon in late antiquity.

2 Richard Krautheimer, *Three Christian Capitals: Topography and Politics* (Berkeley, 1983).

3 Roger Ling, *Ancient Mosaics* (Princeton, 1998), 104–9.

4 See Michael Roberts, *The Jeweled Style: Poetry and Poetics in Late Antiquity* (Ithaca, 1989). Henry Maguire, in *Art and Eloquence in Byzantium* (Princeton, 1981), has traced the continuation of this traditionally close relationship between the literary and visual arts into later, highly schooled Byzantine church culture. This paper is more concerned with personal responses to and uses of visual-poetic conventions, recognizing commonplace tropes that ally the visual and the verbal as informative for reconstructions of settings for artifacts of everyday life.

5 Diane Lee Carroll, *Looms and Textiles of the Copts* (Seattle, 1988), 29. Annemarie Stauffer's *Textiles d'Egypte de la Collection Bouvier: Antiquité tardive, période copte, premiers temps de l'Islam* (Fribourg, 1991), 13–20, and *Textiles of Late Antiquity* (New York, 1995), 7–9, are useful for their informed considerations of the fuller aesthetic implications of this technical development in its wider geographical and cultural contexts, although such is implicit throughout in Mechtild Flury-Lemburg's discussions of late antique works in *Textile Conservation and Research* (Bern, 1988).

6 In its original condition, this piece might well have been compositionally as dense as a contemporary hanging now in the Textile Museum in Washington, DC. For illustration and description, see James Trilling, *The Roman Heritage: Textiles from Egypt and the Eastern Mediterranean 300 to 600 A. D.* (Washington, DC, 1982), 42.

3

7 On tapestry-weaving, see Dorothy K. Burnham, *Warp and Weft: A Textile Terminology* (Toronto, 1980), 144–49.

8 Emphasis added to underscore the Silentiary's notice of pattern-weaving technique, i.e., his awareness that this composition was created not by embroidery—sewing on fabric—but by weaving. The emphasized phrases also suggest these dazzlingly intricate textiles gave new meaning to the cliché describing a finely woven fabric as a web.

9 Translation in Cyril Mango, *The Art of the Byzantine Empire, 312–1453: Sources and Documents* (Englewood Cliffs, NJ, 1986), 88–89.

10 John Scheid and Jesper Svenbro, *The Craft of Zeus: Myths of Weaving and Fabric* (Cambridge, MA, 1996), 4, present a fascinating discussion of metaphors concerning cloth and cloth production as "generative mythology" in Greek and Roman culture. Many of the themes they outline remain current throughout late antiquity.

11 Compare to illustrations in Jutta-Annette Bruhn, *Coins and Costume in Late Antiquity* (Washington, DC, 1993), 43, and esp. 47. For a brief discussion of a textile design imitating metalwork, 51–52. On imitation across media in late antique ornament, see below, n. 14.

12 For possible heroic as well as divine associations of the figure's nudity, see Larissa Bonfante, "Nudity as a Costume in Classical Art," *American Journal of Archaeology* 93 (1989), 543–70.

13 Some examples of late antique poetic associations drawn between the physical properties of crafted materials and unseen sensations are especially apt, e.g., a sixth-century poem by Agathias on a portrait painted in encaustic (*Greek Anthology*, book 16, no. 80; trans. Mango, 119): "I have been a courtesan in Byzantine Rome and offered my love for sale to all comers. I am crafty Callirhoe. Smitten by passion, Thomas has set up this, my portrait, showing all the ardor he has in his breast; for like wax is his heart melting."

14 And, in turn, mosaics imitated textiles, just as they also mimicked precious stones. Artifactual examples of media imitations abound, but written sources provide many further instances of transgressions based on enhanced affinities between media. Thus, in the following sixth-century description of the Church of the Virgin Katapoliane in Paros (Nicetas Magister, *Vita S. Theoctistae Lesbiae*, 3–4, AASS, Nov. 4, 226; Mango, 104): "So delicately did the craftsman finish the stone, that the wall seemed to be clothed with purple fabric, while the glitter of the stone exhibited such liquid refulgence as to surpass the brilliance of pearls." Bruhn, *Coins and Costume*, 34, speaking of a pattern-woven representation of jewelry on an article of clothing: "It must have been such a jeweled garment of which the sixth-century poet Venantius Fortunatus wrote, 'Indeed, that man is exceedingly happy when his limbs are covered by the gleam of precious stones instead of by wool.'"

This is, of course, part of a larger aesthetic enterprise, that of the jeweled style. Roberts, *The Jeweled Style*,117–18, for example, notes comparisons between ornaments on fabric and ornaments in literature as colorful units of composition: "Segmenta are brilliantly colorful patches applied to areas of fabric. To achieve similar effects in other media, late antiquity employed precious stones. Jewels are everywhere in this period; in addition to the more obvious items (necklaces, earrings, bracelets, diadems, crosses, brooches), they appear on cups…, bowls, the trappings of horses, weapons and helmets, scepters, shoes and clothing, buildings, beds, and musical instruments—in fact any geometrically circumscribed space. Late antique taste did not tolerate the unadorned; brilliance of effect, the play of contrasting colors is all." Similarly, descriptive terms could be applied in late antiquity equally to the visual and written arts. "The Greek word *graphe*, for example, was used for both writing and painting, *historia* could mean either a written history or a picture" (Maguire, *Art and Eloquence*, 9). These same interrelations are expressed in now famous late antique quotations, such as Asterius' "We men of letters can use colors no worse than painters do" and John of Damascus' "The word is to the hearing what the image is to sight" (ibid., 22).

15 Hangings were not necessarily hung from rods and displayed flat but were often hung from hoops and hooks, which themselves could have visually mischievous inflections and could take, for example, the shape of a bent finger: an example is illustrated and described in Eunice Dauterman Maguire, Henry P. Maguire, and Maggie J. Duncan-Flowers, *Art and Holy Powers in the Early Christian House* (Urbana, 1989), 50.

16 Bettina Bergman, "The Roman House as Memory Theater: The House of the Tragic Poet in Pompeii," *Art Bulletin* 76 (1994), 254; Dominic Monserrat, *Sex and Society in Graeco-Roman Egypt* (London, 1996), 220–22.

17 Egypt is unusual for the preserving qualities of its dry climate, and because of the abundance of textiles surviving there, all late antique pattern-woven textiles were once thought to be Egyptian (Coptic) in origin. Syrian excavations, however, continue to add important evidence for more broadly dispersed trends in textile manufacture and consumption, and archaeological projects in Eastern Europe, the Middle East, and the Far East necessitate drastic revisions to the restrictive attributions of late antique textiles, even those found in Egypt; see Stauffer, *Textiles of Late Antiquity*, 7–8; Trilling, *The Roman Heritage*, 16–17.

18 Written documents point to similar functions for textiles in real spaces. They also confirm use of textiles as "doors," suggesting the need for care in application of the term wall hanging. The following fifth-century description of a door hanging (Epiphanius, Letter to John, bishop of Aelia; Mango, 42–43), describes a cleric's hostile reaction to large-scale fabrics with figured compositions in religious settings:

3

As we were proceeding to the holy place of Bethel in order to join thy Honor, and when we came to the village called Anautha, we saw a lighted lamp and, upon enquiring, were informed that there was a church in that place. Having entered [the church] to perform a prayer, we found at the door a dyed curtain upon which was depicted some idol in the form of a man. They alleged that it was the image of Christ or one of the saints, for I do not remember what it was I saw. Knowing that the presence of such things in a church is a defilement, I tore it down and advised that it should be used to wrap up a poor man who had died. But they complained, saying, "He should have changed the curtain at his own expense before tearing this one down."

19 Homily 1. "Weaving" is translated by Mango, 50, as "vain and curious broidery." Greek words describing pattern-woven textiles are not infrequently rendered as "embroidered." See A. J. B. Wace, "Weaving or Embroidery?" *American Journal of Archaeology* 52 (1948), 51–55.

20 I thank Anthony Kaldellis for this unpublished translation.

21 Mango, 50–51. Unlike Asterius and Epiphanius (n. 18), and like Paulus Silentarius, other early Christian writers appreciated the overwhelming aspects of this late antique aesthetic of luxury. The sixth-century rhetorician Choricius of Gaza, for example, wrote (*Laudatio Marciani*, 1.23; Mango, 61): "When you enter [the church], you will be staggered by the variety of the spectacle. Eager as you are to see everything at once, you will depart not having seen anything properly, since your gaze darts hither and thither in your attempt not to leave aught observed: for you will think that in leaving something out you will have missed the best."

22 Luke 16:19–31: "There was a rich man who used to dress in purple and fine linen and feast magnificently every day. And at his gate there lay a man called Lazarus, covered with sores, who longed to fill himself with the scraps that fell from the rich man's table. Dogs even came and licked his sores. Now the poor man died and was carried away by the angels to the bosom of Abraham. The rich man also died and was buried." Guess who was tormented in Hades!

23 From an unpublished translation by Anthony Kaldellis.

24 Theodosian Code, 10.21, nos. 1–3 prohibit private use and manufacture of purple-dyed silk as well as the highest grade of linen and gold threads; and in no. 3 (Theodosius to Maximinus, Count of the Sacred Imperial Largesses, Constantinople, January 16, 424), the crime is classified as "high treason" and thus open to punishment by exile or death. Trans. Clyde Pharr, *The Theodosian Code and Novels and the Sirmondian Constitutions* (New York, 1952), 288. According to Theodosian Code, 10.20.18 (to Apollonius, Count of

the Sacred Imperial Largesses, Constantinople, March 8, 436), officials who allow the clandestine purple dyeing of silk are to be punished by exile to dye works in Syria.

25 Trilling, *The Roman Heritage*, 81 (no. 83) and pl. 7, catalogues a roundel from Egypt that is tapestry-woven with gold threads and purple wool in imitation of purple silk.

26 This is especially the case for purples described as, e.g., pseudo-purple (*pseudoporphuron, porphuro rhidzias*) vs. shell-dyed (*alethinocrustae*). See also Pliny, *Historia naturalis*: on dyes, book 9, 18–19; on wool, book 7; on silk, book 11.

27 On works possibly of Syrian origin, traded to Egypt, see Stauffer, *Textiles of Late Antiquity*, 9; and on unresolved questions of the origins of a group of large wall hangings with red backgrounds that resemble Persian products, Dominique Bénazeth and Patricia Dal-Prà, "Renaissance d'une tapisserie antique," *Revue du Louvre* 45/4 (1995), 29–40, esp. 34.

28 In the event of a unique commission, the purchaser could have had a good deal of input into the devising of the hanging's imagery. Such personally inspired commissions are described in Asterius' Homily 1 (Mango, 51): "The more religious among rich men and women, having picked out the story of the Gospels, have handed it over to the weavers." Many models for clothing designs are preserved; see Ulrike Horak, *Illuminierte Papyri, Pergamente und Papiere*, vol. 1 (Vienna, 1992).

29 Bénazeth and Dal-Prà, "Renaissance," discuss the famous hanging with two "nereids" in the Dumbarton Oaks collection (acc. no. 32.1; cf. the reference to Sirens in n. 37 below) and a hanging with multiple registers of offering putti in the Textile Museum (cited in n. 6 above).

30 *Greek Anthology*, Book 5, no. 249; trans. W. R. Paton, LCL (London, 1916–18; rpt. Cambridge, MA, 1969–83), with emendations here and elsewhere.

31 *Greek Anthology*, Book 5, no. 261.

32 *Greek Anthology*, Book 5, no. 226.

33 *Greek Anthology*, Book 5, no. 240.

34 *Greek Anthology*, Book 5, no. 231.

35 For recent discussions of the appropriate and thoughtful placement of decorative themes in wall painting and mosaic, see Bergman, "The Roman House as Memory Theater," 225–56; see also Andrew Wallace-Hadrill, "Engendering the Roman House," in *I, Claudia: Women in Ancient Rome*, ed. Diane E. E. Kleiner and Susan B. Matheson, exh. cat. (Austin, 1996), 104–15.

3

36 Clement of Alexandria, *Exhortation to the Greeks*, ch. 4; trans. G. W. Butterworth, LCL (London, 1919; rpt. Cambridge, MA, 1953).

37 See, for example, *Greek Anthology*, Book 5, no. 241, by Paulus Silentarius: "'Farewell' is on my tongue, but I hold in the word with a wrench and still abide near you. For I shudder at this horrid parting as at the bitter night of hell. Indeed your light is like the daylight; but that is mute, while you bring me that talk, sweeter than the Sirens, on which all my soul's hopes hang."

zaid abuhamar. Primus q̃ kabalabbar. sequentiū omniū testimonio. cum in scripturis ppham hunc sctō nascitu rum studiose didicisset. omnéq; histo riam uiri astrologico testimonio ap pbasset. ecce sctōp serie inipsis dieb' suis. uirū natū audit inciuitate arabię ieserab. omīa pruidentię suę signacta preferente. Celebri demū fama fre quentiq; testimonio motus hominē adit. qué undiq; uersum pspiciens. omnéq; modū eius & conuersationē obseruans. ita quidē ut ipsas etiam corpis notas easdem quas presigna uerat repiret. ut in fronte maclam. inter scapulas huiusmodi karacterem. hunc ipsum esse

Mahvmeth

The "Portrait" of Muhammad in the Toledan Collection

4

Walter B. Cahn

In the years 1142–43, the abbot of Cluny, Peter the Venerable, traveled to Spain on a church-political mission and, perhaps, for the purpose of making a pilgrimage to the shrine of St. James at Santiago de Compostela. In the course of his journey, he arranged for a Latin translation of the Koran and other writings on Islamic doctrine and traditions to be made, employing for this purpose a team of learned men that included a Mozarabic cleric, Peter of Toledo; an Englishman named Robert of Ketton, archdeacon of the cathedral of Pamplona; and a scholar with scientific interests and impressive literary gifts, Herman of Dalmatia.[1] Although famed for his mild and judicious temperament, Peter was an ardent and combative defender of the faith. His involvement with Islam followed the composition of an earlier tract directed against the Petrobrusian heresy, completed around 1139,[2] and preceded the writing of an equally venomous refutation of Jewish beliefs, which is thought most likely to have been written between the years 1144 and 1146–47.[3] The translation of the Koran and accompanying texts, known as the Toledan Collection, has come down to us in a number of complete or partial manuscripts and was published in an edition printed in Basel in 1543.[4] In spite of its polemical character, it represented a considerable advance in the knowledge concerning Islam that had been available in the Latin West and was to remain for a long time the principal source of information about the life and religion of its founder.

In a groundbreaking article published in 1948, Marie-Thérèse d'Alverny was able to demonstrate that a manuscript in the Arsenal Library in Paris was in fact the original copy of the compilation, brought back from Spain by the abbot of Cluny.[5] In her meticulous description of the contents of the volume, a work of rather sober disposition with little decorative embellishment, d'Alverny drew attention to the presence on folio 11 of a depiction of the prophet Muhammad—the earliest thus far uncovered—of which she furnished a description and illustration in the form of a pen sketch.[6] It has since then acquired a certain familiarity through photographic reproduction in books like Norman Daniel's *Islam and the West* and the introductory volume of John Williams' recent *The Illustrated Beatus*.[7] Measuring approximately 3 cm in height, it shows a composite creature with the head of a bearded man, staring forward intently, and a body roughly shaped like a fish,

4

attached rather awkwardly to it (Fig. 4.1). Along the upper right side of the design and touching a plume-like fin connected to the creature's "shoulder" is an irregularly drawn and somewhat flattened oval, in which is inscribed, in a display script mixing capital and minuscule letters, the name *Mahumeth*.[8]

The drawing is executed in a vermilion red color, with the exception of the name of the prophet, which is written in a dark brown ink, while touches of the same dark color are used to give emphasis to the pupils of the eyes and the curvature of the eyebrows. It is a scribal ornament, drawn in a sketchy manner, though with a certain deliberation. Although it has been described as a caricature, this requires some qualification with respect especially to the facial features, which are by no means notably

4.2. "Face initial." New Haven, Yale University, Beinecke Rare Book and Manuscript Library, MS 635 (Cistercian Customary), fol. 39v. Photo: author.

distorted or grotesque in their effect but rather convey a vague impression of earnest and faintly quizzical concentration. The physiognomic type is known to us from the familiar, though as yet not much studied, "face initials" of early medieval and Romanesque book illumination, of which a Cistercian Customary from Fitero, in northern Spain, recently acquired by the Beinecke Rare Book and Manuscript Library at Yale University, provides a series of examples (Fig. 4.2).[9]

D'Alverny credits J. Baltrušaitis with the not very well-founded observation that the drawing resembles certain Mozarabic ornamental letters featuring fish or parts of fish in their construction, but she also advanced another, more plausible explanation of her own for the design, pinpointing its source in a passage of Peter the Venerable's writings. In one of the introductory texts of the Toledan Collection, a summary of Muslim beliefs entitled *Summa totius haeresis Saracenorum*, or *Summa brevis*, Peter criticizes what he sees as the eclectic and incoherent nature of these doctrines, citing by way of figurative support for this contention the opening passage of Horace's *Ars poetica*: "Suppose a painter wished to couple a horse's neck with a man's head, and to lay feathers of every hue on limbs gathered here and there, so that a woman, lovely above, foully ended in an ugly fish below; would you restrain your laughter, my friends, if admitted to a private view?"[10] It should be noted that this citation occurs on folio 2v of the Arsenal manuscript and thus at a distance of some eight leaves from the drawing that concerns us, though this is not

4.3. Initial to Horace, *Ars Poetica*. Biblioteca Apostolica Vaticana, Reg. Lat. 1701, fol. 60r. Photo: Biblioteca Apostolica Vaticana.

necessarily a disabling objection to its relevance here. A more serious cavil could be the fact that Horace speaks—in the truncated version of his words given by Peter—of the monstrous coupling of a man's head with a feather-covered horse's neck, while the drawing appears to conjoin man and fish. Yet the fish forms are rendered, perhaps intentionally, with a certain freedom or imaginative elaboration that strikes one as consistent with the spirit of the poetic dictum, if not the precise letter.

Early medieval illustrations containing the *Ars poetica* and inspired by the verses which concern us have been collected by Claudia Villa.[11] These enable us to get some sense of the range of interpretation stimulated by the poet's description of an undoubtedly complicated image. The fine opening initial H in a German manuscript of the eleventh century preserved in the Vatican Library (Fig. 4.3) gives Horace's figure the head of a woman, a winged, scaly body terminating in a spiraling foliage frond, and the forequarters of a horse.[12] Other manuscripts seem to agree in giving the figure a female head, but in some cases the creatures have bird or bird-like or equine bodies and in others they terminate in the tail of a fish.

The drawing of the prophet is attached to the fourth item included in the Arsenal manuscript, entitled "On the Birth and Nurture of Muhammad" (*De generatione Mahumet et nutritura eius*), which was translated, according to the rubricated title, by the already mentioned Herman of Dalmatia.[13] Occupying a space spanning the last four lines of text along the right edge of the first of the two text

4

columns that fill the page, it is not an improvised addition but must have been planned by the scribe, who adjusted the lines of writing to make room for it. The somewhat flattened curvature of the head and upper body of the creature takes the line of text above it into account, as does the irregularly shaped cartouche with the prophet's name, while the curling fish tail is threaded with some strain between the words *ipsum* and *esse* along the bottom of the page. This type of nonfunctional textual ornament—it is neither an initial nor a line ending—is quite rare in medieval manuscript illumination, though something like it is found in the Beatus of Valladolid of ca. 970, where a depiction of a drowned corpse and a raven, the customary appendage to depictions of Noah's Ark in Beatus manuscripts, floats in a sea of writing on the preceding page.[14]

De generatione Mahumet is a legendary account of the prophet's genealogy reaching back to Adam and the creation, when a "seed of light" that was eventually to descend upon Muhammad came into being.[15] We follow its transmission by way of Enoch and Methuselah, Noah and his son Shem, through Ishmael, Abraham's son by Hagar, to the immediate family of the prophet at Mecca. *De generatione* begins with a list of authors consulted by the compiler of this flattering history, followed by the testimony of the last-mentioned among these, a certain Ka'b al-Ahbār, a Yemenite Jew well known to us from other sources, who was an early convert to Islam.[16] Ka'b, we are told, knew that Scripture and astrology concurred in predicting the appearance of a new prophet. Having heard of Muhammad's birth, he journeyed to Mecca, observed his "manner and conversation," and noted that his body bore a mark between his shoulders (or shoulder blades), which he took as a decisive sign of God's conferral of the prophetic office upon him. The drawing that concerns us occurs at the very point in the text where the author refers to the mark, and it is evident from the wording "*inter scapulas huius modi*" that the design, or some aspect of it, was meant to refer to this sign.

The birthmark, or "seal," of the prophet is mentioned in Ibn Ishaq's eighth-century biography of Muhammad, known to us in the edition of Ibn Isham (d. 833), which is the oldest account of his life that we have.[17] Here it is described as being "like the imprint of a cupping glass" and elsewhere as being a "fleshy protuberance or a kind of mole the size of a pigeon's egg,"[18] while another author claims that the spot was marked by a tuft of hair.[19] In a later section of *De generatione*, where an account of the miraculous events that surrounded Muhammad's birth is given, we learn that three men with "faces radiant as the sun" came to him with gifts, a story that was in all likelihood inspired by the relation of the journey of the wise men to Bethlehem in the Gospels. Muhammad received the seal-like mark from one of these men, who impressed it on his body.[20] The Islamic tradition treats the mark in the first instance as a sign of Muhammad's prophetic calling. But it also understands the notion of the mark or seal to designate Muhammad as the last of the

4

prophets, the rightful successor to Abraham, Moses, and Jesus. As the Koran states (33:40): "Muhammad is the father of no man among you. He is the apostle of Allah and the Seal of the Prophets."

The word *character* used by the translator, along with *macula*, to describe the mark merits special attention. In the Vulgate Bible, it is employed seven times, and exclusively in the Apocalypse, in place of the word *signum*, preferred elsewhere, to denote the mark of the Beast that was placed on the hand or forehead of the wicked followers of the demon.[21] Thus, the Beast of the Earth "will cause all, the small and the great, and the rich and the poor, and the free and the bond, to have a mark on their right hand and on their foreheads [*habere characterem in dextera manu sua aut in frontibus suis*] and it will bring about that no one may be able to buy or to sell, except him who has the mark, either the name or the number of its name [*nisi qui habet characterem, aut nomen bestiae, aut numerum nominis eius*]" (Apoc. 13:16–17). Particularly significant for our purposes is Apocalypse 19:20, which relates the defeat of the Beast and of his acolyte, "the false prophet who did signs before it wherewith he deceived those who accepted the mark of the Beast and who worshipped its image [*quibus seduxit eos, qui acceperant characterem bestiae*]." We may take it for granted that the negative connotations of *character* were understood by readers for whom the biblical text, and the Apocalypse in particular, were familiar fare. The effect of its use by the translator was thus to transform the mark from a sign of divine election into its opposite, fastening on Muhammad and his teaching the charge of false prophecy and demonic inspiration.

There has been much speculation about the nature of the dreaded Apocalyptic mark. The term *character* suggests a mystical letter of some sort, and the Apocalypse speaks of it rather obscurely as exhibiting "the name of the Beast or the number of its name," which it gives as 666 (Apoc. 13:18). Early Christian commentators used esoteric correspondences between letters and numbers to interpret the figure as a reference to a Roman world ruler, identified as Gaius Caesar, or, according to another reading, Nero.[22] Illustrations of the Apocalypse sometimes render the mark as a simple spot, but more often than not, it is omitted, presumably reflecting the view that it was visible only through the aid of higher, spiritual insight.[23] It is my contention that the cartouche with the name *Mahumet* that adjoins the drawing in the Arsenal manuscript refers to this distinctive and shameful mark and that it is so situated as to point to the location *inter scapulas*, as the text has it. The oval shape of the cartouche may well have been intended to suggest an ancient seal or amulet.[24] This absorption of the Apocalyptic *character* into the realm of magic and the occult could only bring it under greater suspicion. It is, in any case, a connection that a man like Herman of Dalmatia, the translator of *De generatione*, would have been well prepared to make. Herman specialized in the translation of Arabic philosophic texts and Arabic versions of ancient scientific

4
———

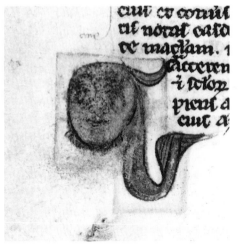

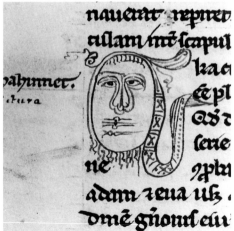

4.4. Muhammad. Paris, Bibliothèque nationale de France, MS lat. 3668 (Toledan Collection), fol. 12v. Photo: Bibliothèque nationale de France.

4.5. Muhammad. Oxford, Corpus Christi College, MS 184 (Toledan Collection), fol. 20r. Photo: Corpus Christi College.

literature, having produced, among other works, Latin editions of Euclid's *Elements*, the *Planisphere* of Ptolemy, and two compilations of astrological lore.[25] Indeed, his efforts on behalf of Peter the Venerable's anti-Islamic project is his only known involvement in the cause of Christian apologetics.

Medieval exegesis of the Apocalypse and eschatological speculation do not present a consistent view on the identity of the demonic figure who draws those bearing his mark into his service. The commentary of Beatus, faithful to the spiritualizing approach of Tyconius, does not explicitly connect the time of tribulations in the last days with a specific enemy of God's elect, or with Islam or its prophet in particular, while other, more historically grounded readings propose for the embodiment of the rule of the Beast a variety of past and present champions. Muhammad is identified as Antichrist in Paul Alvarus' *Indiculus luminosus*, written in order to justify the provocative actions of Christians who incurred martyrdom at Cordoba, and later, by Pope Innocent III in the context of crusading ideology, but these seem to have been isolated instances.[26] On the other hand, Muhammad was commonly ranked by Christian controversialists among the false or pseudo-prophets, in relation to the passage from the Apocalypse already cited and Matthew 24:11, "And many false prophets shall arise and shall seduce many," placing him in a long line of heretics, *sectatores*, and impostors who, through their nefarious teachings, prepared the way for the coming of Antichrist. This is the argument made by an anonymous ninth-century Asturian or Mozarabic polemic, entitled *Adnotatio Mammetis*

4

Arabum principis, in which he is called "Mammet hereticus, Arabum pesudo-prophetarum sigillus, Antichristi precessor."[27] It is also the argument developed by Peter the Venerable, who sees Muhammad as having given nourishment to the seeds sown by the heresiarch Arius, which Antichrist will eventually bring to full fruition.[28]

The drawing in the Arsenal manuscript appears as well in two later copies of the Toledan Collection, which descend, according to d'Alverny, from a revision of the original compilation made at Cluny. A version of it, found in a fourteenth-century manuscript of the Bibliothèque Nationale, transmits the design in somewhat economical fashion, using opaque colors and placing it within a squarish panel (Fig. 4.4).[29] The full significance of the original design was probably no longer intelligible, for the image has been displaced into an indentation on the left side of the text column in the manner of an initial letter, though it does not in fact precede a particular word. The "mark" with the name Muhammad is also omitted, but the basic elements of the original composition, rendered in a simplified form, can still be made out, in spite of some damage due to rubbing: a plump, inexpressive face with staring eyes and a plume-like "fin" at the back, to which is attached a fish tail, thin and twisted like a serpent's. A second example of the image, found in a late thirteenth- or early fourteenth-century manuscript at Oxford, is executed in the calligraphic arabesque of Gothic flourished letters and accompanied by the marginal inscription *Mahumet* (Fig. 4.5; the word *pictura* beneath is a later addition).[30] Like the painted version in the Paris manuscript, it emphasizes the head in relation to the now barely residual body, and it is also placed along the left edge of the text, simulating the effect of an initial. We may assume that these features reflect the disposition of the Cluniac archetype, which is now lost.

Beyond the placement of the design in the text column and its functional transformation into a *faux* initial, a second alteration occurred in the Cluny scriptorium. While the creature in the Arsenal manuscript brought back from Spain could be described, consistent with the words of Horace that I have quoted, as being of a mixed and anatomically uncertain character, the copies simplify, abbreviate, but also fortify its marine or fishy personality, leaving it now unambiguous. Hybrid monsters, half-men and half-fish, distant descendants of the sea creatures of ancient mosaic pavements and sarcophagi, occasionally make an appearance in early medieval and Romanesque art.[31] A twelfth-century capital of unknown origin preserved in the Mittelrhein-Museum in Koblenz features such a hybrid, whose tonsure and monastic cowl probably harbor a moralizing or satirical purpose (Fig. 4.6).[32]

In the present context, however, the allusion made by the image of the Toledan Collection—intentional, I would like to think—is to the sea creature that most vividly embodied for the Middle Ages the mixture of seductive and deadly deceitfulness that characterized false doctrine: the siren. Romanesque art displays a certain fondness for this dangerously beguiling figure of ancient mythology.[33]

4

Following Homer and the *Physiologus*, sirens were half-woman, half-bird, while others, on the authority of the seventh- or eighth-century *Liber monstrorum*, had fish bottoms. In book illumination as well as in sculpture, both variants are sometimes seen side by side. The siren's mellifluous song, luring Odysseus' sailors to their perdition, could be likened to the deceptive attractions of the world and of false doctrine. This is the interpretation given by the third-century theologian Hippolytus, who in his *Philosophoumena* (or *Refutation of All Heresies*) argues that just as Odysseus filled the ears of his companions with wax and bound himself to his ship's mast in order to withstand the lure of the sirens' song, those whose weakness would expose them to the seduction of heretical teachings should stop up their ears or bind themselves to the cross of Christ and so escape from harm.[34]

Writings defending orthodox doctrine and decrying dissidence not surprisingly avail themselves of the example implicitly to equate true belief with chaste self-denial and heresy with the pleasurable snares of *voluptas*.[35] The innuendo of temptation and seduction indeed constitutes one of the principal strands in the criticism leveled by Peter the Venerable against Muhammad, his alleged sensuality, a sure mark for him of the prophet's fundamental inauthenticity.[36] But, of course, the scraggly-bearded, lubricious old triton of the Arsenal manuscript is no siren at all, for in the polemical perspective of the work, even the fraudulence of imposture cannot be trusted to be the genuine thing.

4.6. Capital with monk-headed fish. Koblenz, Mittelrhein-Museum. Photo: Gauls, Koblenz.

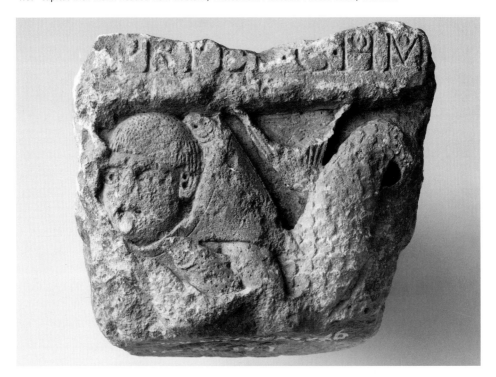

Reading Medieval Images

1 Charles Julian Bishko, "Peter the Venerable's Journey to Spain," in *Petrus Venerabilis, 1156–1956*, ed. Giles Constable and James Kritzeck, Studia Anselmiana, vol. 40 (Rome, 1956), 163–75 [rpt. in the author's *Spanish and Portuguese Monastic History, 600–1300* (London, 1984), no. XII]; James Kritzeck, *Peter the Venerable and Islam* (Princeton, 1964), 3ff.; Jean-Pierre Torrell and Denise Bouthillier, *Pierre le Vénérable et sa vision du monde*, Spicilegium sacrum Lovaniense. Études et documents, fasc. 42 (Louvain, 1986), 59ff. This brief essay gratefully acknowledges Ilene Forsyth's long interest in Cluny and contributions to Cluniac studies.

2 *Contra Petrobrusianos hereticos*, ed. James Fearns, CCCM 10 (Turnhout, 1968); and idem, "Peter von Bruis und die religiöse Bewegung des 12. Jahrhunderts," *Archiv für Kulturgeschichte* 48 (1966), 313–17.

3 *Adversus Iudeorum inveteratam duritiem*, ed. Yvonne Friedman, CCCM 58 (Turnhout, 1985); and eadem, "When Were Peter the Venerable's Polemical Works Written?" in *Confrontation and Coexistence*, Bar-Ilan Studies in History, vol. 2 (Ramat-Gan, 1984), 123–37. Dominique Iogna-Prat's *Ordonner et exclure: Cluny et la société chrétienne face à l'hérésie, au judaïsme et à l'islam, 1000–1150* (Paris, 1998), which became available after the completion of this article, provides a welcome, refreshingly critical synthesis of the abbot's polemical writings. According to Iogna-Prat (104), the qualifier *venerabilis* was applied to Peter as early as the end of the 1180s in the Chronicle of Robert de Torigny.

4 Theodor Bibliander, *Machumetis Saracenorum principis eiusque successorum vitae ac doctrina, ipseque Alcoran* (Basel, 1543).

5 Paris, Bibliothèque de l'Arsenal, MS 1162. Marie-Thérèse d'Alverny, "Deux traductions latines du Coran au moyen âge," *Archives d'histoire doctrinale et littéraire du moyen âge* 16 (1947–48), 69–131; eadem, "Pierre le Vénérable et la légende de Mahomet," *À Cluny. Travaux du Congrès scientifique . . . , 9–11 juillet 1949* (Dijon, 1950), 161–70.

6 D'Alverny, "Deux traductions," 81–82.

7 Norman Daniel, *Islam and the West: The Making of an Image* (Edinburgh, 1960), pl. 5; John Williams, *The Illustrated Beatus: A Corpus of the Illustrations of the Commentary on the Apocalypse*, 2 vols. (London, 1994), 1:140. See also the same author's "Purpose and Imagery in the Apocalypse Commentary of Beatus of Liébana," *The Apocalypse in the Middle Ages*, ed. Richard K. Emmerson and Bernard McGinn (Ithaca, 1992), 233, where the drawing is called "a derisive caricature."

8 The name of the prophet is usually given as Mahumet in the manuscript, though Mahumeth (fol. 140r) and Machometh (fol. 172v) also occur.

9 Yale University, Beinecke Rare Book and Manuscript Library, MS 635 (late 12th or early 13th century), fol. 39v. For these designs, see François Garnier, *Le langage de l'image au moyen âge*, 2 vols. (Paris, 1989), 2:352–53; and Paul F. Reichardt, "Paginal Eyes: Faces among the Ornamented Capitals of MS Cotton Nero A. x, Art. 3," *Manuscripta* 36 (1992), 22–36, which, however, concern much later examples.

10 In Peter's compressed version: "et sic undique monstruosus ut ille ait, 'humano capiti, cervicem equinam et plumas avium copulat'" (PL 189, 655). The translation of the entire passage is from *The Complete Works of Horace*, ed. Casper J. Kraemer, Jr. (New York, 1936), 397. Another, substantially similar version of Peter's *Summa* circulated independently as part of his letter collection. See Giles Constable, ed., *The Letters of Peter the Venerable*, 2 vols. (Cambridge, MA, 1967), 1:274–99, no. 111. (The citation from Horace is found on p. 297.) Peter cites the same verses, to make a different point, in a letter to his brother Pontius (ibid., 1:22–24, no. 16). Erasmus, in his *Moriae encomium*, quotes them in order to satirize foolish and incompetent preachers (*The Praise of Folly*, trans. H. H. Hudson [Princeton, 1970], 92). Among the illustrations of Hans Holbein for the Basel edition of the work (1521), there is a marginal drawing of the monstrous creature. See Oskar Bätschmann and Pascal Griener, *Hans Holbein* (London, 1997), 14–15, and fig. 5.

11 Claudia Villa, "'Ut poesis pictura': Appunti iconografici sui codici dell'*Ars poetica*," *Aevum* 62 (1988), 186–97.

12 Biblioteca Apostolica Vaticana, Reg. Lat. 1701, fol. 60r. See ibid., 194 and fig. 4; *Vedere i classici: l'illustrazione libraria dei testi antichi dall'età romana al tardo medioevo*, ed. Mario Buonocore, exh. cat. (Rome, 1996), 208–9, no. 22. I am grateful to Professor Charles Buchanan of Ohio University for bringing this publication to my attention.

13 Kritzeck, *Peter the Venerable and Islam*, 84, identifies the Arabic text, a collection of legends of Jewish and Islamic origin concerning the creation and the lives of the patriarchs and prophets, as the *Kitāb Nasab Rasūl Allāh*.

14 Valladolid, Biblioteca de la Universidad, MS 433, fol. 74r. Williams, *Illustrated Beatus*, vol. 2, fig. 168.

15 Kritzeck, *Peter the Venerable*, 84–88.

16 Israel Wolfensohn, *Ka'b al-Ahbār und seine Stellung im Hadīt und in der islamischen Legendenliteratur*, Ph.D. diss., Frankfurt am Main (Gelnhausen, 1933); and Haïm Z. Hirschberg, "Ka'b al-Ahbār," *Encyclopaedia Judaica*, vol. 10 (Jerusalem, 1971), 488.

17 William Muir, *The Life of Muhammad from Original Sources* (Edinburgh, 1912), 529–30.

18 Annemarie Schimmel, *And Muhammad Is His Messenger: The Veneration of the Prophet in Islamic Piety* (Chapel Hill, 1985), 34; Valerie I. J. Flint, *The Rise of Magic in Early Medieval Europe* (Princeton, 1991), 56–57, 65, for the scrutiny of animals' shoulder blades (scapulomancy) as a method of divination in the early Middle Ages. The subject is treated in greater

4

detail by Charles S. F. Burnett in "Arabic Divinatory Texts and Celtic Folklore: A Comment on the Theory and Practice of Scapulomancy in Western Europe," *Cambridge Medieval Celtic Studies* 6 (1983), 31–42, a study kindly brought to my attention by Elizabeth Sears. Norman Cohn, in *The Pursuit of the Millennium*, rev. ed. (New York, 1970), 73, 103, 143, cites several examples of figures whose prophetic or messianic claims were said to be proclaimed by a mark of the cross between their shoulder blades. Hermann von Grauert's study (cited by Cohn, 73), "Das Schulterkreuz der Helden mit besonderer Beziehung auf das Haus Wettin," in *Ehrengabe deutscher Wissenschaft, dargeboten von katholischen Gelehrten* [Johann Georg Herzog zu Sachsen zum 50. Geburtstag gewidmet], ed. Franz Fessler (Freiburg im Breisgau, 1920), 703–20, gives additional examples drawn from epic literature.

19 Muir, *Life of Muhammad*, 530.

20 Kritzeck, *Peter the Venerable and Islam*, 88.

21 Apoc. 13:16–17; 14:9–11; 16:2; 19:20, and 20:4. For the range of meanings, see Du Cange's *Glossarium*, s.v. *character*; and for *signum*, Ruth Mellinkoff, *The Mark of Cain* (Berkeley, 1981); and Jean Daniélou, "Le signe du Tav," *Les symboles chrétiens primitifs* (Paris, 1961), 143–52.

22 Fulcran Vigouroux, "Bête," *Dictionnaire de la Bible*, vol. 1 (Paris, 1912), 1645; E. Renoir, "Chiffre de la Bête," in *DACL*, 3/1 (Paris, 1913), 1341–53; Richard Kenneth Emmerson, *Antichrist in the Middle Ages: A Study of Medieval Apocalypticism, Art, and Literature* (Seattle, 1981), 40–41; Rosemary Muir Wright, *Art and Antichrist in Medieval Europe* (Manchester, 1995), 132, 135.

23 *The Interpreter's Bible*, vol. 12 (New York, 1957), 466ff.; Emmerson, *Antichrist in the Middle Ages*, 114, 132, 135–36.

24 See, for example, the selection inventoried by Erika Zwierlein-Diehl, *Magische Amulette und andere Gemmen des Instituts für Altertumskunde der Universität zu Köln* (Opladen, 1992).

25 Charles Homer Haskins, *Studies in the History of Mediaeval Science* (Cambridge, MA,1927), 43–66; and Charles S. F. Burnett, "Arabic into Latin in Twelfth Century Spain: The Works of Hermann of Carinthia," *Mittellateinisches Jahrbuch* 13 (1978), 100–34.

26 Paul Alphandéry, "Mahomet–Antichrist dans le moyen âge latin," in *Mélanges Hartwig Derenbourg* (Paris, 1909), 261–77; and Kenneth Baxter Wolf, "The Earliest Spanish Christian Views of Islam," *Church History* 55 (1986), 281–93.

27 Manuel C. Díaz y Díaz, "Los textos antimahometanos más antiguos en codices españoles," *Archives d'histoire doctrinale et littéraire du moyen âge* 37 (1970), 149–64, esp. 153.

28 PL 189, 655. Edmond Jacob, "Quelques remarques sur les faux prophètes," *Theologische Zeitschrift* 13 (1957), 479–93; Jean-Pierre Torrell, "La notion de prophétie et la méthode apologétique dans le 'Contra Saracenos' de Pierre le Vénérable," *Studia monastica* 17 (1995), 257–82; and Daniel, *Islam and the West*, 47ff.

29 Paris, Bibliothèque nationale de France, MS lat. 3688, fol. 12v. The manuscripts of the Toledan Collection are inventoried by d'Alverny in "Deux traductions," 110–13, and "Quelques manuscrits de la 'Collectio Toletana,'" in *Petrus Venerabilis* (as n. 1), 202–18.

30 Oxford, Corpus Christi College, MS 184, fol. 20r. H. O. Coxe, *Catalogus codicum manuscriptorum qui in Collegiis aulisque Oxoniensibus hodie adservantur*, vol. 2 (Oxford, 1852), 73–74.

31 See Neil Stratford, "A Cluny Capital in Hartford (Connecticut)," in *Current Studies on Cluny = Gesta* 27 (1988), 9–21, and the literature there cited.

32 Gunther Fabian, *Die Skulpturen vom 12. bis 18. Jahrhundert*, Bestandskataloge des Mittelrhein-Museums Koblenz, vol. 3 (Koblenz, 1993), 15–17, no. 3. The inscription on the impost has unfortunately not yet been deciphered. Fabian cites and illustrates another representation of this kind on the Pfarrhof Portal at Remagen.

33 Waldemar Déonna, "La sirène, femme-poisson," *Revue archéologique*, ser. 5, 27 (1928), 17–25; Denise Jalabert, "De l'art oriental antique à l'art roman: Recherches sur la faune et la flore romanes. II. Les sirènes," *Bulletin monumental* 95 (1936), 433–71; Edmond Faral, "La queue de poisson des sirènes," *Romania* 74 (1953), 433–506; Debra Hassig, *Medieval Bestiaries: Text, Image, Ideology* (Cambridge, 1995), 104–15.

34 *Refutatio omnium haeresium*, in *Hippolytus Werke*, vol. 3, ed. Paul Wendland, Die griechischen christlichen Schriftsteller (Leipzig, 1916), 190–91. See Hugo Rahner, "Odysseus am Mastbaum," *Zeitschrift für katholische Theologie* 65 (1941), 123–52; Theodor Klauser, "Studien zur Entstehungsgeschichte der christlichen Kunst. VI. Das Sirenenabenteuer des Odysseus—ein Motiv der christlichen Grabkunst?," *Jahrbuch für Antike und Christentum* 6 (1963), 71–100, at 96ff.; Jacqueline Leclercq-Marx, *La sirène dans la pensée et dans l'art de l'antiquité et du moyen âge: Du mythe païen au symbole chrétien* (Brussels, 1997).

35 See, for example, Jerome, *Adversus Iovinianum* (PL 23, 215) and the citations given by Klauser, "Studien," 99 n. 81.

36 "Circumcisionem insuper velut ab Ismaele gentis illius primo sumptam tenendam esse docuit, et super haec omnia, quo magis sibi allicere carnales mentes hominum posset, gulae ac libidini frena laxavit, et ipse simul decem et octo uxores habens, atque multorum aliorum uxores, velut ex responso divino, adulterans, maiorem sibi, velut exemplo prophetico numerum perditorum adiunxit" (PL 189, 654–55).

4

5 Portraits in Counterpoint: Jerome and Jeremiah in an Augsburg Manuscript

Elizabeth Sears

To place an author portrait before a text, in the central Middle Ages, was to declare the authority of that text. The image focused readers' attention, before reading, on the voice speaking through the transcribed words. It served both to signal an author's high stature and to establish that author's particular status, for illuminators employed an array of visual signs—costume, attributes, setting, posture, gesture, expression—to locate a writer among writers. Readers might learn whether authors were sacred, ecclesiastical, secular, or pagan, whether they were monks or nuns, prelates, priests, or teachers, whether they had written the text alone or jointly with a secretary, a redactor, or another author, and at whose behest or in whose honor. Many medieval author portraits, including the twelfth-century images to be discussed in this paper, showed authors literally "writing" their texts, quill in hand, surrounded by scribal paraphernalia—thereby personally assuring the accuracy of the exemplar on which all subsequent copies would depend.[1] This was an ancient pictorial formula, employed most influentially in the rendering of the four evangelists.[2] Amplifying it, illuminators were able to make subtle visual statements.

Among surviving medieval author portraits, some of the most subtle are double portraits, created in response to the knowledge that two authorial voices were intertwined in a single text. Such intertwinings were characteristic of exegetical texts—works in which an expositor had proceeded systematically through an earlier text, often biblical, quoting a passage, explicating it, and then moving on to the next. In the medieval monastic schools, where students learned to read set texts with the help of standard commentaries, authors and expositors alike were held in reverence. The illuminator who set out to embody both voices in a frontispiece, or even in a small opening initial, had the delicate task of distinguishing between two writers of high stature but of different status. Such images are highly revealing of medieval attitudes toward authors and authorship, especially when studied in conjunction with related documents emanating from the schools. The following paper concerns an unusually intricate double author portrait, surprisingly little known. Functioning as a kind of visual prologue, it will be examined in the light of and in

5

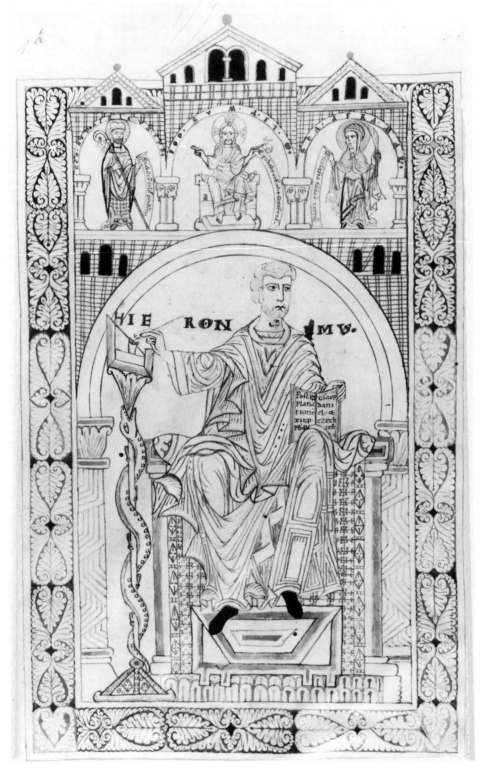

5.1. Portrait of Jerome. Augsburg, Staats- und Stadtbibliothek, 2° cod. 36 (Jerome, *In Hieremiam prophetam*), fol. 1v. Photo: Staats- und Stadtbibliothek.

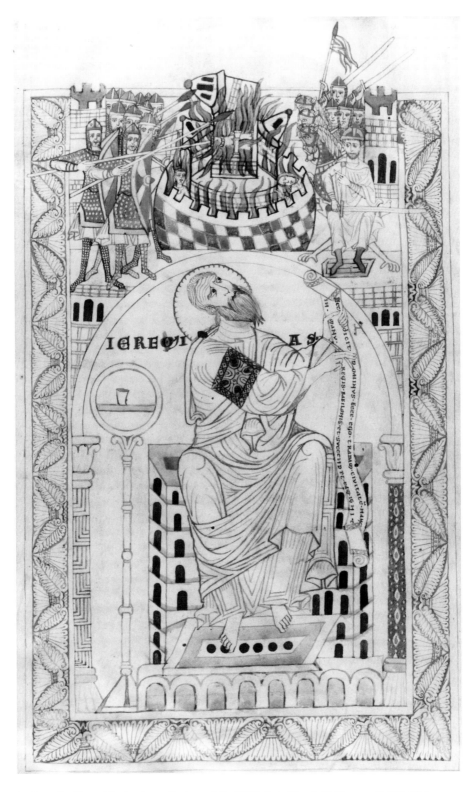

5.2. Portrait of Jeremiah. Augsburg, Staats- und Stadtbibliothek, 2° cod. 36 (Jerome, *In Hieremiam prophetam*), fol. 2r. Photo: Staats- und Stadtbibliothek.

comparison to verbal prologues (*accessus ad auctores*), which played so significant a role in medieval school instruction, elementary and advanced.

<p style="text-align:center">∼</p>

An imposing portrait of the church father Jerome faces a no less powerful portrait of the Old Testament prophet Jeremiah in a manuscript made for the Benedictine monastery of Sts. Ulrich and Afra in Augsburg in the first half of the twelfth century (Figs. 5.1, 5.2).[3] Preceding a transcription of Jerome's commentary on the Book of Jeremiah,[4] extending across an opening in which each page measures 43 x 23.5 cm, the double portrait occupies a significant expanse: few medieval author portraits can have been larger, or more complex. The commentator and the visionary, distinctively depicted, sit beneath arches that support densely inhabited superstructures.

The paired pages impress not so much by their material lavishness—there is no gold or silver or purple—as by the opulent variety of surface pattern and the lively distribution of bright colors (red, red-orange, green, blue, and yellow-brown). Immediately engaged by this exuberance, the viewer soon becomes aware that the busyness is deftly controlled. Blank parchment is used to good effect, throwing the principal figures into prominence. And all the intricate linework, which the illuminator favors over opaque infill, is contained within bounded forms whose contours are readily grasped, the more so because a single composition is repeated on the two pages. Similarities between the juxtaposed portraits highlight differences, and the viewer, experimenting, learns to derive meaning from visual distinctions.

Jerome (IERONIMVS), one of the four fathers of the Latin Church, and Jeremiah (IEREMIAS), one of the four major prophets of the Old Testament, are equally massive figures, occupying like spaces. If stature is measured by visual weight, each, it can be inferred, is great in his own sphere. The balance that is effected by size and setting extends even to the homologizing of the authors' names: beginning with the same three letters, each is transcribed so as to have precisely the same number of characters.[5] But plotted asymmetries, setting in motion a process of matching and comparing, lead a viewer to reflect upon the particular status of each writer. The sober commentator sitting beneath the static cross-section of a church presents a striking contrast to the perturbed visionary gazing up at a scene of mayhem.

Jerome, with calm purposiveness, dips his quill in an ink horn set in the surface of a writing stand ornamented with an entwined serpent. Sitting sedately on a cushion on a bench draped with a fine cloth, he prepares to write a text that is shown already written: he displays an open codex, inscribed, which rests stably on his knee. There is, in contrast, nothing deliberate in Jeremiah's pose or actions. Perched on a more rugged architectural throne, the prophet twists around as if

5

about to write the text already inscribed on an undulating scroll he holds in his hand. The distinction between codex and scroll highlights the contrast between written text and recorded speech and also, perhaps, between Christian and pre-Christian understanding.[6] Jeremiah is the Hebrew prophet to whom the Lord said: "Behold I have given my words in thy mouth" (Jeremiah 1:9).[7] He appears as one possessed. His brow is furrowed, line upon line, and he bears signs of holiness and strangeness. Haloed, barefoot, endowed with the full beard proper to a prophet of old, Jeremiah wears the robe of an ancient sage, which is, however, decorated with a prominent arm patch in full color, possibly evocative of foreign custom, significantly bearing a cross.[8] In point by point contrast, Jerome is unhaloed (although counted among the saints of the church), shod, tonsured, and clad in ecclesiastical garb. As Jerome directs his gaze toward Jeremiah, toward the sacred author who prophesied before the coming of Christ, it is revealed that his task is to interpret the words of God's prophet for the church.

The minute inscriptions on Jerome's book and Jeremiah's scroll entice the viewer to approach the manuscript page and to become involved in solving puzzles of meaning. Jerome speaks in his own voice: *Post explanationem xii prophetarum esaye daniel & ezechiel* ("Following upon the elucidation of the 12 [minor] prophets, and Isaiah, Daniel, and Ezekiel").[9] The reader need only turn the page to confirm that these are the opening words of Jerome's prologue. In this prefatory text the aging expositor explains to Eusebius of Cremona that he has at last set his hand to the book of Jeremiah, having written commentaries on all the other prophets, and he justifies his procedures by condemning detractors with characteristic venom. The church father's procedures needed no justification among twelfth-century Benedictine readers. As the revered translator of the Vulgate Bible, his linguistic skills were greatly admired. It would have been known that Jerome's own version of Jeremiah's text was woven into the commentary that followed and that the biblical passage inscribed on Jeremiah's undulating scroll had been spoken by the prophet in Hebrew but translated into Latin by Jerome.[10]

The inscribed text is a prophecy in the voice of God (Jeremiah 34:2): *Hec dicit dominus. Ecce ego tradam civitatem hanc in manu regis babilonis et succendet eam igni, e* ("Thus saith the Lord. Behold I will deliver this city into the hands of the king of Babylon, and he shall burn it with fire"). The prophet gazes up at a depiction of his vision of the fall of Jerusalem and the punishment of an impenitent people, a prediction he delivered to Zedekiah, king of Judah, at the time of the Babylonian captivity. The topicality of the subject would not have been missed in the age of the Crusades: in this image knights in mail attack the Holy City as instruments of God's will. A viewer might even have drawn a connection between the cross worn by Jeremiah on his right arm and the crusaders' badge, similarly placed.[11] The illuminator utilizes current conventions for evoking devastation through war.

5

We see a walled city under siege, orange flames engulfing its buildings, towers falling, and a man and a woman caught in the chaos; in the center there is a column, likely a reference to the Temple, which was despoiled (Jeremiah 52:17ff.). Foot soldiers and cavalry, the former bearing lances and shields, the latter carrying swords and standards, converge on the doomed city. Overseeing the whole is the Babylonian king to whom the Lord delivered Jerusalem: Nebuchadnezzar sits on a ruler's fald-stool, crown on head, sword on knees, ordering the destruction with a gesture of his hand. The viewer would carry the knowledge that the proud Nebuchadnezzar would be humbled (Daniel 4) and Babylon would fall (Daniel 5) and that, when the Israelites returned from captivity after 70 years, a new and everlasting covenant would be established, as Jeremiah had predicted (Jeremiah 31:31ff.), which Jerome, and others with him, interpreted mystically as referring to the Christian New Testament.[12]

In the superstructure above the church father there rises a basilica. Christ, with cross-nimbus, sits enthroned in its nave, while Sts. Ulrich and Afra—the patron saints of the monastery where the manuscript was housed—stand reverently in the side aisles. This image of a church, its interior elevation Romanesque in form, would have served multiple functions: it could refer at once to the heavenly paradise, the universal Church, and a particular church in southern Germany. Seen laterally across from the fallen Jerusalem and the temple destroyed, it could trigger pious meditations. For the opposition draws a contrast between the Old Testament and the New, *Synagoga* and *Ecclesia*, shadow and fulfillment, in a way fully in keeping with the Christian understanding of the history of salvation, in which the pivotal event was the advent of Christ.

Above the figure of Christ is inscribed a self-description of cosmic import drawn from the Apocalypse (1:8): *Ego sum α et ω* ("I am Alpha and Omega, the beginning and the end…who is, and who was, and who is to come, the Almighty"). The two local saints who flank him are identified through labels: *Sanctus Udalricus episcopus* is the pious bishop of Augsburg who died in 973 and was canonized in 993,[13] appropriately shown with a bishop's miter and crozier; *Sancta Afra martyris*, the church's original patron, martyred in the early Christian era, bears a martyr's palm. All three carry speech scrolls with inscriptions, carefully selected. The Augsburg saints speak in single voice. The passage on Ulrich's scroll concludes on Afra's: *Stabilivit celos prudentia / dominus sapientia fundavit terram* ("The Lord by wisdom hath founded the earth, hath established the heavens by prudence"). Extracted from the Old Testament Book of Proverbs (3:19)—which was attributed in the Middle Ages to the wise king Solomon—these words of praise were under-stood mystically to refer to Christ and the foundation of his church before his com-ing.[14] They introduce the theme of divine wisdom and are in harmony with the verse inscribed on Christ's scroll, which reveals the deity himself to be the source of

Jerome's authority (Luke 21:15): *Ego dabo vobis os et sapientiam* ("For I myself will give you utterance and wisdom").[15] The verbal blessing, approving Jerome's work, is confirmed by visual signs. Parallels in pose between Christ above and Jerome below allow a viewer to draw appropriate deductions: Christ's blessing hand occupies the same relative position as Jerome's writing hand; his speech scroll corresponds to Jerome's book. And even the serpent spiraling up the post of Jerome's writing desk—possibly evoking actual carved ornament on Romanesque church furniture—could not but carry a symbolic charge. Biblically literate viewers, beyond thinking of Satan, could have called to mind the gospel passage: "Be therefore wise as serpents" (Matthew 10:16) and applied it to Jerome, or they may have thought of Psalm 139:4 as referring to Jerome's adversaries: "They have sharpened their tongues like a serpent."[16]

Monastic readers, before reading, were thus encouraged by the intricate images to pause and contemplate the two authors and their work. They would have absorbed the knowledge that the words, whose ultimate source was divine, were authentic and true. Jeremiah's prophetic utterances were authored by God. It is no accident that they are evoked in the most vivid patch of painting in the composition, with the most opaque infill: the material image seeks to reproduce a spiritual vision, more potent than any human dreaming or imagining. Jerome's exposition, blessed by Christ, is of another order. His words are authoritative by virtue of their having been written by a man of orthodox faith, a Christian scholar able to bring clarity to the reading of a prophetic text replete with mysteries and thus to satisfy those who might want to know "what the words relate of the past, what they make known of the present, what they foretell of the future."[17]

\approx

The Augsburg double portrait is singularly ambitious but not without parallel. Another frontispiece produced in the same years in a similar milieu provides an instructive comparison. Here, too, an expositor and a prophet are brought together, but in this case it is the Venerable Bede (d. 735) and the evangelist John—inspired author of the last book of the New Testament. This double portrait precedes a copy of Bede's commentary on the Apocalypse made in the first half of the twelfth century for the Benedictine abbey of Lambach in Upper Austria (Fig. 5.3).[18] Executed in brown line with red accents, the more modest Lambach product occupies a single page, placed directly opposite the opening of Bede's prologue. The two authors now share a space beneath an arch supporting a simpler superstructure, uninhabited. Whereas in the Augsburg manuscript Jerome's sidelong glance, and a slight movement toward Jeremiah, sufficed to draw the two authors into connection, here the writers are placed in fictional interaction and the dove of the Holy Spirit, shown

5

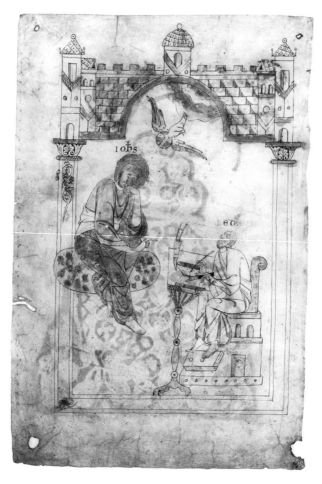

5.3. Bede, John the Evangelist, and the dove of the Holy Spirit. Washington, DC, National Gallery of Art (1950.16.290); formerly Lambach, Stiftsbibliothek, cod. VI (Bede, *In Apocalypsim*). Photo: Board of Trustees, National Gallery of Art.

descending from a bank of clouds toward John, is introduced as a character. The sacred writer sits resting his head on his hand in a classic posture of perturbation and contemplation; this, rather than a depicted vision, serves to establish his status as visionary. He perches not on a bench but on the island of Patmos—where the divine visions were granted him—rendered in small scale in its entirety. The island, extending over the page frame, seems to hover on the page. From this unstable vantage point John looks down upon the tonsured Bede, significantly smaller in scale, who sits foursquare on a solid high-backed seat, behind a writing desk. Shown holding a quill and a knife,[19] Bede is very much the scribe, equipped with the instruments of the occupation: two quills stand waiting in an ink horn, which is threaded illogically through two holes in his desk so as to be perfectly legible. John gestures

5

Reading Medieval Images

down toward the expositor almost as if dictating to a secretary in his service. Bede in turn gazes up at the seer as if preparing to write.

The relationship between the two cannot be taken literally: Bede's role is not to transcribe the visionary's words but to elucidate them. Rather, the adapted scheme establishes the place of the two authors in a hierarchy and describes a line of transmission from the ultimate source of truth. As the Holy Spirit authorizes John's words, so John, in this fiction, confers authority on Bede's. The sacred writer, hovering above, and Bede, wholly down to earth, while joined in a collaborative undertaking, are shown to belong, as authors, to radically different spheres and times. By placing the two authors in a dynamic, if hierarchical, relationship, the Lambach illuminator accomplished what the Augsburg illuminator effected by visual counterpointing. Different visual formulae were employed: yet the miniatures similarly prepared a reader for reading by establishing the authors' authority and inducing a mood of reverent respect for the text that followed.

~

Monastic viewers—those whose Latin was adequate to comprehend Jerome's or Bede's expositions when read aloud in the choir or refectory or contemplated in private study—would have come to these images with prior knowledge and expectations. They had proceeded through a course of study that fostered a set of mental skills and aptitudes which would have informed their looking. The culture of the classroom is difficult to reconstruct, of course; verbal instruction is ephemeral.[20] Hence the exceptional interest of Conrad of Hirsau's *Dialogue on the Authors*, composed in the first half of the twelfth century by a Benedictine scholar and teacher. This text, which circulated in southern German and Austrian monasteries, precisely the region of interest to us, simulates an exchange between a master and a pupil.[21] Conrad's fiction is that a student, feeling keenly his ignorance, is demanding promised instruction from a reluctant master. Toward the beginning of the dialogue he makes this request:

> I want you to explain briefly and in summary form what we must look for in each
> of the school authors who are used in training the blossoming minds of beginners,
> namely, who the author is, what he has written, the scale of his work, when he has
> written it, and how, that is whether it is in prose or verse, with what subject matter
> or intention each has begun his work, what end the composition has in view.[22]

Contained in this demand is a set of seven questions. Naturalized here, as if a self-evident sequence of queries, the list had developed over centuries and existed in numerous versions, shorter and longer. Answers to such questions, it was believed,

5

would supply a sound basis for discussion. The sets of headings gave structure to a literary genre popular in the twelfth century: the *accessus ad auctores*, or academic prologues to the authors.²³ Mirroring introductory school lectures, these texts were prefixed to Latin classics read in elementary arts courses, but they also served to introduce medical, legal, and exegetical texts elucidating the biblical books. Conrad of Hirsau, in this elementary tract, collected and recast prologues to twenty-one school authors, ranging from Aesop—one of the beginners' texts—to Virgil.²⁴ Anyone who had learned Latin in a monastic school is likely to have had a good idea of what it was necessary to know before approaching a text.

It might thus be productive to look again at the double portrait of Jerome and Jeremiah (Figs. 5.1, 5.2) but now as if it were a visual prologue in a very specific sense. By asking of it the questions posed by Conrad's pupil, we might learn what sorts of information a literate monastic viewer would have been primed to look for in the two portraits. At the same time we will begin to define for ourselves distinctions between visual and verbal modes of introducing authors to their readers.

"Who the author is" (*quis*) and "what he has written" (*quid*) are set out in a straightforward way. As the figure labeled IERONIMVS looks over at the figure labeled IEREMIAS, the authors are identified and the text is unequivocally revealed to be Jerome's commentary on Jeremiah. The related question, "When he has written it" (*quando*), was to be answered not with absolute dates but rather with reference to persons or events in the author's era. The church above Jerome indicates only that he lived in the Christian era, but Jeremiah's vision, viewed in this light, becomes a temporal marker: he is the prophet who prophesied in the time when Jerusalem fell to the Babylonian king, that is, in the eleventh year of Zedekiah, in the fourth month (Jeremiah 39:2), or, in our calendar, July 587 BCE.

"How much" (*quantum*)—the scale of the work—referred to the number of parts in a text, while "in what manner" (*quomodo*) meant the mode in which an author wrote, whether in prose or in verse. Verbally, both questions could be answered with dispatch. Visually, the issues had to be attended to in the body of the text: the designer of the manuscript, possibly the scribe, determined that foliate initials would be placed at the beginnings of sections and made certain that all text divisions were announced in a systematic way ("Here ends book 2, here begins book 3"), thus ensuring that a reader would know Jerome's commentary comprised six books.²⁵ Further, by transcribing biblical citations in red ink or setting marks in the margins alongside, the scribe distinguished—if not prose from verse—sacred text from commentary upon it.

"Subject matter" (*materia*) and motivating intention (*intentio*), on the other hand, were effectively conveyed in the double portrait itself. Inscriptions and the image of Jerusalem's fall establish the visionary character of the material Jerome would gloss. The church father's glance toward Jeremiah discloses his ambition to

interpret the prophet's words, an idea reinforced in the passage on his codex announcing his program of elucidating all the prophetic books. "What end the composition has in view" (*ad quem finem*) is clarified for both authors especially through the choice of inscriptions. The prophet's obligation, imposed upon him by the Lord, is to forewarn: "Thus saith the Lord." Jerome's task, authorized by Christ, who gave him "utterance and wisdom," may be defined by paraphrasing Conrad of Hirsau: "to open up the mysteries of the Scriptures by the key of divine wisdom."[26]

It need hardly be stated that no medieval author portrait, single or double, would have been conceived as a response to a checklist of questions. The exercise of systematically applying a twelfth-century set of queries to the double portrait, nonetheless, serves to demonstrate just how much information deemed fundamental could be gleaned from perusal of the complex image. At the same time we learn that the communication of facts was but a small part of the function of such prefatory images. The array of figures and inscriptions would have led the viewer's thoughts well beyond biography. More important than Jeremiah's or Jerome's personal histories is their authority to speak. Setting, attributes, pose, and demeanor, in conjunction with inscriptions, encouraged readers to approach the text in a receptive frame of mind. And if the images of Sts. Afra and Ulrich contribute no knowledge specifically relevant to the reading of Jerome's exposition, they would have evoked strong personal response from the monks under their care.

That the material preceding a work was accorded serious attention in the reading process is made remarkably clear as Conrad's *Dialogue* continues. The importunate pupil perseveres in his questions: "I also want to find out about the introductory page" (*pagina liminaris*), and he continues: "what is the difference between a title, a preface, a proem, and a prologue?"[27] Before Conrad can answer, the student poses his next question, one that takes us to an issue immediately relevant to the reading of double portraits. He asks to be told the difference between a poet, a writer of history, and a writer of discourses. Later in the dialogue he restates and amplifies his query: "Tell me also, what is the difference between an author, a poet, a writer of history, a commentator, a bard, an expositor of texts, and a writer of discourses?"[28] Conrad, in the voice of the master, duly defines all the different kinds of writers. Students would have learned early in their study to call Jerome and Bede *expositores*, for expositors are "those who unravel the mystical sayings of Holy Scripture."[29]

The pupil's queries and the master's responses reveal that the drawing of distinctions among items in a class was practiced as an essential academic exercise. This skill, or mental habit, would have helped a monastic viewer to derive full benefit from the illuminators' efforts. Having become sensitive to the contrapuntal rhythms in the Augsburg double portrait or to the hierarchic distinctions in the Lambach

5

miniature, this viewer would have been well equipped to draw inferences from the multiple contrasts between visionary and expositor.

Even an elementary education, it emerges, primed readers to seek knowledge about an author before turning to a text. Alert to differences among generic features of books—"title, preface, proem, and prologue"—and aware that each served designated functions, they would have been prepared to take seriously a visual prologue, a feature that added one more layer of material aiding in the comprehension of a text. Demanding time, guiding but not regulating thought, the images were well adapted to the monastic goal of fostering meditation and contemplation.[30] The Augsburg double portrait, although brilliantly clear in general structure, could be read in many ways, ruminated upon in any number of sequences. If less efficient than verbal *accessus ad auctores* in conveying factual data, these visual prologues were more effective in conveying authors' privileged access to truth. Conrad of Hirsau's succinct definition of the "prologue" as a genre may, in a transferred sense, be applied to the frontispieces of the Augsburg Jerome and the Lambach Bede: "The prologue makes the reader or listener readily taught, attentive, and well disposed."[31]

1 Scribes were quite similarly depicted when their pious labor in hand-copying texts was memorialized, though as scribes (*scriptores*) they were shown subordinate to authors (*auctores*) if they inhabited the same pictorial space. On medieval scribal portraits, see Joachim Prochno, *Das Schreiber- und Dedikationsbild in der deutschen Buchmalerei bis zum Ende des 11. Jahrhunderts* (Leipzig and Berlin, 1929); Anton Legner, "Illustres Manus," in *Ornamenta ecclesiae: Kunst und Künstler der Romanik*, 3 vols. (Cologne, 1985), 1:187–230; and essays in the forthcoming volume *Medieval Depictions of Scribes*, ed. Michael Gullick and Randall A. Rosenfeld (Red Gull Press). Jacqueline Perry Turcheck identifies four types of author portraits in twelfth-century manuscripts: "author as ordinary scribe," "author as inspired scribe," "author as attesting figure," and "author as teacher." See "A Neglected Manuscript of Peter Lombard's *Liber Sententiarum* and Parisian Illumination of the Late Twelfth Century," *Journal of The Walters Art Gallery* 44 (1986), 48–69, esp. 54–56. Horst Wenzel, in his study, "Autorenbilder: Zur Ausdifferenzierung von Autorenfunktionen in mittelalterlichen Miniaturen," in *Autor und Autorschaft im Mittelalter: Kolloquium Meissen 1995/1*, ed. Elisabeth Andersen et al. (Tübingen, 1998), 1–28, responds to the work of Roland Barthes ("The Death of the Author") and Michel Foucault ("What is an Author?") in his reading of a selection of tenth- to fifteenth-century author portraits, mostly German.

2 The extensive literature on portraits of the writers of the gospels begins with A. M. Friend, "The Portraits of the Evangelists in Greek and Latin," *Art Studies* 5 (1927), 118–47; 7 (1929), 3–29. For a conspectus of images see "Evanglisten" in the *Reallexikon zur deutschen Kunstgeschichte*, vol. 6 (Stuttgart, 1973), 448–517.

3 Augsburg, Staats- und Stadtbibliothek, 2° cod. 36, fols. 1v–24r. Herrad Spilling, *Handschriftenkataloge der Staats- und Stadtbibliothek Augsburg*, vol. 2, *Die Handschriften der Staats- und Stadtbibliothek Augsburg 2° Cod. 1–100* (Wiesbaden, 1978), 59; Norbert Hörberg, *St. Ulrich und Afra zu Augsburg im 11. und 12. Jahrhundert nach Zeugnissen der Klosterbibliothek* (Göttingen, 1983), 47, 56–57, 169–70; *450 Jahre Staats- und Stadtbibliothek Augsburg: Kostbare Handschriften und alte Drucke*, exh. cat. (Augsburg, 1987), 11. The manuscript was once owned by Dürer's friend Conrad Peutinger, who wrote comments in the margins.

4 Jerome's commentary (*In Hieremiam prophetam*) remained incomplete, treating only 32 of the 52 chapters in the Book of Jeremiah. The makers of the manuscript compensated by transcribing books 13–20 of Hrabanus Maurus' ninth-century *Expositio super Jeremiam* (fols. 74v–155v), picking up just where Jerome left off, a point Hrabanus signaled in the body of his commentary (cf. PL 111, 793–94). See Spilling, *Handschriften*, 59.

5

Reading Medieval Images

5 *Ieronimus* being the longer name in Latin, the scribe made the final VS into a monogram; in both cases he left off the aspirating H—which a later hand clumsily inserted before Jerome's name.

6 A later writer on liturgical symbolism, Willliam Durandus (1230–96), noted that patriarchs and prophets were painted with rolls in their hands because, before the coming of Christ, faith was presented figuratively; rolls signify imperfect knowledge. The apostles, perfectly taught, sometimes carry books, through which perfect knowledge is designated. *Rationale divinorum officiorum*, 1.3.11; ed. A. Davril and T. M. Thibodeau, CCCM 140 (Turnhout, 1995), 39.

7 The authorial situation was more complex than the image suggests. Readers of the book of Jeremiah knew that Baruch, son of Nerias, had played a role: "and Baruch wrote from the mouth of Jeremias all the words of the Lord, which he spoke to him, upon the roll of a book" (Jeremiah 36:4). Those who read Jerome's prologue knew he did not claim sole authorship. Ridiculing a detractor he wrote: "He does not understand the rules of commenting . . . and is not aware that in our books we give the opinions of many different writers, the authors' names being either expressed or understood, so that it is open to the reader to decide which he may prefer to adopt." *In Hieremiam prophetam*, prologus; ed. S. Reiter, CCSL 74 (Turnhout, 1960), 1–2; trans. W. H. Fremantle, Nicene and Post-Nicene Fathers, 2d ser., vol. 6 (Edinburgh, 1893; rpt. Grand Rapids, 1989), 499.

8 Jeremiah's arm patch likely had eastern connotations, possibly recalling the *tiraz* band worn on the upper sleeve in noble Islamic dress. See Janet Ellen Snyder, "Clothing as Communication: A Study of Clothing and Textiles in Northern French Early Gothic Sculpture" (Ph.D. diss., Columbia University, 1996), 11–12, 60–62, 541. In an image of the Crucifixion in the late twelfth-century *Hortus deliciarum* (now destroyed), *Synagoga* wears an arm band while *Ecclesia* does not. See Rosalie Green et al., *The Hortus deliciarum of Herrad of Hohenbourg*, 2 vols. (London, 1979), 2:267. I am grateful to Christina Waugh for these references. See also n. 11 below.

9 *In Hieremiam prophetam*, prologus (CCSL 74, 1).

10 Hugh of St. Victor in the late 1120s wrote of Jerome's translation that it is "deservedly preferred to the others because it adheres more closely to the original words and it is clearer in its insight into meanings." *Didascalicon* 4.7; trans. Jerome Taylor (New York, 1961), 106. Episodes from the life of Jerome relating to his work as translator of the Bible were illustrated in ninth-century frontispieces to the Vivian Bible and the Bible of San Paolo fuori le mura. Reproduced in Herbert L. Kessler, *The Illustrated Bibles from Tours* (Princeton, 1977), figs. 130, 131.

11 A chronicle of the First Crusade covering the years 1095 to 1099 records a description of the Frankish crusaders: "They are well-armed, they wear the badge of Christ's cross on their right arm or between their shoulders, and as a war-cry they shout all together, 'God's will, God's will, God's will!'" *Gesta francorum et aliorum Hierosolimitanorum* 1.4; ed. and trans. Rosalind Hill in *The Deeds of the Franks and the Other Pilgrims to Jerusalem* (London, 1962), 6–7. Cited by Snyder, 61 n. 2.

12 *In Hieremiam prophetam*, 6.26 (CCSL 74, 318–20).

13 On Ulrich's canonization—the earliest recorded papal canonization—see Franz Xaver Bischof, "Die Kanonisation Bischof Ulrichs auf der Lateransynode des Jahres 993," in *Bischof Ulrich von Augsburg, 890–973 = Jahrbuch des Vereins für Augsburger Bistumsgeschichte* 26/27 (1993), 197–222.

14 On this passage Hrabanus Maurus (*Expositio in Proverbia Salomonis*, PL 111, 695) wrote: "God the Father created all things through the Son. Figuratively he founded the earth by wisdom when through him he established the holy church in the firmness of faith. He established the heavens by prudence when through him he illuminated the exalted hearts of his preachers."

15 The passage continues: "which all your adversaries will not be able to resist or gainsay"—strikingly applicable to Jerome.

16 It is also possible that the primary reference was to a class of church furniture decorated with animal forms. Such single-legged writing stands, sometimes carved to look like upright fish, had been depicted in manuscripts from the Carolingian period if not before. See Eddy van den Brink, "Das Evangelistenpult und seine karolingische Ikonographie," *Aachener Kunstblätter* 61 (1995–97), 371–79. A similar serpent stand is encountered in a portrait of Jerome prefacing a copy of his polemical tract *Contra Iovinianum* transcribed in the Benedictine monastery of Prüfening ca. 1125 (Munich, Bayerische Staatsbibliothek, clm 13102, fol. 1av). Here the serpent holds the ink horn in its mouth; Jerome, depicted alone, appears as a saint—tonsured, haloed, and barefoot—sharpening his pen with a knife. See Elisabeth Klemm, *Die romanischen Handschriften der Bayerischen Staatsbibliothek*, vol. 2 (Wiesbaden, 1980), no. 68.

17 The words are borrowed from Jerome's preface to book 8 of his commentary on Ezekiel. *In Hiezechielem prophetam*, ed. F. Glorie, CCSL 75 (Turnhout, 1964), 333.

18 Formerly fol. 1 of a manuscript still in Lambach (Stiftsbibliothek, cod. VI), the leaf with the double portrait now belongs to the National Gallery of Art, Washington, DC, inv. no. 1950.16.290 [formerly B-17, 715] (35.2 x 23.5 cm). Georg Swarzenski, *Die Salzburger Malerei*, vol. 2 (Leipzig, 1913; rpt. Stuttgart, 1969), 155n; Kurt Holter, "Die Handschriften und Inkunabeln," in *Die Kunstdenkmäler des Gerichtsbezirkes Lambach*, ed. Erwin Hainisch, Österreichische Kunsttopographie, vol. 34, no. 2 (Vienna, 1959), 213–67, esp. 214, 234; *Medieval and Renaissance Miniatures*, ed. Gary Vikan (Washington, DC, 1975), no. 27. Green and yellow wash was later applied to the author portrait (1v), likely by the hand

5

responsible for the foliate initial A (1r) seen bleeding through the page. A second image of the writing Bede appears on fol. 37v. For the history of the abbey and its scriptorium, see Kurt Holter, "Zwei Lambacher Bibliotheksverzeichnisse des 13. Jahrhunderts," *Mitteilungen des Instituts für Österreichische Geschichtsforschung* 64 (1956), 262–76; Robert G. Babcock, *Reconstructing a Medieval Library: Fragments from Lambach* (New Haven, 1993).

19 The knife, held in the left hand, served multiple functions, from trimming the pen and scraping out errors to keeping the parchment steady and supporting the writing hand, held in an elevated position. On the knives' form and function, see Albert d'Haenens, "Écrire, un couteau dans la main gauche: Un aspect de la physiologie de l'écriture occidentale aux XIe et XIIIe siècles," in *Clio et son regard: Mélanges d'histoire, d'histoire de l'art et d'archéologie offerts à Jacques Stiennon*, ed. Rita Lejeune and Joseph Deckers (Liège, 1982), 129–41, esp. 132ff.

20 On the twelfth-century monastic schools, see Philippe Delhaye, "L'organisation scolaire au XIIe siècle," *Traditio* 5 (1947), 211–68; Jean Leclercq, *The Love of Learning and the Desire for God: A Study of Monastic Culture*, trans. Catherine Misrahi (New York, 1982), esp. 182–88; C. Stephen Jaeger, "Cathedral Scools and Humanist Learning, 950–1150," *Deutsche Vierteljahrsschrift für Literaturwissenschaft und Geistesgeschichte* 61 (1987), 569–616; *Vocabulaire des écoles et des méthodes d'enseignement au moyen âge*, ed. Olga Weijers (Turnhout, 1992).

21 *Dialogus super auctores*, ed. R. B. C. Huygens in *Accessus ad auctores* (Leiden, 1970), 71–131; partial trans. A. J. Minnis and A. B. Scott, in *Medieval Literary Theory and Criticism, c. 1100–c. 1375: The Commentary-Tradition* (Oxford, 1988), 37–64. On the book's circulation, see Huygens, 10–12. Conrad of Hirsau (before 1100–after 1150) wrote several other dialogues, including the *Speculum virginum* (?), the *Dialogus de mundi contemptu vel amore*, and the *Altercatio Pauli et Gamalielis*.

22 *Dialogus*, 46–50 (Huygens, 72; Minnis and Scott, 40–41): "quis auctor sit, quid, quantum, quando vel quomodo, id est utrum metrice vel prosaice, scripserit, qua etiam materia vel intentione opus cuiusque exordium sumpserit, ad quem finem ipsa scriptionum series relata sit."

23 Essential literature on the *accessus* includes Edwin A. Quain, "The Medieval Accessus ad Auctores," *Traditio* 3 (1945), 215–64; rpt. New York, 1986; Richard William Hunt, "The Introductions to the 'Artes' in the Twelfth Century," in *Studia mediaevalia in honorem admodum reverendi patris Raymundi Josephi Martin* (Bruges, 1948), 85–112, esp. 93–98; Jerold C. Frakes, "Remigius of Auxerre, Eriugena, and the Greco-Latin Circumstantiae-Formula of *Accessus ad Auctores*," in *The Sacred Nectar of the Greeks: The Study of Greek in the West in the Early Middle Ages*, ed. Michael W.

Herren (London, 1988), 229–55; A. J. Minnis, *Medieval Theory of Authorship*, 2d ed. (Philadelphia, 1988), 9–39; Heinz Meyer, "*Intentio auctoris, utilitas libri*: Wirkungsabsicht und Nutzen literarischer Werke nach Accessus-Prologen des 11. bis 13. Jahrhunderts," *Frühmittelalterliche Studien* 31 (1997), 390–413. For translations, Minnis and Scott, 12–36. Conrad's pupil relies on an old-fashioned set of headings related to the seven "circumstances" identified by authors of the early Middle Ages. Later in the text, *Dialogus*, 215–20, the master states explicitly that the "ancients" asked seven questions but modern writers ask four, inquiring after subject matter, the writer's intention, the final cause of writing, and the part of philosophy to which the text belongs.

24 No fewer than thirteen of the twenty-one authors Conrad introduces were represented in the school library at Lambach, as reconstructed on the basis of a twelfth-century booklist and surviving manuscript fragments. See Babcock, *Reconstructing a Medieval Library*, 53–56. On the growth of the canon, see Günter Glauche, "Die Rolle der Schulautoren im Unterricht von 800 bis 1110," in *La scuola nell'occidente latino dell'alto medioevo*, in *Settimane di studio del Centro italiano di studi sull'alto medioevo*, vol. 19 (Spoleto, 1972), 617–36.

25 In ancient rhetoric a distinction was made between topics discussed "before the work" (*ante opus*)—title, cause, and intention—and things regarded "in the work itself" (*in ipso opere*), which included number of parts as well as order and explanation. See Hunt, "Introduction to the 'Artes,'" 94; Minnis, *Medieval Theory of Authorship*, 15.

26 *Dialogus*, 74–75 (Huygens, 73; Minnis and Scott, 41).

27 *Dialogus*, 50–51 (Huygens, 72; Minnis and Scott, 41).

28 *Dialogus*, 133–34 (Huygens, 75; Minnis and Scott, 43): "Iunge quae sit differentia inter auctorem, poetam, historiografum, commentatorem, vatem, expositorem, sermonarium." The sacred writer was known to be in a class of his own.

29 *Dialogus*, 142–45 (Huygens, 75–76; Minnis and Scott, 43–44). Such distinctions would be pondered more systematically in succeeding centuries, when the Aristotelian four causes were applied to the analysis of texts. See, for example, St. Bonaventure's treatment of the "efficient cause," or author, of Peter Lombard's *Sentences* (Minnis and Scott, 228–30). See Minnis, *Medieval Theory of Authorship*, 75–84. For recent consideration of the role of "paratext," see Gerard Genette, *Seuils* (Paris, 1987), esp. 182–218 ("Les fonctions de la préface orginale").

30 Leclercq, *Love of Learning*, ch. 5 ("Sacred Learning").

31 *Dialogus*, 127–28 (Huygens, 75; Minnis, 43): "prologus vero docilem facit et intentum et benivolum reddit lectorem vel auditorem."

6 "Seeing and Lecturing": Disputation in a Twelfth-Century Tympanum from Reims

Michael Camille

> The word "reading" is equivocal. It may refer either to the activity of teaching and being taught, or to the occupation of studying written things by oneself. Consequently, the former, the intercommunication between teacher and learner, may be termed (to use Quintilian's word) the "lecture"; the latter, or the scrutiny by the student, the "reading," simply so called.[1]
>
> John of Salisbury

This short essay focuses on a single piece of sculpture, produced at Reims and usually dated ca. 1160 (Fig. 6.1), that represents the act of lecturing as described in John of Salisbury's famous defense of the verbal and logical arts of the trivium, the *Metalogicon*, written in 1159. The description quoted above, part of John's defense of grammar in Book 1 of his work, is as relevant to the problem of "reading" pictures as words. For it describes communication as a dynamic two-way process, something that it has always been in the reading, lecturing, and writing of Ilene Forsyth. One of the most powerful of Professor Forsyth's many articles, which was important in terms of my own personal development as a medievalist, was her discovery of the intersection of classicizing erotics and monastic pedagogics in a place no one else had ever looked before—a Romanesque capital at Vézelay showing the rape of Ganymede.[2] In trying to be as attentive to the power of medieval images to shape and mold young minds, I have chosen to treat in this paper a sculptural fragment that also uses complex visual cues to teach. But this time, I shall argue, it does not lecture to the novice in the twelfth-century cloister but to the schoolboy, student, or canon attending another important twelfth-century institution of learning—the cathedral school. In examining this image, I also want to rethink some of the notions I first explored in an essay that I wrote when still a graduate student, "Seeing and Reading: Some Visual Implications of Medieval Literacy."[3] Today, to argue *contra* my own position there, I want to emphasize the dialectical process at work in the twelfth-century image, viewing it more as a kind of interactive "lecture" in John of Salisbury's sense than as a "text" to be read by an isolated individual.

6

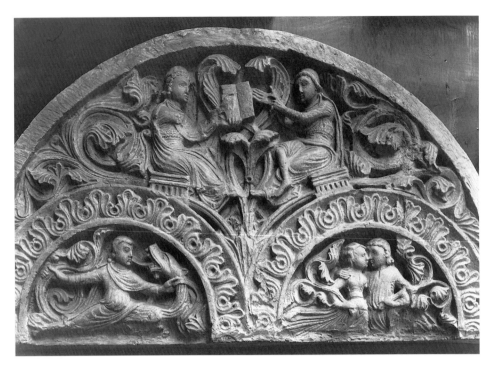

6.1. Tympanum with disputing figures, figure fighting serpent, and two figures kissing. Plaster cast after original in the Musée Saint Remi, Reims. Photo: Archives photographiques, Reims.

If I have learned anything over the past fifteen years, it is that images can work not just as alternatives or supplements to texts but also independently of them and on their own terms. That is their power.

The semicircular lunette carved in soft limestone, measuring 5 ft. 2 in. by 3 ft., that is displayed today in the Musée Saint Remi at Reims is highly evocative of the great revival of learning still called "The Twelfth-Century Renaissance" (Fig. 6.1). It was found in 1857 in the foundations of a house, known as the "maison de la Chrétienté de Reims" on the Place du Parvis, which belonged to the cathedral chapter.[4] This proximity to the cathedral is important and immediately calls into question the use of the term "secular" to describe the work.[5] Most likely carved to go over a window, it represents a rare extant example of an important category of twelfth-century sculpture, for it was connected with a dwelling rather than a church but still came under ecclesiastical jurisdiction as part of the canonical quarter. The division of the arch into two smaller semicircular fields within the larger one appears in other examples of sculpted window decoration. A thirteenth-century house opposite the west façade of Chartres cathedral has a window that is similarly split into three, as are two twelfth-century examples: a triple window from a house at Trie-Chateau near Gisors, now in the Victoria and Albert Museum, London

(1175–1200), and the lunettes of another canon's house at Chartres.[6] Like the Chartres examples, the Reims sculpture also probably adorned a house belonging to the canons or, even more suggestively, it may have functioned as a sign announcing the location of one of the schools of the celebrated masters linked to the cathedral.

Already in the first half of the century, according to contemporary accounts, students flocked to Reims in order to attend the classes of its most famous teacher, Alberic. This was not the Alberic under whom John of Salisbury studied but the man who later accused Abelard at the Council of Soissons in 1121 and rose to the position of bishop of Bourges by the end of his life.[7] Hugh Primas of Orléans, who taught the Liberal Arts at Orléans before arriving in Reims, wrote a poem that includes praise of Alberic's lectures. Unlike the schools of Paris or Chartres that were homes of disputation and discord, he wrote, the school of Reims produced students proficient not in Plato and the poets but in the Gospel of St. John and the prophets: "This is not a school for vanities; here they lecture on the verities."[8] Despite its traditionalism and orthodoxy, however, all was not peace and harmony in the city. R. W. Southern has drawn attention to some of the difficulties that arose there, which included "overcrowding... tension between the single dominant master and potential rivals" as well as "uneasy relations with the local people."[9] Another important textual source that offers a glimpse of Alberic's school at this time is a long biographical poem written by a clerk called Anselm, describing the youthful life of a German noble, Adelbert of Saarbrücken, who would later be archbishop of Mainz. Coming to Reims to perfect his knowledge of the trivium and quadrivium, Adelbert enrolled in the school of Master Alberic, which is again praised for championing the study of the "sacred page" over ancient learning.[10]

How does the Reims tympanum fit into this particular intellectual and social situation? The scene in the upper part of the sculpture undoubtedly depicts teaching, but the two lower scenes, showing a figure struggling with a serpent and two lovers, are more elusive. Willibald Sauerländer alluded to their undisclosed "allegorical significance," while Joan Evans, following the earlier French scholar Jadart, described the subject matter of the whole tympanum as "a beautiful trinity of Learning, Strength, and Love."[11] I am not convinced of the harmony of this Trinity, and my reading will be much more conflictual, suggestive of the *sic et non* of academic debate. In the rest of this paper I want to ask whether the visual logic by which this sculpture was "read" in the late twelfth century was the same as the textual logic that students learned when they walked up to it. But is it even addressed to the literate student, who was being taught inside the window? Or was it meant for the illiterate laity outside, reminding them of the learning from which they were excluded?

If we are to "read" this image, we have to think of reading in medieval, that is, performative terms. Reading, far more than being a simple, linear flow of information as we think of it today, implicated the whole body and mind in a

6

process of active participation, what John of Salisbury called "intercommunication" between teacher and learner. Did the same apply to object and viewer? When reading a text, the subject moved his mouth, arms, and hands, interacting with the discourse he was performing. Did the viewers of this relief embody and enact similitudes of sculpted gestures they saw carved there? Hugh of St. Victor compared the moral and physical perfection gained through discipline and scholarship to "exquisite statues," and later in the thirteenth century the Parisian master John of Garland told his students to take as "models of deportment" the sculptures they saw carved on churches.[12] The Reims sculpture was not, however, part of a church, which makes the "framework" for its reading more complex and, perhaps, more closely adapted to the kinds of poetic, playful readers trained in the Latin schools. Are we to infer that the two figures disputing in the upper lunette, because higher up, are more positive in meaning, or that the right-hand pair of lovers is on the negative, or damned, side, as would be the case on a Judgment tympanum on the west portal of a church? Finally, is there a distinctly different iconographic mode or practice at play here than that which we might find in an ecclesiastical program?

The Open Book

Symmetry is very important in twelfth-century visual culture, and what lies on the central axis of this tympanum is the spine of an open book. Here, at the place where Christ's body or his cross might be in a traditional Last Judgment tympanum, flesh of a different kind lies open in the form of a parchment codex, which itself has a long and complex history as a sign of power and communication. This is not the Book of Life that sometimes appears in the Apocalyptic imagery of Judgment portals and which reveals the good and bad deeds of sinners. It is the book whose knowledge is open to interpretation, like the tympanum itself.[13] The position of these two figures, higher than the others, might suggest that their actions are the "model" ones. The figure at the upper left was once pointing directly at the volume with his now broken right hand, while the figure on the right makes a very deliberate "counting" gesture by placing his forefinger to his palm—a gesture known as the *comput digital* and often found in scenes of disputation.[14] Both are male, and the figure holding the book wears a small cap, perhaps, like his gesture, indicating his superior status as a master. Describing his own teacher, Bernard of Chartres, John of Salisbury noted how he "would point out, in reading the authors, what was simple and according to rule."[15] The bare-headed interlocutor has his legs crossed, which immediately introduces the possibility of a negative and a positive interpretation, since this gesture was often a sign of pride or tyranny.[16] The fact that both figures are the same size suggests this is not a traditional teaching scene but a disputation, as becomes clear once we compare it to scenes of biblical teaching, such as Solomon instructing Rehoboam, found in twelfth-century Bibles.[17] Rather than the teaching of children, it depicts

6

lecturing in the way that twelfth-century teachers like John of Salisbury understood it, as a form of dialogue or *disputatio* between master and student. A number of contemporary images, for obvious reasons usually found in manuscripts, show the act of *disputatio*.[18] These normally depict two gesticulating figures arguing points, if not necessarily around an open book, which is an unusual and insistently central sign here. At Reims the *divina pagina* is the subject of their discourse, just as it was the focus of study in Alberic's famous school.

During the twelfth century visual and verbal discourse were not as separate as we might at first think. One of the tasks John of Salisbury set teachers of grammar, again in the first book of the *Metalogicon*, is to recognize *diacrisis*. According to this practice, "which we may translate as 'vivid representation' (*illustrationem*) or 'graphic imagery' (*picturationem*)," the authors, "when they would take the crude materials of history, arguments, narratives, and other topics, would so copiously embellish them by the various branches of knowledge, in such a charming style, and with such pleasing ornament that the finished masterpiece would seem to image all the arts."[19] The major ornamental form used by the carver of this vivid representation was acanthus, which swirls in lush abundance in a symmetrical pattern that divides the upper part of the tympanum into two.[20] Apart from the two chairs upon which the lively interlocutors are seated, the richly striated leaves form a kind of bower under which philosophical discourse flowers in the form of the open book held by the left-hand figure. Metaphors associating learning with fruits and flowers are absolutely standard at the time. John of Salisbury describes grammar itself as "the root of scientific knowledge," which implants the seed of virtue in nature's furrow "until it fructifies in good works."[21]

It is significant that neither of the disputing figures is tonsured; indeed both wear sumptuously patterned belts suggesting that they are secular figures and even, perhaps, classical luminaries. The cap surmounting the master's tight curls may also indicate his authority as an author, as one of the *auctoritates* of the past whose works were taught in the schools, perhaps even Boethius himself, who emphasized that all learning is concerned with proper speech, or an earlier Roman orator, such as Cicero or Priscian.[22] Even though Hugh Primas of Orléans praises the school of Reims for rejecting the "arts" of Priscian and Socrates for the truth of John's gospel, his own poetry often incorporates metaphors and ideas from Virgil, Ovid, and other pagan authors. From the first stumbling efforts at grammar to the sophisticated word play of the Goliardic poets, Latin discourse was founded upon the writing of classical authors. The same tension between ancient sources as dangerous illusions on the one hand and as ideal models on the other can be seen in the Reims tympanum. Its composition emphasizes the authority of Christian discourse but is simultaneously "classicizing." The carver shares with Mosan metalworkers of the same period a strong influence from ancient sculpture, especially in the finely articulated

6

curly-haired physiognomies and the lyrical flow of draperies, which are as much "quotations" from the antique as those found in contemporary Latin poetry.[23]

Images, of course, are silent and cannot speak. Their articulation, however, like good speech, is based on proper order. The most obvious and important way we "read" the silent speech of the medieval image is by understanding its distribution, its spatial ordering, from top to bottom or vice versa. This is not to say that there is any single semiotic structure to "reading" a medieval image, despite some scholars' recent attempts to create one, either at the micro-level of individual gestures or at the macro-level of sequential narrative.[24] The only rule I feel able to apply to the structuring of meaning in medieval art is that there are no rules or, at least, that rules are often there to be broken. For example, in this particular instance the "rule" that high is positive and low negative might suggest that this is a triumphal image declaring the superiority of learning, represented by the two disputing figures, over the worldly pleasures of the warrior and lover below. But once we look more closely at the two lower scenes, this apparent "superiority" is not as straightforward as it initially seems.

The Dragon's Tongue

That the two lower lunettes depict acts in which the young man should *not* indulge is suggested by the Chartres house window already referred to, which shows two wrestlers and two men playing dice in the same place in the lunette as the youth and dragon and the kissing couple here. These are struggling figures, who, like the paired figures on the Reims tympanum, embody a tension or opposition that suggests both attraction and repulsion, the force of separation and the desire for union. Bipartite structures of animosity and conflict have a long history in Romanesque art going back to the affronted animals based on non-western sources, which only later developed into culturally specific evocations of specific vices. But is what we see on the lower left of the Reims carving an image of vice?

A youthful male figure with a cloak attached by a pin at his shoulder grabs a serpent or dragon by the throat with one hand and holds a branch of sprouting foliage with the other. The serpent's mouth is wide open, and its long slithery tongue curls out to touch his. In folk tradition the serpent's tongue is usually a sign of taint or poisonous evil, but here its meaning depends upon whether we see the young man, whose own lips are closed, as succumbing to the serpent or as controlling it, keeping it at arm's length, not allowing it to penetrate his own mouth and thus triumphing over whatever temptation it represents.[25] Serpents and dragons are also often associated with false doctrine and heretical belief, which would here be contrasted with the orthodox learning depicted above. Hugh Primas of Orléans' poem eulogizing the teaching of his master Alberic also describes how another famous master with a slicker tongue was threatening to rival the renowned Reims

teacher. "You've been hearing God's own word: shall a convict's voice be heard?" he asks.[26] Some scholars have argued this may be a reference to Abelard, but most now assume it refers to a hated, perhaps heretical preacher of a slightly later period. Does the serpent's tongue similarly indicate the dangerous lure of heretical voices that can lead the young man astray? Walter Cahn has recently warned us about seeing Romanesque public sculpture as containing prescriptions against heresy.[27] If not heresy per se, the serpent seems likely to represent more generally the evils of the tongue that the student must avoid, perhaps blasphemy and swearing or even the useless exercises of sophistry, which the poet of the Life of Adelbert thought had destroyed proper learning in France.[28]

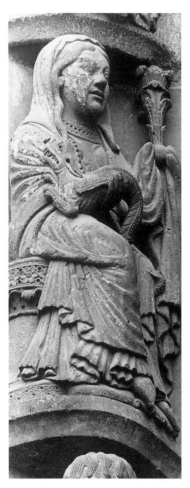

6.2. Dialectic with her flowering rod and serpent. Chartres cathedral, west façade, south portal. Photo: Foto Marburg/Art Resource, NY.

The serpent's tongue can, of course, be a sign of argument itself, as the serpent is a traditional attribute of Dialectic, the second of the seven Liberal Arts, and even of Prudence.[29] In the course of the twelfth century, Dialectic was carved on the west portal of Sens cathedral, at Laon cathedral, and on the more famous west portal of Chartres cathedral, where she holds both the flowery staff of Rhetoric in one hand and the monstrous serpent with its snapping jaws in the other (Fig. 6.2). The serpent is an image of *opponens* and *respondens*, the logical duel of interpretation. In the Reims carving it has neither the dog-like head of the Chartres west portal nor the knotted tail, which appears in a contemporary Darmstadt drawing of Lady Dialectic, who also holds a dragon as one of her attributes.[30] The serpent can allude to a whole gamut of things, both positive and negative, and the issue here is what fits best in this particular context. A poem by a monk of St. Remi of Reims, written in the 980s about the schoolmaster Constantine of Fleury, includes among his virtues the way he combines the chastity of the dove with the cunning of the serpent.[31]

John of Salisbury shared with the older Alberic a rather negative view of the new Dialectic as leading youths away from learning the basics, and in the *Metalogicon* he

6

attacks what he sees as the empty scholastic logic dominant in his day. Alberic's school at Reims had earlier been praised by contemporaries for transcending the wrangling in the budding schools of the dialecticians of Paris. The replacement of grammar by the more sophisticated art of dialectic in the course of the twelfth century, stimulated by the newly available logic of Aristotle, disturbed many, and this too may be relevant to the mouths and meanings in the tympanum.[32] But the serpent in the Reims sculpture, quite different from Dialectica's vociferous viper, is carved so as to seem to join with the boy's own body. We should not be shocked at the sexuality implicit in the two lower images. As historians of medieval pedagogy have shown, "One of the most distinctive—and to the modern reader unexpected— aspects of the word-play in the texts used to teach rhetoric and composition to young students during the Middle Ages is the intense figuration and suggestiveness of the language."[33] The dragon's head issues from the youth's own loins in a kind of masturbatorial fantasy of self-pollution or phallic self-destruction.

This pair, like the lovers opposite, also seems to emerge from the foliage as part of the circular rhythm of nature, which makes them figures literally submerged in a lower, vegetal realm. They are not whole people like the two scholars above but only half human, hybrids prey to the animal appetites of their own lower halves. Whereas the two philosophers stand outside or above nature in the form of the sprouting acanthus leaves, and their hands come into contact only with the culture of the book, their non-bookish counterparts below grasp at nature, the dragon's victim holding the stem of the acanthus with his other hand and the two lovers seeming to merge with the flowery world of the flesh, which, unlike the *flores* of learning above, will wither and die. This mingling of human and vegetal, person and nature is very common in later twelfth-century art in all media, including metalwork and initials painted in manuscripts.[34]

The Woman's Mouth

> A further feature of Bernard's method was to have his disciples compose prose and poetry every day and exercise their faculties in mutual conferences (*collationibus*). . . . Nothing serves better to foster the acquisition of eloquence and the attainment of knowledge than such conferences, which also have a salutary influence on practical conduct, provided that charity moderates enthusiasm, and that humility is not lost during progress in learning. A man cannot be the servant of both learning and carnal vice.[35]

The adjacent semicircle shows two figures whose mouths meet, the woman on the left dressed in a tight bodice that reveals her body and the young man holding a flower and looking like a representation of the youthful figure of May in calendrical cycles of the period.[36] Does this struggle echo that being performed in the other two

scenes, or does it not rather contrast with them as a bad form of conflict, representing the sweaty struggle of lust rather than the strife that is to be overcome by the civilized combat of proper learning or the intellectual struggle over the dragon's tongue? Alternatively, is there a symmetrical visual relationship between the kissing couple and the dragon's slurpy tongue under the other arch, since preachers often described the dangers of women in terms of these beasts? Women were *vipera pessima*, the worst serpents, "in heart, in words, or in actions a woman is a dreadful dragon, and in her inmost parts a most grievous flame crawls like venom."[37] The woman, significantly, is symmetrically counterposed with the dragon opposite, whereas the youth in both cases inhabits the outer edge. Another inhabitant of a canonical quarter, in Amiens not Reims, Richard de Fournival, described in his *Bestiaire d'amours* how "the dragon does not bite anyone, but it poisons with the flick of its tongue."[38] In this reading the dragon's tongue obscenely licking at the man on the left becomes another sign for sexual sin. The poisonous parts of women's bodies are described in the misogynistic words of numerous preachers of the period, for what made the cathedral schools different from the traditional monastic centers of learning was their being set up in cities, with all their attractions and worldly temptations. The poet of the metrical biography of Adelbert describes the traps of vice and dangerous delights of the sirens who ensnare the young students who come to Reims to study, and two of the poems of Hugh Primas are invectives against whores who lead scholars astray.[39]

Yet to counter this reading of the serpent and woman as solely negative symbols, we might just as easily cite recent research on twelfth-century pedagogic techniques, which has emphasized the function of both violence and sexuality in the teaching of Latin. In the process of learning, images of violent sexuality had their place not as exemplars of evil to be shunned but as metaphors to play with and solve. Jan Ziolkowski has published a number of Latin poems by secular clerics from the north of France that display this allusive and often highly obscene invective, where serpents appear in the margins as doodles pointing to places of particularly sharp wit. Likewise the use of Ovid's amatory language and obscene punning was commonplace in the classroom.[40] Surely there is a joke visible in the Reims carving, linking two if not three kinds of penetrative tongue work that the young can enjoy.

This association of the school and sex has its spatial reality as well. While it might seem strange to us today to place an image of illicit sexuality in such close proximity to that of a morally didactic teaching scene, we should remember that early in the thirteenth century Jacques de Vitry described how in Paris a brothel and a school might occupy the same building, so that while the masters disputed philosophy with their students above, the whores disputed prices with their clients below.[41] Even if this does not describe the actual living conditions of the period, the fact that the preacher uses this rich rhetorical juxtaposition of one kind of learning and

6
———

another, drawing a contrast between virtuous knowledge and forbidden desire, is no less significant for understanding our "window" on the world of twelfth-century learning at Reims.

The designer of the Reims tympanum made brilliant use of the purely visual pattern of dialectical opposition in order to make a statement about oppositions in the world as well as in the schoolroom. Recently historians have become especially keen to construct twelfth-century images as sites of conflict and contestation. There is a third textual source of information about Alberic's school that may be useful here, a prose life of the Abbot of Marchiennes (1148–56) that describes how, "At that time there was burning there [in Reims] great zeal for learning and the city was much frequented because of its learned men and those to be indoctrinated in wisdom. Many of these had convened there, so many, say those who witnessed it, that once when clerks and laymen were in conflict, the clerks because of their numbers would have overcome the townsmen, had not peace between them been speedily restored and the former had returned to their schools and the latter to their homes."[42] The conflict represented in the tympanum is thus not only the sanctioned disputation that took place in the schoolroom but also that battle with the dragon which could erupt between clerics and townsmen in the form of dangerous liaisons between clerics and the townsmen's daughters.

The danger of finding conflict in Romanesque images by "reading" them as straightforward mirrors of social process often ends up occluding the actual historical tensions and contradictions that they embody. For example, Hugh's text also relates that the famous Alberic was not as skilled in dealing with questions as he was at lecturing, which led to open conflict between him and a master called Walter of Morton, who left to set up his own rival school elsewhere in the town. Here again the text does not provide an exact match with what we see in the image but tells us something about the gesture of the figure on the right, who is putting the *quaestio* to the master in response to the master's lecturing on a text. The problems inherent in the interpretation of sculpture that was not meant to be placed on or in a church setting, not to say secular art in general, is one of the greatest challenges in the future study of medieval art. How are we to integrate the vast systems of theological meaning we have spent a century constructing with a whole new substratum of imagery from elsewhere? While we can more easily "read" complex cathedral programs such as Chartres, where the Liberal Arts are appropriated as part of the divinely ordained harmonious universe, and time and space collapsed into stone (Fig. 6.2), those sculptures that existed in the world and not as part of the church surely have to be understood differently.

The Reims tympanum, existing as it did half within and half outside the world, is a good example of the importance of the artist's sharing the mentality of his audience. Whether it depicts the superiority of learning over conflict (left) and love

6

Reading Medieval Images

(right), the split between the old grammatical learning "according to the book" (above) and the new dialectical debates (below), the dangers of heresy versus God's authority or the conflicts between town and gown that we know erupted earlier in the century, or all of these—it is structured like a lecture. Its designer was working in a pictorial *sic et non* rooted in chiasmus and rhetorical use of opposing figures and forms. Whereas the tympana of the cathedrals are closed books, articulating difference only in order to damn it, the open book in this little fragment proclaims a more adventurous spirit of ambiguity and contradiction. There are real difficulties inherent in relating intellectual structures to visual ones. Erwin Panofsky attempted to do this in *Gothic Architecture and Scholasticism*, and more recently an interesting study by Charles Radding and William Clark explored the same relationships.[43] But when we are dealing with the pictorial language of verbal/visual arguments, indeed images that themselves represent intellectual arguments like this one, it is crucial to interpret them not as reflections of an already constructed learned discourse but as stages in argument—implicated in but always before and above the textual.

1 *Metalogicon*, 1.24: "Sed quia legendi verbum aequivocum est, tam ad docentis et discentis exercitium quam ad occupationem per se scrutantis scripturas, alterum, id est quod inter doctorem et discipulum communicatur, ut verbo utamur Quintiliani dicatur praelectio. Alterum quod ad scrutinium meditantis accedit, lectio simpliciter appelletur." Ed. J. B. Hall, CCCM 98 (Turnholt, 1991), 51; trans. Daniel D. McGarry in *The Metalogicon of John of Salisbury: A Twelfth-Century Defense of the Verbal and Logical Arts of the Trivium* (Berkeley, 1955), 65–66.

2 Ilene H. Forsyth, "The Ganymede Capital at Vézelay," *Essays in Honor of Sumner McKnight Crosby*, ed. Pamela Z. Blum = *Gesta* 15 (1976), 241–46.

3 Michael Camille, "Seeing and Reading: Some Visual Implications of Medieval Literacy and Illiteracy," *Art History* 8 (1985), 26–49. Ilene Forsyth reviewed the article generously in "The Monumental Arts of the Romanesque Period: Recent Research. The Romanesque Cloister," in *The Cloisters: Studies in Honor of the Fiftieth Anniversary*, ed. Elizabeth C. Parker (New York, 1992), 3–25.

4 C. Givelet, H. Jadart, and L. Demaison, *Catalogue du Musée Lapidaire Rémois* (Reims, 1895), no. 44; H. Jadart, "Musées de Reims," *Congrès archéologique de France* (Paris, 1911), 150–57, fig. facing p. 154; and Willibald Sauerländer, "Chefs-d'oeuvre romans des musées de province," *Kunstchronik* 11 (1958), 39–40, fig. 4. I reproduce the plaster cast from the Musée des Monuments Français, Paris, since this is more legible than the original, now luridly spotlit in the dark display at the museum in Reims.

5 Madeline Harrison Caviness, *Sumptuous Arts at the Royal Abbeys in Reims and Braine: Ornatus elegantiae, varietate stupendes* (Princeton, 1990), fig. 89, labels them secular figures.

6 For the later window at Chartres showing a pair of wrestlers and dice players in the lunettes, see Yves Esquieu, *Le quartier cathédral: une cité dans la ville* (Paris, 1994), 96. For the twelfth-century examples, Paul Williamson, *Catalogue of Romanesque Sculpture: Victoria and Albert Museum* (London, 1983), 42; A. Mayeux, "Maison du XIIe siècle à Chartres," *Bulletin monumental* 79 (1920), 217–22.

7 For the confusion between the two Alberics sometimes found in the literature, see Martin Tweedale, "Logic (i): From the Late Eleventh Century to the Time of Abelard," in *A History of Twelfth-Century Western Philosophy*, ed. Peter Dronke (Cambridge, 1988), 225 n. 128.

8 Poem 18, ll. 51–52: "Non est scola vanitatis, sed doctrina veritatis." Both original text and translation are cited from *Hugh Primas and the Archpoet*, ed. Fleur Adcock (Cambridge, 1994), 46. For fuller discussion of Hugh's poem and its context, see F. J. E. Raby, *A History of Secular Latin Poetry in the Middle Ages*, 2d ed., 2 vols. (Oxford, 1957), 2:177–79; and C. J. McDonough, "Two Poems of Hugh Primas Reconsidered: 18 and 23,"

6

Traditio 39 (1983), 115–34. Another of Hugh's poems, no. 16, ll. 65-68, discusses in negative terms the maker of "ingenious sculptures…and carved wooden gargoyles" (Adcock, 39).

9 R. W. Southern, "The Schools of Paris and the School of Chartres," in *Renaissance and Renewal in the Twelfth Century*, ed. Robert L. Benson and Giles Constable (Cambridge, MA, 1982), 118. On the importance of Reims as a teaching center during the eleventh and twelfth centuries, see L. Demaison, *Une description de Reims au XII siècle* (Paris, 1893); Georges Boussinesq and Gustave Laurent, *Histoire de Reims depuis les origines jusqu'à nos jours*, 3 vols. (Reims, 1933), 1:365; John R. Williams, "The Cathedral School of Reims in the Time of Master Alberic, 1118–1136," *Traditio* 20 (1964), 93–114; C. Stephen Jaeger, *The Envy of Angels: Cathedral Schools and Social Ideals in Medieval Europe, 950–1200* (Philadelphia, 1994), 56–62.

10 *Vita Adelberti II Moguntini*, ll. 603-6: "Qui, nova pandendo set non antiqua silendo, / littera quae celat vetus aut nova scripta, revelat, / dogmatis immensi dux primus in urbe Remensi, / testamentorum pandens secreta duorum." Ed. Philipp Jaffé, *Biblioteca rerum Germanicarum*, vol. 3. *Monumenta moguntina* (Berlin, 1866), 586. Cited in Williams, "Cathedral School of Reims," 97.

11 Willibald Sauerländer, *Gothic Sculpture in France, 1140–1270* (New York, 1972), 414–15, pl. 55; Joan Evans, *Art in Mediaeval France, 987–1498* (Oxford, 1948), 227, fig. 223A, following Jadart, "Musée de Reims," 155: "Le tympan de la baie d'une maison romane représente la science, la force et l'amour symbolisés par des personnages."

12 *Morale scolarium*, ll. 549–50: "Templi sculpturas morum dic esse figuras, / Vivas picturas in te gere non perituras." Ed. and trans. Louis John Paetow, *Morale scolarium of John of Garland (Johannes de Garlandia), A Professor in the Universities of Paris and Toulouse in the Thirteenth Century* (Berkeley, 1927), 174, 243. For Hugh of St. Victor's ideas about sculpture and morality, see Jaeger, *Envy of Angels*, 347. Jaeger focuses on the much later Gothic statues of the wise and foolish virgins at Strasbourg cathedral as embodiments of the civilizing courtliness he sees emerging from the eleventh- and twelfth-century cathedral schools, when, in fact, our Reims tympanum would be a much closer parallel, both chronologically and geographically.

13 Michael Camille, "Visual Signs of the Sacred Page: Books in the *Bible moralisée*," *Word & Image* 5 (1989), 111–30.

14 For this gesture, see O. Chomentovskaja, "Le comput digital: Histoire d'un geste dans l'art de la renaissance italienne," *Gazette des Beaux-Arts* 20 (1938), 157–72.

15 John of Salisbury, *Metalogicon*, 1.24 (CCCM 98, 52; McGarry, 67).

16 François Garnier, *Le langage de l'image au moyen âge: Signification et symbolique* (Paris, 1981), 231; Adelheid Heimann, "The Capital Frieze and Pilasters of the Portail Royal, Chartres," *Journal of the Warburg and Courtauld Institutes* 31 (1968), 80.

17 See Solomon teaching a tiny Rehoboam in the twelfth-century Dover Bible (Cambridge, Corpus Christi College, MS 4, fol. 43r). For the iconography of teaching in the later thirteenth century, see Michael Camille, "An Oxford University Textbook Illuminated by William de Brailes," *Burlington Magazine* 137 (1995), 292–99.

18 For disputing images, *Reallexikon zur deutschen Kunstgeschichte*, vol. 3 (Stuttgart, 1954), 1387–1408, s.v. "Dialektik" and "Dialog"; and the examples described in *Ornamenta Ecclesiae: Kunst und Künstler der Romanik* (Cologne, 1985), vol. 1, nos. A24 and A25. A good survey of the development of medieval pedagogic imagery is found in Karl-August Wirth, "Von mittelalterlichen Bildern und Lehrfiguren im Dienste der Schule und des Unterrichts," in *Studien zum städtischen Bildungswesen des späten Mittelalters und der frühen Neuzeit*, ed. Bernd Moeller, Hans Patze, and Karl Stackmann (Göttingen, 1983), 256–370; for an initial from a later Parisian university manuscript illustrating Dialectic, see Michael Camille, "The Discourse of Images in Philosophical Manuscripts of the Late Middle Ages: Aristoteles Illuminatus," in *Album: I luoghi dove si accumulano i segni (dal manoscritto alle reti telematiche)*, ed. Claudio Leonardi et al. (Spoleto, 1996), fig. 4.

19 John of Salisbury, *Metalogicon*, 1.24 (CCCM 98, 52; McGarry, 66–67).

20 For the Christological meaning of the tree in association with the liberal arts as *sapientia Dei*, see Karl-August Wirth, "Notes on Some Didactic Illustrations in the Margins of a Twelfth-Century Psalter," *Journal of the Warburg and Courtauld Institutes* 33 (1970), 20–40.

21 John of Salisbury, *Metalogicon*, 1.23 (CCCM 98, 50; McGarry, 65). For analysis of these vegetal metaphors for learning, see Ivan Illich, *In the Vineyard of the Text* (Chicago, 1993), and Gert Melville, "Zur 'Flores-Metaphorik' in der mittelalterlichen Geschichtsschreibung: Ausdruck eines Formungsprinzips," *Historisches Jahrbuch* 90 (1970), 65–80.

22 See Diane Bolton, "Illustrations in Manuscripts of Boethius' Works," in *Boethius: His Life, Thought and Influence*, ed. Margaret Gibson (Oxford, 1981), 428–37.

23 See Willibald Sauerländer, "Architecture and the Figurative Arts: The North," in *Renaissance and Renewal in the Twelfth Century*, ed. Robert L. Benson and Giles Constable (Cambridge, MA, 1982), 671–710.

24 For a semiotic macro-reading of stained glass in relation to twelfth-century poetic and narrative theory, see Wolfgang Kemp, *The Narratives of Gothic Stained Glass* (Cambridge, 1997); and for a micro-level dissection of gestural codes, see Garnier, *Langage de l'image*. For a

6

study of the complexity and ultimate incoherence of medieval gestural codes, see Jean-Claude Schmitt, "The Ethics of Gesture," in *Fragments for a History of the Human Body*, pt. 2, ed. Michel Feher (New York, 1989), 129–47.

25 Emma Frank, *Der Schlangenkuss: Die Geschichte eines Erlösungsmotivs in deutscher Volksdichtung* (Leipzig, 1928).

26 Poem 18, ll. 104–5 (Adcock, 49).

27 Walter Cahn, "Heresy and the Interpretation of Romanesque Art," in *Romanesque and Gothic: Essays for George Zarnecki* (Woodbridge, Suffolk, 1987), 27–33.

28 *Vita Adelberti*, ll. 350–70 (Jaffé, 579).

29 See Adolf Katzenellenbogen, "The Representation of the Seven Liberal Arts," in *Twelfth-Century Europe and the Foundations of Modern Society*, ed. Marshall Clagett et al. (Madison, 1961), 39–55; Ludwig Heydenreich, "Eine illustrierte Martianus Capella-Handschrift des Mittelalters und ihre Kopien im Zeitalter des Frühhumanismus," in *Kunstgeschichtliche Studien für Hans Kauffmann* (Berlin, 1956), 59–66. For Prudence with a serpent, see Caviness, *Sumptuous Arts*, 39.

30 For this drawing (Darmstadt MS 2282, fol. 1v), see Jean Wirth, *L'image médiévale* (Paris, 1989), fig. 3; and Michael Camille, "The Dissenting Image: A Postcard from Matthew Paris," in *Criticism and Dissent in the Middle Ages*, ed. Rita Copeland (Cambridge, 1996), 138, fig. 4.10.

31 Jaeger, *Envy of Angels*, 57.

32 For the debate between grammarians and rhetoricians, see Martin M. Tweedale, "Grammar and Dialectic," in *A History of Twelfth-Century Western Philosophy* (as n. 7), 211–16.

33 See Jan Ziolkowski, *Alan of Lille's Grammar of Sex: The Meaning of Grammar to a Twelfth-Century Intellectual* (Cambridge, MA, 1985); Marjorie Curry Woods, "The Teaching of Writing in Medieval Europe," in *A Short History of Writing Instruction from Ancient Greece to Twentieth-Century America*, ed. James J. Murphy (Davis, CA, 1990), 88; and Jody Enders, "Rhetoric, Coercion and the Memory of Violence," in *Criticism and Dissent in the Middle Ages* (as n. 30), 24–55.

34 Jan Van der Meulen, "Der vegetabilische Mensch in der romanischen Kapitellplastik," in *Mensch und Natur im Mittelalter*, Miscellanea Mediaevalia, vol. 21/2 (Berlin, 1992), 911–29; and Michael Camille, *Gothic Art: Glorious Visions* (New York, 1996), 133–61.

35 John of Salisbury, *Metalogicon*, 1.24 (CCCM 98, 54; McGarry, 70).

36 Michael Camille, "Gothic Signs and the Surplus: The Kiss on the Cathedral," *Yale French Studies: Style and Values in Medieval Art and Literature* (1990), 151–69. See now Yannick Carré, *Le baiser sur la bouche au moyen âge: Rites, symboles, mentalités à travers les textes et les images, XIe–XVe siècles* (Paris, 1992). For contemporary images of couples in twelfth-century sculpture, see Nurith Kenaan-Kedar, *Marginal Sculpture in Medieval France: Towards the Deciphering of an Enigmatic Pictorial Language* (Brookfield, VT, 1995), 22–23.

37 *Scorn for the World: Bernard of Cluny's De Contemptu Mundi*, trans. Ronald E. Pepin (East Lansing, 1991), 105.

38 Ed. Cesare Segre, *Li bestiaires d'amours di Maistre Richart de Fornival e li response du bestiaire* (Milan, 1957), 94; trans. Jeanette Beer, *Master Richard's Bestiary of Love and Response* (Berkeley, 1986), 33.

39 *Vita Adelberti*, ll. 424–30 (Jaffé, 581); Hugh Primas, Poems 7 and 8 (Adcock, 12–18).

40 Jan Ziolkowski, "A Bouquet of Wisdom and Invective: Houghton MS Lat. 300," *Harvard Library Bulletin* 1/3 (1990), 20–48.

41 Jacques de Vitry, *Historia occidentalis*, 7; ed. John Frederick Hinnebusch, Spicilegium Friburgense, vol. 17 (Fribourg, 1972), 91. Cited in James A. Brundage, *Law, Sex and Christian Society in Medieval Europe* (Chicago, 1987), 390–91.

42 Cited in Williams, "Cathedral School of Reims," 99.

43 Charles M. Radding and William W. Clark, *Medieval Architecture, Medieval Learning: Builders and Masters in the Age of Romanesque and Gothic* (New Haven, 1992).

6

Geometry and Architectural Design

As medieval architects designed buildings, sorting out the complex proportional geometries of plan and elevation and visualizing the articulation of mass and space, they sometimes used drawings to make concepts concretely visible. These drawings are diagrammatic, representing three-dimensional space in two dimensions, offering explanations of ideas rather than depictions of things. They are distinctive among visual rhetorical genres, characteristically describing forms with utmost economy, showing relations among parts, often providing the mathematical rationale underlying a scheme. Their functions were multiple: they could aid in the creative process, offering the architect a site for the exploration of ideas; they could offer instruction to the mason, responsible for realizing architectural ideas; they could provide a means for designers to present plans of unbuilt buildings to patrons; they could record design methods and thus serve in the transmission of architectural knowledge.

Even with drawings, geometrical relations are not easy to convey to those not accustomed to conceiving spatial relations in geometrical terms. We may imagine the problems encountered by the sixth-century architects Anthemius of Tralles and Isidorus of Miletus, who were responsible for the design of Hagia Sophia in Constantinople. Academic experts on conical sections and projective geometry, stereometry and physics, they applied their knowledge brilliantly and innovatively to architectural design.[1] Any presentation drawings they may have prepared are long since lost, but something of the conversations had at the time may be recovered, perhaps, through a contemporary description of the church. Procopius, a historian at Justinian's court, displays proudly, if awkwardly, his newly acquired technical vocabulary. He provided this explanation of the geometry underlying the design of the interior east end of the church, responsible for its dramatic visual effects:

> A construction of masonry rises from the ground, not in a straight line, but gradually drawing back from its sides and receding in the middle, so as to describe a semi-circular shape which is called a half-cylinder by specialists, and this towers to a precipitous height. The extremity of this structure terminates in the fourth part of a sphere, and above it another crescent-shaped form is lifted up by the adjoining parts of the building, wonderful in its beauty yet altogether terrifying by the apparent precariousness of its composition.[2]

The efficacy of graphic representation over written description is clear: the design of Hagia Sophia could never be reconstructed from such an account. But architectural drawings themselves are not easily interpreted by the untrained. To read them requires

knowledge of the graphic conventions in use and a certain kind of visual imagination. This was recognized by Isma'il b. al-Razzaz al-Jazari, thirteenth-century author of an Arabic treatise on ingenious mechanical devices:

> In drawing it [the picture of the door] I have not aimed for completeness. My purpose was to present a [general] arrangement so that it can be understood in the whole and in detail. One realizes that there is obscurity in the representations of solid bodies, but in the imagination one can fit one thing to another, view it from an angle, dissect it, and thus assemble it step by step.[3]

In the essay that follows, Linda Neagley analyzes a fifteenth-century drawing of an ornate late Gothic portal. The visual code is complex: Neagley demonstrates how earlier diagramming practices were adapted to render the spatially more sophisticated designs of the Flamboyant style.[4] She shows that the drawing represents three-dimensional spatial relations in a two-dimensional perspectival system based on a previously unidentified design grid. To aid her analysis of the compact, densely nested composition, Neagley exploits the capacities of computer assisted design (CAD) and, by overlaying color-coded annotations on the drawing, is able to recreate the intricacies of the viewing process and to demonstrate the ingenuity of the designer.

T. K. T.

1 Richard Krautheimer, *Early Christian and Byzantine Architecture*, rev. ed. (New Haven and London, 1986), 206, mentions perspectival renderings as part of the design process for the church. See Roland Mainstone, *Hagia Sophia: Architecture, Structure and Liturgy of Justinian's Great Church* (New York, 1988), 152ff., for extended discussions of design development.

2 *De aedificiis*, 1.1.23ff.; trans. Cyril Mango in *The Art of the Byzantine Empire, 312–1453* (Englewood Cliffs, NJ, 1972; rpt. Toronto, 1993), 74.

3 Cited by Gülru Necipoğlu in *The Topkapi Scroll— Geometry and Ornament in Islamic Architecture: Topkapi Palace Museum Library MS H. 1956* (Santa Monica, CA, 1995), 152. See ch. 8, "Theory and Praxis: Uses of Practical Geometry," for a consideration of developments in the use of geometry in architectural design from Greek antiquity through the Middle Ages in western Europe, Byzantium, and the Islamic East.

4 Neagley contributes to discussions surrounding the idea that "high scholasticism" supplied the intellectual context for the unified designs of high Gothic church architecture. Promoted in Erwin Panofsky's influential *Gothic Architecture and Scholasticism* (Latrobe, PA, 1951), the idea has recently been revisited by Charles M. Radding and William W. Clark in *Medieval Architecture, Medieval Learning: Builders and Masters in the Age of Romanesque and Gothic* (New Haven, 1992).

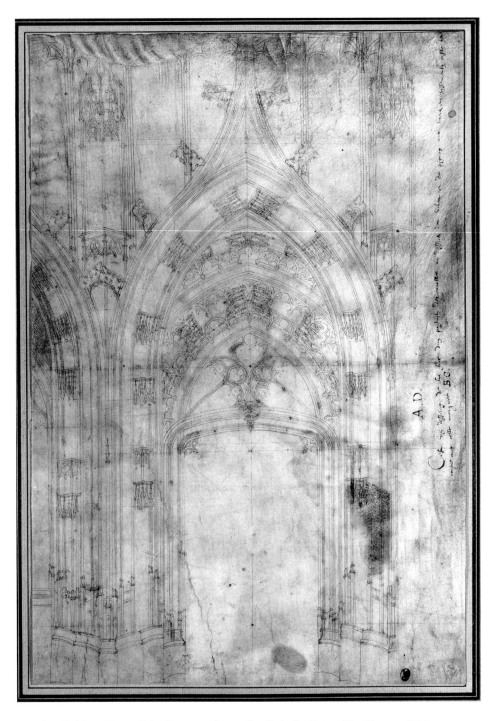

7.1. Late Gothic architectural drawing on parchment. New York, The Metropolitan Museum of Art, The Cloisters Collection (68.49). Photo: The Metropolitan Museum of Art.

7 A Late Gothic Architectural Drawing at The Cloisters

Linda Neagley

Soon after its acquisition by The Cloisters in 1968, Robert Branner published an article on a fifteenth-century architectural drawing of a Gothic portal and porch, providing a detailed description, identifying it as a "show drawing," and assigning it to the region of Montbrison in south central France or possibly Normandy (Fig. 7.1).[1] Although he was unable to attribute it to any known Late Gothic architect or to connect it with any existing building, Branner recognized its importance, stating that it was one of only four extant medieval French drawings of Flamboyant monuments. Nonetheless it has rarely been cited, and the full range of its visual clues has yet to be explored.[2] This paper draws upon recent research on medieval architectural drawings, medieval design methods, and French Flamboyant architecture in general to shed further light on the Cloisters drawing. New computer technology is employed to enhance the drawing's faintly visible design grid and then to analyze proportional schemes controlling the design. This analysis demonstrates how a master mason struggled to express three-dimensional spatial relations with his limited geometric tools and within the limitations of traditional medieval two-dimensional design systems and, in the process, invented a unique perspectival but isometric system of representation.

The drawing on parchment, measuring $17\,^9/_{16}$ by $11\,^3/_4$ inches, carefully executed with rule and compass in brown ink, is clearly generated from a grid of horizontal, vertical, and diagonal guide lines in chalk.[3] This design grid can be seen with the naked eye assisted by a magnifying glass (it is faintly visible in Fig. 7.2). Branner, relying on his eye, dismissed the three diagonal lines—two in the center of the portal opening and one in the upper right-hand corner (Color Plate 2, lines 14, 15, and 17)—as possibly executed in pencil and "probably made at the time the drawing was to be reproduced in 1844."[4] Moreover, he failed to mention the seven horizontal lines (Color Plate 2, lines 1–7), six vertical lines (lines 8–13), and an additional diagonal line (line 16), as well as the numerous small lines executed freehand that seem to function as frames for the niches and crockets. In addition, dozens of pinpricks located on these lines and in the center of the circles forming the cusping of tracery are revealed upon close examination. There is no evidence that the three diagonal lines Branner assigned to the nineteenth century are not

medieval. Computer enhancement reveals that the chalk lines, in fact, lie beneath the ink lines of the drawing.

The precise position of the underlying grid and pinpricks in relation to the drawing becomes clear when the image is scanned into the computer using Adobe Photoshop and enlarged using the drafting program MiniCAD. (In Color Plate 2, to further differentiate these design guidelines from the actual drawing, they have been rendered in red.) Computer technology both facilitates the viewing of the object with its ability to enhance details and aids analysis with its power to construct and manipulate geometries, dimensions, and proportional systems without any danger to the original work due to handling. Enhancement in this instance allows us to study more closely the preliminary stage in the execution of the Cloisters drawing, a crucial feature that was never meant to be seen but that functions as evidence of the creative process.[5] The chalk grid, in effect, provided a constructional scaffolding for the ruler and compass that enabled the draftsman to lay out and define, with great accuracy, the major proportions and dimensions of the portal, embrasures, and gable.

The task of uncovering the role of the design grid in the execution of the Cloisters drawing is made difficult by a number of factors. The drawing has been cut down from its original size, thereby altering the proportional relationships and making the identification of an overall design system impossible (fortunately, as we shall see, coherent proportional relationships are still present in the construction of the portal and porch).[6] Further, due to some shrinkage of the parchment, the guide lines, although executed with a straight edge, are no longer always straight or perfectly aligned. Moreover, the underdrawing occasionally exhibits carelessness in execution: for instance, the intersection of two prominent diagonals does not perfectly pass through point c (Color Plate 3).[7]

The portal and porch are drawn with elegant, fluid but perfectly controlled lines that articulate every molding, base, niche, crocket, and gable. There is a single omission: perhaps because figural sculpture fell outside his own expertise, the author eliminated the statues that would have filled the niches in the concave scoops of the door jambs and arches and the sculpted figure that would have stood before the glazed tympanum on the foliate console rising from the center of the arch lintel.[8] Perfectly proportioned, finely detailed, and executed with ease, everything about the drawing goes to suggest a confident and experienced draftsman intimately familiar with the architectural vocabulary and design methods of the most sophisticated urban workshops of late fifteenth-century northern France.

The drawing is conceived on two planes (Fig. 7.1). In the foreground, a porch surmounted by an ogee gable with crockets and finial pierces a façade wall that is articulated above with rectilinear paneling. Behind this porch, and visible through its arch, lies a delicate Flamboyant portal framed by continuous moldings

that rise from fillet bases and deep concave embrasures, and capped by an *anse de panier*.[9] The glazed tympanum above the portal lintel is filled with curvilinear tracery in the form of two paneled mouchettes and a soufflet. Surrounding the tympanum are two ranks of voussoir niches and three rows of suspended trefoiled cusping. Although only a fragment of the original, the Cloisters drawing seems to depict the main portion of a façade elevation with a suggestion of a blind traceried wall to the left. The space to the right of the portal is left blank, but as Branner suggests, this was frequently the case with façade drawings in which symmetry was achieved or implied by the mirroring of the left portion.[10]

The Design Grid

The starting point for the sizing of the porch and portal is the width of the porch. This opening is based on a square (ABCD) defined by red lines 2 and 4 of the underlying grid and provides the inner width and height of the porch opening from the top of the bases to the portal lintel (Color Plate 3). The location of the springing of the porch arch is found by using the diagonal of square ABCD to create a $\sqrt{2}$ rectangle ABFE, the most common proportional construction in Gothic design.[11]

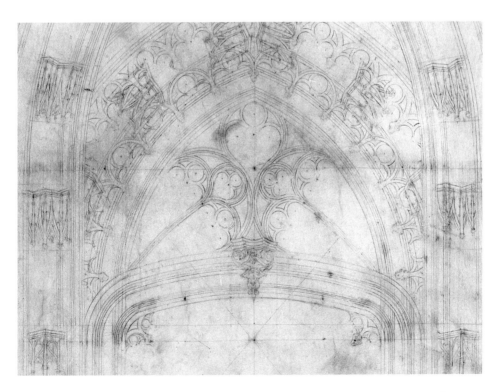

7.2. Late Gothic architectural drawing on parchment: detail. New York, The Metropolitan Museum of Art, The Cloisters Collection (68.49). Photo: The Metropolitan Museum of Art.

Drawing at The Cloisters

Other relationships in the design of the porch and façade elevation that exist in the foreground plane and that derive from the design grid can be found by manipulating this square and √2 rectangle. A vertical block of two √2 rectangles defines the height of the porch opening to red line 6, and the distance between the height of the porch opening (point f) and the top of the porch ogee (point i) is equivalent to the basic square. A second larger square (GHIJ)—defined by the center of the porch buttress and wall niche on the left and by red line 9 on the right as well as horizontal red lines 1 at the bottom and red line 5 at the springing of the porch arch—is similarly used to determine the placement of the upper buttress niches and the design center for the tracery of the rectilinear paneling adjacent to the porch ogee. Although much of the residual chalk grid cannot be explained so neatly, identification of the two basic squares and the √2 rectangle provides explicit evidence of a proportional design system at work in this drawing of a Flamboyant façade.

More interesting are the tracings that demonstrate an attempt to convey spatial relationships in the design without abandoning traditional medieval design methods. The mason/architect clearly communicates that the portal lies on a plane behind the porch. Full view of the two ranks of framing voussoirs with sculptural niches and three ranks of cusping surrounding the glazed tympanum is cut off by the porch opening arch. In addition, both the porch and portal embrasures recede in concave scoops along diagonal lines, providing clear evidence of overlapping planes and a spatial gap between the foreground porch and background portal. How then does the design of the portal relate spatially to the design of the porch, when the latter is generated from a two-dimensional geometry located on the foreground plane? How could the draftsman communicate a homogeneous or perspectival space containing porch and portal without sacrificing the two-dimensional proportional relationships demanded of working drawings? Our architect "invents" his own system by adjusting medieval methods to new spatial realities.

He is careful to exclude from his two-dimensional constructions the portion of the drawing that is rendered in perspective (i.e., the porch and portal socles that spatially recede). His seminal design unit, the basic square ABCD from which the key dimensions of the porch are derived, lies above these socles and is constructed on a single foreground plane. Only the larger square GHIJ contributes to the design in both planes. While it defines the overall width of the porch opening in the foreground, it also determines the base line for the background portal indicated on the original drawing by a small dash labeled line 1 and perpendicular to the central axis line 12.

Secondly, a clear distinction between spatial planes occurs in the location of lines that define the arch openings. The architect generates the curves of the porch opening from points n and o on line 5 (see Color Plate 4, where all curves for these arch openings are designated by dotted lines with arrows). However, the arches

of the portal that exist in the background plane are generated from line 3, parallel to and directly below line 4. Here are located the compass points for the arches of the lintel (points j and k). Points l and m—located on the lintel but not on any constructed line—become the compass points for the tympanum and voussoirs. Only point b, which can be read as existing on the foreground grid and square ABCD or on the spatially neutral central axis line 12, becomes the location for a third compass point of the *anse de panier* arch on the background plane.

Thus the background plane and the foreground plane are generated from separate design grids. To link the two spatially (suggesting a continuous or homogeneous space) the mason draws two prominent diagonals that extend from the foreground grid line 2 to the background grid line 3. There seems to be no other purpose for these oblique lines than to express spatial continuity between the foreground and background design grids.[12] This spatial system allows the mason/architect to create spatial homogeneity in his drawing without having to abandon traditional two-dimensional geometric design schemes or to sacrifice the dimensional accuracy demanded by linear perspective.

Late Gothic Architectural Drawings

Spatial layering indicated by distinct planes of construction and spatial recession indicated by oblique portal embrasures are rare in architectural drawings before the fifteenth century. Both are absent in the façade drawings of the Reims Palimpsest and the Strasbourg drawings of the mid-thirteenth to mid-fourteenth centuries. Typically in drawings of the fifteenth century, spatial representation is directly related to the function of the drawing, with working drawings intended to assist the masons in construction having the least suggestion of space, and show or presentation drawings intended for patronal consumption the most.[13]

The Cloister drawing stands alone as a fifteenth-century attempt to construct a homogeneous space by linking discrete foreground and background planes that have been constructed with two-dimensional geometry. It was both a working drawing with a precise proportional system and a drawing that satisfied a new desire to communicate space. This is not the place to explore the cultural and pragmatic reasons why architectural drawings of the late fifteenth century needed to communicate both sets of information, but it is clear that traditional methods of design were inadequate to do so.[14]

The design evidence provided by the Cloisters drawing also affords the opportunity to compare regional design methods with those prescribed by textual sources. Hanns Schmuttermayer's *Fialenbüchlein*, dating to the 1480s and contemporary with our drawing, describes a step-by-step method for the construction of the elevation of a gable by taking its key dimensions from the section of a pinnacle. Although the outward appearance of Schmuttermayer's drawing is strikingly similar

7

———

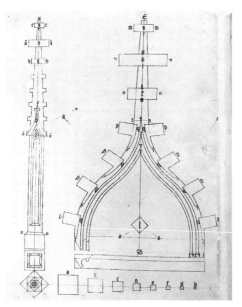

7.3. Design of pinnacle and gable from Hanns Schmuttermayer's *Fialenbüchlein*. Photo: Germanisches Nationalmuseum, Nuremberg.

to the Cloisters portal with its ogee gable, crockets, and finial, it seems that the French architect arrived at his design using an entirely different method of construction (Fig. 7.3).[15] The difference in approach raises important questions about localized design practices and challenges the notion of the "international homogeneity" of Late Gothic style. Design procedures may have developed regionally even when similar results were achieved. The only relationship between the "design" of the two gables is seen in the handling of the gable crockets. Schmuttermayer indicates the eight blocks to be carved by the master mason, *appareilleur*, or sculptor in the same way that the author of the Cloisters drawing blocks out a frame for the crockets which he then executes freehand.

Although there is no evidence that the Cloisters drawing served as a model for any existing building, it is remarkably similar to the west façade of the parish church of Saint-Maclou in Rouen designed by Pierre Robin in the 1430s and executed under the direction of Ambrois Harel in the 1480s.[16] The gabled polygonal porch with its triple openings stands as a diaphanous screen before the triple portal of the west façade. Like the Cloisters drawing, the porch and portals of Saint-Maclou are conceived in terms of sharply delineated elements and fluid curves and the use of a progressive language of bases, moldings, and tracery (compare Figs. 7.1, 7.4). Both Robin and the anonymous author of the Cloisters drawing layer architectural elements to achieve carefully structured spatial sequences that reflect new concerns about modulating the layman's movement through church space from the worldly to the sacred.[17] Like Robin's design for Saint-Maclou, the Cloisters drawing expresses an almost canonical form of Gothic design brought up to date by fashionable architectural vocabulary and manipulated to respond to new spatial realities.[18]

7

Reading Medieval Images

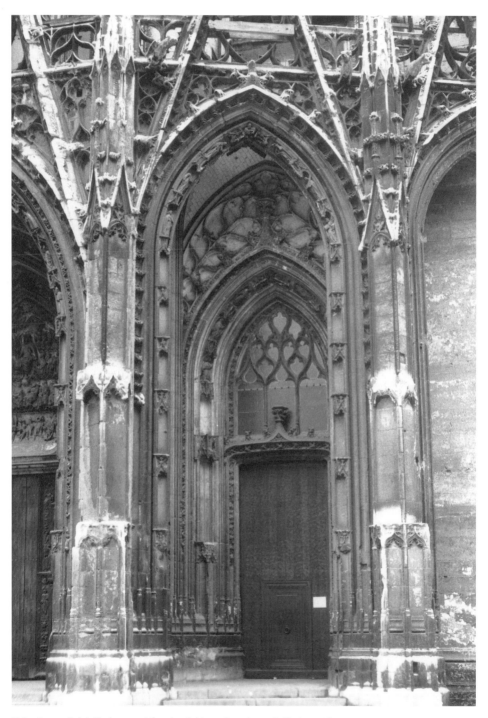

7.4. Rouen, Saint-Maclou, west façade, right porch and portal. Photo: author.

Drawing at The Cloisters

I would like to thank Julian Chapuis, Assistant Curator at The Cloisters, for his generosity in letting me examine the drawing out of its frame. I am also indebted to Hu Li, graduate student in the School of Architecture at Rice University, and Wen-Kai Zhong, graduate student in the School of Architecture at UC Berkeley, for their assistance and patience in teaching me MiniCAD, the software used in the analysis of the drawing. I would further like to thank Judith Brown, Dean of the School of Humanities at Rice University, for supporting the computer work over the summer of 1997.

1 Robert Branner, "A Fifteenth-Century Architectural Drawing at The Cloisters," *Metropolitan Museum Journal* 11 (1976), 133–36. The drawing had been previously listed among new acquisitions in the *Metropolitan Museum of Art Bulletin*, n.s. 27 (1968), 114–15, and in *Metropolitan Museum of Art: Notable Acquisitions, 1965–1975* (New York, 1975), 147. Prior to its acquisition by the Metropolitan Museum in New York the drawing had been in the collections of Vionnois (1844), Destailleur (1896), and Beurdeley (1920). Alfred Beurdeley's (1847–1910) collector's seal is stamped on the lower right corner of the drawing. The drawing was first published and discussed by J. Renouvier and A. Ricard in *Des maîtres de pierre et des autres artistes gothiques de Montpellier* (Montpellier, 1844), 55–56, and later listed in the *Catalogue de dessins originaux de la collection de feu M. Alfred Beurdeley* (Paris, 1920), 12–13.

2 Branner, "A Fifteenth-Century Architectural Drawing," 133–34, identifies the Reims Palimpsest, the façade drawing of Clermont-Ferrand, and the *cathedra* plans for Rouen Cathedral as the remaining extant French works. To this list should be added the portal drawing for the cloister of the Hôpital Saint-Jacques-aux-Pèlerins, Paris, 1474, discussed and illustrated in *Les bâtisseurs des cathédrales gothiques*, ed. Roland Recht (Strasbourg, 1989), 357–59.

3 The condition of the drawing is remarkably good, with some slight buckling and a few creases and folds. A small section on the upper left margin was replaced by a semicircular patch measuring about 12 cm. A gray stain, possibly mold, colors the right jamb of the portal, and a small brown stain is found near the center lower margin. Although a few pinpricks have pierced the thickness of the parchment, the back of the drawing is smooth and has no chalk residue or incised or penned lines. See museum dossier, The Cloisters.

4 Branner, "A Fifteenth-Century Architectural Drawing," 136.

5 See the detailed analysis by Stephen Murray of a thirteenth-century façade drawing, "The Gothic Facade Drawings in the 'Reims Palimpsest,'" *Gesta* 27 (1978), 51–55. Murray has suggested that the façade of "Sheet B" was designed around a grid of 16 squares. Unlike the pinpricks in the Cloisters drawing, which were left by a compass constructing the arches of the porch and portal and the tracery cusping, the pinpricks in the Reims Palimpsest drawing seem to be a method of transferring the design to another surface.

6 The original size of the Cloisters drawing is unknown. There are indications that the parchment was cut along three sides—the top, left, and right margins—while the inscription along the right-hand side reveals that it was once attached to a second piece of parchment. This inscription, written in a sixteenth-century hand in three lines, was first published by Renouvier and Ricard in 1844 and translated by Branner in 1976: *A.D. Cest un(g) desseing de la face dun portail des carolles au dessus des vitres et du pignon avec leurs enrichissements ceste la / cousue avec celle marquee B.C.* ["A.D. This is a design for the elevation of a façade, from the aisles to (a point) above the windows and gable, with their embellishments; this part / sewn together with the one marked B.C."]

7 The purpose of the small vertical lines 10, 11, and 13 that pass through the lintel remains ambiguous. Although line 17 reflects the swing of the compass from point p that inscribes the outer edge of the gable, its presence seems superfluous.

8 Occasionally sculpture is included in façade elevation drawings, such as those from Strasbourg, but it is generally absent from the niches in the drawings most comparable to the Cloisters drawing.

9 An *anse de panier* is a flattened lintel arch or what is commonly called a three-centered arch, in which the curve of the arch is constructed using three separate compass points. See Color Plate 4, points j, b, and k, for the construction of an *anse de panier*.

10 Branner, "A Fifteenth-Century Architectural Drawing," 134. He indicates that the drawings of Strasbourg A imply a mirroring of the side portal adjacent to the central portal.

11 A √2 rectangle, also known as a diagon or golden section rectangle, is created when the diagonal of a square becomes the long side of the rectangle.

12 See Samuel Y. Edgerton, Jr., *The Heritage of Giotto's Geometry: Art and Science on the Eve of the Scientific Revolution* (Ithaca, 1991), 9. Edgerton cites the work of perceptual psychologists who have observed that oblique lines indicating recessive space are not cultural constructions but universally read as suggesting spatial recession.

13 Extant fifteenth-century architectural drawings display the variety of ways in which architects wrestled with the conflicting demands of two-dimensional design and three-dimensional space. The Clermont-Fermond façade study and compendium to an expertise dated to 1496 is perhaps closest in style to the Cloisters drawing, with its fine detail executed with ruler and compass. Michael T. Davis ("'Troys Portaux et Deux Grosses Tours': The Flamboyant Façade Project for the Cathedral of Clermont," *Gesta* 22 [1983], 67–83) identifies it as both a working plan and a presentation drawing intended for its patrons. Slight recession is suggested by the diago-

7

Reading Medieval Images

nally receding jambs, but there is no evidence of a design grid indicating how the proportional relationships were constructed. Separate cross-sections below the elevation drawing communicated the necessary spatial information needed to construct the three-dimensional jambs, buttresses, and niches. Less elaborate but similar in function is the drawing of a cloister portal by architect Guillaume Monnin for the Hôpital Saint-Jacques-aux-Pèlerins in Paris from 1474 (illustrated in *Bâtisseurs des cathédrales*, 357–59). Monnin also prepared for his patron a planar elevation drawing with a cross-section of the embrasures below, thereby eliminating the need to indicate spatial relationships in the elevation drawing.

The interior elevation of San Juan de los Reyes, designed by Juan Guas between 1479 and 1480 and discussed by Sergio Sanabria ("A Late Gothic Drawing of San Juan de los Reyes in Toledo at the Prado Museum in Madrid," *Journal of the Society of Architectural Historians* 51 [1992], 161–73), is perhaps the most spatially suggestive of all fifteenth-century elevation drawings. It is a presentation drawing made for the Catholic monarch Ferdinand and his wife Isabella, executed freehand, with rich decorative accoutrements. Design and dimensional relationships are completely absent.

Moritz Ensinger resorted to extensive freehand delineation of space in his 1470 studies of the Ulm cathedral elevation with its porch and multilayered façade (illustrated in *Les bâtisseurs des cathédrales,* 410–11), while Konrad Roritzer's diagonal porch at Regensberg, executed about 1456–59, is based on a curious theory of projection in which diagonality is implied by the compression of the arches rather than any consistent system of linear or spatial perspective. See François Bucher, "Design in Gothic Architecture: A Preliminary Assessment," *Journal of the Society of Architectural Historians* 27 (1968), 49–71, esp. 65–66.

14 I hope to explore elsewhere the cognitive shifts that led to the redefinition and use of space in fifteenth-century French architecture.

15 Lon R. Shelby, *Gothic Design Techniques: The Fifteenth-Century Design Booklets of Mathes Roriczer and Hanns Schmuttermayer* (Carbondale, 1977), 134–42. Schmuttermayer recommends that design be rooted in the "high and liberal art of geometry," so that the individual design freedom (or "feeling, speculation and imagining") can be "better subjected, after memorization, to the true basis of measured work" (126–27). The starting point for Schmuttermayer is not a pragmatic point of reference such as the width of the porch, as suggested by the Cloisters drawing, but is based on eight inscribed squares that become the dimensional building blocks for setting out the pinnacle and gable. For example, the side of the second square (called the "Old Shoe") becomes the distance between the horizontal lines used to swing the arches of the gable. This would be equivalent to lines 4 and 5 in the Cloisters drawing. The width of the gable is based on nine times the side of square b, while the height of Schmuttermayer's gable is sixteen times the side of b, with the midpoint being the height of the gable opening.

16 Branner was cautious in attributing the Cloisters drawing to a specific workshop or master, but it almost certainly came from the creative orbit of Rouen between 1460 and 1500. Although the architectural vocabulary used in the drawing was ubiquitous, taken as a whole, the style is completely consistent with late fifteenth-century Parisian/Rouennais Flamboyant. The formal details—continuous moldings and fillet bases, embrasures with concave scoops, combinations of double-curved and geometric tracery, and ogee gables stabilized by rectilinear tracery—and, more importantly, the elegant, linear precision are wholly characteristic of the work of celebrated Rouennais masters such as Guillaume Pontis and Jacques Le Roux, masters at Rouen cathedral and the parish church of Saint-Maclou. Both were deeply influenced by the academic and canonical approach to Gothic design characteristic of the workshop at Saint-Maclou defined by Pierre Robin, whose experimentation stretched the limits of the High Gothic design canon. See Linda Neagley, *Disciplined Exuberance: The Parish Church of Saint-Maclou and Late Gothic Architecture in Rouen* (University Park, PA, 1998), 89–94.

17 Through the use of barriers on the interior of thirteenth- and fourteenth-century churches, including *jubés* or rood screens and choir and chapel enclosures, architecture controlled access to space and created structured sacred and social hierarchies. The reintroduction of the porch by Pierre Robin extended sequentially nested spaces to the exterior and contributed to the notion of movement to and through the church as a localized pilgrimage. Although porches had been frequent in Gothic architecture prior to the fifteenth century (e.g., the elegant porch screen of the west façade of Saint-Nicaise at Reims), Robin's elegant and skillfully wrought porch at Saint-Maclou served as a model or source of inspiration for a large number of fifteenth-century churches in Normandy, including St.-Vincent in Rouen, Notre-Dame in Alençon, Saint-German in Argentan, Notre-Dame in Louviers, and La Trinité in Falaise. See Neagley, *Disciplined Exuberance*, 94–95.

18 I have argued elsewhere that painters such as Jan van Eyck were deeply impressed by the new level of sophistication in architectural draftsmanship. Van Eyck seems to imitate an architectural drawing in his depiction of the tower in the Antwerp *Saint Barbara*. See Neagley, *Disciplined Exuberance*, 101–7.

Audience

Many of the essays in this volume explore the circumstances in which works of art were made and viewed.[1] In order to ground their readings of images and objects, authors seek to reconstruct context, and this context is typically sought in the originating culture. Increasingly art historians work on the premise that awareness of audience is key to proper interpretation: artisans, whatever the context, create works in anticipation of conveying something to someone, and viewers respond by endowing these works with meaning.

To some degree "audience" is understood to be no more than a convenient fiction. Often, especially in the case of medieval audiences, the evidence for viewership is incomplete or inconclusive and, even when the audience can be relatively fully characterized, meaning cannot be definitively circumscribed: the intersubjective spaces between art work and individual viewer or collective public continually nuance the specific impact of the work.[2] Yet, as a strategy, to consider audience is to make the interpreter focus not on inherent meaning but on how meaning might have been generated in a given situation; it is to open up the interpretive process, allowing for the study of a work's changing significance over time. In the following two essays, issues of reception play a dominant role. Striking differences in the nature and extent of evidence about original audience partially determine the authors' divergent interpretive strategies.

Michael T. Davis offers a reading of a sculptural cycle whose original viewership was restricted to a clerical audience, certain of whose members had very likely designed it. Seven reliefs set into the exterior wall of the choir of Notre-Dame cathedral in Paris were located in the canons' quarters, inaccessible to the general public. Situating the reliefs within a micro-cultural context, Davis constructs a reading in the light of the audience's "constellation of knowledge, experience, and concerns." He shows how movement and memory, as well as the ritual and meditative practices in which the clerics engaged, would have combined to stimulate different and deeper readings upon multiple viewings.

In contrast, the original producers and users of a bronze aquamanile now in the Louvre,[3] treated by Oleg Grabar, are difficult to locate within even a broadly defined cultural context, despite the existence of a bilingual inscription concerning the object's creation. Analysis of the inscription, in Arabic and Latin, supports an assignment of the vessel to Ummayad Spain in the tenth century, but it is impossible to determine whether it was intended for an Islamic or a Christian audience, or if it was a "speculative commercial venture for a broad market."[4] Lacking information crucial to a firm contextual explanation, Grabar shifts the interpretive playing field from the pre-history of the object

(everything that influenced its production) to its post-history (reactions to the work from its first viewing to its hypothetical last). Elsewhere he has described the consequences of this shift: "The finiteness and the theoretically logical rigor of pre-history is replaced in post-history by the immense, constantly changing, and in some sense cumulative wealth of human taste and emotions."[5]

T. K. T.

1 As recent theory teaches, and the assembled essays reveal, context can be construed in many ways, varying according to perspective and approach. In this area of study there has been continual cross-fertilization with other disciplines, especially anthropology, sociology, history, and archaeology, as well as the emergent field of cultural studies. The work of the sociologist Pierre Bourdieu, including his anthology *The Field of Cultural Production: Essays on Art and Literature*, ed. Randal Johnson (New York, 1993), has much influenced art-historical and archaeological approaches to context. See Paul Mattick, Jr., "Context," in *Critical Terms for Art History*, ed. Robert S. Nelson and Richard Shiff (Chicago, 1996), 70–86. The essays in *The Archaeology of Contextual Meanings*, ed. Ian Hodder (Cambridge, 1987), provide examples of Bourdieu's sociological interests influencing archaeological approaches.

2 Norman Bryson, "Art in Context," in *Studies in Historical Change*, ed. Ralph Cohen (Charlottesville, 1992).

3 For articulation of the issues surrounding the modern museum as a site for the display of medieval objects, see Robert S. Nelson, "The Discourse of Icons, Then and Now," *Art History* 12 (1989), 144–57.

4 For the cross-cultural transfer of material artifacts, see Oleg Grabar, "The Shared Culture of Objects," in *Byzantine Court Culture from 829 to 1204*, ed. Henry Maguire (Washington, DC, 1997), 115–29. On the ways groups maintained separate identities, see, for example, *Strategies of Distinction: The Construction of Ethnic Communities, 300–800*, ed. Walter Pohl and Helmut Reimitz (Leiden, 1998), esp. Pohl's essay, "Telling the Difference: Signs of Ethnic Identity," 17–69.

5 "Different but Compatible Ends," *Art Bulletin* 76 (1994), 396–99. This short essay is part of a series on "The Object of Art History."

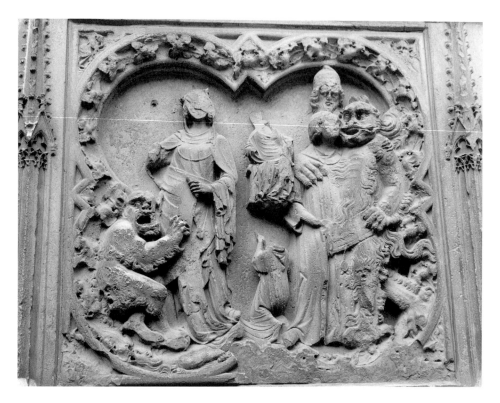

8.1. Story of Theophilus. Paris, Notre-Dame, north side of choir. Photo: author.

Canonical Views: The Theophilus Story and the Choir Reliefs at Notre-Dame, Paris

Michael T. Davis

Of the myriad miracles of the Virgin Mary, the story of Theophilus enjoyed singular popularity in the visual arts of medieval Europe from the twelfth to the fourteenth century. Included in the *Golden Legend* and related in verse by Gautier de Coinci and by Rutebeuf, the parable recounts how Theophilus, a bishop's deputy (*vidame*), entered the service of the devil to regain his lost administrative post, repented, and was saved by the intervention of the Virgin.[1] With its resonant mix of the personal and universal, the profane and the spiritual, this tale of repentance and salvation appeared frequently in devotional manuscripts as well as in public programs of sculpture and stained glass.[2] To the individual leafing through a psalter or book of hours in the quietude of a private chapel, the miracle offered hope of redemption from sin through God's mercy and Mary's mediation. At the same time, the Church deployed Theophilus on portals and in windows as a potent *exemplum* to warn an upwardly mobile secular society of the pitfalls of blind ambition.[3] In this paper, I explore a rendering of the Theophilus legend that straddled the private and corporate spheres: the sculptural relief set into the north flank of the choir of Notre-Dame, Paris (Fig. 8.1). At first glance, it would seem to offer few interpretive challenges, for in theme and composition it echoes the Souillac tympanum so brilliantly studied by Meyer Schapiro nearly sixty years ago.[4] But like a word on a page, this single panel was positioned within the larger context of a "sentence" of seven reliefs devoted to the Virgin Mary located in the cathedral cloister (Fig. 8.2). Reading the environment illuminates the original details and gestures that reinvented this Theophilus story for a specific audience, the Notre-Dame clergy.

The Cycle

Although the cathedral reliefs survive as the single example of fourteenth-century Parisian architectural sculpture preserved *in situ*, they have attracted little attention apart from occasional stylistic analysis.[5] This neglect seems to arise from the belief

that they are *spolia* from a dismantled interior monument whose incomplete translation to the exterior shattered the iconographic coherence of the ensemble.[6] However, while the panels are not coursed in with the regular ashlar masonry of the chapels, they clearly were part of the original mural fabric (Fig. 8.3). The delicate pinnacled frames of each relief are interlaced carefully into the molding at the base of the wall, a sure indication that their exact size and placement were foreseen when construction of the new chapels circling the ambulatory was inaugurated in 1296.[7] The three chapels into which they are set, dedicated to Saints Ferréol and Ferrutien, Saint Michel, and Saints Anne and Martin "had been built" by 1320, but the uniformity of the masonry suggests that the lower walls of the entire eastern envelope were raised in a single rapid burst of building.[8] Thus, it is likely that these seven scenes were cut within the first decade of the fourteenth century during the tenure of master mason Pierre de Chelles.[9] More important, they are not flotsam but integral elements in the ambitious program of expansion and decoration of the cathedral choir.

Reliefs of the Dormition and Funeral of Mary begin the cycle, which continues in the third panel with a representation of the Assumption. In the fourth scene, Christ, surrounded by angels, cradles the soul of his mother, and this is followed by a relief of the Coronation of the Virgin. The sixth panel, the Majesty panel, depicts

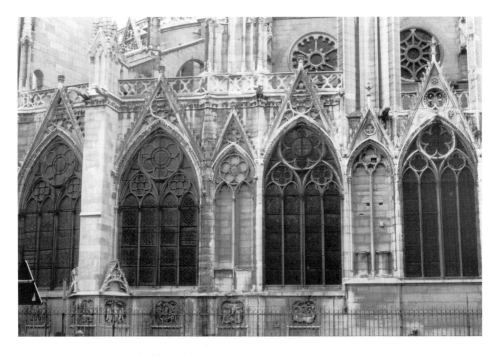

8.2. Paris, Notre-Dame, north side of choir. Photo: author.

Reading Medieval Images

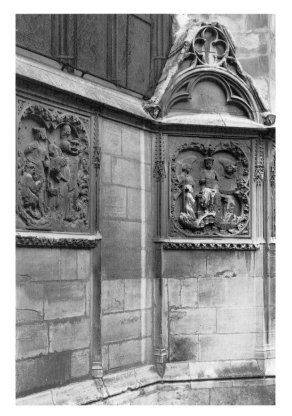

8.3. Paris, Notre-Dame, north side of choir, chapel wall showing reliefs of Theophilus (foreground) and Christ in Majesty. Photo: author.

Christ adored by the Virgin, while the seventh and last portrays the drama of Theophilus (Fig. 8.4). Certainly the reliefs *can* be read from west to east as a coherent narrative that relates the posthumous history and activities of the Virgin, embracing her corporeal departure from the earth, celestial glorification, and the most popular of her rescue missions to sinful humanity. But simultaneously, each image is experienced as a component of fluid pictorial groups that invite multiple patterns of viewing. The architectural frame of the Notre-Dame chapels divides the panels into smaller thematic units. Set in an unbroken section of wall (Fig. 8.2), the first three events—the Dormition, the Funeral, and the Assumption—together confirm the bodily resurrection of the Virgin celebrated in the cathedral liturgy.[10] Then, in the three scenes on the projecting buttress, the focus shifts to Christ. Further, paired panels, forming diptychs, hinge these subgroups together: the Assumption couples with the adjacent image of Christ and the angels, in which he holds the miniature figure of his mother, to depict the reception of the Virgin's body and soul into heaven, while the Majesty image joins the Theophilus panel to highlight Mary's role as mediatrix (Fig. 8.3).[11] Recurrent themes and motifs also form networks of associations.

8

For example, the Funeral of the Virgin, in which a Jew attacks Mary's bier, and the Theophilus panel together cast the Jews as perfidious enemies of the Church, while the pose of the Virgin in the Assumption ties the panel to the Theophilus relief in a visual explanation of her extraordinary powers of intercession.[12]

Differing from the continuous, compact sequence of a lintel usually read left to right from a single vantage point, the seven vignettes arrayed along the chapel walls were encountered one at a time, like leaves in a manuscript (compare Figs. 8.2, 8.6).[13] Yet, in an experience distinctly different from looking at discrete illuminated miniatures, the viewer's arc of vision encompassed several panels in gatherings that shifted with each change of position. This unusual and complex mode of presentation, which relied both on the unifying rhythms of repeating frames, compositions, poses, and gestures as well as on memory to build meaning, was developed in response to a specific physical and ceremonial setting. No less than its internal details, this external environment must be read carefully if we are to understand this version of the Theophilus story.

Cloister and Audience

Eccentrically placed in contemporary Parisian urban space, the sculpted panels were designed for the medieval cathedral cloister. They faced an alley that connected the small church of Saint-Jean-le-Rond at the northwest corner of Notre-Dame with the north transept portal and the small church of Saint-Denis-du-Pas immediately behind the chevet (Figs. 8.4, 8.5).[14] Processions frequently passed along this route: every Sunday after Terce as a prelude to mass, on feast days (including the Maundy Thursday Mass of the Holy Oils and Second Vespers on All Saints' Day), during official installations, and for occasional funerals.[15] Not surprisingly, the chapel reliefs share Marian motifs encountered in these offices and, in particular, in the liturgy of the Assumption. Compare the sculpture's celebration of the Virgin's ascent to Heaven, her powers of intercession, and Christ's majesty with the lyrical words of a motet sung at the feast of the Assumption:

> A Virgin from Judea is raised up high and an earthly body, becoming golden, is sanctified; the blessed mother is encircled with laurel and is glorified. Throughout all the regions of the world the living heavenly consort resounds ... I shall not be cast down from amongst the band of the faithful by the tempest, for lo, the Star of the Sea fills with prayers the ear of the holy Son—she who with the Son rules in the starry throne.[16]

However, the sculptures, despite these suggestive echoes between the imagery and the chants, do not mark liturgical stations, so far as is known, for they are never mentioned in the rubrics of Notre-Dame's liturgical books.[17]

8

Reading Medieval Images

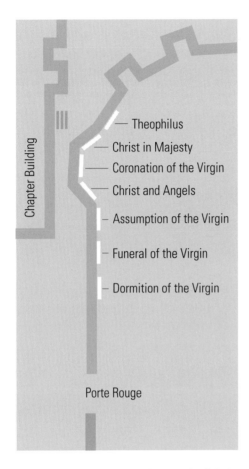

Chapter Building

— Theophilus

— Christ in Majesty

— Coronation of the Virgin

— Christ and Angels

– Assumption of the Virgin

– Funeral of the Virgin

– Dormition of the Virgin

Porte Rouge

8.4. Paris, Notre-Dame, plan of north side of choir showing location of reliefs.

The cloister defined not only a processional artery but also the arena of Notre-Dame's clerical life, whose hub was the chapter building (Fig. 8.4). This imposing edifice, depicted in early maps of Paris (Fig. 8.5), approached the scale of the episcopal palace. Fronted by a tower at the west, it housed stables, a judicial tribunal hall (*auditoire*), a prison (?), the library, and the chapter room on two or three stories whose upper levels were reached by an impressive staircase on the south side.[18] Here the canons assembled three times a week at Prime; here, on Maundy Thursday after Vespers, a priest washed the feet of twelve of the poor.[19] The Virgin reliefs, centered between the Porte Rouge—which served as clerical entrance into the choir from the cloister—and the chapter building formed a constant feature in the visual environment of Notre-Dame's canons as they passed back and forth through the cloister in ritual processions, on business, or for personal reasons (Figs. 8.4, 8.5). Their two-way movement explains why the reliefs' planners conceived a loosely woven cycle that avoided the strictures of linear narrative. Episodes follow in "correct" temporal order only in moving from west to east, but the concentration on the Virgin's afterlife focuses attention on her symbolic identities—as the glorified Church, as the Bride of Christ, as intercessor—that do not depend on sequential order for comprehension.

During the Middle Ages, the cloister and, thus, the seven reliefs on the choir chapels were off limits to the public. The northern flank of Notre-Dame, indeed the entire northeast quadrant of the Ile de la Cité, was the exclusive preserve of the cathedral chapter (Fig. 8.5). Four monumental gates blocked access from contiguous streets and the river, detailed regulations imposed stringent height restrictions on neighboring buildings to insure visual privacy, and ten armed sergeants patrolled the precinct.[20] Teaching and student activity were exiled in the early twelfth century, women's entry was tightly controlled, and even the bishop was

8

8.5. Paris, view of the Ile de la Cité in 1550, from the plan of Truschet and Hoyau. Photo: Universitäts-bibliothek, Basel.

required to apply for admission.[21] Although these strictures were relaxed in special circumstances and sometimes violated, by 1300 the cloister was insulated architec-turally and legally from the surrounding secular city.[22] Apart from the visitors to the capitular buildings or the stray glance of a passing household servant, the seven choir reliefs were seen regularly only by the clergy of Notre-Dame, which included the fifty-one canons of the cathedral, the canons of Saint-Aignan, Saint-Denis-du-Pas, and Saint-Jean-le-Rond, lesser clerics charged with the performance of the *opus dei*, vicars, chaplains, and choirboys—a community of fewer than 250 men.[23]

While the sculpted portals of the west façade, like vernacular sermons, aimed to communicate to the people an essential outline of sacred history and to

8

Reading Medieval Images

popularize clerical culture,[24] the sequestered reliefs in the cloister addressed an audience with a significantly different constellation of knowledge, experience, and concerns. The educated, theologically erudite canons would have been primed and ready to read these sculptures in a sophisticated, polysemous way. Like the wax tablets impressed with images in the "architectural mnemonic" schemes of artificial memory set out in such ancient treatises as *Rhetorica ad Herennium* and revived by Thomas Aquinas and Albertus Magnus, the reliefs immured into the Notre-Dame chapels, as we have seen, were "arranged in a series...so that one cannot become confused in the order. One can thus proceed forwards from start to finish, or backwards, or start in the middle."[25] Further, the cycle's use of dramatic exempla, such as the Miracle of Theophilus, its studied connections and contrasts established through composition and subject, and the crucial role of movement in its experience invited the exercise of rhetorical and mnemonic strategies to cast a net of associations meaningful in this elite, clerical frame of reference.[26]

What then might the priestly spectator have read into these scenes? Entering and exiting the sanctuary, the canons may have recognized themselves in the figures of the apostles who crowd the Dormition and Funeral as guardians of the Virgin, symbol of the Church. According to the *Golden Legend*, the Virgin summoned John and the other apostles to her side for protection against a Jewish conspiracy to seize and destroy her corpse, an attack that was launched during her funeral.[27] It is tempting to set the reliefs' vilification of the Jews against the contemporary background of rising anti-Semitism as a pointed ideological statement by the men who were charged with the care of Mary's architectural body, the cathedral.[28]

The seven choir reliefs articulated the topography of the cloister in terms of its residents' liturgical, judicial, and pastoral activities. The procession of Mary's bier, borne like a reliquary, must have recalled familiar rites in which treasured chasses were carried around the cathedral close and throughout the city.[29] The Theophilus relief, spotlighting contracts, faced the chapter house where the canons conducted important business.[30] The Majesty panel, showing Christ seated as judge, fittingly ornamented the gabled buttress opposite the tribunal hall of the bailiff (Figs. 8.3, 8.4). At the same time, the panel's accent on Christ's naked torso, his exposed wounds, and the crown of thorns reminded the Notre-Dame canons, as they exited the chapter house to celebrate mass in the cathedral choir, of his sacrifice as commemorated by the sacrament of the Eucharist. The image also captured the climate of increasing devotion to Christ's body that culminated in the institution of the feast of Corpus Christi in Paris by the early 1320s.[31] Following the Coronation of the Virgin, it emphasized that only the Church and its sacraments guarantee the redemption depicted in the Theophilus scene. The sacraments and, in particular, the Eucharist were the exclusive privilege of the priesthood: Thomas Aquinas declared in the *Summa Theologica* that "the dispensing of Christ's body belongs to the

8

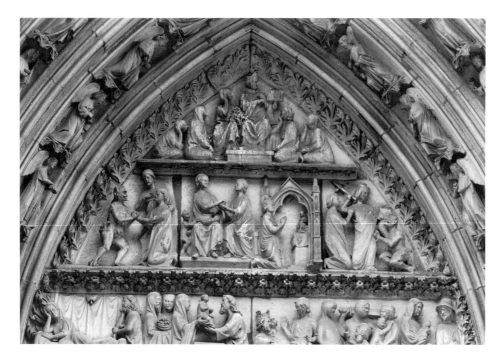

8.6. Story of Theophilus. Paris, Notre-Dame, north transept portal, tympanum. Photo: author.

priest...[who]...thereby...is put upon a level with them to whom the Lord said, 'Do this for a commemoration of me.'"[32] These are, of course, only a sample of possible connections, but they illustrate not only the coordination of images with a distinctive setting but also the shifts in nuances of meaning created by specific situations.

The Theophilus Panel

Framed by an ornate foliate quatrefoil, the chapel relief of Theophilus compresses the dramatic core of the story into three succinct scenes (Fig. 8.1). At the right, a grinning hairy devil and Theophilus throw their arms around each other's shoulders. The pair holds a sealed parchment to confirm their infernal bargain as the Jewish intermediary looks on. In the center, the repentant *vidame*, his back to the viewer, raises his hands in prayer to a seated figure of the Virgin (holding her child?). Finally, Mary pulls the contract from the grasp of the cowering demon as she slams her scepter into its face. Symmetrically organized, the panel sets up visual equations and contrasts that sharpen the impact of the episodes. The brute's thick misshapen form presents a distorted impersonation of Mary's tall, swaying body; their left arms and bent left legs echo across the picture plane, and the opposition of her crown and the Jew's peaked cap signals the antithesis of beautiful virtue and grotesque evil. Of the story's main characters, only the devil is represented in a con-

8

Reading Medieval Images

sistent scale, but his conspicuous transformation from the confidently erect protagonist on the right to discomfited groveler at the Virgin's knees on the left highlights the crushing defeat on which this exemplum turns.

Comparison with other versions of the Theophilus story reveals the originality of the choir relief. Here, a distinctive message was fashioned from a familiar narrative template through artful editing and a judicious selection of detail. A second example of the legend appears, surprisingly, within the Notre-Dame cloister in the mid-thirteenth-century portal of the north transept (Fig. 8.6).[33] The inclusion of Theophilus' distribution of alms and the bishop's sermon in this five-scene narrative strikes a marked social chord that must reflect the urban face of contemporary clerical action. The public demeanor of the program fits this portal, which was used as a ceremonial entrance and as an occasional set for liturgical dramas.[34] By excising these scenes, the chapel panel takes the action out of the communal realm to concentrate instead on the Virgin's decisive response to a sinner's change of heart. The internal, spiritual crux of this story is "represented" by the elimination of architectural props. Most images of this scene, including those in the glass of the Virgin Chapel of Beauvais cathedral (ca. 1245) and the Escorial manuscript of the Cantigas de Santa Maria (ca. 1280), depict the church setting. Emphasis on the ecclesiastical stage and its devotional furniture, as Schapiro remarked, enclosed the unmediated relation to God within the physical framework of organized, orthodox religion.[35] To the contrary, the figures of Theophilus and the seated Virgin in the quatrefoil are placed against a resoundingly empty background as if to visualize the prayer itself. In the words of Rutebeuf:

> Dame ton chier Filz proie
> Quie soie desprez.
> Dame, car leur veez,
> Qui mes mesfez veez,
> Qui n'avoie a leur voie.
> Vous qui lasus seez,
> M'ame leur deveez,
> Que nus d'aus ne la voie.

> Lady, pray to your dear Son
> That I be delivered.
> Lady, prevent them,
> You who see my sins,
> From leading me on their path.
> You who sit on high,
> Refuse them my soul,
> Hide it from their eyes.[36]

8
———

Note that Theophilus begs Mary to carry his desperate suit to Christ. By glancing to the right, the viewer sees her "praying to her dear Son" in the Majesty panel, which becomes an amplifying subplot to the main act of the narrative (Fig. 8.3).

The chapel relief's emphasis on the personal nature of this tale is best appreciated, it seems to me, in the remarkable representation of the contract scene. In Rutebeuf's play, the devil, named Salatin, concludes their parley with the command: "Or joing / Tes mains, et si devien mes hon. / Je t'aiderai outre reson" ("So join / Your hands and become my vassal. / I will help you beyond all measure").[37] And most images, following the text, show Theophilus kneeling, hands raised in the prescribed gesture of feudal homage.[38] Breaking from written and visual models, the Notre-Dame panel illustrates the pact with the devil as an act of mutual intimacy.[39] Theophilus stands next to the devil, the sealed document rising from his groin; their cheeks touch tenderly, their two forms fuse into a single body. Like a solicitous husband, the fiend's embrace signals the protection of his mate, whose own gesture reciprocates the affection. The nearly identical height and similar full-face positions of both figures announce that this is a relationship of equals.[40] Portrayed as lovers, the two recall images of the vice of Luxuria depicted in sculptural programs.[41] As a pair, they stress that the demon has not merely won the service of Theophilus' body but has truly seduced his soul: Theophilus is in love with evil.

Eliminating the ritual of homage directs the relief away from a profane audience and toward clerical viewers for whom the carnal pleasures of the material world, nevertheless, offered intense temptation.[42] Parodying the chaste clasp of Christ and the Sponsa in miniatures of the Song of Songs, the embrace of this hideous couple may have encouraged meditation on spiritual love through the example of its complete opposite.[43] As the cleric's gaze finally fell on the figure of the Virgin, he was reminded that her Assumption, which made possible her powers of intercession, also prefigured the soul's union with God.[44] In the Virgin, symbol of the Church, he found the model for his own sacerdotal calling, for, just as Christ had assumed flesh through Mary, the priest offered that redemptive sacrifice to the world at each celebration of the mass.[45]

Conclusion

The sculpted reliefs of the Notre-Dame choir, which ornament the chapel walls like a predella, exemplify the way in which a specific setting and an audience's frame of reference can condition the reading of images. Presenting episodes of the glorification of the Virgin Mary, the seven panels were seen by the cathedral canons passing through the cloister on their way to mass, in procession, or en route to the chapter house. Each variation of movement produced a different configuration of scenes and shifts among linear narrative, thematically related subgroups, and individual images. The unusual flexibility with which this ensemble could be viewed allowed

the canons, informed by an exceptional theological knowledge, to see in the reliefs not only the obvious exaltation of the patron of their cathedral but also a network of references to the Church, the sacraments, liturgy, and spiritual union. By including familiar objects, gestures, costumes, or figures, the panels invited a further level of association that linked the actions of Christ, the Virgin, and the apostles to the contemporary practices of the Notre-Dame clergy. Finally, in addition to their collective connections and themes, each relief was exhibited as an independent and framed devotional image designed for meditation that would lead the viewer to a higher level of spiritual awareness.

Although the imaginative responses of individual clerics as they stood gazing at these scenes remain beyond our reach, the reliefs suggest that the new devotional attitudes that transformed contemporary monastic and lay piety also invested the cathedral cloister.[46] Through carefully scripted visual details, the Theophilus story of the Notre-Dame chapels aimed to appeal to both collective and personal experience. Anchored to the corporate ceremony of the liturgy as it showcased the efficacy of private prayer, the relief served as a trigger for the spiritual encounter of a viewer who, like Theophilus, "having received the body of Christ as a lamp is illumined by light, was called through the Mother of God to the celestial kingdom to see the true light, Christ, in the light of the Father."[47]

1 Jacobus de Voragine, *The Golden Legend*, trans. William Granger Ryan, 2 vols. (Princeton, 1993), 2:137; Gautier de Coinci, "Comment Theophilus vint a penitance," *Les miracles de Nostre Dame*, ed. V. Frédéric Koenig, vol. 1 (Geneva, 1966), 50–176; Rutebeuf, "Le miracle de Théophile," *Oeuvres complètes*, ed. Michel Zink, 2 vols. (Paris, 1989–90), 2:22–67.

2 For examples of the Theophilus story in art, Alfred C. Fryer, "Theophilus, the Penitent, as Represented in Art," *Archaeological Journal* 92 (1935), 287–333; Louis Réau, *Iconographie de l'art chrétien*, vol. 2/2 (Paris, 1957), 628–30; Émile Mâle, *The Gothic Image: Religious Art in France of the Thirteenth Century*, trans. Dora Nussey (New York, 1958), 259–62; Florens Deuchler, *Der Ingeborgpsalter* (Berlin, 1967), 67–70; Michael W. Cothren, "The Iconography of Theophilus Windows in the First Half of the Thirteenth Century," *Speculum* 59 (1984), 308–41.

3 Meyer Schapiro, "The Sculptures of Souillac," *Medieval Studies in Memory of A. Kingsley Porter*, 2 vols. (Cambridge, MA, 1939), 2:374–76; rpt. in *Romanesque Art* (New York, 1977), 117–19. Cothren, "Iconography of Theophilus Windows," 333, singles out a "small group of wealthy and powerful men who ... wielded temporal, secular authority" as the most likely audience for the stained glass programs.

4 Schapiro, "Sculptures of Souillac" (1977), 102–30.

5 Cesare Gnudi, "I rilievi esterni del coro di Notre Dame e la Vergine Annunciata del Metropolitan Museum," *Études d'art français offerts à Charles Sterling* (Paris, 1975), 41–46; Dorothy Gillerman, *The Clôture of Notre-Dame and Its Role in the Fourteenth Century Choir Program* (New York, 1977), 105–6; eadem, *Enguerran de Marigny and the Church of Notre-Dame at Ecouis* (University Park, PA, 1994), 98–102; Alain Erlande-Brandenburg, *Notre-Dame de Paris* (Paris, 1991), 206.

8

6 Eugène E. Viollet-le-Duc, *Dictionnaire raisonné de l'architecture française du XIe au XVIe siècle*, vol. 9 (Paris, 1858), 371 n.1, writes: "Cette sculpture [the relief of the Assumption] fait partie des bas-reliefs qui ornaient autrefois le cloître de Notre-Dame et que l'on voit encore sur les parois des chapelles du chevet, côté nord." Although the language may be ambiguous, Viollet-le-Duc does not appear to propose the reliefs' transfer, as Gillerman, *Clôture of Notre-Dame*, 105–6, believes. See also Erlande-Brandenburg, *Notre-Dame de Paris*, 206.

7 For the fourteenth-century construction at Notre-Dame, see Marcel Aubert, *Notre-Dame de Paris: Sa place dans l'histoire de l'architecture du XIIe au XIVe siècle* (Paris, 1920), 137–76; Gillerman, *Clôture of Notre-Dame*, 154–75; and Michael T. Davis, "Splendor and Peril: The Cathedral of Paris, 1290–1350," *Art Bulletin* 80 (1998), 34–66.

8 In 1320, chanter Hugues de Besançon founded a chaplaincy "in honor of Saints Ferréol and Ferrutien at the altar of the last chapel of the three chapels which have been built near the door by which one enters directly to the main altar of the church and exits to the chapter house" ("in honore sanctorum martyrum Ferreoli et Ferrucii, ad altare ultime capelle in tribus capellis que de novo in dicta edificantur seu construuntur ecclesia, propinquioris porte per quam itur directius ad magnum altare, dictam ecclesiam intrando, et ad capitulum de eadem ecclesia exeundo"). This testament is published by Benjamin Guérard, *Cartulaire de l'église Notre-Dame de Paris*, 4 vols. (Paris, 1850), 4:79–83.

9 According to Aubert, *Notre-Dame de Paris*, 156, Pierre was master of the cathedral between 1296 and 1318. See also Alain Erlande-Brandenburg, *Le roi est mort: Étude sur les funérailles, les sépultures et les tombeaux des rois de France jusqu'à la fin du XIIIe siècle* (Paris, 1975), 171–72, for the documents relating to Pierre de Chelles' work on the tomb of Philip III in 1307.

10 The corporeal assumption of the Virgin, which was related only in apocryphal sources, was the subject of prolonged theological exploration. Jacobus de Voragine discusses the question extensively in the *Golden Legend* (Ryan, 2:77–97). On the theology, liturgy, and iconography of the Assumption in the West, see Marie-LouiseThérel, *Le triomphe de la Vierge-Église* (Paris, 1984), 16–38, 48–70. On the liturgy of Notre-Dame, consult Rebecca A. Baltzer, "The Geography of the Liturgy at Notre-Dame of Paris," in *Plainsong in the Age of Polyphony*, ed. Thomas Forrest Kelly (Cambridge, 1992), 45–64; and her "The Little Office of the Virgin and Mary's Role at Paris," in *The Divine Office in the Latin Middle Ages*, ed. Margot Fassler and Rebecca Baltzer (Oxford, 2000), 463-84, esp. 470-74. I am grateful to Professer Baltzer for allowing me to read an unpublished paper, "Performance Practice, the Notre-Dame Calendar, and the Earliest Latin Liturgical Motets," delivered in 1985 in Wolfenbüttel.

11 Sister Mary Vincentine Gripkey, *The Blessed Virgin Mary as Mediatrix in the Latin and Old French Legend prior to the Fourteenth Century* (Washington, DC, 1938), 10–12, 211–15.

12 See William Chester Jordan, *The French Monarchy and the Jews* (Philadelphia, 1989), 46, for the elaboration of anti-Jewish leitmotifs in Gautier de Coinci's miracles of the Virgin, which included the story of Theophilus. Philippe Verdier, *Le couronnement de la Vierge: Les origines et les premiers développements d'un thème iconographique* (Montréal, 1980), 110–11, brings together the Assumption and Theophilus.

13 Brigitte Buettner, in *Boccaccio's* Des cleres et nobles femmes: *Systems of Signification in an Illuminated Manuscript* (Seattle, 1996), 1–2, 54–59, discusses the generation of meanings through relational models. Also consult Wolfgang Kemp, *The Narratives of Gothic Stained Glass*, trans. Caroline D. Saltzwedel (Cambridge, 1997), esp. 129–35, 154–59, for the structure of stained glass narratives.

14 For descriptions of the cathedral cloister, see Erlande-Brandenburg, *Notre-Dame*, 47–49; Adrien Friedmann, *Paris, ses rues, ses paroisses du moyen âge à la Révolution* (Paris, 1959), 50–60; A. Outrey, "Le cloître Notre-Dame au XVIe siècle," *Bulletin de la Société de l'histoire de Paris et de l'Ile-de-France* 73–77 (1946–51), 57–59; Craig Wright, *Music and Ceremony at Notre Dame of Paris, 500–1550* (Cambridge, 1989), 27–33.

15 Processions are discussed by Baltzer, "Geography of the Liturgy," 45–64; Abbé G. de Montjoye [C. P. Gueffier], *Description historique des curiosités de l'église de Paris* (Paris, 1763), 309–12, 413–16; and Wright, *Music and Ceremony*, 339–41. See also Guérard, *Cartulaire*, 1:431–34, for the unusual burial of Emeline and Benedict de Chaumont [de Calvo Monte] in 1237 "in via per quam itur a claustro ad ecclesiam Beati Dyonisii de Passu."

16 "Virgo de Iudea sursum tollitur, testes fit aurea corporea sanctitur, laurea redimitur, mater beata glorificata. Per cuncta mundi climata civium consortio laude resolvitur. . . . Non ero de cetero iactatus a procella ecce, maris stella aurem pii filii precibus impregnat, que stellato solio cum filio regnat." The text of this motet, *Flos de spina rumpitur*, is taken from Baltzer, "Performance Practice," who follows the translation by Gordon A. Anderson in *The Latin Compositions in Fascicules VII and VIII of the Notre-Dame Manuscript Wolfenbüttel Helmstadt 1099 (1206)*, vol. 1 (Brooklyn, 1976), 113. Mâle, *The Gothic Image*, 261, remarks that the miracle of Theophilus was included in the eleventh-century liturgy of the Office of the Virgin. However, it is not clear whether it was sung at Notre-Dame three hundred years later.

17 See Baltzer, "Geography of the Liturgy," 56–58, for the liturgy of the Assumption at Notre-Dame. The procession of the day was staged after Terce.

8

18 The chapter building is discussed by Outrey, "Le cloître Notre-Dame," 58; Erlande-Brandenburg, *Notre-Dame*, 47–49. For early plans of Paris with views of the cathedral, see Jean Derens, "Le plan de Paris par Truschet et Hoyau 1550," *Cahiers de la Rotonde* 9 (1986), 68.

19 For chapter meetings, see J. Emmanuel des Graviers, "'Messeigneurs du chapitre' de l'église de Paris à l'époque de la guerre de cent ans," *Huitième centenaire de Notre-Dame de Paris* (Paris, 1967), 211; for the *pedilavium* ceremony, Wright, *Music and Ceremony*, 53–54. Wright, 33, speculates that the canons enjoyed instrumental musical entertainment in the chapter house during "moments of clerical recreation." Nothing is known about the interior architecture and decoration of this important space. In 1367, its windows were in a dilapidated state and required repair, as mentioned by Graviers, 202.

20 New doors were made for the gates in 1276, for which see Guérard, *Cartulaire*, 2:478–82. Regulation of claustral life and security measures are discussed by Graviers, "'Messeigneurs,'" 196–203. Charters from 1223 and 1228 limiting the height of contiguous buildings are published in Guérard, 1:351–52. Allan Temko, *Notre-Dame of Paris: The Biography of a Cathedral* (New York, 1952), 249, speaks of "crowds" moving through the cloister, a view that is not supported by the documentation.

21 The documents confirming the inviolability of the cloister in 1119 and again in 1200 are published by Guérard, *Cartulaire*, 1:264–65, 283. For the transfer of students from the close to the episcopal compound, consult Guérard, 1:338; A. L. Gabriel, "Les écoles de la cathédrale de Notre-Dame et le commencement de l'université de Paris," *Huitième centenaire* (as n. 19), 144–47; and Wright, *Music and Ceremony*, 31. Restrictions on women and the bishop can be found in Guérard, 1:cviii–cxii, 2:405; Graviers, "'Messeigneurs,'"199; Wright, ibid., 27–29.

22 In 1429, the bishop was granted a key by the chapter to allow him access to the Seine. See Graviers, "'Messeigneurs,'" 198. Taverns were banned from the cloister in 1245, along with animal entertainments, and again in 1328, as in Guérard, *Cartulaire*, 2:406; 3:421. See also Guérard, 3:436–38, for brawls in the cloister.

23 Wright, *Music and Ceremony*, 20–24, discusses the clerical positions at Notre-Dame.

24 Michel Zink, *La prédication en langue romane avant 1300* (Paris, 1982), 357; see also 231–33 for a discussion of sermons on the theme of the Assumption.

25 Mary J. Carruthers, *The Book of Memory: A Study of Memory in Medieval Culture* (Cambridge, 1990), 72. See her extended discussion of the "architectural mnemonic" and the art of memory, 71–79, 122–55; also Wright, *Music and Ceremony*, 325–29, for the importance of trained memory to the performance of services at Notre-Dame.

26 For a discussion of exempla and their importance, Claude Brémond, Jacques Le Goff, and Jean-Claude Schmitt, *L'"exemplum,"* Typologie des sources du moyen âge occidental, fasc. 40 (Turnhout, 1982); Zink, *Prédication*, 204–10. Even the choirboys would have been familiar with rhetoric, as discussed by Wright, *Music and Ceremony*, 174. Bettina Bergmann, "The Roman House as Memory Theater: The House of the Tragic Poet in Pompeii," *Art Bulletin* 76 (1994), 225–56, investigates the use of mnemonic and rhetorical models in the context of Roman domestic wall paintings.

27 Jacobus de Voragine, *Golden Legend* (Ryan, 2:78–81).

28 The deteriorating situation of the Jews, accused of host desecration in Paris in 1290, is discussed by Jordan, *French Monarchy*, 179–99. Mary was frequently described in architectural metaphor, as in the *Golden Legend*, where she is called an ark, a sustaining wall, a temple (Ryan, 2:82, 89, 94). To Bonaventure, she "signified a house erected by Wisdom with the seven columns of the seven gifts of the Holy Spirit" (*Speculum Beatae Mariae Virginis*, lectio 6, in *Opera omnia*, vol. 14 [Paris, 1868], 248). See also the extended parallels drawn between the Virgin and buildings by Honorius Augustodunensis in his *Sigillum Beatae Mariae* (PL 172, 498). For the chapter's control over the cathedral, Pierre-Clément Timbal and Josette Metman, "Evêque de Paris et chapitre de Notre-Dame: La juridiction dans la cathédrale au moyen âge," *Huitième centenaire* (as n. 19), 115–40, esp. 124.

29 Processions with relics are mentioned by Graviers, "'Messeigneurs,'" 215–16; Montjoye, *Description historique*, 212–14; Albert Mirot and Bernard Mahieu, "Cérémonies officielles à Notre-Dame au XVe siècle," *Huitième centenaire* (as n. 19), 223–90, at 269. The Funeral of the Virgin resembles closely representations of contemporary events such as the Procession of the Relics of Saint Louis in the Hours of Jeanne d'Evreux (New York, Metropolitan Museum of Art, The Cloisters, fol. 173v).

30 Numerous acts ratified "in capitulo nostro," "in capitulo Beate Marie Parisius," or "in capitulo Sancte Marie" are published by Guérard, *Cartulaire*, vols. 1 and 3, passim.

31 Gillerman, *Clôture of Notre-Dame*, 60–63, 154–55, discusses the feast of the Corpus Christi in Paris. For explorations of devotion to the body of Christ, see Caroline Walker Bynum, *Holy Feast and Holy Fast: The Religious Significance of Food to Medieval Women* (Berkeley, 1987), 45–60, and especially Miri Rubin, *Corpus Christi: The Eucharist in Late Medieval Culture* (Cambridge, 1991).

32 *Summa Theologica*, pt. 3, quest. 82, art. 1; trans. Fathers of the English Dominican Province, 17 (London, 1923), 413–14.

8

33 Dieter Kimpel, *Die Querhausarme von Notre-Dame zu Paris und ihre Skulpturen* (Ph.D. diss., Bonn, 1971), 111–13; Willibald Sauerländer, *La sculpture gothique en France, 1140–1270* (Paris, 1972), 151–52, pl. 186; Erlande-Brandenburg, *Notre-Dame*, 161–62.

34 Montjoye, *Description historique*, 413–15, describes the eighteenth-century itinerary at the installation of a new bishop in which the chapter processed to Saint-Denis-du-Pas by way of the north transept portal. For the staging of plays in the cloister, consult Graviers, "'Messeigneurs,'" 200; Wright, *Music and Ceremony*, 29–30. Temko, *Notre-Dame*, 255–65, imaginatively sets the performance of Rutebeuf's "Le miracle de Théophile" outside the north transept portal.

35 Schapiro, "Sculptures of Souillac" (1977), 119.

36 "Le miracle de Théophile," ll. 532–39 (Zink, 2:58–59).

37 Ibid., ll. 239–41 (Zink, 2:38–39).

38 The meaning of the *immixtio manuum* has been studied by Jacques Le Goff, "The Symbolic Ritual of Vassalage," in *Time, Work, and Culture in the Middle Ages*, trans. Arthur Goldhammer (Chicago, 1980), 240–44, 284–85, and François Garnier, *Le langage de l'image au moyen âge* (Paris, 1981), 108.

39 The relief's version of the contract scene parallels most closely the *Golden Legend* narrative (Ryan, 2:157): "Thereupon Theophilus, at the demon's command, renounced Christ and his mother, repudiated the Christian faith, wrote a statement of his renunciation and repudiation in his own blood, signed and sealed the script, and gave it to the demon, thus pledging himself to his service."

40 This mutual embrace, a relatively rare gesture in Gothic imagery, is discussed by Garnier, *Langage de l'image*, 76, 214, and Buettner, *Boccaccio's De cleres et nobles femmes*, 66–67. See Garnier, ibid., 146, for the significance of head positions.

41 Luxuria is also represented by embracing lovers on the left pier of the central portal of the south transept porch at Chartres cathedral and on the dado of the central portal of the west façade of Amiens cathedral. See also Adolf Katzenellenbogen, *Allegories of the Virtues and Vices in Mediaeval Art* (London, 1939), 82 n. 1, for other examples of the motif of embracing lovers, "which is capable of many an interpretation in both good and evil senses."

42 *Le Roman de Fauvel*, written between 1310 and 1315, offers a lengthy comment on Carnality in ll. 1423–1500. The author brings his description to bear on priests (ll. 1469–76). See *Le Roman de Fauvel in the Edition of Mesire Chaillou de Pesstain: A Reproduction in Facsimile of the Complete Manuscript, Paris, Bibliothèque nationale, fonds français 146* (New York, 1990). Consult Guérard, *Cartulaire*, 3:415–16, for a 1325 act that regulated the behavior and dress of cathedral clergy. Among other things, priests were forbidden to play dice and to circulate around the city wearing pointed shoes.

43 See Jeffrey Hamburger, *The Rothschild Canticles: Art and Mysticism in Flanders and the Rhineland circa 1300* (New Haven, 1990), 70–87, for a discussion of miniatures of the Song of Songs in the Rothschild Canticles.

44 Honorius Augustodunensis, in *Speculum ecclesiae*, "De assumptione Sanctae Mariae" (PL 172, 991–94), brings together the Assumption, the story of Theophilus, and the Virgin as the agent for the soul's union with God. Hamburger, *Rothschild Canticles*, 104–5, underscores the close connections between Marian and mystical theology.

45 For the controversial question of Mary's priesthood, consult Barbara G. Lane, *The Altar and the Altarpiece: Sacramental Themes in Early Netherlandish Painting* (New York, 1984), 71; also Carol J. Purtle, *The Marian Paintings of Jan van Eyck* (Princeton, 1982), 13–15, 27–29, 153; and see Bynum, *Holy Feast*, 268, for Bernard of Clairvaux's implicit connection between the Virgin and the celebrant.

46 Jeffrey Hamburger, "The Visual and the Visionary: The Image in Late Medieval Monastic Devotions," *Viator* 20 (1989), 161–82.

47 Honorius Augustodunensis, *Speculum ecclesiae*, "De assumptione Sanctae Mariae" (PL 172, 994).

8

9 About a Bronze Bird

Oleg Grabar

There are many objects in public and private collections which are quite well known, as they appear regularly in catalogues of exhibitions and in survey books on art, but whose function, documentary value, or esthetic character remains unexplained. Such is a bronze vessel in the Louvre usually but restrictively called an aquamanile (Figs. 9.1, 9.2).[1] It is in the shape of a bird, probably meant to be a peacock, and it is celebrated primarily for being inscribed in two languages, Latin and Arabic. Usually ascribed to the twelfth century, out of habit rather than for any clearly established reasons, the object has generally been understood as reflecting the tastes, needs, and technical competencies reasonable to assume for areas like Sicily or Spain and for periods like that of the Crusades, which established, without compelling, consistent contacts between users of Arabic and Latin. Most often the object is assigned to some place in Spain, correctly I believe, for reasons to some of which I shall return shortly.

The bird is about forty centimeters high and thirty-eight centimeters wide. Its short legs are held together by a horseshoe-shaped stand, which ensures stability. The body is entirely covered with scales meant to evoke feathers, except for a rectangular panel in front containing the two inscriptions (Figs. 9.3, 9.4). The Latin one is above: + OPVS SALOMONIS ERAT, followed by a diagonal squiggle; the Arabic one is below: *'amal 'abd al-malik al-nasrâni.*[2] I am not providing translations at this stage, since much of the paper is devoted to the question of how to understand these inscriptions. Both scripts are quite clear, and in both many letters are embellished with apostrophe-like marks of a kind apparently not rare in Latin inscriptions of medieval Spain or Sicily; this common feature suggests that the same engraver copied both inscriptions. Whether he knew both languages (something most scholars seem to reject without the serious consideration such a hypothesis deserves), or whether he knew only one, or none, is impossible to determine on the basis of this one example.

Whereas the Latin inscription is continuous, the Arabic one is divided into two parts separated by an empty space where there may initially have been an opening to fill the vessel; at some later stage the hole now seen on the upper part of the body would have replaced it. The bird's head is topped with a decorative crest, almost like an architectural railing. The upper part of its beak is curved, while the

9

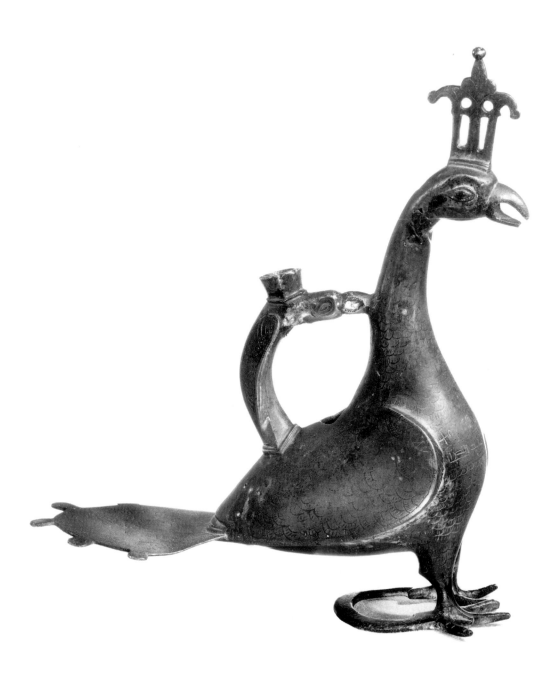

9.1. Aquamanile. Bronze. Paris, Musée du Louvre, Département des Antiquités Orientales (MR 1569). Photo: Christian Larrieu, La Licorne 1994.

lower part is flat for the smooth pouring of whatever liquid was normally in the container; its form suggests that such liquids were meant to be poured slowly and sparingly. The tail, its surface covered with much-effaced arabesque ornament, is unusual for being disproportionately large, flat, and parallel to the ground. It is as though it was intended to carry something, perhaps a cup or some other small container into which the liquid was poured. The bird is provided with a handle in the shape of a bird's neck and head; it was possible to fill the object through a high knob artfully set on this handle. From the front the bird has a rather fierce and almost frightening look (Fig. 9.4), while from the sides it appears quite peaceful and at rest. Except for its large tail, its proportions are harmonious. Altogether, as a recent writer put it felicitously, it exhibits a "quiet arrogance."[3]

There is no question about the broad category to which the Louvre "peacock" belongs. Zoomorphic objects are a permanent fixture of nearly all artistic traditions, reflecting perhaps some universal apotropaic function of animals. Birds form a particular species within zoomorphic objects and a subspecies attributed to the Muslim world has been preserved, usually undated: there is, to my recollection, only one exception, a bird in the Hermitage Museum probably dated 796–97 CE by an Arabic inscription.[4] Two birds, one in the Cagliari Museum in southern Italy and the other one fleetingly visible at a Sotheby's sale, are particularly close to the Louvre piece, without being identical to it.[5] Nothing is known about the place of manufacture of these objects. It may be worthwhile to point out that, while zoomorphic objects long continued to be manufactured in western Christian lands and in China, India, and Africa, they tended to disappear from the Muslim world after the thirteenth century, especially within the sunni world of the Mamluks and of the Ottomans. In this sense, and even though older zoomorphic objects continued to be used (in the Alhambra, for example) and a few were newly made (under the Safavids and the Mughals), they belong on the whole, within Islamic history, to the taste of the medieval era before the momentous changes of the second half of the thirteenth century. How to date any one of these objects, individually or as part of a group of comparable items, between 800 and 1250 remains an unanswered question. The place of their manufacture is equally unclear, because the technique of manufacture does not require unusual or novel skills and nothing in any of the objects compels an exclusive geographical setting.

Yet a careful scrutiny of the information provided by the Louvre bird leads beyond the generalities previously expressed about it and, without resolving all difficulties, makes it possible to focus a bit better on the kinds of investigations needed to understand the vessel fully. I shall be brief on technique and function and then concentrate on the inscriptions, which will provide rather unexpected possibilities.

Technical analyses of the metallic surface, both inside and outside, should, when undertaken, provide a history of the object and its various restorations and

9

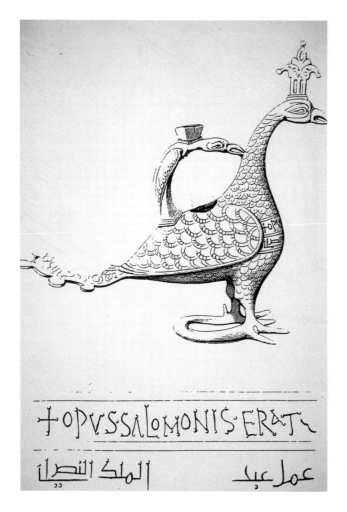

9.2. Aquamanile. Drawing in Longpérier, *Revue archéologique* (1865).

determine what kind of liquid would have been kept in it. Was it a drinking vessel that held liquids like wine, which possibly reacted unfavorably with the metal? Or should we assume that the bird was primarily or exclusively a container for water, perfumed or not, and that it was therefore used for washing, perhaps after meals? Stability of stance suggests that the object was to be easily maneuvered, and I have already suggested that the large flat tail held some smaller container like a cup. Within a Christian context, the bird could have served a secular or religious purpose; its function would have been exclusively secular within a Muslim setting. Nothing in its shape or decoration implies a specific ceremonial or liturgical use, and it is possible, although not necessary, to conclude that the Louvre "peacock" was made as a speculative commercial venture for a broad market without apparent and specific cultural ties.

9

Reading Medieval Images

The inscriptions pose much more complicated problems. Their prominence is obvious, and no individual letter is difficult to identify. But how should they be read, and what do they mean? For nearly a century the Latin inscription was read as "it [the bird] was the (or a) work of Solomon," meaning either that Solomon was the name of the artisan who made the aquamanile or that it was a beautiful object worthy of the biblical king, in line with a common medieval expression, "Solomonic work," used to indicate the high quality of something.[6] The problem with the first explanation is that the use of the past tense *erat* instead of the present *est* or the past *fuit* (more logical but, to my knowledge, unknown in inscriptions on objects) makes the identification of Solomon as an artisan most unlikely. The second meaning is also problematic, as the use of the past tense suggests a quality that is no longer there. Yet the very same inscription—OPVS SALOMONIS ERAT, this time not associated with an Arabic one—appears on a bronze lamp found in Spain and now in the Madrid Archaeological Museum (Fig. 9.5).[7] The wording of the Latin inscription on the Louvre "peacock" is, therefore, not an accident but reflects a very special and probably rare context in the Spanish peninsula.[8]

This would seem to have been demonstrated by Robert-Henri Bautier in a short but incisive article that has been completely ignored by all writers on the Louvre bird.[9] He argued that ERAT should be read as ERA T, a date in a calendar used in Spain, and only in Spain, up to the middle of the twelfth century in which T means 1000, counting from the conquest of central Spain by the Romans in 38 BC.

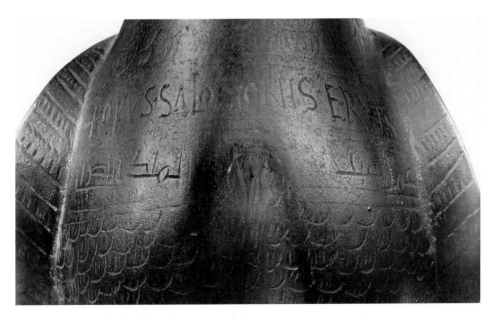

9.3. Aquamanile, detail of inscription. Paris, Musée du Louvre, Département des Antiquités Orientales (MR 1569). Photo: author.

9

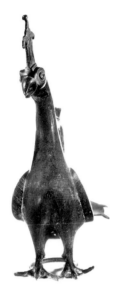

9.4. Aquamanile, seen from front. Paris, Musée du Louvre, Département des Antiquités Orientales (MR 1569). Photo: Christian Larrieu, La Licorne 1994.

Bautier thought that he saw an X, meaning 10, after the T, but the diagonal squiggle that is indeed there seems more ornamental than denotative, and a date of 962 CE, if this interpretation of the letters is correct, is thus preferable to 972, as proposed by Bautier. Such a date places the object in the tenth century, at the height of Umayyad power and glory in al-Andalus, instead of one and a half or two centuries later, as historians of art have traditionally assumed.

Bautier's plausible reading of *erat* as a date where everyone else had seen a verb eliminates the need to explain the latter's peculiar tense, but it introduces instead a problem of cultural context. Quite amazingly, the same sort of quandary emerges with the Arabic inscription. It has been read in two ways. The first translation is: "work of (or made by) Abd al-Malik, the Christian." The only oddity in this reading is that the religious identification of an artisan is quite contrary to all known practices of metalworking in the Muslim Middle Ages; still, in theory at least, we can imagine a context in which such an identification would be possible. The second is: "work of (or made by) the servant of the Christian king." Grammatically possible, this reading is culturally very dubious, as the identification of a king by his faith rather than by his name would constitute an anomaly in every respect. Whatever problems it raises, the first reading should almost certainly be preferred.

There is a point, however, in looking at the two inscriptions together. For they are not a single statement uttered in two languages, presumably for two different audiences, as was the case, for example, in the celebrated trilingual inscription of Roger II in Palermo's Palazzo Reale. They were meant either to provide different information about the same object to people with different linguistic competencies or to make a single statement in two languages, both of which would presumably be understood by whomever viewed or used this object. From the varying readings of the Latin and Arabic inscriptions provided so far, the following six "joint" meanings (rather than word-for-word translations) can be proposed:

(1) "A work of Solomonic [beauty], year 962, made by Abd al-Malik the Christian";

(2) "A work by [a man called] Solomon, year 962, made by Abd al-Malik the Christian";

(3) "A work of Solomonic [beauty], year 962, made by the servant of the Christian king";

Reading Medieval Images

(4) "A work for (or by) [a man called] Solomon, year 962, made by the servant of the Christian King";

(5) "It was (or could have been) a work [worthy of] Solomon [but or and?] it was made by Abd al-Malik the Christian";

(6) "It was (or could have been) a work [worthy] of Solomon, [but or and?] it was made by the servant of the Christian king."

Before deciding on the best interpretations, a few additional remarks are in order. One is that, even if (as has been done)[10] we can construe the fourth interpretation as an Arabic text modifying the Latin one (it would be Solomon who is the servant of the Christian king), such an interpretation would require a most unlikely kind of verbal association on the part of the maker and user. We must, I believe, assume that the use of the two languages means either that different messages were meant to be communicated to different people or that the languages had different evocative connotations, perhaps regardless of their meaning.

Since a cross precedes the Latin inscription, we must probably assume that the bird was either ordered by a Christian patron or made to be sold to one. The value of the Arabic inscription lies less in the information it provides, which would be immaterial to a Latin buyer, than in the slightly ambiguous exoticism it elicits by its very presence. The Latin inscription does not say that it was a work of Solomon's time, but, if the buyer wanted to consider it as such, nothing would prevent him from doing so. Variants on such practices still exist in today's art market. In a Latin setting exoticism can be seen as dominating through the use of a bilingual inscription, and the factual information, especially prominent in the Arabic, becomes secondary.

But perhaps the argument can be reversed: perhaps a Muslim market was targeted by the maker of the bird. For reasons that are much beyond my concern here and that have not yet been fully worked out, an association between Solomon—Hebrew king and Muslim prophet-king—and central Spain, more particularly Toledo, had been made since the Muslim conquest in the early eighth century. This association was specifically connected with objects, the most celebrated one being a huge table carried off from Jerusalem to the Umayyad caliph in Damascus.[11] The identification of the maker as a Christian or even as the servant of the Christian king, and the presence of a cross, become more difficult to explain, but, even though we are far better aware of a snobbish value being attributed by medieval Christians to objects manufactured in the Muslim world regardless of the specifically religious signs on them, the reverse process is not necessarily excluded, especially in Spain and possibly Sicily.

Taking all these remarks into consideration, only the first and the fifth of my interpretations of the two texts together seem possible. All others provide

9

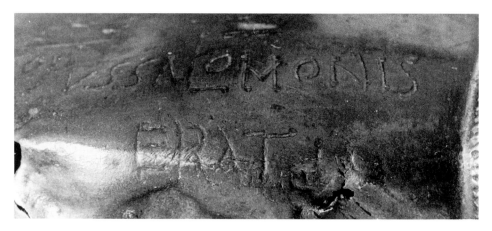

9.5. Inscription on bronze lamp. Madrid, Museo Arqueológico Nacional (6241/1). Photo: Archivo Fotográfico, Museo Arqueológico Nacional, courtesy of Dr. Juan Zozoya.

additional and probably unnecessary difficulties. If we accept the first reading and understand the bird to be from a half-century truly dominated by the power and the culture of the caliphate of Cordova, then we should possibly see it as a secular rhetorical expression of the very rich and complex symbiosis of Christians and Muslims in tenth-century Spain recently analyzed by Jerrilynn Dodds.[12] It would have been one of those works of Mozarabic art whose content is profoundly tied to Christianity but whose forms are associated with the Muslim world.

If we accept the fifth reading, we are, first of all, less tied to Spain, even though other factors like the style of writing and the comparable Latin inscription on a lamp found in Spain make a Spanish origin likely. But in this interpretation neither place of origin nor time of manufacture is particularly important. The object would have been made for a market in which cultural or ethnic allegiances were less significant than the evaluation of an object's quality, where taste and functions remained constant for many decades, if not for centuries.

In one sense, then, the meaning of the aquamanile is still in suspense, and it may well have been meant to be ambiguous from the very beginning. Solomon could have been an artisan, an owner, or the royal prophet of old; or perhaps his name was simply invoked to indicate quality. As Bautier has argued, all these possibilities are open, and none is certain to be true. The lesson to be derived from the inscription is that the art historian's almost pathological concern for locating an object in time and space, and determining authorship and function, is only pertinent when the information provided by the object emphasizes these categories, as it does in part in the first of my two preferred explanations. In reality, the most remarkable works of art are those that remain meaningful and intriguing, because somewhat mysterious, to all those who deal with them.

9

1 Musée du Louvre, MR 1569. The first and still the only complete discussion of the bird is by Adrien de Longpérier, "Vase arabo-sicilien de l'oeuvre Salomon," *Revue archéologique*, n.s. 6 (1865), 356–67; rpt. in his *Archéologie orientale* (Paris, 1883), 442–55. It is found in most catalogues of relevant Louvre exhibitions like *L'Islam dans les collections nationales* (Paris, 1977), no. 147; or *Arabesques et jardins de paradis: Collections françaises d'art islamique*, ed. Marthe Bernus-Taylor (Paris, 1989), no. 119, with references to earlier or alternate explanations. Standard brief mentions are found in Manuel Gomez-Moreno, *Ars Hispaniae*, vol. 3 (Madrid, 1951), 335; and Jacques Fontaine, *L'art préroman hispanique*, vol. 2 (La-Pierre-qui-Vire, 1977), 373–76. The two most recent references with discussions of some interest are Sotheby's *Islamic Works of Art, Carpets and Textiles* (October 14, 1987), 128, and *Eredità dell'Islam: Arte islamica in Italia*, ed. Giovanni Curatola (Venice, 1993), 125–26. In both cases the Louvre bird is discussed in relation to other, closely related, birds.

2 I have not capitalized possible proper names for reasons that will appear below.

3 Maguy Charritat, in *Arabesques et jardins*, 148.

4 M. M. Diakonof, "Arabskoia Nadpic na bronzovom orle Ermitazha," *Epigrafika Vostoka* 4 (1951), 24–27. There are several alternate readings of the date, but they are not pertinent to our purposes here.

5 See Sotheby's *Islamic Works* and Curatola, *Eredità dell'Islam*, for the last two birds. To find the others requires browsing through the major catalogues of permanent and temporary exhibitions.

6 Longpérier, "Vase arabo-sicilien," was the first to have suggested this meaning.

7 The lamp is known primarily from its publication by Gomez-Moreno in vol. 3 of *Ars Hispaniae*, fig. 393a. I am most grateful to Dr. Juan Zozoya for new and remarkably clear photographs of this unusual object.

8 There has been much discussion of the Spanish versus the Sicilian origin of the Louvre bird, the latest Sicilian salvo being fired by the commentators in Sotheby's *Islamic Works*, 128. This is an instance where, to my mind, the uniqueness of the inscription overwhelms the looser claims of formal characteristics.

9 Robert-Henri Bautier, "La datation et la provenance du 'paon aquamanile' du Louvre," *Bulletin de la Société nationale des antiquaires de France* (May 1977), 92–101. I am also grateful to Professor Jean Vézin, who clarified for me several points of detail about the Latin inscription and to Jannic Durand, from the Département des Objets d'Art in the Louvre, for several leads to scholars and objects.

10 A. S. Melikian-Chirvani in *Arts de l'Islam des origines à 1700 dans les collections publiques françaises*, exh. cat. (Paris, 1971), 102.

11 The latest remarks on the subject known to me are by M. J. Rubiera Mata in "La mesa de Salomón," *Awrâq* 3 (1980), 26–31.

12 Jerrilynn D. Dodds, *Architecture and Ideology in Early Medieval Spain* (University Park, PA, 1990), esp. 111–16. It is curious but certainly coincidental that one of the "martyrs of Cordoba," who compelled their own execution by their provocative behavior, was called Solomon.

9

Style and Ideology

The effort to link stylistic development with social and cultural change is fundamental to the art-historical enterprise. Meyer Schapiro, in an article entitled "Style" (1953) describing aspects of the art historian's task, wrote: "By considering the succession of works in time and space and by matching the variations of style with historical events and with the varying features of other fields of culture, the historian of art attempts, with the help of common-sense psychology and social theory, to account for the changes of style or specific traits."[1] It is possible to treat style autonomously, of course, and much important art-historical work has been accomplished under these conditions: through the cataloguing of shared features of form, developmental sequences have been traced, influences charted, schools and movements defined, and individual works of art dated, localized, and attributed. "Style," says James Ackerman, "provides a structure for the history of art."[2] But tantalizing parallels across cultural spheres have led art historians to seek connections between style and other phenomena, to identify the mechanisms for the transference of ideas, and to develop theories to account for links.

In the 1930s Schapiro, working from a Marxist perspective, wrote a series of now classic articles on Romanesque art in which he moved toward a sociologically informed analysis of artistic style. In "From Mozarabic to Romanesque in Silos" (1939), he studied stylistic change in a situation of profound cultural transformation, focusing on a moment in the late eleventh century when two distinctive styles were employed concurrently at the monastery of Silos in northern Spain. The new Romanesque style, imported from France, was adapted for the sculptures of the cloister. But simultaneously the indigenous "Mozarabic" style—an abstract, schematized style, an "art of color," remote from what Schapiro regarded as the progressive naturalism of the Romanesque—was deliberately employed in the illumination of a "Beatus" manuscript.[3] The stage was thus set for a study of stylistic change, in O. K. Werckmeister's words, as a "socio-historical drama."[4]

The Silos Beatus, like all Spanish Beatus manuscripts, contains a cycle of some 100 images illustrating a commentary on the Apocalypse composed by the Spanish monk Beatus of Liébana (d. 798). Most of the miniatures depict John's apocalyptic visions, and these are placed to follow the relevant biblical passage (*storia*) and to precede the commentary on it (*explicatio*). The Silos Beatus stands apart, however, for interpolated in the traditional Mozarabic cycle are new images not demanded by the text—including a pair of *jongleurs* performing their dance—rendered in the nascent Romanesque style. Such profane intrusions, Schapiro argued, are characteristic of the Romanesque era,

when "secular interests acquire an independent value and begin to modify the extreme spiritualistic views of the early Middle Ages."[5]

In the following essay, O. K. Werckmeister resumes a long-standing dialogue with Schapiro and his work, offering a re-reading of the style, iconography, and ideological purchase of the image of the *jongleurs* in the Silos Beatus. He qualifies Schapiro's statements about the realism and secularity of the image, showing how geometry determines its design and drawing parallels to biblical images of secular musical performance. He redraws Schapiro's ideological oppositions between the church and the progressive middle class, focusing on the monks of Silos as a social group and investigating social tensions within the monastery. Werckmeister's work may be regarded as a probing response to Schapiro's call for "the critical correlation of the forms and meanings in the images with historical conditions of the same period and region."[6]

<div align="right">E. S.</div>

1 Originally published in *Anthropology Today*, ed. Alfred L. Kroeber (Chicago, 1953), 287–312; rpt. in *Selected Papers*, vol. 4 (New York, 1994), 51–102, at 51. Discussed by James S. Ackerman in "On Rereading 'Style,'" *Social Research* 45 (1978), 153–63; and, recently, by Alan Wallach, "Meyer Schapiro's Essay on Style: Falling into the Void," *Journal of Aesthetics and Art Criticism* 55 (1997), 11–14. Other important considerations of style as a category include: James S. Ackerman, "The Concept of Style," in *Art and Archaeology*, ed. James S. Ackerman and Rhys Carpenter (Englewood Cliffs, NJ, 1963), 164–86; David Summers, "Conventions in the History of Art," *New Literary History* 13 (1981), 103–25; Willibald Sauerländer, "From Stilus to Style: Reflections on the Fate of a Notion," *Art History* 6 (1983), 253–70.

2 Ackerman, "Concept of Style," 165.

3 Schapiro was himself a painter and draftsman, unusual for his friendships with contemporary artists. It is reported that he showed Fernand Léger the tenth-century Beatus manuscript in the Pierpont Morgan Library in New York (Thomas B. Hess, "Sketch for a Portrait of the Art Historian among Artists," *Social Research* 45 [1978], 7).

4 Review of Meyer Schapiro's *Selected Papers*, vol. 1. *Romanesque Art*, in *Art Quarterly*, n. s. 2/2 (1979), 211–18, at 212. In this rigorous survey of Schapiro's work, Werckmeister says: "In my own view, the article remains the most profound piece of writing on Romanesque art by anyone to this day" (214).

5 "From Mozarabic to Romanesque in Silos," rpt. in *Romanesque Art*, 28–101.

6 "From Mozarabic to Romanesque," 29.

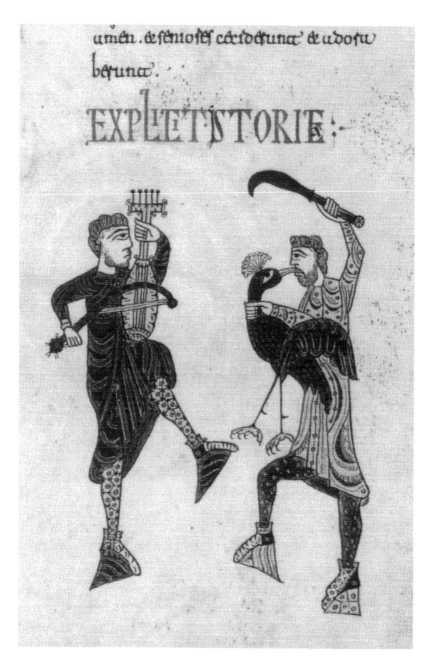

10.1. Musical performers. London, British Library, Add. MS 11695 (Beatus of Liébana, *In Apocalypsim*), fol. 86r. Reproduced by permission of the British Library.

10 The Image of the "Jugglers" in the Beatus of Silos

O. K. Werckmeister

The Artist's Work

Several lengthy colophons in the Beatus of Santo Domingo de Silos narrate how the manuscript was produced in two stages.[1] Two resident monks, Dominicus and Nunnio, completed its transcription on April 18, 1091. Since a Beatus Commentary is an integral complex of text, exegesis, and illustration, these scribes must have had at their disposal an exemplar containing miniatures as well as texts, and they left the spaces for the illustrations blank. However, when they had finished the transcription, no painter was around to fill them in. More than eighteen years later, on July 1, 1109, an artist newly arrived in the abbey, the prior Petrus, accomplished the task of "completing" the manuscript, "and, while completing it, illuminated it throughout."

The model to which Petrus could now do justice seems to have been painted much earlier in a purely "Mozarabic" style. The last such Beatus manuscript, that of Seu de Urgell, had been illustrated about a century before. Since then, time after time, painters had viewed their task as one of creatively recasting in Romanesque forms the early medieval schematism and abstraction in which the cycle had originally been conceived. Prior Petrus could have done the same, as is proved in a few scattered miniatures he painted that formed no part of the original cycle. But for the Beatus miniatures themselves he held back, apparently because he had been charged with preserving the appearance of the exemplar in all its purity. His task, that of re-creating an illuminated manuscript from a distant past without the benefit of a living, local school tradition, had been the obstacle on which the completion of the job had stalled for eighteen years. In the end, Petrus was able to revive the style of the past with the same strenuous reflection as, for example, English or German illuminators of the tenth and eleventh centuries carefully reproduced the appearance of outstanding Carolingian models in streamlined, flattened versions of their own. The miniature of the musical performers on folio 86r is one of the scattered instances where he made his own artistic sense prevail to some extent, since here he was not beholden to the appearance of his model.[2]

Iconography

The miniature depicts a musician playing the rebec[3] for a performer engaged in a mock struggle with a crested bird (Fig. 10.1; Color Plate 5). The performer holds the

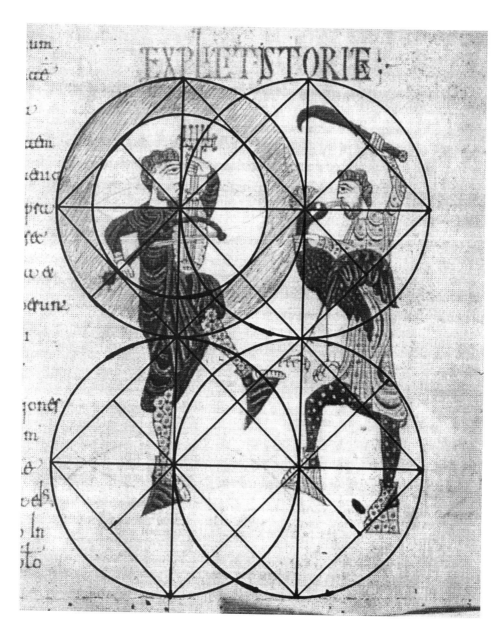

10.2. Musical performers. London, British Library, Add. MS 11695 (Beatus of Liebana, *In Apocalypsim*), fol. 86r. Diagrammatic overlay by author.

the middle axis of the circle overleaf, whereas the performer is pushed into the right-hand segment of the extrapolated circle encasing him.

Color Composition

The strict formal regularization of the two-figure group extends to the color scheme (Color Plate 5).[15] The four colors of the basic chord observed in "Mozarabic" book painting—red, dark blue, dark green, and yellow[16]—are distributed in the compartmentalized components of the two figures by way of crosswise alternations. The triangular heels of the shoes are blue on the left, yellow on the right; the stockings are yellow on the left, blue on the right; the tunic is dark green with admixtures of blue on the left, yellow on the right; the object of the performance is yellow on the left—the rebec—and dark green with admixtures of blue on the right—the bird. A secondary pattern of dots and lines, painted in red and yellow on these surfaces, reinforces the alternating symmetry. This color composition, with its adherence to the basic chord, finds a precedent in one of the initials of the Psalms Commentary from San Millán de la Cogolla.[17] In the troper illustration from southern France mentioned above, on the other hand, where the pair of performers is also painted in the four colors, yellow, red, blue, and green, the painter has made no effort at a regular alternation of these colors. The artist of Silos, by contrast, has locked the foreign iconographic motif into his indigenous color style. In a further step, he has polarized the light and dark areas within the symmetrical composition. The yellow constitutes the light hue, while the dark hue is jointly made up by the blue and green. A black-and-white reproduction of our miniature shows that, just like the hues, the tones alternate crosswise among the bodies, legs, and objects.

Rhythm

The miniature's deliberate compositional logic links the figures' rhythmic choreography with the counterpoising of their gestures. Its numerical regularity would fit the theme of the tetrachord inherent in the image as a result of its derivation from troper iconography. There are four main areas in each figure, eight in all, in which the alternating color correspondence is displayed. As the eye moves back and forth among them, it reenacts the measured rhythm of the seesaw dance in a four- or eight-fold regularization reminiscent of Gregorian prosody. The painter has cast the traditional four-color chord in the arithmetic sequences of rhythm and modulation, which in early medieval architecture, poetry, and music were drawn upon to regulate a potentially all-pervasive liturgical aesthetics. But whereas Gregorian chant subordinates rhythm to continuous modulations, here the beat is marked as paramount. It makes the two performers act out their antagonistic minuet-like dance as a show of order, of command and submission.

10

Pictorial Conventions

"Iconography," when opposed to "style," refers to the "content" of a work, in contradistinction to its "form." As a mode of inquiry, iconographical analysis has traditionally proceeded from the identification of pictorial types to the exploration of broader cultural assumptions implicit in the choice and specific rendering of themes. Iconographical analysis found its most sophisticated practitioner, most would say, in the figure of Erwin Panofsky (1892–1968), a German expatriate who dominated the field of art history in the United States from the 1930s through the post-war era. Resident at the Institute for Advanced Study in Princeton, Panofsky wrote a broad range of works that dealt with the content of works "in a deeper sense." The word *iconography* had limiting connotations. Panofsky drew upon the vocabulary of the Hamburgian cultural historian Aby Warburg (1864–1928) and employed the term *iconology* to describe that variety of intellectual activity which his works promoted.

When Panofsky arrived in Princeton in 1934, the university had a thriving Department of Art and Archaeology, where iconographical study was seriously pursued. Charles Rufus Morey, chair of the department, had founded the Index of Christian Art as a tool for interdisciplinary research—a function that the Index, on-line, continues to perform. By Panofsky's day, a system had been developed to label and categorize things represented in Christian art in all media up to 1400—figures, scenes, objects, natural phenomena, symbols. Cataloguers, called "readers," followed a strict regime when describing a work, proceeding, insofar as possible, from left to right, from top to bottom, accurately and economically identifying all persons, props, and actions in a given pictorial field in their interrelations. A description of a fourth-century sarcophagus scene, in the developed Index language, reads: "Front, zone 1: Christ: Miracle of raising Lazarus— Mary or Martha of Bethany, veiled, kneeling before gabled tomb enclosing standing mummy struck with rod held by Christ, holding roll."[1]

"Iconographical analysis in the narrower sense of the word" became the second level in Panofsky's famous tripartite scheme for discerning the meaning of a work of art, first published in English in 1939 in the introduction to his *Studies in Iconology: Humanistic Themes in the Art of the Renaissance*.[2] At this, the level of "secondary or conventional meaning," the interpreter links pictorial motifs and compositions with literary themes, thus decoding meanings consciously encoded by the artist. Logically prior is the pre-iconographical level of understanding, where the interpreter draws upon practical experience in the world to recognize that given forms represent given things or events. Following upon the first two is a third level, that of "intrinsic meaning or content," where the interpreter relies on "synthetic intuition" and examines a work as symptomatic of the

attitudes and mental habits of a culture and time. Panofsky's model has been criticized for limitations: for a bias toward Renaissance and Baroque art and a consequent privileging of naturalistic imagery and depictions with literary underpinnings. Moreover, current interest in the role of viewer response has denaturalized the search for intrinsic content. Yet the scheme endures as a classic reflection on method, impressive for its economy and coherence, for its insistence on the shifting meaning of pictorial types over time, for the attention to minutiae of form on which it depends.

The two essays that follow, each treating a panel of relief sculpture, demonstrate that accurate pre-iconographical and iconographical description is a precondition for broader interpretive initiatives. Dorothy F. Glass shows how the simple correction of an iconographical error can set the course of scholarly inquiry on new paths. Her analysis of a lintel on the Romanesque church at San Cassiano a Settimo begins with a new identification of a single figure and expands into an investigation of issues of civic identity in twelfth-century Tuscany. Lois Drewer relies on precise comparative description of a group of works on a common biblical theme in order to define the visual peculiarities of a particular Iberian rendering. This enables her to consider how an artisan, re-engaging with a biblical story, might defy or manipulate received artistic conventions for expressive ends.

E. S.

1 For a glimpse into the principles governing the early cataloguers' efforts, see Helen Woodruff, *The Index of Christian Art at Princeton University: A Handbook* (Princeton, 1942).

2 On Panofsky's scheme and its reception see, among others, Jan Białostocki, "Iconography and Iconology," in *Encyclopedia of World Art* 7 (London, 1963), esp. 774–81; Lubomir Konečny, "On the Track of Panofsky," *Journal of Medieval and Renaissance Studies* 4 (1974), 29–34; Christine Hasenmueller, "Panofsky, Iconography, and Semiotics," *Journal of Aesthetics and Art Criticism* 36 (1978), 289–301; Michael Ann Holly, *Panofsky and the Foundations of Art History* (Ithaca, 1984), 158–93; Keith Moxey, "Panofsky's Concept of 'Iconology' and the Problem of Interpretation in the History of Art," *New Literary History* 17 (1985), 265–74; Georges Didi-Huberman, *Devant l'image* (Paris, 1993), 120–34, 145–53; Joan Hart, "Erwin Panofsky and Karl Mannheim: A Dialogue on Interpretation," *Critical Inquiry* 19 (1993), 534–66; David Summers, "Meaning in the Visual Arts as a Humanistic Discipline," in *Meaning in the Visual Arts: Views from the Outside. A Centennial Commemoration of Erwin Panofsky (1892–1968)*, ed. Irving Lavin (Princeton, 1995), 9–24.

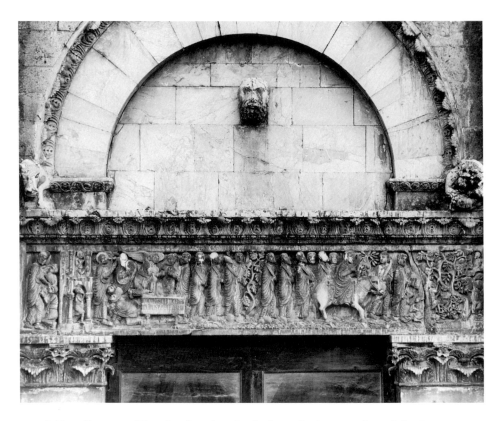

11.1. Raising of Lazarus and Entry into Jerusalem. San Cassiano a Settimo, central portal, lintel.
Photo: Alinari/Art Resource, NY.

"Then the eyes of the blind shall be opened": A Lintel from San Cassiano a Settimo

Dorothy F. Glass

There has of late been much discussion concerning the place of iconography within the discipline of art history and a consequent re-evaluation of the premises of one of its most influential practitioners, Erwin Panofsky.[1] Yet much may still be gained from Panofsky's fundamental essay, "Iconography and Iconology: An Introduction to the Study of Renaissance Art,"[2] in ways that are perhaps unexpected. I am referring neither to the specific discussion of the perceived differences between iconography and iconology, a distinction abjured by Panofsky later in life, nor to those aspects of his methodology that have rightly, in my view, been criticized as being too closely bound to texts. Rather I am thinking of the first step in Panofsky's tripartite program for determining the meaning of works of art: pre-iconographical description or, put plainly, looking and describing.[3] "If the knife that enables us to identify St. Bartholomew is not a knife but a corkscrew," Panofsky writes, "the figure is not a St. Bartholomew."[4] Some ramifications of this fundamental point are demonstrated in what follows.

The parish church (*pieve*) of San Cassiano a Settimo is located near the Arno, a few miles southeast of Pisa.[5] Its three façade portals each have a sculpted lintel. That decorating the central portal—important as the only work both signed and dated by the famed sculptor Biduinus—is of concern here (Fig. 11.1). It depicts, reading from left to right, three episodes: a scene previously identified as the Healing of the Blind, the Raising of Lazarus, and the Entry into Jerusalem. The sarcophagus from which Lazarus rises bears an inscription: HOC OPVS QVOD CERNIS BIDVINVS DOCTE PEREGIT ("Biduinus did in learned fashion this work you see"), while a lengthier inscription on the upper edge of the lintel reads: VNDECIES CENTVM ET OCTAGINTA POST ANNI TEMPORE QVO DEVS EST FLVXERVNT DE VIRGINE NATVS ("1180 years have passed since the time when God was born of the Virgin").

The miracle scene is not difficult to identify: Lazarus, in his grave wrappings, four days dead, stands upright in his tomb, having been brought to life by Christ with a gesture often associated with healing. Standard formulae are also used for the depiction of the Entry into Jerusalem: Christ, riding on an ass, accompanied

by his apostles who process before and behind him, makes his way into the city, while boys in a tree look on. That these two Christological scenes should appear adjacent to each other is not unexpected, for not only does the Raising of Lazarus immediately precede the Entry into Jerusalem in the Gospel of John, but it took place in Bethany, less than a mile from Bethpage, where the Entry itself commenced. The same cannot be said of the Healing of the Blind. Although it is certainly one of the better known of Christ's miracles, its description is not contiguous with the other two in any of the gospel accounts. Nor are there comparable instances of this arrangement of scenes in other Romanesque cycles or narratives. Hence, it is perhaps wise to return to the beginning of the process, that is, to pre-iconographic visual analysis, in order to lay the essential groundwork for the ensuing iconographical observations.

Three figures are fit into a narrow rectangular space on the far left of the lintel. A bearded man in a long robe and mantle extends an arm toward one of two figures, smaller in scale. Previous commentators, assuming that this scene, like the other two, was Christological, interpreted the gesture as one of healing and imagined it was a scene of the Healing of the Blind. But closer scrutiny reveals a number of incongruities. Unlike the figure of Christ in the adjoining Raising of Lazarus, this Christ neither sports a nimbus nor carries a cross. Moreover, with his left hand, "Christ" pulls the hair of one of the two smaller figures. And of these two supposedly blind men, one is holding an open book! Clearly, the Healing of the Blind cannot be the subject at hand. Had careful visual analysis been undertaken *ab initio*, the scene would never have entered the literature so labeled.

I can think of no text, biblical or other, that explains the curious scene on the lintel of San Cassiano a Settimo. I can, however, think of an analogous image: the figure of Grammar, one of the seven liberal arts, in the archivolt of the south portal of the west façade of Chartres cathedral (Fig. 11.2). There a seated figure, female in this case, seems to be attempting to teach reading to two reluctant students seated just below her. All three figures hold open books, and Grammar carries as well a flail for encouraging students to diligence. Save for the different gender of the professing figures, the two scenes are similar. But what could possibly be the relationship between two images in such diverse locales? Are the visual analogies merely coincidence? In fact the parallel provides the solution to the iconographical conundrum. For it so happens that Saint Cassian of Imola, the saint to whom the church of San Cassiano a Settimo is dedicated, was a schoolmaster, a teacher of reading and writing who suffered a dramatic martyrdom in Early Christian times. When Cassian refused to worship at pagan altars, a Roman judge set his pupils on him, and they vengefully killed him, so the story is told, with thousands of pricks of their writing utensils.[6] Here Saint Cassian is depicted attempting to teach his pupils prior to his unfortunate demise. He and the personification of Grammar at

Reading Medieval Images

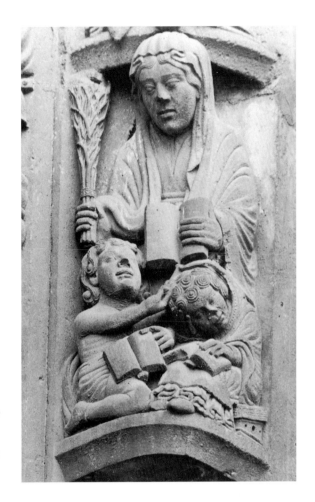

11.2. Grammar. Chartres cathedral, west façade, south portal. Photo: Foto Marburg/Art Resource, NY.

Chartres thus share an occupation. His vigorous gesture might suggest the sternness for which he was too amply repaid. The absence of a nimbus and the presence of an open book at San Cassiano a Settimo are thus rather easily explained: it is the patron saint of the church who is being honored on the lintel.

The proper identification of the scene opens new paths of inquiry, for the lintel can immediately be connected with two other lintels from western Tuscany that depict the Entry into Jerusalem in combination with the patron saint of the church, who appears at the far left: that from Sant'Angelo in Campo near Lucca, signed but not dated by Biduinus and now in the Palazzo Mazzarosa in Lucca (Fig. 11.3), and that on the portal from San Leonardo al Frigido, a village near Carrara, now in The Cloisters in New York City (Fig. 11.4). The former, although signed by Biduinus, differs stylistically from his signed work at San Cassiano a Settimo, while the latter has been attributed to Biduinus but is most likely not by his hand. Both

11

date from around 1180 and are thus contemporary with the lintel at San Cassiano a Settimo. The former depicts Saint Michael, the Holy Angel, fighting the dragon, and the latter shows Saint Leonard holding a staff and processing with the apostles toward Jerusalem.

The presence of the dedicatory saint on each of the three contemporaneous lintels suggests a number of lines of investigation, of which three appear to be the most fruitful: the functioning of sculptors' workshops in medieval Tuscany, the character of devotion to local saints in medieval Italy and its place in the formation of civic identities, and the nature of the participatory engagement expected of local audiences viewing the lintels.

Unlike the Burgundian churches on which Ilene Forsyth has shed so much light, Tuscan Romanesque churches are sculpturally sparse. At San Cassiano a Settimo, the three façade lintels are unaccompanied by other exterior sculpture. No sculpture besides the lintel survives from the Sant'Angelo in Campo portal, nor is any other sculpture known to have existed. The lintel from San Leonardo al Frigido, together with the capitals on which it rests, were likely carved at a different time from the portal's decorated doorposts; the portal as a whole is best viewed as a pastiche (Fig. 11.4). The paucity of Italian Romanesque architectural sculpture and its rather small scale suggest that, at least in the case of the monuments discussed here, there was no need to establish a large, resident workshop at any of the sites. Instead, the lintels could easily have been sculpted at a central workshop, perhaps in Lucca, and transported by land or water to the appropriate location. In the latter case, the Arno, Serchio, and Frigido rivers would have served well. There is clear and abundant evidence from the Roman era, and even earlier, for the transport by water of

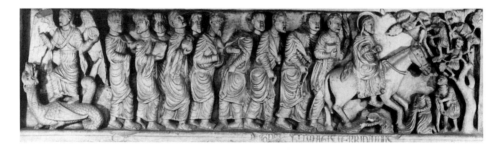

11.3. Entry into Jerusalem. Lintel from Sant' Angelo in Campo. Lucca, Palazzo Mazzarosa. Photo: Soprintendenza per i Beni A.A.A.S., Pisa.

Reading Medieval Images

sarcophagi and other large stone works.[7] The respective churches would then have ordered a lintel portraying the Entry into Jerusalem "personalized," so to speak, with the appropriate patron saint, much as antique sarcophagi were purchased with individualized portraits of the deceased. This observation is especially pertinent to the lintel at San Cassiano a Settimo and to that now in the Palazzo Mazzarosa, for the saints are not linked visually to the remainder of the lintel in either.

But why would the lintels on three rather small churches in Romanesque Tuscany, comprising fully one-third of the area's extant historiated lintels from the second half of the twelfth century, feature both the church's patron saint and the Entry into Jerusalem, a subject relatively uncommon in monumental sculpture? We may infer that the Entry into Jerusalem, and by extension entry into the Holy Land, was of particular interest to those residing in western Tuscany. To understand that local interest, it is helpful to be aware of the key geographical position of the region during the Middle Ages and its importance in international commerce and travel. Pilgrims came to venerate famous relics on their way to yet greater pilgrimage sites, including Jerusalem itself. In his diary of a journey to the Holy Land taken between

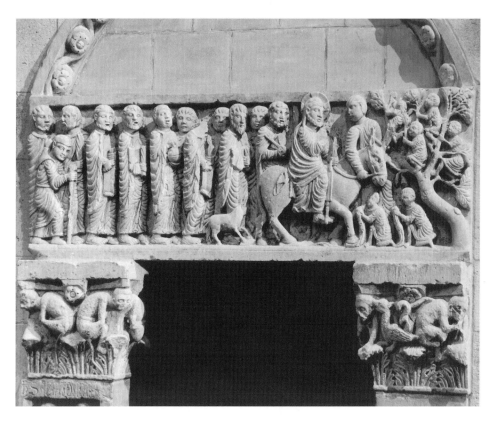

11.4. Entry into Jerusalem. Portal from San Leonardo al Frigido, lintel. New York, The Metropolitan Museum of Art, The Cloisters Collection (62.189). Photo: The Metropolitan Museum of Art.

Lintel from San Cassiano 147

1154 and 1158, the Icelandic pilgrim Nikulas of Munkathvera, for example, noted that Luni, less than ten miles from San Leonardo al Frigido, was located at the intersection of two significant pilgrimage roads, that to Rome and that to Santiago de Compostela. San Cassiano a Settimo lies just outside Pisa, a significant port whose activities in the Holy Land, including transport of pilgrims, predate the first Crusade. Sant'Angelo in Campo stood in the fields outside Lucca, where pilgrims came to see the *Volto Santo*. Lucca was located on the Via Francigena, built by the Lombards, the primary pilgrimage and commercial road for northerners bound for Rome. Those traveling on the still viable Roman road, the Via Cassia, could stop at Pistoia to venerate in the cathedral a piece of the head of Saint James Major that the perspicacious Bishop Atto had acquired from Santiago de Compostela shortly before 1140. Because western Tuscany, rich in relics, was located at the nexus of land and sea routes to more distant holy sites, it stands to reason that Jerusalem, as well as Rome and Santiago de Compostela, would loom large in the minds of its inhabitants.

It is noteworthy that the depictions of the Entry into Jerusalem on churches in western Tuscany can be clearly differentiated from those elsewhere. For example, at Saint-Gilles-du-Gard, located on the Via Tolosana, the southernmost pilgrimage route to Santiago de Compostela, the Entry into Jerusalem appears at the beginning of an extensive Passion cycle rather than in isolation. Nor is the scene at Saint-Gilles-du-Gard connected with an image of the patron saint of the church. In contrast, the three Tuscan lintels—each depicting a biblical event of central importance to all Christendom, commemorated annually on Palm Sunday, in relation to the patron saint of the particular church for which the lintel was made—appear to be a curious amalgam of the universal and the local. It is precisely this combination that is characteristic of so much Romanesque art in central Italy.

The same combination occurs in the Emilia–Romagna, a province adjoining Tuscany to the north and east, where much attention is also paid to the cult of local saints.[8] At Modena cathedral, for example, the lintel of the south flank portal, the *Porta dei Principi*, contains an extensive series of scenes from the life of Saint Geminianus, the cathedral's patron saint. It, too, is fitted into a universal context, for the apostles appear on the doorposts of the same portal. At San Zeno in Verona, the patron, featured on the central portal of the main façade, appears as a large, standing iconic image in the center of the tympanum. Small scenes from his life run along the lower edge of the tympanum, while Old and New Testament scenes are depicted in reliefs to the left and right. At the cathedral of Fidenza, formerly known as Borgo San Donnino, the life of the patron, Saint Domninus, appears as a series of frieze-like scenes beginning at the left of the central portal, continuing along the lintel, and ending to the right of the central portal, thereby forming the only extended narrative on a complex façade program whose precise interpretation is still debated.[9]

11

Reading Medieval Images

The sculptor, thought by some to be Benedetto Antelami himself, emphasized the local nature of the legend, for both the Stirone River and the nearby town of Piacenza are depicted and clearly inscribed.

The strong emphasis on the local is a primary characteristic of central Italian medieval art, a situation attributable in part to the early growth of communes. Pride in one's city, or even one's village, was engendered by the communal effort required to make the locus habitable, to adorn it, and to nurture its commercial and financial success. It was, of course, the patron saint of the city who made all of this possible by acts of intercession. The citizenry was, therefore, more than happy to finance churches in honor of their saint and to embellish them with scenes from his life.

The processions of Christ and the apostles depicted on the Tuscan lintels would have called to mind actual experience, for elaborate public ceremonies are known to have taken place locally on Palm Sunday during the Middle Ages, as they had in Jerusalem from at least the fourth century. On the lintel of San Cassiano a Settimo, the apostles in the Entry into Jerusalem hold palm fronds, thereby reenacting the Palm Sunday procession recounted in John 12:12–19. The dramatization of the scriptural account at San Cassiano a Settimo is notably precise, for, as indicated above, the Raising of Lazarus—the event immediately preceding the Entry—is depicted to the left. In medieval Tuscany in fact a hymn concerning that very miracle was sung during Palm Sunday processions.[10] On the lintel from Sant'Angelo in Campo, the contemporary liturgical nature of the Palm Sunday procession is further emphasized by the censers held by some of the apostles. The situation is similar on the lintel from San Leonardo al Frigido, where many of the apostles bear palms, now broken, and some also hold censers, books, or scrolls, as, with mouths wide open, they sing fervently. On this lintel, moreover, St. Leonard, the patron saint, actually takes part in the procession.

The presence of the appropriate patron saint on each of the lintels and the depiction of a procession well known to all cast the observer in the role of an engaged participant in the solemn events that marked the beginning of Holy Week throughout Christendom. The liturgical and historical became local and personal, thereby reminding individual Tuscans not only of the rituals of Holy Week but also of the ongoing crusades and pilgrimages to the Holy Land. With their own eyes, hearts, and minds, citizens could travel to the East with the local saint, thereby participating vicariously in the long journey that held such fascination for medieval Italians. The three lintels may be viewed simultaneously as liturgical ritual and mimetic reenactment.[11]

The proper identification of Saint Cassian, the schoolmaster assailed by his ungrateful students, has yielded a rich art-historical harvest. Not only are we now able to see more clearly the relationships among three Romanesque lintels that were

11

geographically proximate, but we are also able to speculate about workshop practice, popular piety and civic identity, liturgical mimesis and the lintels' audiences. The results of our intellectual quest surely demonstrate the fundamental importance of exacting pre-iconographic analysis in the practice of art history.

Quotation in title from Isaiah 35:5.

1 See, for example, Brendan Cassidy, ed., *Iconography at the Crossroads: Papers from the Colloquium Sponsored by the Index of Christian Art, Princeton University, 23–24 March 1990* (Princeton, 1993).

2 Erwin Panofsky, "Iconography and Iconology: An Introduction to the Study of Renaissance Art," in *Meaning in the Visual Arts* (Garden City, NY, 1955), 26–54; first published in *Studies in Iconology* (London, 1939).

3 It seems especially fitting to examine this activity, so central to the discipline of art history, in a volume honoring Ilene Forsyth, whose fascinating studies of Burgundian Romanesque sculpture have always included rigorous and exacting visual analyses.

4 Panofsky, "Iconography and Iconology," 30.

5 The *pieve*—and related monuments—are treated more extensively in Dorothy F. Glass, *Portals, Pilgrimage and Crusade in Western Tuscany* (Princeton, 1997). Gavina Cherchi Chiarini arrived independently at the identification of the saint, although she did not pursue its implications. See her *Il cervo e il dragone: Simboli cristiani e immagini cosmiche sulla facciata della Pieve di San Casciano di Cascina* (Pisa, 1995), 73–79. I am grateful to Prof. Gigetta Dalli Regoli for calling this publication to my attention.

6 On the cult of St. Cassian in Italy, see Magdalen Bless-Grabher, *Cassian von Imola: Die Legende eines Lehrers und Märtyrers und ihre Entwicklung von der Spätantike bis zur Neuzeit* (Bern, 1978), 93ff.

7 See, for example, Patrizio Pensabene, "Considerazioni sul trasporto di manufatti marmorei in età imperiale a Roma e in altri centri occidentali," *Dialoghi di archeologia* 6 (1972), 317–62.

8 On the cult of saints in central Italy, see Paolo Golinelli, *Città e culto dei santi nel medioevo italiano* (Bologna, 1991; 2d ed., 1996); and Diana Webb, *Patrons and Defenders: The Saints in the Italian City-States* (London, 1996).

9 See Dorothy F. Glass, "Civic Pride and Civic Responsibility in Italian Romanesque Sculpture," in *Le vie del medioevo*, Atti del Convegno internazionale di studi, Parma, 28 settembre–1 ottobre 1998, ed. A. C. Quintavalle (Milan, 2000), 183–92.

10 This hymn appears in the tenth-century Romano-German pontifical, a liturgical text known at Lucca from an early date. See Cyrille Vogel, *Medieval Liturgy: An Introduction to the Sources*, rev. and trans. William G. Storey and Niels K. Rasmussen (Washington, DC, 1986), 320–21; originally published as *Introduction aux sources de l'histoire du culte chrétien au moyen âge* (Spoleto, 1981).

11 Glynne Wickham, *The Medieval Theatre*, 3d ed. (Cambridge, 1987), 39. The three lintels thus address the relationship among Romanesque art, liturgy, and drama explored early on, primarily in France, and taken up again by Ilene H. Forsyth in her magisterial "Magi and Majesty: A Study of Romanesque Sculpture and Liturgical Drama," *Art Bulletin* 50 (1968), 215–22.

11

Reading Medieval Images

12 The Alcaudete Sarcophagus

Lois Drewer

A fragmentary fifth- or sixth-century sarcophagus from Alcaudete in southern Spain (Fig. 12.1) is one of the rare surviving Early Christian funerary monuments produced in the Iberian peninsula.[1] This sarcophagus presents an interpretative challenge because it is both familiar—in the basic type of funerary monument, a double-frieze sarcophagus front, and in the choice of scenes represented, the Raising of Lazarus, David and Goliath, and Daniel in the Lions' Den—and anomalous—in composition, style, and iconographic details. Despite similarities with the Early Christian funerary art of Rome, the narrative strategies of the carver of the Alcaudete sarcophagus have proved to be difficult to explain. In a thorough discussion of the possible iconographic sources of the scenes represented on the sarcophagus, Helmut Schlunk considered two possible types of models: abbreviated scenes found on the sarcophagi and catacomb frescoes of Rome, and more expansive narratives based on manuscript illumination.[2] Neither comparison, as I will seek to demonstrate, accounts in a satisfactory way for the mode of representation of the biblical scenes found on the Alcaudete sarcophagus. In this paper, I would like to advance a third interpretative model suggested by the literary techniques employed by the fifth-century writer Sedulius and other Early Christian authors of biblical epics.[3] The innovative approach of the carver of the Alcaudete sarcophagus, I believe, can be seen as a visual correlative of this poetic form, which combines paraphrase and exegesis.

Two large connecting fragments of the Alcaudete sarcophagus are preserved. An almost-complete scene of the New Testament miracle of the Raising of Lazarus occupies the upper zone, while two Old Testament subjects, David beheading Goliath and Daniel in the Lions' Den, are illustrated in the lower zone. There is no doubt that this relief was once part of a double-frieze sarcophagus front. The upper edge is established by the preserved molding. Schlunk provides a plausible reconstruction of the surviving fragments as comprising roughly the left half of the original sarcophagus front.[4] It is clearly modeled after a fourth-century Roman double-frieze sarcophagus of a type imported into Spain and therefore presumably familiar to the carver.[5] In a representative example from Rome (Fig. 12.2; Lateran 175), we see a combination of Old and New Testament scenes depicted in two registers, separated by a plain border. In the center, a medallion, in this case a shell, frames portraits of the deceased.[6]

12

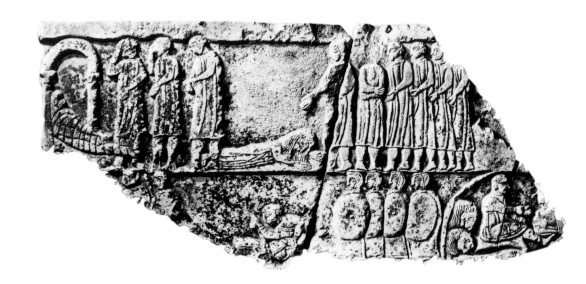

12.1. Sarcophagus with the Raising of Lazarus, David and Goliath, and Daniel in the Lions' Den. Madrid, Museo Arqueológico Nacional (309). Photo: Archivo Fotográfico, Museo Arqueológico Nacional.

12
—

Reading Medieval Images

The subjects depicted on the Alcaudete relief also belong to the standard Roman repertory. The Raising of Lazarus is among the most commonly represented stories in Roman catacomb paintings and sculpture, while Daniel in the Lions' Den is almost as popular.[7] On Lateran 175, the Raising of Lazarus, depicted in the upper left corner, consists of three figures. With a wand Christ indicates the mummy of Lazarus standing upright in a gabled tomb with steps, while one of his sisters kneels in thanksgiving at Christ's feet. In the scene of Daniel in the Lions' Den, shown directly under the portrait medallion, Daniel stands nude, his arms raised in prayer, between two miniature lions. He is flanked by a wingless angel and Habakkuk bringing food.

The particular strategy of visual communication employed on Roman sarcophagi and in catacomb frescoes is defined by André Grabar as a "signative" process.[8] It depends on the use of an abbreviated composition or "sign" that calls up in the minds of viewers a series of complex ideas of personal salvation through a limited selection of figures and attributes. In this respect, it finds a literary parallel in Early Christian funerary prayers such as the *Commendatio animae*, which lists the names of Old and New Testament figures, including Lazarus, Daniel, and David, in whose lives God intervened directly.[9] The names pronounced in the prayers and the abbreviated scenes on the sarcophagi and in the catacomb frescoes alike invoke hope for personal salvation in those who recollect the full biblical stories.

The carver of the Alcaudete sarcophagus, however, employs a different strategy. This can be seen first of all by comparing the compositions of the surviving scenes. Two are very expansive, taking up perhaps half of the original width of the sarcophagus front. In both cases we are viewing a single narrative scene composed of two groups of standing figures flanking a low horizontal central figure, the prostrate sister of Lazarus and the fallen body of Goliath, respectively. In contrast, the scenes on Roman double-register frieze sarcophagi such as Lateran 175 typically follow one another in quick succession through a crowded sequence of vertical figures, with the beginnings and ends of each scene framed by figures turned in three-quarter view toward the right and then the left, but without appreciable blank spaces, either within or between individual subjects.

How can we explain this difference in approach to the relation of figure and field? This may be a matter of local practice. Here we are handicapped by a scarcity of comparative examples. Schlunk has linked the Alcaudete sarcophagus with two others found in the region of Cordoba: the Ecija sarcophagus, a single-frieze sarcophagus with representations of the Sacrifice of Isaac, the Good Shepherd, and Daniel in the Lions' Den, and a fragment from Chimorra of an unidentified scene with a closely spaced crowd of male figures.[10] All three are carved of local stone, presumably in or near Cordoba. Stylistically they seem to be related in general terms, but one would hesitate to assign the three pieces to the same workshop.

12

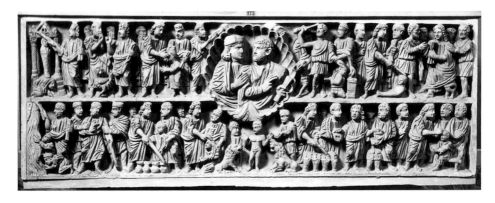

12.2. Roman double-frieze sarcophagus (Lateran 175). Rome, Museo Pio Cristiano. Photo: Alinari/
Art Resource, NY.

On the Ecija sarcophagus there is ample background space within and between scenes, but the relations of figures and ground and the density of the narrative are very different from the Alcaudete sarcophagus.[11] All that these two examples can suggest, however tentatively, is a regional approach to composition differing from that in the Roman frieze sarcophagi.

When we turn to an iconographical analysis of the Alcaudete sarcophagus, the non-Roman features are even more striking. Daniel, rather than standing in an orant pose flanked by symmetrical groups of lions, is shown in profile view, seated in a cave surrounded by lions in various poses.[12] When David's encounter with Goliath appears in Roman funerary art, for example on a fourth-century sarcophagus now in Ancona,[13] the two figures simply face each other, David holding a sling and Goliath a shield. On the Alcaudete sarcophagus, David is already victorious and is beheading the fallen giant, while a compact group of Israelite soldiers looks on and the Philistines flee toward the left.[14]

As Schlunk has already pointed out, the Raising of Lazarus scene also departs drastically from Roman conventions.[15] On the Alcaudete sarcophagus, the cast of characters has been expanded to include three male mourners—two raising hands to their foreheads, the third wringing his hands—and five disciples following Christ. Lazarus, wrapped as a mummy, slumps within a tomb with a round arch rather than a triangular pediment. The tomb structure has no steps. Instead, the body of Lazarus seems to be reclining on some kind of mattress. Christ has neither wand nor cross, and he gestures toward Mary while glancing at Lazarus in his tomb. Most dramatically, Lazarus' sister has thrown herself full length at Christ's feet, her hair loose and wild in her grief. This is a supplicatory figure, not one giving thanks. As Schlunk observes, the miracle of the raising has not yet taken place. This is extremely rare in Early Christian art.

12

If the carver rejected the scene of the Raising of Lazarus typical on Roman

Reading Medieval Images

sarcophagi, how might he have proceeded? According to an explanatory model developed by Kurt Weitzmann, narrative scenes in Early Christian art were most likely derived from manuscript illumination, where expanded compositions or a sequence of episodes from a story ("continuous narration") were invented to illustrate the biblical texts they accompanied. These scenes were then adopted by artisans in other media, including stone carvers, through the intermediary of some kind of model book or set of working sketches.[16]

Schlunk, following this approach, explores some possible parallels for the Alcaudete scenes in manuscript illumination. The Raising of Lazarus scene in the sixth-century Rossano Gospels is offered as an example of an expanded narrative where there are similar clusters of spectators. But here the supplication by Lazarus' sisters is combined with the actual moment of the miracle, as Lazarus stands at the mouth of the cave tomb.[17] Schlunk also suggests that the Alcaudete sarcophagus scene may be an excerpt from a more extensive manuscript cycle.[18] The eleventh-century Farfa Bible, possibly continuing the narrative strategies of earlier Spanish illuminated manuscripts, includes three episodes: Christ and his disciples with the messengers sent to tell him of Lazarus' sickness and death, the two sisters kneeling before Christ (one almost fully extended on the ground) while Lazarus lies on a bed or bier in a house, and finally a group of onlookers witnessing Christ's miracle as he gestures toward the upright mummy of Lazarus in a gabled tomb while the sisters kneel in prayer and thanksgiving.[19] The central scene depicts the same moment as the Alcaudete sarcophagus, before the miracle occurs, but with different gestures and setting.

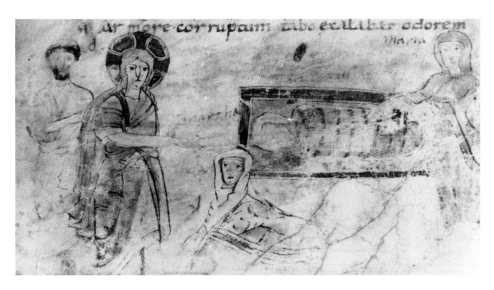

12.3. The Raising of Lazarus. Antwerp, Museum Plantin-Moretus, M.17.4 (Sedulius Scottus, *Carmen paschale*), fol. 30v. Photo: Museum Plantin-Moretus.

Another possibility to consider is that the artist is interpreting a different textual version of the story. The Raising of Lazarus miniature in the Antwerp manuscript of the *Carmen Paschale*, a biblical epic written by the poet Sedulius in the fifth century, shows the same rare moment of supplication before the miracle as on the Alcaudete sarcophagus (Fig. 12.3).[20] Lazarus, wrapped in his shroud, lies dead in an open sarcophagus.[21] Both sisters appeal to Christ, one gesturing toward Lazarus' body, the other prostrate at Christ's feet. In the text, Sedulius retells the story related in John 11:1–44 selectively. He describes the grief of the sisters and recounts their hesitant faith through a series of rhetorical questions. He then evokes the miracle through Christ's words calling Lazarus forth from the tomb (John 11:43) and concludes with several amplifying verses celebrating Christ's victory over death.[22] The miniature is placed after verse 4.274, which paraphrases John 11:39, where Martha says: "Lord, by this time there will be an odor, for he has been dead four days." The illuminator has clearly derived his inspiration from Sedulius' verses. The pictorial details of the scene on the Alcaudete sarcophagus, however, are quite different from the miniature in the Antwerp manuscript, so the likelihood of a common visual prototype is small.

Sedulius' literary technique in composing his version of the Raising of Lazarus in the *Carmen Paschale*, however, suggests another explanation for the equally anomalous treatment of the Lazarus miracle on the Alcaudete sarcophagus. The poet's method has been characterized as verse "paraphrase," since one of the aims of the genre of biblical epic is to recount the Bible stories accurately, but with amplification and interpretation as well as selection and differing emphasis.[23] In other words, Sedulius provides a type of exegesis in verse of the biblical account of the Raising of Lazarus story. Is it possible that the Alcaudete carver, working in his own medium, might similarly have provided an original, in this case visual, exegesis of the biblical narrative? It is striking how well the Alcaudete sarcophagus story conveys the flavor of the biblical text.[24] The sense of hopelessness and grief because Christ has arrived too late, after Lazarus' body has already begun to stink, is expressed by the slumped body of Lazarus and the vivid gestures of grief made by the mourners. Mary literally throws herself on the ground, her disheveled hair framing her face.[25] Christ responds to her grief and her plea. The only deviation from the text is the substitution of an arched tomb for the cave mentioned in John 11:38.

The Alcaudete carver thus dramatizes the moment of greatest pathos in the Raising of Lazarus cycle. Mary's unrestrained grief is conveyed through traditional gestures of lament,[26] and her dramatic figure presents a striking contrast to the decorous pose of the kneeling, veiled woman seen on Roman sarcophagi. Mary's grief is matched by her faith, and Christ's affirming gesture toward her, silhouetted against the negative space in the center of the composition, assures the coming victory

12

over death. On the same axis directly below, and also isolated within a spatial caesura, another sign of God's miraculous deliverance is presented. David, armed only with a sling, has defeated the champion of the Philistines and is decapitating the giant with his own sword. Here again the biblical text rather than the Roman pictorial tradition or a manuscript model is followed, including the reaction of the Philistine soldiers: "And when the Philistines saw that their champion was dead, they fled" (1 Samuel 14:41). Daniel likewise sits amidst the lions in a cave-like "den" corresponding directly to the text (Daniel 6:16). All three scenes, in short, seem to be a fresh response to the biblical text rather than a copy or adaptation of existing visual models.

In weighing the possibilities, we need to take into account the situation of the Alcaudete carver. As far as we can tell, he did not belong to an established workshop with a ready body of pictorial compositions to borrow and adapt to a client's requirements.[27] He wished to emulate a prestigious type of funerary monument of the previous century, the Roman double-frieze sarcophagus, but drew upon his own exegetical skills to invent pictorial equivalents for themes known from the Gospel texts. A carver, using a working procedure similar to that of Sedulius and the other Early Christian poets who wrote verse paraphrases of the Bible, could select and amplify aspects of the story to convey his own visual interpretation. In a situation where artisans are experimenting with unfamiliar artistic forms, I would argue, we should be willing to recognize not only imaginative recombinations of motifs and scenes but also fresh visual interpretations of familiar biblical stories.

I hope with this offering to pay tribute to Ilene Forsyth's willingness to consider medieval artisans as intelligent craftsmen, concerned both with the practical workshop aspects of getting the job done and with sensitive interpretation of the visual message to be conveyed. In writing this essay, I have benefited greatly from discussions with Kim Bowes and Pamela Sheingorn. It would not have been possible without the resources of the Index of Christian Art.

1 Madrid, Museo Arqueológico Nacional, 309. Carved of local gray stone; greatest preserved height, 56 cm; length, 124 cm.

2 Helmut Schlunk, "Die Sarkophage von Ecija und Alcaudete," *Madrider Mitteilungen* 3 (1962), 132–45, fig. 4, pls. 28–35, 41; Helmut Schlunk and Theodor Hauschild, *Die Denkmäler der frühchristlichen und westgotischen Zeit* (Mainz, 1978), 22, 152–53, pl. 45; *The Art of Medieval Spain, A.D. 500–1200*, exh. cat (New York, 1993), 46, no. 2, figure. The dating is uncertain; Schlunk places the sarcophagus generally in the fifth or sixth century.

3 For an introduction to this literary genre, see Michael Roberts, *Biblical Epic and Rhetorical Paraphrase in Late Antiquity* (Liverpool, 1985).

12

4 Schlunk and Hauschild, *Denkmäler*, 152. Schlunk assumes that the tomb of Lazarus marks the left boundary of the upper zone and that the lower zone was equal in height to the upper. He places the Daniel scene in the center of the lower zone.

5 About forty sarcophagi imported from Rome are still extant in Spain and Portugal. See Manuel Sotomayor, *Sarcofagos romano-cristianos de España: Estudio iconográfico* (Granada, 1975). Schlunk provides a very useful map showing the locations of imported and locally produced Early Christian sarcophagi in Spain (Schlunk, "Sarkophage," fig. 1; Schlunk and Hauschild, *Denkmäler*, fig. 11).

6 *Repertorium der christlich-antiken Sarkophage*, 1. *Rom und Ostia*, ed. Giuseppe Bovini and Hugo Brandenburg (Wiesbaden, 1967), 37–38, no. 42, pl. 13.

7 J. Stevenson, *The Catacombs: Rediscovered Monuments of Early Christianity* (London, 1978), 78–80, 92–93.

8 André Grabar, *Christian Iconography: A Study of Its Origins* (Princeton, 1968), 7–14.

9 For the chronological problems posed by extant funerary prayer texts, see P. Corbey Finney, *The Invisible God: The Earliest Christians on Art* (New York, 1994), 282–86.

10 Schlunk, "Sarkophage," 119–32, 145–48, pls. 23–26, 39–40; Schlunk and Hauschild, *Denkmäler*, 22, 150–51, fig. 12, pls. 42–43.

11 Note also the very distinctive framed inscriptions on the Ecija sarcophagus.

12 Schlunk interprets the curving border around the Daniel scene as part of a medallion at the center of the lower zone of the sarcophagus front, but it may simply have outlined the curving walls of a cave.

13 Theodor Klauser, *Frühchristliche Sarkophage in Bild und Wort* (Olten, 1966), 41, pl. 29 (cover).

14 As Schlunk points out ("Sarkophage," 139), one of the Dura Europos baptistery frescoes depicts the same moment. See Carl H. Kraeling, *The Excavations at Dura-Europos: The Christian Building* (New Haven, 1967), 69–71, 212–13, pls. XXII, XLI.

15 See also Robert Darmstaedter, *Die Auferweckung des Lazarus in der altchristlichen und byzantinischen Kunst* (Bern, 1955); Jan Partyka, *La résurrection de Lazare dans les monuments funéraires des nécropoles chrétiennes à Rome* (Warsaw, 1993). Fred C. Albertson, "An Isiac Model for the Raising of Lazarus in Early Christian Art," *Jahrbuch für Antike und Christentum* 38 (1995), 124–27, gives a convenient summary of the basic types.

16 Kurt Weitzmann, *Illustrations in Roll and Codex: A Study of the Origin and Method of Text Illustration* (Princeton, 1947). See also the essays in *The Place of Book Illumination in Byzantine Art* (Princeton, 1975).

17 Rossano, Cathedral, fol. 1r. Kurt Weitzmann, *Late Antique and Early Christian Book Illumination* (London, 1977), color pl. 29.

18 It is always possible that a second episode of the Lazarus story occupied the missing upper right half of the Alcaudete sarcophagus.

19 Biblioteca Apostolica Vaticana, Vat. lat. 5729, fol. 369r. Wilhelm Neuss, *Die katalanische Bibelillustration* (Bonn, 1922), 121–22, fig. 145.

20 Antwerp, Museum Plantin-Moretus, M.17.4, fol. 30v. This manuscript is thought to be a Carolingian copy of an Early Christian exemplar. See Carol Lewine, "The Miniatures of the Antwerp Sedulius Manuscript: The Early Christian Models and Their Transformations" (Ph.D. diss., Columbia University, 1970), 163–69, fig. 12.

21 In Early Christian art, it is very unusual to show Lazarus in a sarcophagus. Lazarus' body is shown reclining in a sarcophagus in a fresco in an Early Christian hypogeum at Thessaloniki. See Theocharis Pazaras, "Two Early Christian Tombs from the Western Cemetery at Thessaloniki," *Makedonika* 21 (1981), 386–87 (in Greek with English summary).

22 *Carmen Paschale*, 4.271–90, ed. J. Huemer, *Sedulii opera omnia*, CSEL 10 (Vienna, 1885), 109–11.

23 For analysis of the literary strategies employed by Sedulius in general, see Roberts, *Biblical Epic*, passim, and for this passage, 112–13, 142, 166–69; and Carl P. E. Springer, *The Gospel as Epic in Late Antiquity: The Paschale Carmen of Sedulius* (Leiden, 1988), 1–22, and for this passage, 116 n. 5.

24 This is in contrast to the standard Roman representation of the scene, which departs strongly from the text. For the significance of Christ's wand, one of the most obvious additions, see the chapter, "The Magician," in Thomas F. Mathews, *The Clash of Gods: A Reinterpretation of Early Christian Art* (Princeton, 1993), 54–91.

25 Henry Maguire, "The Depiction of Sorrow in Middle Byzantine Art," *Dumbarton Oaks Papers* 31 (1977), 123–74, traces the gestures of the hand raised to the head and the hands clasped together; he includes examples of "unbound hair" but not of the totally prostrate figure.

26 Cf. Margaret Alexiou, *The Ritual Lament in Greek Tradition* (Cambridge, 1974).

12

27 Note the similar freedom from standard pictorial types in the Bureba sarcophagus group, also produced by local Iberian carvers. The scene of the Vision of Perpetua, convincingly identified by Schlunk, has no known Early Christian visual parallels. See Helmut Schlunk, "Zu den frühchristlichen Sarkophagen aus der Bureba," *Madrider Mitteilungen* 6 (1965), 139–66; Schlunk and Hauschild, *Denkmäler*, 21, 141–42, pl. 35.

Narrative

"[T]he history of narrative art is indeed but a series of repeated attempts to smuggle the time factor into a medium which by definition lacks the dimension of time."[1] The words are Otto Pächt's (1902–88). A member of the "New Vienna School" between the wars, Pächt completed a dissertation on narrative in medieval art in 1925 and returned to the topic in 1962, offering then an examination of the dramatized narrative modes that emerged in the twelfth century. To analyze the means and ends of pictorial narration is a core art-historical task. As early as 1895, in a landmark study, Franz Wickhoff (1853–1909), a member of the first Vienna School, submitted to scrutiny the episodic biblical narratives in the sixth-century Vienna Genesis. Seeking to situate the late antique cycle historically, he concluded that "pictorial art has only three ways of telling a story" and suggested that these emerged in antiquity in this sequence: 1) "complementary," in which events before and after a key event are indicated without repetition of characters; 2) "isolating," in which a single decisive moment is represented; and 3) "continuous," in which successive episodes are represented and central characters repeated in a continuous space.[2] Such schemes now seem less enlightening, perhaps, than probing analyses of individual instances. When Pächt examines pictorial structures—when he observes, for example, that paired scenes in a given hagiographical cycle "explain each other mutually in so far as they appear to be interlocked like question and answer"[3]—he makes the kind of observation that captures our attention today.

Recent developments across the disciplines have given prominence to the study of verbal and visual narrative: fed by semiotic and structuralist theory, narratology has emerged as a veritable subdiscipline.[4] Pictorial narratives, like verbal, are analyzed as offering structured representations of events occurring in time—past, present, and future. And yet there is this obvious difference: while words are normally received in sequences determined by the author, pictures are apprehended along visual paths determined by the viewer, or largely so. Through the disposition of forms and figures, it is seen, the pictorial narrator exerts a measure of control over reception and encourages viewers to construct particular readings of stories—even readings at variance with the written texts on which the pictures sometimes depend. The following four essays take multi-scenic narratives as their object of study and show how analysis of the temporal dimension of depictions can expand into discussion of audience reception and serve as a springboard for inquiry into broader cultural issues.

Harvey Stahl, calling attention to the visual echoes and inversions that generate relations among forms and figures within and among the sixteen panels of the bronze doors of Hildesheim, demonstrates how the work effectively instructs the viewer in its

own reading. Introducing the Ottonian taste for the plays of Terence into his discussion, he probes the protagonists' emotional depth and shows how the cycle effectively moves beyond a typological model to embrace a devotional one. Elizabeth C. Parker analyzes the opening images of the Anglo-Saxon *Liber vitae*, the first of which records the event of Queen Emma and King Cnut donating a relic-bearing cross to the monks at Winchester. Like Stahl, Parker suggests that there would have been special meanings for the visually literate: she shows how allusive motifs in the frontispiece may have prompted viewers to associate the royal couple with Helena and Constantine, givers of the prototypical True Cross.

Cynthia Hahn and Charles T. Little turn to twelfth-century hagiographical cycles, namely, a life of Valerie on one face of a reliquary chasse made in Limoges and scenes commemorating the martyrdom of Thomas Becket on the two sides of an ivory liturgical comb produced at Canterbury. Broad experience with saints' lives, both authors suggest, would have ensured that medieval viewers could recognize the typical and exceptional in these cycles. When, on the Valerie chasse, the expected left-right sequence was abandoned in favor of a chiastic structure, and specific visual alignments emerged as important, viewers would have been prepared to understand that stress was being placed on certain aspects of Valerie's saintly sacrifice. And when the carver of the ivory comb called attention to particular events in Becket's struggles, doing so with unusual fidelity to the earliest eyewitness accounts, viewers would have been ready to draw lessons about the sanctity and sovereignty of the church.

E. S.

1 Otto Pächt, *The Rise of Pictorial Narrative in Twelfth-Century England* (Oxford, 1962), 1. On Pächt's contributions, see Christopher S. Wood, introductions to Pächt, *The Practice of Art History: Reflections on Method* (London, 1999) and to *The Vienna School Reader: Politics and Art Historical Method in the 1930s* (New York, 2000).

2 Franz Wickhoff, *Die Wiener Genesis* (Vienna, 1895); trans. in part as *Roman Art: Some of Its Principles and Their Application to Early Christian Painting* (London, 1900), 13 and passim. Kurt Weitzmann, in *Illustrations in Roll and Codex: A Study of the Origin and Method of Text Illustration* (Princeton, 1947; 2d ed., 1970), 12–13, 33–36, took exception to Wickhoff's categories, identifying antiquity's three methods of rendering literary content as "simultaneous," "monoscenic," and "cyclic."

3 Pächt, *Rise of Pictorial Narrative*, 14.

4 For a summary, see Wolfgang Kemp, "Narrative," in *Critical Terms for Art History*, ed. Robert S. Nelson and Richard Shiff (Chicago, 1996), 58–69.

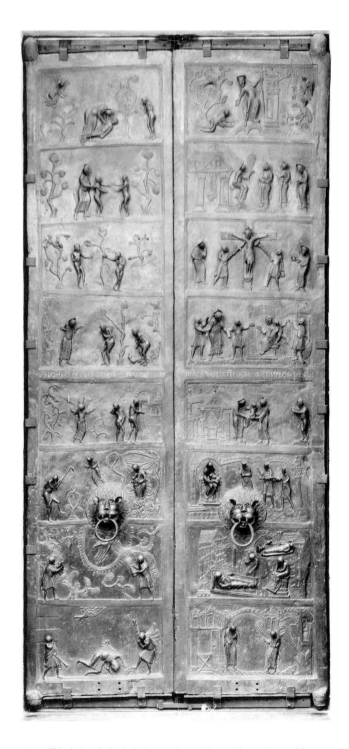

13.1. Hildesheim, Cathedral. Bronze doors. Photo: Hirmer Fotoarchiv.

13 Eve's Reach: A Note on Dramatic Elements in the Hildesheim Doors

Harvey Stahl

Of the sixteen panels on Abbot Bernward's famous bronze doors at Hildesheim, one of the most revealing is the second in the series. It illustrates the moment just after Eve has been created, when the Lord introduces her to Adam (Figs. 13.1, 13.2). In no other representation of this event do the unclothed figures of Adam and Eve approach each other with arms outstretched, about to touch. The relief describes the electrifying moment before the first human contact, and it suggests, in the way their bodies adjust and their arms reach out, that the next instant will bring a full embrace. Yet in spite of the exceptionally physical terms in which the event is pictured, no contact is actually made. The choice of this penultimate moment heightens the drama and has several secondary effects, for it is also a way of deferring contact, of thematizing expectation, of shaping a contingency that will play out in the other panels. It is an innovative maneuver, one that strengthens the thematic coherence of the doors and exemplifies the current interest in the dramatic potential of traditional forms and structures.

Innovation is a well-known attribute of these doors. Commissioned by Bishop Bernward of Hildesheim about 1012, probably for the western entrance to the cathedral at Hildesheim, they are the first large-scale sculptures in the lost wax technique since antiquity and the first historiated doors since the early Christian era.[1] Like many of the other works this important prelate commissioned, they are much indebted to the Roman and earlier medieval monuments that Bernward is likely to have seen on his several missions for emperor and church to such cities as Milan and Rome, Paris and Tours. Such costly and ambitious projects would have come naturally to a man who, as tutor to the future Otto III, was at court at the height of the so-called Ottonian Renaissance and whose ideas about ecclesiastical patronage were probably formed at Mainz under Archbishop Willigis.[2] His biographer, Thangmar, describes him as a collector and even a painter.[3] While there are precedents for the project of these doors and for many of their features, no preserved work of art accounts for two of its most remarkable aspects: its programmatic structure and its dramatic innovations. These need to be described before we return to the panel with Adam and Eve.[4]

13

At its most basic, the doors wed two ways of reading. One is vertical, historical, and progressive and follows from the way the sixteen panels are organized, with eight events from Genesis on the left valve and eight events from the Life of Christ on the right. Many earlier works pair Old and New Testament subjects, individually or in series, in order to show the relation between events before and after the advent of Christ. However, this seems to be the earliest extant work in which the two series of events move in opposite directions, with the Old Testament subjects beginning at the Creation and moving downward to the Fall of Man and the Murder of Abel, and the New Testament scenes proceeding upward from the Annunciation to the Ascension.[5] Both directions are sustained at the level of composition, action, and detail—for example, in the way the Creator bends down in the first panel or the murdered Abel falls over in the last, or in the high arches in the Infancy scenes and the diagonally rising movement of the Ascension. Since the events of one door literally decline into sin, while those of the other rise toward redemption, a chronological reading shows how the era of the New Testament implicitly reverses that of the Old. Fate unfolds in the movements we register on each door and within each panel.

The second axis of reading is horizontal, comparative, and figural; that is, each Old Testament event is construed in relation to its New Testament counterpart, which it antecedes and in which it is fulfilled. The relation hinges on some parallel—be it in situations, persons, objects, or actions—that enables each Old Testament event to be understood as a type, that is, to be interpreted allegorically as well as historically, in order to reveal its prophetic, moral, and salvational import.[6] Such typological relations are a commonplace in medieval exegesis as well as in medieval art, and the doors provide several clear examples, such as the juxtaposition of the Fall and the Crucifixion at the third level (Figs. 13.2, 13.3). Texts going back to Paul understood the Fall as a prefiguration of the Crucifixion, as showing how the sin in Eden is to be understood as a first death that was reversed only with Christ, the New Adam, whose death restored the possibility of redemption or eternal life.[7] The parallel arrangement of trees and figures underscores these correspondences, and the thematic inversion of death in life and life in death is characteristic of the rhetorical strategies such typologies employ. Yet few other pairings in these doors are so recognizable or, for that matter, have any historical basis in medieval exegesis. Even so, the formal and rhetorical relations we have just seen still apply, as do the concepts of Christian eschatology they express, only now these meanings depend less on a prior knowledge of types than on the ability to sort out the visual and narrative relations between opposed panels. To a degree rarely seen in earlier medieval art, those relations are dramatic.

Take for example the two panels at the fourth level where the Creator pronounces judgment against Adam and Eve, who deny their sins and blame each

Reading Medieval Images

other, and where Pilate condemns Christ.[8] There are evident parallels in the position of the Creator and Christ, in the narrative arrangement whereby arms and pointing gestures link figures across the space, and in the dominant themes of accusation and judgment. We are thus led to compare the panels, to see them as related events in a larger story, and to understand what new meanings they reveal when seen together. Their relation is clearly antithetical, for not only has the left/right direction been reversed but so have the roles of protagonist and antagonist and of accuser and accused. In a general sense, the inverse relation between the two panels reiterates the relation between the two eras of history and reinforces the larger programmatic relation between the doors. But in a narrower sense, their juxtaposition serves no typological or allegorical purpose, since one accusation or punishment is not reversed or fulfilled in the other.[9] Rather, it serves to focus more sharply the dramatic situation in each one and to call attention to the implicit ironies when they are seen together.[10]

This is especially clear in the two representations of the deity. In the left panel the Creator is freestanding and powerful. His shoulders and arms are raised, and his body is so drawn up in anger that he seems to stand on the balls of his feet. He leans forward and lowers his head so that his eye aligns behind his pointing finger and the full force of his sight and speech, mind and body is directed at Adam and Eve. In contrast, Christ in the opposite panel is captive and meek, his head bent and shoulders fallen. With his chest partially exposed and his arms held down, he cannot cover himself as Adam and Eve do but is vulnerable and compliant, a powerless link in the chain of arms that hold him before Pilate. These studies in body language bring us more deeply into the narrative of each door, for the Creator's anger follows from the sin of the Fall in the previous panel, just as Christ's resignation foreshadows his sacrifice on the Cross in the next one.[11] Together these panels not only reiterate the antithetical relation of the two eras of history but encourage reflection on guilt and innocence, acceptance and denial, betrayal and judgment. They create a structure of analogies and inversions that encourages the viewer to explore new relations: thus it becomes possible to understand Eve in the same negative terms as Pilate or to find, in these contrasting characterizations of the deity, a moving description of the humanity of Christ and the tragic reversal of fortune he suffers. What is surprising is the degree to which all of these readings hinge on the positioning of the figures and their body language.

A related aspect of this staging and body language pertains not to the figures at all but to the trees alongside them. In medieval art highly animated or luxuriant flora frequently function as signs of vitality or spiritual presence or as symbols of fertility or rebirth, their shapes and movements framing the visual field and clarifying the narrative.[12] This is also the case in these doors, but here, especially in the four scenes set in Paradise, the trees are just as legible and spatially prominent as

13

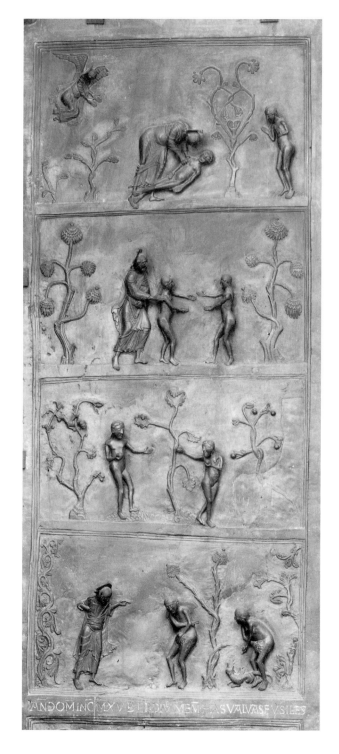

13.2. Hildesheim, Cathedral. Bronze doors: detail, left door, upper four panels. Photo: Hirmer Fotoarchiv.

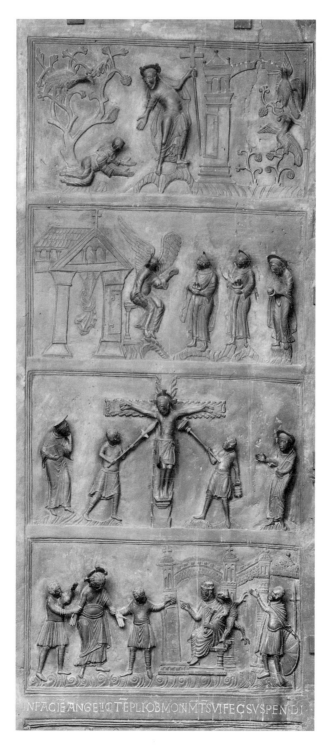

13.3. Hildesheim, Cathedral. Bronze doors: detail, right door, upper four panels. Photo: Hirmer Fotoarchiv.

the figures are and have flowers and branches that turn and reach like heads and arms. They stand alongside the figures, often in a one-to-one relation, miming their actions, giving form to their emotions, and reiterating what is thematically central. In the Creation, three plants, each at a different stage of growth (or is it one plant in three stages?), stand for the process of creation, with the third one suggesting, in its configuration of branches, the Creator and Eve in a final, upright position.[13] In the second panel, the lowest branch of each tree extends toward the center and up, gently urging the figures closer. The trees in the Fall are dry, shriveled, and skeletal, restating the theme of death in life referred to earlier. And in the fourth panel the vine at the left reaches upward in a series of taut reversing curves, reiterating the anger that wells up in the body of the Creator; in contrast, the branches of the trees at the right lean and cross and point, as the bodies and arms of Adam and Eve do. These practices involve more than the usual animism and metaphor, for these trees are construed bodily; they perform, sometimes enacting what the figures do not. They are thus able to enlarge the stage and extend the action, to address the viewer in a mediating voice, like a narrator or chorus, and to suggest how all creation participates in the drama of salvation.

The sources for these doors remain problematic. One knows of elaborate Carolingian programs comparing Old and New Testament events and of a few works in which flora are narratively and thematically critical.[14] But what is unusual in these doors is the way many scenes turn on the perception not just of action but of behavior, so that individual scenes can become, secondarily, an account of character in a specific situation, one that effectively personalizes the larger themes of sin and redemption. The latter is, of course, traditional in saints' lives, and attention to the individual dilemma was already familiar in Ottonian art's increasingly moving depictions of Christ's life and suffering.[15] But these interests generally do not extend to Old Testament narrative or produce such unforgettable figures as the angry Creator or the physically self-conscious and knowingly defiant Eve of the fourth panel. For such characterizations and for the resulting narrative charge, the most telling parallel I know is not in the visual arts at all but in Ottonian drama, specifically in the works written about a half-century earlier by Hrotsvitha of Gandersheim. Take for example *The Conversion of the Harlot Thais (Pafnutius)*, a play in rhymed rhythmic prose in which the hermit Pafnutius, intent on converting the whore Thais, visits her in the disguise of a lover.[16] She finds a pleasant room for them, but when Pafnutius asks for a more private place, she remarks that there is one so hidden that no one but God knows it. It soon becomes clear to Pafnutius that she recognizes God and thus practices her trade with full knowledge of its sinfulness. At this he explodes in anger. Thais asks him why he trembles, changes color, and cries, and he so forcefully tells her that she deserves damnation that his words "pierce her inner heart."[17] At this point she decides to repent, and so Pafnutius now

13

Reading Medieval Images

takes her to a truly private place—a cell in a nunnery—where for three years she must suffer the stench of her own bodily functions. Just before her death, Pafnutius leads her out of her cell and tells her she will find heavenly bliss. In their final speeches, she explains how everything on Earth—even the least sprout or bush or the waterfall's rush—should praise God, who rewards the penitent, and Pafnutius responds with how all of creation returns to Him in the resurrection. As we shall see, both sentiments, though commonplace, figure in the two uppermost panels of the doors.

Such plays can hardly have been a direct source or influence on these doors, but they are indicative, I believe, of the circulation of certain dramatic forms and interests that may have also been familiar to the artists and perhaps the audience of the doors. Although Hrotsvitha was of an earlier generation than Bernward and there is no evidence that he either read her plays or attended a reading of them, the great poetess was still alive during the first decade of Bernward's episcopate and during much of the controversy with Gandersheim that brought him often to that royal nunnery.[18] More importantly, both were educated in the highest intellectual circles of the Saxon court, one in which ancient Roman literature was familiar reading. As Hrotsvitha herself explains in one of her prefaces, her plays imitate the then currently admired style of Terence but adapt it to Christian themes.[19] Although her purpose could hardly be more different from Terence's, many of her structural and rhetorical forms and dramatic devices derive from his work.[20] Of particular interest to us is the way she developed themes through dual sets of characters that are sharply delineated in dialogue, description, and action, her extensive use of analogous situations and plot reversals, and the way her stories illustrate how God's grace makes possible the triumph over sin. It is also relevant that many of the situations in her plays are strikingly visual and that at least one of her plays may have incorporated narrative illustrations.[21] Finally, the kind of two-part structure we see in the doors seems also to have shaped the way the poetess organized her seven legends and seven plays, for there are continuities in plot and in thematic groupings within each genre and, at the same time, clear correspondences and often reversals in theme and ideas between each pair of legends and plays.[22] Dronke, citing the Hildesheim doors as a later parallel, describes the overall structure of Hrotsvitha's work as "the boldest and most elaborate compositional design in Carolingian or Ottonian literature and art, at least as far as surviving monuments go."[23] For us, her work clearly indicates a taste for more dramatically moving techniques of narrative that center upon character types in opposition, highly charged dialogue, and clearly drawn moral predicaments. It also indicates an ability to apply these principles to new subjects and to arrange them in an intricate program showing the workings of redemption.

With these structures in mind, let us return to the second panel (Figs. 13.2, **13**

13.3). Having just created Eve, the Lord now "brought her to Adam," who says, "This now is bone of my bones, and flesh of my flesh." (Genesis 2:22–23). We are not told how the Lord brought Eve to Adam or what their reaction to each other was. The relevant iconographic tradition has the Lord holding the stiff figure of Eve at the shoulder and almost pushing her forward, as Adam addresses her with an oratorical gesture.[24] At Hildesheim, body language and composition suggest complex shades of intent. The Creator steps boldly forward but gently urges Eve on, touching her right shoulder only with the tips of his fingers. Adam and Eve approach each other with arms outstretched, their legs forward and back in complementary positions. Eve leans slightly to one side, her left hand a bit lower than Adam's, as if she were positioning herself for an embrace. With the Creator and even the trees urging them on, their embrace seems inevitable. Yet in contrast to the Creator, who leans forward, his dynamic body in a gliding turn, Eve is still a bit stiff, her steps small, and alongside the pointing branches there are others that oddly droop. Moreover, Adam and Eve, like the trees, are distinctly upright, so that the composition is one of strong verticals and horizontals, with none of the rhythmic relations or physical tension between figures that we see in the previous or following panels. One is tempted to explain these details as the natural awkwardness of figures who are just created and do not know each other, or as an anticipation of the Fall in the next panel, but what remains most striking and pictorially operative is the central, dominant shaft of space between the figures. For all of the promise of embrace, there is much keeping them apart and postponing their union.

Their union is implied in the next verse of Genesis ("and they shall be two in one flesh," 2:24). However tentative the panel's suggestion of union in a carnal sense, their union in the allegorical sense was necessary, even essential, for typologically this meeting of Adam and Eve can be understood as anticipating the marriage of Christ and his Church; their desire for each other, expressed by their outstretched arms, is a confirmation of spiritual love, like that of the lovers in the Song of Songs.[25] So strong is this interpretation of the episode that one writer has labeled the panel "The Marriage of the First Parents."[26] As we have seen, this kind of typological reading applies to other panels in the doors and to the general relation of its two parts, but the interpretation does not fit the opposite panel of the Women at the Tomb, and it does not take account of the hesitation, the backward pull that makes the Adam and Eve panel so absorbing. Indeed, the next two panels in the series show just how critical that contrarian tension is because in each of them the space between the figures increases. It can be no coincidence that the previous panel of the Creation is the only one in which figures are intimately joined at the center and that in each subsequent panel of the left door, the field broadens until, at the bottom, the two figures of Cain stand at its lateral edges. The space between the figures in this second panel is thus linked to the extreme separation between them in the

13

———

Reading Medieval Images

fourth. When the first four panels are seen as a group, the fourth is clearly the turning point: Adam and Eve may be expelled from Paradise in the next panel, but they are rejected in this one. In the same way, the second panel is a critical transition, the place we first suspect the failings to come in the rest of the panels of the door.

It is precisely the lack of contact in the second panel that most affects the drama of the opposite panel, the Women at the Tomb. Here, as before, two subjects not normally linked in typology are brought together because the dramatic situation is reversed.[27] The left and right panels both center on expectation, the anticipation of meeting, but instead of moving toward each other, like Adam and Eve, the women are halted and find only the angel and the knotted temple curtain, that is, only signs Christ is not there. The interpretation of the right panel is very much controlled by the one on the left. If Adam were addressing Eve, as in the Carolingian works, the emphasis would be on the angel's gesture, on how the women are informed; and if Adam and Eve embraced, the right panel would be about their frustration, the lack of physical closure. But since Adam and Eve are always about to touch, since contact is continuously deferred, the women keep searching. Because of the left panel, we are made to focus on the nature of what is in abeyance, on the calculus of the next step, on the quality of contingency that is created. The panel presents a condition of permanent referral, which ends only as attention is directed elsewhere, from this panel to the next.

True to form, the next scene, the Noli me tangere, which is supposed to be about not touching, is really about the opposite. This top panel combines the Noli me tangere with the Ascension, for the risen Christ strides upward, carrying a triumphal cross, even as he turns back to the kneeling Mary Magdalene, who extends her hands to touch him. Rather than ordering her to keep away, he bends toward her and extends his right hand, palm outward, in a manner identical to the way the Lord extends his large right hand to Abel to accept his sacrifice. In this case the gesture invites Mary Magdalene to follow. The salvific overtones are clear enough. The city walls and gate at the right recall the gate of Paradise in the scene of the Expulsion. The hardened and almost lifeless tree at the left, with its passive bird, contrasts with the youthful budding trees and the exuberant birds spreading their wings within the city walls. They are almost certainly eagles, for not only do they resemble the symbol of John in an illumination in Bernward's own Gospel Book, but in the latter the eagle again appears in relation to the Ascension.[28] It can do so because the eagle was believed to be able to soar to heaven and behold the divinity.[29] In contrast, the passive eagle at the left, in a tree that most recalls the barren ones in the panel of the Fall, has not taken flight, nor do Mary Magdalene's hands even come close to the body of Christ. This non-contact is again critical, especially in comparison to the presentation of the same subject in Bernward's own Gospel Book.[30] There the Magdalene touches Christ's feet as he stands enclosed in a man-

13

dorla. Although seemingly contrary to the account in the Gospels, the miniature, as Deshman has shown, illustrates a line of commentary holding that the Magdalene's contact with Christ was not possible until she could fully see his divinity; in the miniature, the mandorla of light shows that she did.[31] In the Hildesheim panel, however, the Magdalene hardly looks up. Like the eagle and tree, she is still outside the gates of Jerusalem. The victorious Christ beckons her to follow, to leave the old world behind.

The interpretation of Bernward's Gospel Book is consistent with the contemporary view that the Magdalene was the first to believe in Christ and to proclaim his resurrection. In commentary and in contemporary sermons she was understood to be the reverse of Eve: whereas Eve announced death, the Magdalene, like the Virgin Mary, announced life. Also like the Virgin, the Magdalene was identified with the Church and, because of her penitence, with the progress of the faithful toward the Heavenly Jerusalem.[32] This interpretation of the Magdalene not only explains the combination of the Noli me tangere with the Ascension but the juxtaposition of this last panel with the first one of the Creation.[33] The two complement and reverse each other in numerous ways. Each has a diagonally rising composition, but the positions of the two central figures are inverted, with Christ now erect and moving upward and the Magdalene—the counterpart of a figure who must be Eve—facing down.[34] The trees, which had increased in size, now diminish. This same kind of left-right reversal is also to be seen in the flying angel and eagles in Paradise and, beside the larger trees, in the quietly observant Adam and eagle. If Christ invites Mary Magdalene to follow, it is in some measure as the New Eve being beckoned into a New Paradise.

This final panel then, like the second with Adam and Eve, is still about touch. The relation between touch and faith goes back to Augustine and is an important factor in Bernward's Gospels and in his doors.[35] In fact, the two upper panels of each door create a tight narrative circuit in which the viewer pursues the restoration of the intimate contact seen in the first panel. In the figurative logic of these panels, Eve's reaching for Adam makes it possible for the Magdalene to follow Christ. But once again contact with him is not actually shown. As a single depiction of the Noli me tangere, one would hardly expect it to be, but in the context of this circuit of panels, not doing so is a most remarkable way of ending the cycle, for it effectively opens up the narrative to include the viewer. Standing before the doors, at the entrance to the western block of the church known as the "Paradise," the viewer is placed in the same position as the Magdalene is. For both, the next step requires passing through a set of doors. Real contact, which is to say, redemption, lies inside.[36]

13

———

1 For a recent overview of the doors, with extensive bibliography, see Rainer Kahsnitz, "Bronzetüren im Dom," in *Bernward von Hildesheim und das Zeitalter der Ottonen*, ed. Michael Brandt and Arne Eggebrecht, exh. cat., 2 vols. (Hildesheim, 1993), 2:503–12. For Bernward, see Hans Jakob Schuffels, "Bernward Bischof von Hildesheim: Eine biographische Skizze," in ibid., 1:29–43; the best introduction to Bernward in English is still Francis J. Tschan, *Saint Bernward of Hildesheim*, 3 vols. (Notre Dame, 1942–52). For detailed photographs, see Rudolf Wesenberg, *Bernwardinische Plastik: Zur ottonischen Kunst unter Bischof Bernward von Hildesheim* (Berlin, 1955), and Ursula Mende, *Die Bronzetüren des Mittelalters, 800–1200* (Munich, 1994).

2 Tschan, *Saint Bernward*, vol.1, ch. 3. I have been unable to consult Josef Nowak, *Willigis, Domherr zu Hildesheim, Erzbischof von Mainz* (Hildesheim, 1985).

3 Translated extracts in Caecilia Davis-Weyer, *Early Medieval Art, 300–1150* (Englewood Cliffs, NJ, 1971), 122–23. The praise of Bernward's artistic skills may be a rhetorical flourish.

4 The following discussion is much indebted to the studies of several authors, especially Franz Dibelius, *Die Bernwardstür zu Hildesheim* (Strassburg, 1907); Wesenberg, *Bernwardinische Plastik*; Bernhard Gallistl, "Die Tür des Bischofs Bernward und ihr ikonographisches Programm," in *Le porte di bronzo dall'antichità al secolo XIII*, ed. Salvatorino Salomi (Rome, 1990), 145–81.

5 Following this order, the subjects are 1) Creation, 2) Introduction of Eve to Adam, 3) Fall, 4) Denial of Guilt and Judgment, 5) Expulsion, 6) Labor of Adam and Eve, 7) Sacrifice of Cain and Abel, 8) Slaying of Abel and Curse of Cain, 9) Annunciation, 10) Nativity, 11) Adoration of the Kings, 12) Presentation in the Temple, 13) Christ before Pilate, 14) Crucifixion, 15) Women at the Tomb, and 14) Noli me tangere.

6 The most cogent discussion of the intellectual construct remains Erich Auerbach, "Figura," in *Scenes from the Drama of European Literature: Six Essays* (New York, 1959), 11–76; for the Middle Ages, see Henri de Lubac, *Exégèse médiévale: Les quatre sens de l'écriture* (Paris, 1959).

7 1 Corinthians 5:22; Romans 5.

8 The left panel combines two events, Adam transferring the blame to Eve who in turn blames the serpent (Genesis 3:11–13), and the Creator cursing all three (Genesis 3:14–19). These events have also been referred to as the "trial," "judgment," or "reproval" of Adam and Eve; see Kahsnitz, "Bronzetüren im Dom," 506, and Herbert L. Kessler, *The Illustrated Bibles from Tours* (Princeton, 1977), 19–20.

9 Gallistl, "Die Tür," 170, cites a passage comparing the two events by the fifth-century Syrian, Jacob of Sarug, though it is very unlikely that the text was known at Hildesheim at this time.

10 Typology was traditionally understood in rhetorical as well as doctrinal terms; for a discussion of both aspects of typology in another work of Ottonian art, see Christopher Hughes, "Visual Typology: An Ottonian Example," *Word & Image* 17 (2001), 185–98. For these panels, see also Gerd Bauer, "Bemerkungen zur Bernwards-Tür," *Niederdeutsche Beiträge zur Kunstgeschichte* 19 (1980), 24–26. For Early Christian precedents, Caecilia Davis-Weyer, "Komposition und Szenenwahl im Dittochaeum des Prudentius," *Studien zur spätantiken und byzantinischen Kunst: Friedrich Wilhelm Deichmann gewidmet*, 3 vols. (Bonn, 1986), 3:19–29.

11 The latter is also suggested by such details as the way Christ's bare arms are held stiffly out.

12 While there are studies of particular monuments, I know of none addressing the general phenomenon. For Ottonian illumination, see, however, the discussion of ornament in Hans Jantzen, *Ottonische Kunst* (Hamburg, 1959), 98–104. For the plants in the doors, see the resumé in Ursula Storm, *Die Bronzetüren Bernwards zu Hildesheim* (Berlin, 1966), 66–68.

13 On the identity of the figure being formed in this panel, see below, n. 34.

14 Especially relevant may have been the lost Carolingian frescoes at Ingelheim, which Walther Lammers convincingly reconstructs with Old and New Testament scenes opposing each other and read in opposite directions, "Ein karolingisches Bildprogramm in der Aula Regia von Ingelheim," in *Festschrift für Hermann Heimpel*, Veröffentlichungen des Max-Planck-Instituts für Geschichte, 36/3 (Göttingen, 1971), 254 and table 2. For the trees, see, for example, the remarkable tenth-century ivory of the Women at the Tomb recently acquired by the Metropolitan Museum of Art, described by Charles T. Little in *Mirror of the Medieval World*, ed. William Wixom, exh. cat. (New York, 1999), 57–58. There the most forward figure of the women kneels and, in apparent disregard of the angel and the tomb, gestures toward a budding tree. The ivory was apparently in Germany in the eleventh century.

15 Henry Mayr-Harting, *Ottonian Book Illumination: An Historical Study*, 2 vols. (London, 1991), vol. 1, ch. 2, esp. 82–104.

16 *Hrotsvithae opera*, ed. Paul von Winterfeld (Berlin, 1902; rpt. Munich, 1978), 162–80; trans. Katharina Wilson, *The Plays of Hrotsvit of Gandersheim* (New York, 1989), 93–122. For an excellent, brief introduction to her work, see Peter Dronke, *Women Writers of the Middle Ages* (Cambridge, 1984), ch. 3.

13

Eve's Reach

17 Winterfeld, 170, ll. 26–27: "Severitas tuae correptionis / concussit penetral pavidi cordis."

18 There is no firm evidence that her plays were fully staged, and most recent writers believe they were read aloud and possibly mimed. See Dronke, *Women Writers*, 57–59; Sandro Sticca, "Sacred Drama and Tragic Realism in Hrotswitha's *Paphnutius*," in *The Theatre in the Middle Ages*, ed. Herman Braet et al. (Leuven, 1985), 15–20; and Katharina M. Wilson, *Hrotsvit of Gandersheim: The Ethics of Authorial Stance* (Leiden, 1988), 105–6. For the dispute over Gandersheim, which involved a younger generation of canonesses and lasted to 1007, or about five years after the presumed date of Hrotsvitha's death, see Tschan, *Saint Bernward*, vol. 1, chs. 13–14, and Hans Goetting, "Bernward und der große Gandersheimer Streit," in *Bernward von Hildesheim* (as n. 1), 1:275–82. The absence of any mention of the Hildesheim bishops in Hrotsvitha's history of Gandersheim Abbey (*Primordia Coenobii Gandeshemensis*) has been sometimes interpreted to indicate that she actively sided against Hildesheim in the dispute; see Wilson, *Hrotsvit of Gandersheim*, 130–31.

19 Winterfeld, 106–7; Wilson, 3–4.

20 For a detailed discussion of the influence of Terence and his late Roman commentators, see Wilson, *Hrotswit of Gandersheim*, chs. 3–4, who argues that the author tried to make her plays "as classical and as Terentian as possible" (57). In spite of the figures representing moral types, Wilson shows that they do not lack for dynamism and are involved in complex dramatic and moral situations in which the technical prerequisites of drama—*mise-en-scène*, action, dialogue, and impersonation—are richly developed (see esp. 67–72). Dialogue and dramatic devices are also emphasized in Judith Tarr, "Terentian Elements in Hrotsvit," in *Hrotsvit of Gandersheim: Rara Avis in Saxonia*, ed. Katharina M. Wilson (Ann Arbor, 1987), 55–62.

21 On costume and other visual elements, see Dronke, *Women Writers*, 58–59, and Wilson, *Hrotsvit of Gandersheim*, 63. Also noteworthy are the many vivid physical characterizations, such as the "haughty still unbent neck" (*Ac tractim rigida necnon cervice superba / Incedens*) of one of Gongolfus' soldiers or "the darting eyes and pest-breathing lips" of his unworthy wife (*Intorquens oculos subdola sanguineos, / Exagitat caput indomitum impatienter in illum / Et latrat rostro talia pestifero*); see *Gongolfus*, ll. 181–82, 564–66 (Winterfeld, 40, 50). Helena Homeyer, *Hrotsvithae opera* (Munich, 1970), 376, and others have suggested that her *Vision of St. John* is organized with reference to a series of twelve scenes illustrating the Apocalypse. The principal evidence for this assertion derives from the way the poem's brief thirty-five lines summarize events from the Apocalypse and frequently use words such as *hic* and *ecce*, suggesting that the lines are *tituli* referring to a series of scenes in some medium. Dronke, *Women Writers*, 62–63, points out that although the text is not in dialogue, the events might have been performed. To my mind,

the subjects and structure of the *St. John* are consistent with visual tradition at the time.

22 See Hugo Kuhn, "Hrotsvit von Gandersheim dichterisches Programm," *Deutsche Vierteljahrschrift* 24 (1950), 181–96; Dronke, *Women Writers*, 60–63; and Wilson, *Hrotsvit of Gandersheim*, 16–27; although all three authors agree on the basic relationships, I here follow the seven-part schema in Dronke, 60, who treats the *Maria – Ascensio* as a unit analogous to *Gallicanus* I–II. The correspondences and reversals can readily be seen in *Pafnutius*. For example, both it and the preceding play of *Abraham* involve hermits who travel in disguise to save harlots, the central event of conversion occurs in a brothel, and each woman gives up her worldly possessions and finds forgiveness through penitence while isolated in a cell. However, there are important differences in the ages of the two women, in their behavior, and in what motivates their conversion. In addition, the events involving the younger woman, who is seduced and then regains her purity, are framed by Abraham's conversation with his co-hermit at the beginning and end of the play, whereas *Pafnutius* begins by his discussing cosmic harmony with his disciples and ends with his exchange on effectively the same subject with the older and more complex Thais. In contrast, *Basilius*, the legend that is the counterpart to *Pafnutius*, involves the fall and conversion of a man. Many elements are again analogous, but one of the principal differences, apart from the gender reversals, is that Basilius is a bishop and so the process of redemption, which unfolds in an ecclesiastical rather than a monastic setting, has a very different character. For a close reading of the action in *Pafnutius* and its implications, see Sticca, "Sacred Drama," esp. 20–33, and Ferruccio Bertini, "Simbologia e struttura drammatica nel *Gallicanus* e nel *Pafnutius* di Rosvita," in *The Theatre in the Middle Ages* (as n. 18), esp. 53–59.

23 Dronke, *Women Writers*, 64. The two-part structure may also have influenced the internal structure of the *Pafnutius*, which Charlotte Thompson, "Paphnutius and the Cultural Vision," in *Hrotsvit* (as n. 20), 112–25, has interpreted as having the same kind of graded descent to death and rise in analogous stages to redemption that we have seen in these doors (cf. her diagram of the play's structure, 112). Thompson interprets this structure in explicitly visual terms and makes reference to works of art, including the Hildesheim doors, but finds the more abstract, Byzantinizing style of Ottonian illumination to offer a better pictorial analogy to the structure of the play, which she describes as a "speaking picture" (114–15).

24 The similarity of these Old Testament scenes to those in the Touronian Bibles and the so-called Cotton Genesis tradition has long been recognized; for its relation to this panel, see Dibelius, *Bernwardstür*, 13–16, and Kessler, *The Illustrated Bibles from Tours*, 17–18, figs. 1–3, 5. As Dibelius points out, a noteworthy variant appears in the Carolingian Bible of San Paolo fuori le mura (Kessler, fig. 4), where Eve leans back to the Creator but Adam stands just before her with lowered arms and opened hands. Eve's own hands, still by her side, seem to open in response.

13

25 Gallistl, "Tür," 152; idem, *Die Bronzetüren Bischof Bernwards im Dom zu Hildesheim* (Freiburg, 1990), 20–22.

26 Gallistl, "Tür," 152.

27 Gallistl (ibid., 175) interprets this episode typologically with reference to a commentary on the Song of Songs by the early third-century theologian Hippolytus of Rome, a text unlikely to be known in eleventh-century Hildesheim.

28 Hildesheim, Dom and Diözesanmuseum Hildesheim, DS. 18, fol. 175r. See Rainer Kahsnitz, "Inhalt und Aufbau der Handschrift: Die Bilder," in *Das kostbare Evangeliar des Heiligen Bernward* (Munich, 1993), 49, pl. 29; *Bernward von Hildesheim* (as n. 1), vol. 2, no. VIII–30; Robert Deshman, "Another Look at the Disappearing Christ: Corporeal and Spiritual Vision in Early Medieval Images," *Art Bulletin* 79 (1997), 537–39, fig. 8.

29 Ibid., 538.

30 Kahsnitz, "Inhalt und Aufbau," 38–39, pl. 15; Deshman, "Another Look," fig. 20.

31 Ibid., 537.

32 For the often repeated juxtaposition between Eve and the Magdalene and for Mary Magdalene as an example of penitence to all, see Gregory the Great, *XL Homiliae in evangelia*, Homilia 25 (PL 76, 1194B, 1196B); for the former, see also Alcuin, *Commentaria in sancti Ioannis evangelium*, 41 (PL 100, 992A). For the Magdalene as an example of faith, see Pseudo-Odo of Cluny, *Sermo 2, In veneratione sanctae Mariae Magdalenae* (PL 133, 719A, 720C). The latter was written between the ninth and eleventh century and was the preferred text for the monastic office of the feast of Mary Magdalene; see Dominique Iogna-Prat, "'Bienheureuse Polysémie': La Madeleine du *Sermo in ueneratione sanctae Mariae Magdalenae* attribué à Odon de Cluny," in *Marie Madeleine dans la mystique, les arts et les lettres*, Actes du colloque international (Avignon 20–21–22 juillet 1988), ed. Eve Duperray (Paris, 1989), 21–31, who finds that the Magdalene was a link between Eve and Mary especially from the Carolingian period. A section of a hymn to Mary Magdalene attributed to the same author is highly suggestive of the panel: "Surgentem cum victoria / Jesum vidit ab inferis: / Prima meretur gaudia, / Quae plus ardebit caeteris" (PL 133, 515A).

33 Although there are very early visual precedents for the combination of the Noli me tangere and Ascension, it seems to have had new relevance at this time. See Iogna-Prat, "Bienheureuse Polysémie"; also Herbert Schrade, "Zu dem Noli me tangere der Hildesheimer Bronzetür," *Westfalen* 39 (1961), 211–14; Kahsnitz, "Bronzetüren im Dom," 511.

34 The identities of the two nude figures have been much debated in the literature, since the biblical account excludes any witness to Adam's creation and Adam's watching Eve being created (Adam was asleep). With the pictorial precedents being inconclusive, opinions are so divided that some see both figures as Adam, others identify both as Eve, and still others, who base themselves on a spiritual reading, see Eve watching the creation of Adam. For a review of the literature, see Søren Kaspersen, "Cotton-Genesis, die Toursbibeln und die Bronzetüren—Vorlage und Aktualität," *Berwardinische Kunst* (Göttingen, 1988), 81–84; see also Gallistl, "Tür," 147–52, and Kahsnitz, "Bronzetüren im Dom," 506. The coherent narrative and compositional relations described here, both within the panel and in its relation to the Noli me tangere, strongly speak for this being Adam observing the creation of Eve. Neither a conflation nor a vision, the panel is another original formulation of the Hildesheim Master, one that still serves the spiritual and ecclesiological reading of the doors; see Kaspersen, ibid., 92–96.

35 Augustine, *De Tempore*, Sermo 243.2 (PL 38, 1144) and Sermo 245.4 (PL 38, 1153). See also Deshman, "Another Look."

36 The imagery of doors is also important in Bernward's Gospels, both in relation to the act of prayer and to the typological themes of these doors. See Ernst Guldan, *Eva und Maria: Eine Antithese als Bildmotiv* (Graz, 1966), 13–20, 43–45, and William Tronzo, "The Hildesheim Doors: An Iconographic Source and Its Implications," *Zeitschrift für Kunstgeschichte* 46 (1983), 357–66.

13

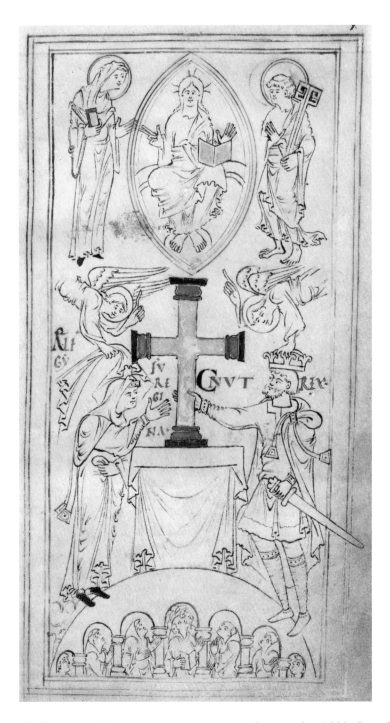

14.1. Queen Ælfgifu (Emma) and King Cnut present a cross to New Minster. London, British Library, Stowe MS 944 (*Liber vitae*), fol. 6r. Reproduced by permission of the British Library.

14 The Gift of the Cross in the New Minster *Liber Vitae*

Elizabeth C. Parker

The frontispiece of the New Minster Register, a product of the important artistic center at Winchester, is a well-known example of the lively virtuosity of pen drawing in Anglo-Saxon manuscript illumination of the early eleventh century (British Library, Stowe 944, fol. 6r; Fig. 14.1).[1] The most prominent element in the composition is a great gold cross, centered on the page, with terminals of a reddish brown edged in green. To the right a regally dressed male figure identified as King Cnut (CNVT REX) places this cross on a cloth-covered altar, while to the left a female figure identified as Queen Ælfgifu (ÆLFGYFU REGINA) extends her hand in a gesture indicating her participation in the king's act. Two half-length angels hover above, one holding a veil over the queen's head, the other a crown over the king's, both pointing an elongated forefinger upward toward the cross-nimbed Christ, who sits frontally within a mandorla directly above the cross. He is flanked by the Virgin Mary on his right and St. Peter on his left. Within the semicircle at the bottom of the page is a graduated series of seven rounded arches inhabited by monks, presumably members of the Benedictine community at New Minster.

What more might be inferred from a sustained reading of this image in light of contemporary Anglo-Saxon politics, custom, and belief? What can be said about the meaning of the gift for the donors as well as for the recipients within the context of the liturgy? Granted the unusual prominence of the queen in the image, is the gift the occasion for an assertion of her royal role as well as the king's? If this cross, a reliquary cross, makes particular reference to the True Cross of Christ's crucifixion, does the importance of the legend of the True Cross to devotional practice in Anglo-Saxon England have a bearing on our understanding of the image? If so, might the king and queen as donors also be seen as making reference to Helena and Constantine, the protagonists of the legend? Would this allusion have a bearing on the depicted assertion of their royal roles? To pose these questions—without preconceived answers—is to engage in the rewards of a level of image reading that Ilene Forsyth has particularly encouraged by the example of her own scholarship.

First of all, the setting: the hierarchical arrangement of the composition sets out three interrelated tiers of social/sacred realms. The smallest figures are the monks—some of whom are perhaps choir boys—in the lowest zone. The largest figure

14

is the king in the middle realm, who stands before the proportionately much larger cross on the altar and looks toward the queen. His toes and hers intersect the semicircle demarcating the monks' domain, while the angels connect the royal pair to the heavenly realm above. The end of Cnut's sword, projecting beyond the frame, seems to connect him alone to the world beyond the sanctuary space. The queen's scale and pose mirror the Virgin's directly above her; St. Peter is tonsured, like the monks below, who echo the open-handed gesture of petition made by the Virgin and St. Peter to Christ.

These three realms can also be read as a schematic rendering of the sanctuary space of New Minster itself: choir, high altar, and apse. The upper zone may even represent New Minster's apse decoration, inasmuch as that church was dedicated to St. Mary and St. Peter.[2] To see the image as reflective of the actual church space ties it more particularly to the principal contents of the book for which it serves as frontispiece. Begun by the scribe Ælsinus ca. 1031, the *Liber vitae*—the Book of Life—was a register, containing an ongoing list that gave "in their appropriate order the names of the brethren, and of the monks, and also of the friends (*familiariorum*) and benefactors, whether living or dead, so that, by the making of a record on earth in this written form, they may be inscribed on the pages of the heavenly book." The preface continues:

> And may the names be entered here of all those who commend themselves
> to its prayers and fraternity, in order that there may be a commemoration
> of them every day, in the holy solemnities of Mass or in the harmonies of
> psalmody. And may the names themselves be presented by the sub-deacon
> every day before the holy altar at the Morrow or principal Mass, and may
> they be read out by him in the sight of the Most High, as time permits.[3]

Thus, we may want to identify the monk in the central arch as the subdeacon reading from this very book names he prays may be inscribed in the Book of Life Christ holds on his knee, as a result, perhaps, of the Virgin's prayers for those listed in the book she holds. A yellow wash on her closed book and on Christ's open one link them with each other and with the large gold cross on the altar. The image confirms what the liturgy achieves: the commemoration at the high altar in New Minster is enacted in the presence of the Most High.[4]

The Book of Life, as described in the New Testament, contains the names of the saved at the Last Judgment (Apoc. 3:5, 20:12), an event depicted on the following two facing pages (Fig. 14.2). In the top register of folio 6v, two angels each lead a group of the blessed to the heavenly kingdom on folio 7r. They include monks and laymen among others, presumably those listed in the *Liber vitae* as coming from Winchester and monastic houses nearby. In the middle register a bishop,

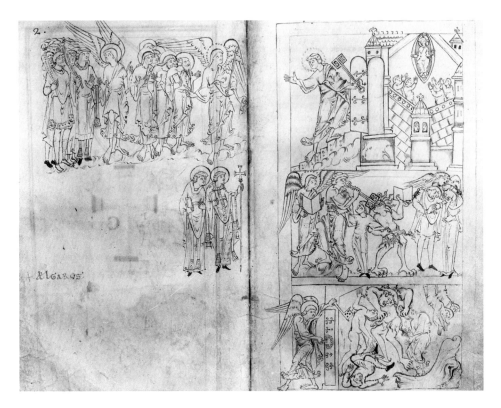

14.2. The Last Judgment. London, The British Library, Stowe MS 944 (*Liber vitae*), fols. 6v–7r. Reproduced by permission of the British Library.

identified by a later hand as "Ælgarus"—a reference to Æthelgar, abbot of New Minster when it was reformed by King Edgar (964–88) and later archbishop of Canterbury (988–90)—stands with a companion, also haloed, and holds a processional cross similar in form to the one on the altar.[5] The Last Judgment is depicted in three registers on the opposite page. In the uppermost tier, St. Peter, keys in hand, opens the gates of the cloudborne walled city of the Heavenly Jerusalem, in which the blessed praise Christ in a mandorla above them. In the middle register, aligned with the bishop, a haloed angel holds open the Book of Life as Peter and the devil, clutching his own book, fight over a young man's soul. Peter strikes the devil with his key as he grasps the boy's hand. To the right a downcast male and female stand in the firm grip of a winged demon. They seem to be the pair diving into the lowest zone, where an angel is depicted locking the gates of hell on a more monstrous and triumphant devil, who tramples one upended figure as he throws two others by their hair into the open hellmouth.

This expansive, somewhat personalized, image of the Last Judgment speaks to the early interest in the theme in Anglo-Saxon Britain.[6] Another distinctively

14

Anglo-Saxon interest reflected in this series of images—one deeply entrenched in the insular tradition—is the theme of the cross as agent of salvation. The devotion to the saving power of the cross stems from the dream of the emperor Constantine in 312 on the eve of his battle with Maxentius, in which an angel showed him a cross in the sky and declared: "in this sign conquer." The subsequent story of the finding of the crosses of Christ and the two thieves on Golgotha in 326—and the miraculous revival of the dead boy that determined which of the three crosses was the True Cross of Christ—was first credited to Helena, mother of Constantine, by Bishop Ambrose of Milan in his eulogy for Emperor Theodosius in 395, and the legend developed thereafter.[7] Firsthand knowledge of the eastern rites of the feasts of the Invention (3 May) and the Exaltation of the Cross (14 September), which centered on the relic of the True Cross, came in Bishop Arculf's report to Abbot Adamnan of Iona on his pilgrimage to Jerusalem and Constantinople in the 680s.[8] Benedict Biscop may have brought early western forms of these rites and the Good Friday Veneration of the Cross from Rome to his monastery at Wearmouth–Jarrow around that time.[9] By then relics of the True Cross were in western hands as well, among the earliest being the imperial gift by Sophia and Justin II to Queen Radegund of Poitiers in 569, which occasioned Venantius Fortunatus' famous hymns to the cross.[10] A rich literary heritage also lies behind the images depicted in the *Liber vitae*, most notably the Anglo-Saxon poem, *The Dream of the Rood*, in which the cross itself speaks of the suffering of Christ and of his triumph at the Last Judgment.[11]

In conceiving his frontispiece, the artist, who may have been the scribe Ælsinus,[12] seems to have made a conscious reference to the frontispiece of the New Minster Charter of 966. There King Edgar, as benefactor, is shown offering the charter to Christ seated frontally above him in a mandorla surrounded by four angels, while the Virgin and a tonsured St. Peter stand as intercessors on either side of Edgar's proportionately larger figure, seen from the back.[13] This important charter mandated the introduction of Benedictine monks at New Minster, an event that led to the formulation of a code of monastic observance at the Council of Winchester in 973, the *Regularis concordia*. Drawing upon the insular monastic tradition as well as more recently reformed customs on the continent, Bishop Æthelwold's document gave new prominence to the cross by adding dramatic elements to the Good Friday liturgy. Unique to England, it also established the king and queen as monastic patrons, for whom prayers were to be recited after all parts of the Divine Office but Prime.[14] Visual links between the frontispieces of the New Minster Charter and the *Liber vitae* suggest that one function of the latter was to assert Cnut's role as successor to Edgar in his efforts on behalf of the abbey. By including the queen, the frontispiece affirms her special importance to the king's political program and places the two at the head of the list of those to be saved at the Last Judgment.[15] By depicting them offering the major gift of the gold cross together, the image makes a clear state-

14

ment of their joint patronage of New Minster. Recorded in the *Liber vitae* is a list of the various relics the "great cross" contained, the most important among them being a piece of the True Cross—"de ligno domini."[16]

Their gift is also the occasion for receiving heavenly rewards: the queen's veil and the king's crown not only imply their separate blessings but also suggest the nature of their royal partnership. Through his scale, pose, and crown, King Cnut is easily recognizable here as a commanding historical personage. The position of Ælfgifu is more problematic. This queen was the widow of King Æthelred II the Unready, who was defeated in 1013 by the Danish king Swein, Cnut's father. As Emma of Normandy, she had married Æthelred in 1002, changing her name to Ælfgifu at that time in honor of King Edmund's sainted queen, mother of Edgar and grandmother of Æthelred II. With her marriage to Cnut in 1017, her Saxon name drew attention to the links between their reign and the Anglo-Saxon royal heritage.[17] In this image, Emma/Ælfgifu seems to defer to the larger, more frontal figure of the king, whose right hand is solidly grasping the cross. She deserves a second look, however, not only because hers is the earliest portrait of a living English queen that we have but also because she stands to the left—that is, on the favored right-hand side of Christ. Madeline Caviness, the first to emphasize this point, has suggested that her placement could even indicate that she was solely responsible for the commission of the cross as an ex-voto for Cnut, who was not in England in 1031, when the *Liber vitae* was copied and the cross very probably given.[18] The placement of a woman to the left of her husband, whether the image is of a royal couple or not, is rare in both Byzantine and western art.[19]

Emma's very presence, then, speaks to the power inherent in her queenship. Her placement suggests that she derives her power from the Queen of Heaven depicted above her, whom she parallels in her royal roles as well as in her pose. The titles given to English queens in the eleventh century mirror the titles given to Mary: Lady of the World, Queen of Heaven, Bride of Christ, Fruitful Mother of the Only Son of God.[20] Pauline Stafford's point that Emma's roles as wife and mother were closely bound to her role as queen is confirmed in the miniature by her modest demeanor as a lady with veiled diadem who receives a marriage veil from the angel, but not the crown bestowed on Cnut from God.[21] The image thus offers visible proof of the importance to Emma of Mary's cult at Winchester, not only in private prayers but in public devotion to her as Queen of Heaven, the model for the English queen.[22] Mary is the Queen who leads the succession of saintly queens. The cult of these queens, mainly out of England's historical past but also including the Frankish queen Radegund of Poitiers, increased in popularity in the early eleventh century, and they served to bolster Emma's power.[23] Stafford argues that the shared rule of king and queen articulated in the English coronation rites of 973 was further emphasized in the revised blessings for the queen adopted for the consecration of

14

Emma and Cnut in 1017 and in the ritual praises of the *Laudes regiae* to both rulers sung on this occasion, thus enhancing her position as a sign of royal continuity after England's conquest by Cnut's father.[24]

Neither Cnut nor Emma kneels in the more customary posture of pious devotion. Instead they stand, actively engaged in offering their gift of the gold cross containing a relic of the True Cross. Their actions are not congruent: Emma only gestures toward the cross with her right hand, while Cnut places it on the altar with his. Simultaneously, with his left hand, he grasps the hilt of his prominent sword, the ritual emblem of his role as protector of the Church and the realm in the coronation rites. Standing as warrior king before the reliquary cross, Cnut's placement seems to allude to Constantine, the first of the Christian warrior kings, during whose reign the True Cross was recovered. Standing to the left of the cross, Emma's pose may refer not only to the model of the Virgin Mary above her but also to Helena, the first of the saintly queens, who found the great relic in Jerusalem.[25] An eastern example of Constantine and Helena together flanking a cross may be seen in the larger of two Byzantine triptychs housed in the mid-twelfth-century Stavelot Triptych in the Pierpont Morgan Library in New York. Here Helena stands to the right of an actual relic of the True Cross; moreover, her upraised hand mirrors the Annunciate Mary's on the right exterior wing of the smaller reliquary triptych above it.[26] In a rare western example, postdating the *Liber vitae*, Helena takes Constantine's favored place to the left of the Cross—Ælfgifu's position—a sign of status permitted, perhaps, because she, and not Constantine, was canonized in the western Church.[27]

English interest in the legend of the True Cross, and in Helena and Constantine as role models, had a long history. As early as 600, Pope Gregory urged King Ethelbert and Queen Bertha of Kent to emulate Constantine and Helena in their missionary zeal.[28] England's important cult of the cross began soon after, according to Bede, with King Oswald of Northumbria's erection of the miracle-working cross that brought him victory in his battle at Heavenfield in 634.[29] Bede also transmits the legend that Constantine's father Constantius died in Britain and that his son as emperor "succeeded to his father's kingdom."[30] Helena's story came alive in the Anglo-Saxon literary tradition through Cynewulf's poem, *Elene*, which, like the *Dream of the Rood*, is difficult to date but may be contemporary. Cynewulf's vivid telling includes the episodes of Constantine's vision of the cross (a battle now located on the Rhine), Helena's sea journey to Jerusalem at his request, her interrogation of the Jews to find the crosses and later the nails, the rage of the devil at the saving of the soul of the boy resurrected by the True Cross, and Helena's gift of the True Cross covered with gold and gems to Constantine, along with a nail from the Cross for his crown. Before the personal *envoi* in which Cynewulf contemplates the close of his own life and the Judgment to come, the poet ends his tale

14

with a prayer that evokes precisely what the *Liber vitae*'s three illuminated folios together depict:

> May hell's door be closed
> And the entrance to heaven, the angels' realm
> And eternal bliss, be open for ever,
> And his lot appointed with the Lady Mary
> For every man who keepeth in mind
> The most hallowed feast, under heaven, of the Cross
> Which the Great Lord of all clasped with His arms.[31]

It is conceivable, therefore, that the Feast of the Invention of the Cross, when the story was recounted in the liturgy, was also the occasion of the gift of the cross by Emma and Cnut, in imitation of Helena and Constantine.[32]

The tradition of Christian rulers linking themselves to the founder generation begins with the Theodosian rulers of the Byzantine East at the time when Ambrose associated Helena with the discovery of the True Cross.[33] Parallel to the Constantinian model of all-powerful warrior king, the queen's power came from her assumption of Helena's role as a pious, generous, peacemaking intercessor with the king on his subjects' behalf. Radegund of Poitiers managed to sustain this image as queen to both King Clothar and his successor King Sigebert, who supported her request to the Byzantine court for the True Cross relic. Jo Ann McNamara has argued that the direct comparison to Helena in the nun Baudonivia's *vita* of Radegund set a precedent in *imitatio Helenae* that extended to both Ottonian and Anglo-Saxon "saintly queens."[34] Despite there being no firm evidence for the association of Emma with Radegund, the particular popularity of her cult in England and especially at Winchester in Emma's day, as well as Emma's endowment of a church in Poitiers, are factors supporting the idea that the *imitatio Helenae* contributed to the shaping of the image of Emma and Cnut offering the gift of the True Cross in the *Liber vitae*.[35] There seems to be sufficient ground in the English liturgical tradition itself for explaining Emma's privileged place on Christ's right; her pose, mirroring that of the heavenly queen above her, is a fitting complement to Cnut's bold pose as the dominant warrior king who protects the Church. Nonetheless, to draw out the association and to see this queen and king as adopting the roles of the "new Helena" and the "new Constantine" when they place the cross on the altar adds a further layer of meaning to this image of their power sharing in a period of crisis for Anglo-Saxon rule.[36]

1 Elzbieta Temple, *Anglo-Saxon Manuscripts, 900–1066* (London, 1976), no. 78; *The Liber vitae of the New Minster and Hyde Abbey, Winchester*, ed. Simon Keynes, Early English Manuscripts in Facsimile, vol. 26 (Copenhagen, 1996).

2 *Liber vitae: Register and Martyrology of New Minster and Hyde Abbey, Winchester*, ed. Walter de Gray Birch (London, 1892), viii (966); for other, earlier dedications, ibid. For the tenth-century renovations of Old and New Minster, see Arnold William Klukas, "*Altaria Superiora*: The Function and Significance of the Tribune-Chapel in Anglo-Norman Romanesque: A Problem in the Relationship of Liturgical Requirements and Architectural Form" (Ph.D. diss., University of Pittsburgh, 1978), 247–55, figs. 70–73.

3 *Liber vitae*, preface (Birch, xv; Keynes, 83). The list begins on fol. 14r with Cynegils (611–42) and ends in the original hand with Æthelred II (978–1016); the last name is Henry V (1413–22). It includes (fol. 56r) Adam, prophets, patriarchs, and other notable figures, written in the original hand (Birch, xv f., 153; Keynes, 104).

4 C. Clifford Flanigan, "The Apocalypse and the Medieval Liturgy," in *The Apocalypse in the Middle Ages*, ed. Richard K. Emmerson and Bernard McGinn (Ithaca, 1992), 333–51.

5 *Liber vitae* (Birch, vii; Keynes, 80).

6 For discussion of a singular example of an early Last Judgment on an Anglo-Saxon ivory of ca. 800, see Pamela Sheingorn, "For God is such a Doomsman," in *Homo, Memento Finis: The Iconography of Just Judgment in Medieval Art and Drama*, Early Drama, Art and Music Monograph Series, vol. 6 (Kalamazoo, 1985), 15–58, esp. 25–28, and fig. 3; Robert Deshman, "Anglo-Saxon Art after Alfred," *Art Bulletin* 56 (1974), 176–83. For a near contemporary relief showing a cross flanked by angels beneath Christ in a mandorla between the Virgin and Peter, see John Beckwith, *Ivory Carvings in Early Medieval England* (London, 1972), 38, 121 (no. 18), fig. 41.

7 On the development of the legend, Jan Willem Drijvers, *Helena Augusta: The Mother of Constantine the Great and the Legend of her Finding of the True Cross* (Leiden, 1992), 95–117; on Ambrose's version, 109–13.

8 Adamnan, *De locis sanctis*, 3.3, ed. L. Bieler, CCSL 175 (Turnhout, 1965), 228–29.

9 *Bede's Ecclesiastical History of the English People*, 4.18, ed. and trans. Bertram Colgrave and R. A. B. Mynors (Oxford, 1969), 388–89: "Abbot John [who came to Wearmouth from Rome]…committed to writing all things necessary for the celebration of festal days throughout the whole year."

10 For the occasion of Fortunatus' *Vexilla regis* and *Pange lingua gloriosi*, standard since the ninth century in western celebrations of the Good Friday Veneration of the Cross and the Feasts of the Exaltation and Invention of the Cross, see Jo Ann McNamara and John E. Halborg, *Sainted Women of the Dark Ages* (Durham, NC, 1992), 63.

11 *The Dream of the Rood*, ed. Michael Swanton (Manchester, 1970), 1–78; Elizabeth C. Parker and Charles T. Little, *The Cloisters Cross: Its Art and Meaning* (New York, 1994), 132–43.

12 For the scribe, see Janet Backhouse et al., *The Golden Age of Anglo-Saxon Art, 966–1066*, exh. cat. (London, 1984), nos. 61 (Prayerbook of Ælfwine), 62 (*Liber vitae*); Temple, *Anglo-Saxon Manuscripts*, nos. 77, 78. For the scribe as artist in both manuscripts, see Keynes, *Liber vitae*, 79.

13 British Library, Cotton Vespasian A.VIII, fol. 2v. Temple, *Anglo-Saxon Manuscripts*, 95, and no. 16, fig. 84; *The Golden Age of Anglo-Saxon Art*, no. 26, color pl. IV; Robert Deshman, *Benedictus Monarcha et Monachus*: Early Medieval Ruler Theology and the Anglo-Saxon Reform," *Frühmittelalterliche Studien* 22 (1988), 223–26.

14 *The Oxford Dictionary of the Christian Church*, 3d ed. (Oxford, 1997), s.v. "Regularis concordia"; Parker and Little, *The Cloisters Cross*, 125–28, with further bibliography; *Medieval England: An Encyclopedia*, ed. Paul E. Szarmach et al. (New York, 1998), 631–33.

15 Richard Gameson, *The Role of Art in the Late Anglo-Saxon Church* (Oxford, 1995), 83. See also n. 3 above.

16 *Liber vitae*, fol. 55v (Birch, lxv, 74; Keynes, 104). For a list of other relics in the cross—of saints, apostles, Holy Innocents, Jesus' crib, the tomb of the Virgin—written in a later hand, see Birch, 151–52; Keynes, 104. For the translation of the abbey to Hyde in 1110 and the destruction of the cross by Bishop Henry of Blois, see Birch, xxxvii f.; Keynes, 35–36, citing later sources describing the cross as being enriched with "gold and silver, with gems and precious stones."

17 See Pauline Stafford, *Queen Emma and Queen Edith: Queenship and Women's Power in Eleventh-Century England* (Oxford, 1997), 172, and, for a genealogical table, ibid., 324–27. The first wives of both Æthelred and Cnut were both also named Ælfgifu.

18 Madeline H. Caviness, "Anchoress, Abbess, and the Queen: Donors and Patrons or Intercessors and Matrons?" in *The Cultural Patronage of Medieval Women*, ed. June Hall McCash (Athens, GA, 1996), 105–54, at 126–27. As queen, Emma controlled the funds in the royal treasury at Winchester, which was the administrative heart of the kingdom and her dower borough from Æthelred. The gift of the cross, attributed to

Cnut alone by later chroniclers, has been placed in the 1020s or ca. 1031, at the time of the transcription of the *Liber vitae*. See Keynes, 35–37; Jan Gerchow, "Prayers for King Cnut: The Liturgical Commemoration of a Conqueror," in *England in the Eleventh Century*, Proceedings of the Harlaxton Symposium, ed. Carola Hicks (Stamford, 1992), 219–38. For Cnut's being in Rome in 1031, see Simon Keynes, *Encomium Emmae Reginae*, ed. Alistair Campbell (Cambridge, 1998), lxi n. 7; and for the possibility that Emma acted as regent in the 1020s, Stafford, *Queen Emma*, 188–89. T. A. Heslop first noted Emma's unique placement in the frontispiece in "The Production of *de luxe* Manuscripts and the Patronage of King Cnut and Queen Emma," *Anglo-Saxon England* 19 (1990), 151–95, at 157 n. 16.

19 For Queen Eleanor of Aquitaine and King Henry II as donors kneeling to the left and right at the foot of a cross in the great east window of Poitiers cathedral, see Caviness, "Anchoress, Abbess, and Queen," 128–29, fig. 20, and 149 n. 51—containing a reference to an unpublished study by Corine Schleif, "The Man on the Right and the Woman on the Left: Place and Displacement in the Sacred Iconography and Donor Imagery," for a copy of which I, too, thank the author. I am also grateful to Catherine E. Karkov for letting me read a draft of "Aelfgifu/Emma: Virgin Queen," to be published in *The Sons of Cnut*, ed. David Hill, British Archaeological Reports (Oxford, 2002), in which she gives Emma more importance than Gerchow did and less than Caviness. Gerchow ("Prayers for King Cnut," 225, 229) cites a number of Ottonian images of royal couples, reflecting the influence of Theophanu, the Byzantine wife of emperor Otto II, but in each case the queen is on the right. See, however, n. 32 below.

20 Stafford, *Queen Emma*, 55. Although the prayers for the queen omit references to her fertility, in the consecration *ordo*, she "is blessed and consecrated to consortship of the royal bed." She also enjoyed the titles of King's Wife, King's Mother, and Lady (ibid., 162–68).

21 Ibid., 179. The queen's *ordo*, conceived as a marriage rite, calls for her to "[r]eceive the crown of glory" as well (ibid., 166–67). For the further reading of the proffered veil as a reference to the *stola prima* or *secunda*—the clothing of the redeemed soul at death or the Last Judgment—see Gerchow, "Prayers for King Cnut," 225.

22 For the ambiguity of the queen's position and the importance of the cult of Mary at Winchester, see Stafford, *Queen Emma*, 72–74. For the image of the "Quinity"—the Virgin and Child with the Trinity—in the prayerbook Ælfwine made when he was deacon of New Minster (British Library, Cotton Titus D. XXVII, fol. 75v), showing the Virgin wearing a diadem similar to Emma's, as "a visual commentary on the consecration prayer of an English queen" by the artist of the *Liber vitae*, see ibid., 178.

23 For the tradition of Anglo-Saxon royal women imitating the model of Radegund of Poitiers, see Jo Ann McNamara, "*Imitatio Helenae*: Sainthood as an Attribute of Queenship," in *Saints: Studies in Hagiography*, ed. Sandro Sticca, Medieval and Renaissance Texts and Studies, vol. 141 (Binghamton, 1996), 67; Stafford, *Queen Emma*, 168–72.

24 Ibid., 174–78, 183–85.

25 For King Athelstan's acquisition of the sword of Constantine in 926, to which one of the holy nails was attached, see McNamara, "*Imitatio Helenae*," 51–56; Amnon Linder, "The Myth of Constantine the Great in the West: Sources and Hagiographic Commemoration," *Studi medievali*, 3d ser., 16/1 (1975), 67 n. 129.

26 William Voelkle, *The Stavelot Triptych: Mosan Art and the Legend of the True Cross* (New York, 1980), figs. 6, 7.

27 Vienna, Österreichische Nationalbibliothek, series nova 2700, p. 338: Antiphonary of Saint Peter's (Salzburg, ca. 1160). Ibid., 22, fig. 52.

28 Richard E. Sullivan, *Christian Missionary Activity in the Early Middle Ages* (Aldershot, 1994), 56–58; McNamara, "*Imitatio Helenae*," 61.

29 Bede, *The Ecclesiastical History of the English People*, 3.2 (Colgrave and Mynors, 214–19).

30 Ibid., 1.8 (Colgrave and Mynors, 36–37).

31 Cynewulf, *Elene*, ll. 1229–35, trans. Charles W. Kennedy, *Early English Christian Poetry* (New York, 1952), 171–214, at 212.

32 For Radegund's gift of the True Cross relic to the convent of the Holy Cross at Poitiers, see McNamara and Halborg, *Sainted Women*, 97–99. A similar donation is depicted showing Abbess Mathilda, granddaughter of Otto I, on the left and her brother Duke Otto of Bavaria on the right on the base of a processional cross, which they gave to her convent at Essen in the late tenth century. See Peter Lasko, *Ars Sacra, 800–1200*, 2d ed. (New Haven, 1994), 100, fig. 135

33 McNamara, "*Imitatio Helenae*," 53–58; Leslie Brubaker, "Memories of Helena: Patterns in Imperial Female Matronage in the Fourth and Fifth Centuries," in *Women, Men and Eunuchs: Gender in Byzantium*, ed. Liz James (London, 1997), 52–75. On the public acclaim for Marcian and Pulcheria as "New Constantine" and "New Helena" at the Council of Chalcedon in 451, see Linder, "The Myth of Constantine the Great," 59; for the gift of Justin II and Sophia to Queen Radegund, Drijvers, *Helena Augusta*, 182–83.

14

34 McNamara, "*Imitatio Helenae*," 63–73, and *Sainted Women*, 86–105; for Baudonivia's *vita* and the comparison to Helena, ibid., 97. Queens even gained a certain edge, liturgically, over their more politically powerful husbands through their association with Helena. See n. 27 above and Linder, "The Myth of Constantine the Great," 86–93, esp. 88, for the spread of her cult as a product of the continental reform movement, and 61–67, for the political importance of the Constantine myth on the continent. Gerchow, "Prayers for King Cnut," 225–30, sees the imagery of the frontispiece as having been shaped by Ottonian precedents—including the gift of a cross as well as the form of the imperial crown, which Cnut had seen in 1027 when he attended the coronation of Conrad II.

35 Stafford, *Queen Emma*, 171–72 nn. 47, 51.

36 Despite her best efforts—including her other pious donations (Stafford, *Queen Emma*, 143–49; Heslop, "The Production of *de luxe* Manuscripts," 156–62) and her self-glorification through the account of Cnut's reign in the *Encomium Emma reginae*, written ca. 1041 to bolster her sons' claims to the throne—Emma's carefully cultivated image did not hold. The negative spin began with the Anglo-Saxon Chronicle's account of the events of 1043, when Edward the Confessor came to the throne and stripped her of her wealth and lands. See *The Anglo-Saxon Chronicle*, trans. G. N. Garmonsway (London, 1953), 162–63. Ironically, William of Malmesbury's harsh judgment of Emma came at a time when other twelfth-century English historians were sanctioning the myths that Helena was the daughter of "Old King Coel" and that Constantine, also English by birth, was the grandfather of King Arthur. See Linder, "The Myth of Constantine the Great," 91–93; Winifred Joy Mulligan, "The British Constantine: An English Historical Myth," *Journal of Medieval and Renaissance Studies* 8 (1978), 257–64; McNamara, "*Imitatio Helenae*," 74.

15 Valerie's Gift: A Narrative Enamel Chasse from Limoges

Cynthia Hahn

No fewer than 22 extant Limoges reliquary chasses attest to the popularity of the cult of the virgin saint Valerie in the Limousin region in the twelfth and thirteenth centuries. This profuse visual evidence for the life and cult of the purported first-century martyr of Limoges contrasts strikingly with the sparse textual evidence of her story—a few abbreviated *vitae* dating no earlier than the tenth century. Even the virgin's relics, dispersed among sites including Saint-Martial in Limoges and Saint-Valerie in nearby Chambon, amount to no more than a heap of dust. Thus, in place of secure texts or palpable bodily remains, the visual evidence takes a premier place in the history of Valerie's cult. Given these circumstances, the historian must ask how the cult became so important. I would suggest that an interactive process between story and audience, a process of "intertextuality" and even "interpictoriality," led to the growth and prominence of the legend and cult.[1] By means of the interaction of many narrative elements—the saint's own *vitae*, the *vitae* of other saints, episodes involving Valerie in local legends, the text of the Bible, liturgical readings, and pictorial versions, as well oral legends and events such as relic displays—Valerie's story was demonstrated to be both like and also, importantly, unlike the stories of other saints. In particular, interactions with the legends of saints in the same saintly class—the virgin martyrs—as well as specific associations with saints of her region, came together to help define Valerie's particular role as willing sacrifice, selfless mediator, and peacemaker.

The intertextual process that I am suggesting is one that would have depended upon active viewer response.[2] Audiences would have brought a store of conventional or otherwise familiar motifs to bear in understanding what they heard, read, or saw. Although our knowledge of the experiences of medieval viewers is still far from adequate, Limoges, it seems, constituted an especially suggestive visual culture. Processions of chasses and statues—providing occasions for witnessing interactions among saints as represented by art works—created a rich visual environment that went beyond the conventional displays of relics in structured ecclesiastical settings. Twelfth-century readers or viewers (including artists) had the

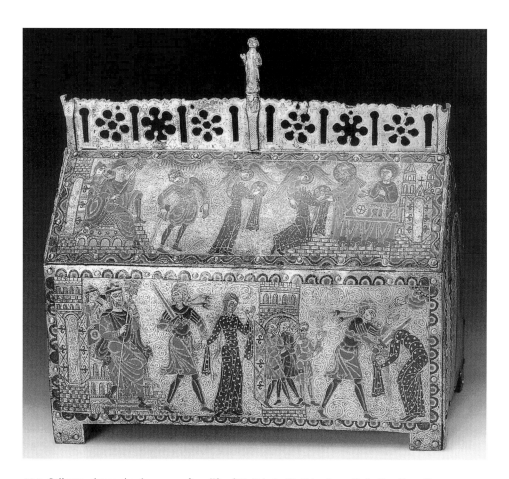

15.1. Reliquary chasse showing scenes from life of St. Valerie. St. Petersburg, State Hermitage Museum, ɸ 175. Photo: State Hermitage Museum.

Reading Medieval Images

opportunity to experience Valerie's story as a multi-layered response to an interactive field of texts and pictures. As I will argue, through this process of "reading," Valerie's story became uniquely important in twelfth- and thirteenth-century Limoges.

In order to explore this process, we will focus first on the finest and largest of the Valerie chasses (23.2 x 28 x 11.5 cm), now in the Hermitage Museum in St. Petersburg and dated approximately 1175–85 (Fig. 15.1).[3] A beautiful and well-preserved example of a narrative reliquary, the St. Petersburg chasse represents an early high point in design and artisanry among the enamel works of Limoges. In its extensive use of narrative and "vermiculation," or vine-scroll background, it is closely comparable to the chasses of two other important Limousin saints— Stephen, to whom the cathedral of Limoges was dedicated, and Martial, the early Christian missionary to Limoges and the city's first bishop.[4] All these chasses exhibit multi-scenic narratives, and each is remarkable for attention to detail and precise execution. Notwithstanding the long series of Valerie chasses (and a similarly extensive series of Thomas Becket chasses), reliquaries with such careful narrative detailing are relatively unusual in the virtual flood of reliquaries and other luxury church furnishings in enamel produced in Limoges for patrons throughout Europe between the twelfth and fourteenth centuries.

Yet perhaps more important than their shared artistic heritage is the spiritual heritage that the reliquaries of Valerie, Stephen, and Martial hold in common. The three saints can justifiably be called the foremost patrons of Limoges and, although it cannot be certain that these three particular chasses were manufactured for use in Limoges itself, they were undoubtedly created in service of the dynamic use of relics that developed in Limoges and the Limousin in the tenth and eleventh centuries and that continued throughout the Middle Ages.[5] However, before establishing any Limousin context for the story on the St. Petersburg chasse, the audience was required to understand the saint's primary sacred status as a virgin martyr. Indeed, a number of elements in Valerie's story are dependent on conventions common in *vitae* of virgin martyrs, where the saint's trial and sacrifice are typically defined as the primary events of her life. These are the scenes featured on the St. Petersburg chasse.

According to the preserved *vitae*, Valerie was the only child of the Roman prefect of Limoges, Leocadius, and his wife, Susanna.[6] She was rich, beautiful, and engaged to her father's successor, Duke Stephen. However, according to Martial's Life,[7] while her fiancé was off fighting barbarians, St. Peter himself sent St. Martial to Christianize Limoges. Valerie and her mother were converted and baptized in fulfillment of Martial's mission, and Valerie donated her inheritance to the church. Stephen, hearing that his fiancée had "married a different spouse,"[8] hastily returned to his city and demanded an audience with her. Valerie refused to recant her beliefs,

and Stephen ordered her execution. Having prophesied the death of her executioner, she went meekly to her death. Her soul was carried to heaven by angels.

This, however, was not the end of Valerie's story. In the star turn of her short passion, Valerie neatly caught her falling head in the moment following her decapitation. Accompanied and even guided by an angel, she walked back into Limoges as a cephalophore (literally: a head-bearer) and presented her head and herself to St. Martial, who was at that moment celebrating the office of the mass. As proof that her soulless body had indeed remained upright, her feet left their mark in the marble floor at the place she stood when she made her final offering. Her executioner, Hostarius, returning to Stephen to report, was miraculously struck down by an avenging angel in fulfillment of the virgin's prophecy (even if he was soon after resurrected through the clemency of Martial), and Duke Stephen was converted by these various miraculous attestations of God's power. Stephen became St. Martial's partner in the Christianization of the region and donated both land and treasure to the church, including the moneys wherewith to build the first cathedral of St. Stephen in the city of Limoges.

Even in this brief summation, it is easy to see that Valerie's history strongly recalls the lives of other virgins, especially that of Thecla, who was the disciple and convert of Paul, but also those of Lucy and Agatha, early Christian virgin martyrs in the Roman canon who abandoned their fiancés to wed the Church. Indeed, the similarities to the lives of the latter two virgins remind us that Limoges claimed to be "like a second Rome" (*quasi secunda Roma*).[9] Celebrating a virgin like Valerie, who bequeathed her political and material inheritance as a wedding gift to the Church, solidified for the Limousin audience the awareness that they were partaking in a Christianity founded in the era of the apostles.[10]

Whether the events of Valerie's life are a pious fiction designed to strengthen the religious prestige of her home town or are in some part historical, the attention given to her cult through the retellings of her story demonstrates that her power in the Limousin was real enough. However, the multiple versions of Valerie's story, it must be emphasized, were by no means equivalent or identical. For example, the narrative on the primary face of the St. Petersburg chasse presents significant departures from the story as recorded in texts, in part because visual representation requires specific detail but in part because emphases had changed in the intervening centuries.

The narrative begins on the lower left. Duke Stephen has already condemned Valerie to death, and the executioner is leading her away to the place of execution, outside the city walls. Valerie, at the center of the panel, is distinguished by a number of meticulous details. Her hair, bound at her forehead in an antique manner, is long and falls freely. Her pose is graceful. Befitting her high status, she wears a blue gown with elegant long sleeves and purple shoes.[11] Her courtly gar-

ment is spotted with white enamel dots in a virtuoso effect attempted in only a few other examples of Limoges enamelwork. These elements of costume, artisanry, and demeanor demonstrated to the medieval viewer that Valerie was the equivalent of a noblewoman or princess.

To Valerie's left, the enthroned Duke Stephen, accompanied by a sword-bearer, holds a scepter topped with a crown shape. In addition to these attributes of his rulership, an ideograph of the city of Limoges behind him establishes his status. In the scene of Valerie's execution at the right, the saint turns to the left and catches her head as it is severed. Her elegant long sleeves serve now to cover her hands as they hold the newly holy relic. Her hair is still bound. Citizens of Limoges stand under the arch of a city gate; some turn toward Valerie, one turns his back, and one mourns with his hand to his face, mimicking reactions of possible viewers. The blessing hand of God confirms Valerie's act as one of martyrdom. In both lower scenes, the executioner, who appears twice, wears exotic clothing. His leather cuirass with *pteryges* is complemented by a ribbon tied high on his chest. These unexpected classical elements find parallels in contemporary and earlier Byzantine art. His turban-like headdress, adorned with ribbons, is somewhat more unusual and may, in its exoticism, make reference for the audience to the new enemies of Christians, the Saracens. Oddly, the executioner seems to exchange gestures with God, looking up and perhaps acknowledging the inevitability of his sin.

To follow the chronology of the story, the viewer returns to the noble, centrally placed figure of Valerie of the first scene and proceeds upward to the roof of the shrine, where she reappears in the depiction of the cephalophoric miracle. The positioning of Valerie's reiterated figure on the central axis clearly emphasizes the miracle and draws attention to the magnitude of her sacrifice. However, in opposition to the strong and active martyr in the lower register, the cephalophore Valerie above is markedly weaker. She is smaller and less elegant in pose; her hair is no longer bound. The saint clearly needs angelic assistance to walk to Martial. The episode concludes with Valerie, depicted a fourth time, presenting her head to Martial, who is vested as a bishop and serves the mass before a portal proleptically representing the cathedral of Limoges. Finally, in a rupture of chronological order, the last scene of the story is placed on the upper left. Rather than the angel mentioned in texts, a bolt of heavenly fire is responsible for the death of the executioner before Stephen. The duke reacts by throwing his hand to his face.[12] Notably, the soldier wears a different headpiece, and Duke Stephen carries a slightly different scepter so that all three of the characters who appear in both registers are presented with some change of attribute or costume.

Most of these details diverge from or add to the surviving texts, and some particularly provoke the viewer's curiosity. Why is the narrative's chronology distorted? Why are there changes in details from bottom to top? Why are these scenes

chosen to the exclusion of others that seem just as significant? That is, where is Valerie's conversion (represented, for example, on the back of the Louvre Martial chasse), and where is the apotheosis of her soul? Where is the avenging angel of the executioner's death, and where is the miracle of his resurrection? Where are Valerie's footprints? Why is the cephalophoric miracle given such prominence? And finally, why is the reverse of the chasse ornamented with an apparently unrelated scene—the Magi's gift to the Christ child? These questions can only be answered by trying to approximate a medieval reception of the shrine—trying to understand how its original viewers would have read it.

Perhaps in an initial impression medieval viewers would have been struck by the images of Valerie's trial before Stephen and her execution. These scenes would have forcefully reminded them of many other scenes of martyrdoms and of virgins before their persecutors. Specifically, in tenth- and twelfth-century pictorial cycles, Agatha and Lucy in their eagerness to witness to Christ (and remember the Greek word martyr means "witness") similarly pull ahead of the soldiers who escort them.[13] Furthermore, many virgins were beheaded by the sword. Thus, just as in the texts relating Valerie's story, the pictures on the chasse begin with an assertion of the saint's typicality, proclaiming her status as a virgin martyr.

Further examination by the viewer would have revealed a markedly less typical element—a divergence from left-to-right narrative order in favor of a chiastic (X-shaped) composition. That is, Valerie's movement in the first scene, bottom left, is picked up and repeated in her progress toward the altar, top right. Likewise, the decapitation in the lower right is punished in the death of the executioner in the upper left. Although similar schematic organizations do occur in medieval narratives, especially in stained glass,[14] here this organization leads the viewer to recognize two interrelated lines of significance that literally intersect in the cephalophoric miracle.

The miraculous type of the cephalophore saint is remarkably common in medieval saints' lives: approximately 120 such saints have been identified in hagiographic literature, the most famous being St. Denis of Paris, the "apostle" to France.[15] Both the general popularity of the miracle and its emphasis here demand explanation. Maurice Coens has pointed to cephalophory's common association with miracles of cephalology, that is, with severed heads that speak, continuing to witness to God's name after death, a phenomenon with a long ancestry in pagan myth.[16] However, because Valerie's head does not speak, the explanation for the prominence of the miracle in this pictorial narrative must lie elsewhere. Another common narrative function of the miracle, as Coens argues, is that it marks a sacred location. That is, the deposit of the head, the saint's most important relic, signifies a choice of burial spot by the saint himself or herself. According to her legend, Valerie was originally buried in Martial's own future tomb in the church of Saint-

15

Martial, a circumstance reminiscent of the prototypical burial of the relics of the martyrs Gervase and Protase in the tomb of the renowned St. Ambrose in Sant'Ambrogio in Milan.[17] However, this explanation, although it would make sense in terms of Valerie's recorded legends, does not quite suit the twelfth-century reality. The saint seems to be donating her head to Martial at the cathedral, not at Saint-Martial, her original burial site. Also, the majority of Valerie's relics were no longer in Limoges when the chasse was made: in the tenth century they had been translated to Chambon, where they came under the care of a dependent community of monks from Saint-Martial.[18] Moreover, some of those relics were presumably in the portable St. Petersburg chasse itself.

Nevertheless, Valerie's donation of her head and body, although not permanent or specific to a location, did satisfy a particular need in medieval Limoges. Given that Martial died the peaceful death of a confessor, the city's foundation legend lacked the essential sacrificial act of martyrdom. To initiate a Christian cult in the Limousin, the Church required not only Valerie's monetary inheritance but also, quite literally, her blood. As the protomartyr of the Limousin, Valerie sanctified the land through her sacrifice. Thus, Valerie's cephalophory, rather than marking the location of her body, signifies her act of donation through martyrdom.

Details on the chasse favor this reading. Without speaking, Valerie walks into Limoges and deposits her head into Martial's hands (not at his feet as one text specifies). Corresponding to the *vitae*, Martial is shown pronouncing the mass. Accompanied by a deacon, he stands behind an altar amply supplied with holy implements: chalice, paten, cross, and candlestick with candle (of Limoges manufacture no doubt). However, the cross-ornamented paten is notably empty. Saints are regularly said to have sacrificed themselves in imitation of Christ's sacrifice on the cross,[19] and even a non-martyr such as Cuthbert, in celebrating the mass, "would himself imitate the rite he was performing, that is to say, he would sacrifice himself to God in contrition of heart."[20] On the Valerie chasse, in the emphatic absence of the host, Valerie's head may thus be read as a literal sacrifice, an offering or "host" for Martial's mass.

As the viewer examines the imagery of the chasse more closely, it becomes increasingly clear that the artist has intended to suggest the theme of saintly sacrifice. For example, the ribbons rightfully attached in the upper register to the bishop's miter, called *infulae* and associated with ancient rituals of sacrifice, are repeated on the pagan executioner's headdress. This detail marks Valerie's decapitation as a sacrificial act. Only at the last moment does the executioner, Hostarius (even the name is derived from *hostia*—sacrifice), realize that the sacrifice is made to God—resulting in that peculiar exchange of gestures noted above. In the upper register, the sacrifice is relocated and given its full significance because it is reiterated by a servant of God, the bishop Martial in the context of the mass.

15

Furthermore, as noted above, at the moment when the executioner returns to Duke Stephen and reports the miracles he has seen, he is struck dead, just as Valerie had prophesied. However, the executioner is not struck down by an angel as required by one of the texts, but instead by a tongue of flame descending from the sky. This means of judgment is yet another reference to sacrifice, one that draws a contrast between improper and godly sacrifice. Similarly, in 1 Kings 18–38, Elijah prophesied that fire from heaven would immolate the bullocks that pagan priests had failed to sacrifice. The small dart-like form of red enamel that crosses the murderer's eye on the chasse may be taken as a vivid representation of such deadly "fire from heaven."[21]

Finally, in recognition of the powers of God revealed in his saints, Duke Stephen witnesses to his own conversion by pointing to his eyes (or shielding them) with a submissive gesture of his hand. Similar gestures of pointing to the eyes in contemporary works have been interpreted as signifying the reception of truth through vision of the holy.[22] In some sense, therefore, Stephen may function as the definitive stand-in and model for the viewer. Texts tell us that his experience led to action—he converted to Christianity and donated a treasure to the Christian church.[23] Similarly, viewers might experience a change of heart in recognition of Valerie's sacrifice and themselves, in turn, make pious donations.

This preliminary reading has been based on details. Given that all but the most privileged of medieval viewers would not have been able to study the chasse in such detail, but would instead have seen it at a distance on an altar or carried past in a procession, is this reading still relevant? Indeed, many of the same themes may be read from the most overtly obvious aspects of the chasse: the overall oppositional composition, the depiction of movement, and the chiastic structure of the narrative. That is, themes of conversion, action, sacrifice, and gift-giving function as comprehensive organizing principles.

For example, the oppositional structure in the composition consists in the contrast of two realms, the secular and the ecclesiastical, on the left and right respectively. These two realms are read as linked and Christianized by Valerie's gift at the center of the X of the chiastic structure. Beginning at the lower right, the beheading of the saint and her prophecy are linked by narrative and miraculous consequences to the upper left and Stephen's conversion. Along the dominant line, rising from left to right, the viewer follows Valerie from the open doors of the city gate along a path in which her mundane power is transmuted into a higher spiritual power. This line ends in the open doors of the church, the cathedral of Limoges soon to be built with the benefit of Stephen's donations.

This composition, in addition to contrasting and yet joining the realms of the secular and the sacred, offers various paths to the viewer. It counsels conversion and action, as in the story of the duke. It proposes selfless sacrifice and spiritual

15

ascent, as in Valerie's story. Or, at the least, in its emphatic movement from left to right, from open door to open door, it recommends liturgical processional movement and perhaps submits that such movement serves as a spiritual pathway beneficial for the soul.

Medieval viewers would have had no difficulty at all in construing such a composition. Opposition would have been a familiar structure because of its similarity to antiphonal or response structure, a common liturgical form.[24] Indeed, the events that are depicted on the chasse could be said to correspond roughly in their succinctness and oppositional quality to the second antiphon of the second nocturn of Valerie's monastic office: "It is the loss of her head that allowed Saint Valerie to attain celestial joy, and the soldier, obeying the order of the Duke, is given death."[25]

Oppositional and chiastic structures, not unusual in medieval narratives and liturgies, may even have been particularly associated with saints' lives. For example, in the life of Lucy illustrated in a contemporary Metz manuscript, one pair of scenes seems to be founded on an opposition featured in the rhymed *vita* by Sigebert of Gembloux referring to the defeat of the pagan emperor that was prophesied by the virgin martyr: "Faith is crowned, perfidy abdicates."[26] The pictures convey Lucy's victory in a similar fashion to that of Valerie (Figs. 15.2, 15.3). On the left, the pagan ruler orders Lucy's torture with flames and burning oils. By means of prayer, the saint celebrates her torture and turns it into an act of purification or anointment. On the facing page, Lucy is relocated to the upper register, victorious in her martyrdom, while the emperor is defeated below. The chiastic structure demonstrates both a reversal of the secular order and the essential Christian reversal of the meaning of death—now become victory. Thus, as in Valerie's life, Lucy's death by sword is not the end of the story, and in a third illustration Lucy survives just long enough to receive the sacrament of the mass.

Finally, a few remaining questions about the context of the chasse beg attention. Can any particular viewer or perspective be proposed? What about the series of Valerie reliquaries *as a series*? A few suggestions may be offered in an all too brief consideration of use and patronage.

Remarkably, one of the Valerie series, a twelfth-century chasse now in the British Museum, is a virtual twin of the St. Petersburg shrine, missing only a few details, although making up for this in liveliness.[27] The existence of the copy would perhaps have reinforced the prestige and importance of the original chasse for viewers. In contrast, the remaining members of the series, almost all of the thirteenth century, are smaller and have much simpler imagery. The very reduction of the narrative to one or two scenes reinforces a likeness to the succinctness of the liturgical antiphon noted above: typically the only scenes depicted on the small chasses are the saint's execution and cephalophoric miracle (often combined in one scene), usually with the apotheosis or burial of the saint.[28] Thus, in some sense, the later chasses may be

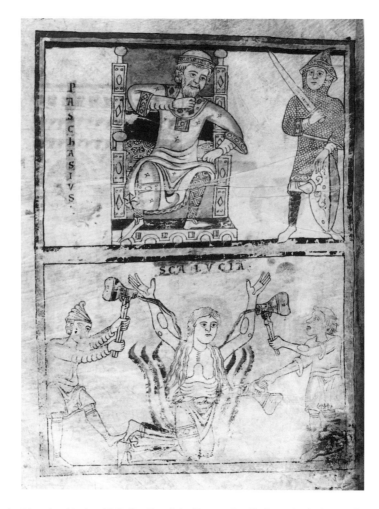

15.2. "Lucy is stripped and tortured." Berlin, Staatliche Museen, Preußischer Kulturbesitz, Kupferstichkabinett 78 A 4, fol. 66v. Photo: Staatliche Museen, Preußischer Kulturbesitz.

seen as a "reader/viewer response" to the effective storytelling and impact of the pair of earlier and more elaborate chasses—again a response perhaps shaped by the liturgy. The message of Valerie's story was clearly received and continued to be reproduced.

Questions about specific patronage of the chasses are more difficult to answer satisfactorily. Although both of the major chasses center upon the imagery of sacrifice or gift-giving in relation to their spiritual meaning (remember that the gifts of the Magi are depicted on the back of the St. Petersburg example), I do not imagine, as does Gauthier, that either of the original pair was a gift of Eleanor of Aquitaine: Gauthier suggests that Eleanor became a patron as she recognized the

Reading Medieval Images

16

The Road to Glory: New Early Images of Thomas Becket's Life

Charles T. Little

The electrifying event of the murder of Archbishop Thomas Becket in Canterbury cathedral on December 29, 1170, launched a hagiographic tradition that is without parallel in the Middle Ages. His martyrdom, and the miraculous cures that took place at his shrine in Canterbury almost immediately thereafter, initiated the widespread creation of images of his life and death. To the corpus of known representations of Thomas Becket new early images can be added in the form of carvings on an ivory comb recently acquired by the Metropolitan Museum of Art (Figs. 16.1, 16.2). Although the early history of this unusual object is unknown, it was once in an important French collection formed at the end of the nineteenth century.[1]

The double-sided object contains a rich assemblage of narrative, symbolic, and decorative elements in near perfect condition. The two principal scenes on either side illustrate events that sealed Thomas's fate. On one side is the rarely depicted episode of Henry II handing Becket his letter of appointment as archbishop of Canterbury, an event that took place at Falaise castle (Normandy) in May 1162. Thomas, dressed in a simple tunic and mantle, receives the royal nomination from Henry, who is enthroned and wearing a crown. Envious and debating courtiers witness the event. This momentous incident set into motion the conflicting loyalties to God and king that ultimately resulted in Becket's martyrdom. The identification of the scene is verified through comparison with the only other surviving representation of the episode, a miniature in the early fourteenth-century Psalter of Queen Mary (Fig. 16.3). Here the composition is nearly identical, to the point of including the advisor behind Henry and the figures behind Becket. Of the early illustrated cycles of Thomas's life and miracles, that in the Queen Mary Psalter is one of the most complete, with twenty-two scenes, and is believed to reflect, in part, a still earlier cycle.[2]

In the adjacent arcs are depicted two secondary scenes directly linked to this historic event. To the right is a sailing vessel, a reference to Thomas's crossing the Channel on his way to Canterbury. Numerous renderings of Becket's tumultuous life show him going into or coming out of exile on a ship. For example, the

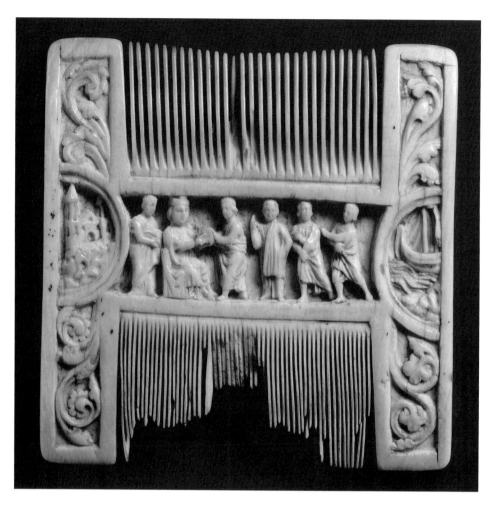

16.1. Liturgical comb with Henry II nominating Thomas Becket as Archbishop of Canterbury. Elephant ivory. New York, The Metropolitan Museum of Art (1988.279). Photo: The Metropolitan Museum of Art.

recently rediscovered single leaves painted about 1220–40 in a style close to Matthew Paris show, among other scenes, Thomas Becket arriving at Sandwich in a very similar boat.³ To the left is a rare image of the façade of Christ Church cathedral, Canterbury, built by Archbishop Lanfranc from 1070, as it existed before the devastating fire of September 1174.⁴ The prominent façade, with its raised arch indicating a central doorway, is framed by twin towers with multi-leveled arcades. Because of its miniature scale, the rendering is highly schematic, yet it approximates what is known of Lanfranc's cathedral before the fire (Fig. 16.4)—a disaster that did not, in fact, significantly damage the west façade, parts of which are immured in the present structure. In many respects the ivory image corresponds to that on the second seal of Christ Church of 1158 showing Canterbury from the south (Fig.

16
———

Reading Medieval Images

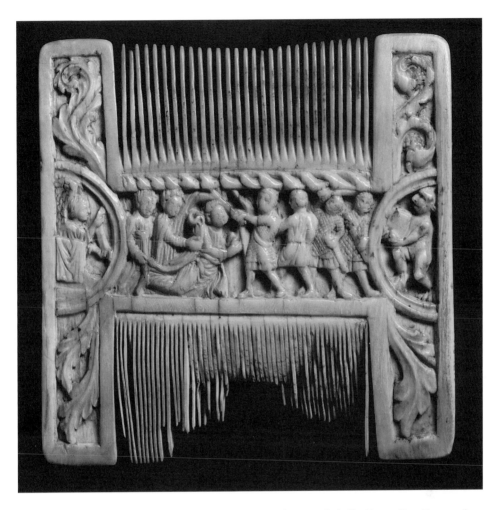

16.2. Liturgical comb (reverse) with the Murder of Thomas Becket. New York, The Metropolitan Museum of Art (1988.279). Photo: The Metropolitan Museum of Art.

16.5).[5] Further evidence that the structure is indeed Christ Church is offered by a small detail on the ivory. Around the church there is a crenelated wall with a gate that closely corresponds to that in the celebrated drawing of the water distribution system installed by Prior Wilbert ca. 1160–65.[6] The archaeological accuracy of the rendering of the façade in ivory indicates that the carver probably had some direct knowledge of the buildings and the topography of the site as they existed in the twelfth and thirteenth centuries.

The opposite side of the comb is no less remarkable. Here the focus is on the martyrdom of Thomas Becket in Canterbury cathedral on December 29, 1170. In an unusually accurate portrayal of the event—as recorded in a number of eyewitness accounts—Thomas, wearing what was described as a black mantle, falls to his

16.3. Henry II nominating Thomas Becket as Archbishop of Canterbury. London, The British Library, MS Royal 2 B. VII (The Psalter of Queen Mary), fol. 290v. Reproduced by permission of the British Library.

knees at the first blow, delivered by the knight Reginald FitzUrse, while the other conspirators (known to be Hugh de Moreville, William de Tracy, and Richard le Bret) approach him from behind with drawn swords.[7] Behind the archbishop is Edward Grim, Becket's friend from Cambridge and future biographer, who thrusts out his arm to ward off a sword blow—the very blow that sliced off the top of the archbishop's head and cut Grim's arm to the bone. Another monk, possibly William of Canterbury, stands behind Grim holding a book. While the rest of Becket's entourage had fled at the unleashing of violence, his chaplain Robert of Merton and William FitzStephen, along with Edward Grim, remained at his side.

The historical narrative is supplemented in the arc on the left by an angel bearing a scroll (?) next to an altar with three steps and, on the right, by a devil holding a book (?). An angel is often found in representations of Thomas's martyrdom, but this seems to be a unique inclusion of the devil. Their positions clearly imply that Thomas Becket resides on the side of the angel (good), while the "king's men" are associated with the devil (evil).

16

Reading Medieval Images

A comparison of the martyrdom scene on the comb to other depictions shows that it corresponds closely to some of the earliest surviving English works representing Thomas's life. The two earliest are the silver niello reliquary in the Metropolitan Museum of Art, usually dated ca. 1173–80, and the illustration in John of Salisbury's *Life of Thomas Becket*, written at Christ Church about 1180.[8] In the manuscript, as on the comb, Edward Grim attempts to protect Becket from his several attackers, while on the reliquary only two knights attack Becket, and Grim is absent, probably due to lack of space. The number of knights was not fixed in the earliest images, and any number from two to four is found. From the written accounts of the murder it appears that all of the knights wore mail, but one of the figures on the ivory is without mail and wears instead a short tunic. His gesture is enigmatic: if not an attacker, he might be attempting to restrain Reginald FitzUrse. In a similar way, the figure between the two knights on the niello casket does not wear mail and is seemingly restraining one of the knights and admonishing him. Both of these early representations thus depart from the records of the event.

The comb is further embellished with leaf patterns in the four corners of each side. Some are stiff leaf sprays, while others are coiled leaves with small buds. The care in the observation of nature is particularly sensitive. A number of the designs bear an astonishing resemblance to the acanthus capitals in the choir of Canterbury, which was erected under the direction of William of Sens and William the Englishman between 1174 and 1184. Although ultimately derived from French models, the acanthus patterns on the ivory display a richness and variety that suggest, again, a firsthand knowledge of the building.[9] The style of the foliate borders seems, therefore, to suggest a date before the end of the twelfth century for the comb.

The style of the figures also supports this date. The carving is linked to the very beginnings of the Gothic style in England, which in architecture is frequently associated with the arrival of the French architect William of Sens in 1174 to build the new choir of Canterbury. In ivory carving, manuscripts, and goldsmith work, English art of the late twelfth century was manifestly transitional in character, and artisans were working in a classicizing style that, for lack of a better appellation, is sometimes called the "Year 1200" style. The miniature stage space upon which the characters act out the drama of the pivotal events in Becket's life is filled with figures that are classically inspired. Mobility and spatially suggestive postures provide psychological animation. Drapery also becomes a vehicle of expression. Dressed in mantles pulled across their torsos, the figures manifest the *all'antica* tendencies of the art of northern France and England around 1200.

In many respects these figures recall, in form and presentation, those found on the contemporary silver-gilt repoussé ciborium in St. Maurice d'Agaune, an English work that has been compared to such manuscripts as the Westminster

16

16.4. Left: Christ Church, Canterbury, built by Lanfranc. Right: Christ Church, Canterbury, as depicted on the comb. Drawings by author.

Psalter (ca. 1200), and to the "transitional style" sculpture on the north doorway of the Lady Chapel at Glastonbury, built between 1184 and 1186.[10] The graceful and noble figures on the ciborium and on the comb appear to have evolved in a similar artistic milieu. English wood carving of this period also supports a date toward 1200. Close in style to the seated king on the comb is the enthroned wood Virgin and Child from Langham (Essex), now in the Victoria and Albert Museum.[11] Both possess fluid drapery forms and thick-set figure types.

An origin in Canterbury, the center of the production of imagery perpetuating Becket's cult, is entirely possible. The apparent accuracy of the narrative scenes, corresponding more closely to the eyewitness accounts of the events than other representations, the reliability of the depiction of the façade of Lanfranc's cathedral, and the similarity of the foliage to the choir capitals collectively argue for a Canterbury provenance.

For whom would such a luxury object have been made? The decoration with scenes devoted to Thomas's life suggests that the object would have belonged to a churchman rather than a lay person and that it would thus have served as a liturgical comb rather than an object for private use. As a liturgical comb it becomes a work of some power and significance. According to the thirteenth-century bishop of Mende, William Durandus, who wrote a tract on liturgical symbolism, the comb was a symbol of discretion. Prior to the celebration of the mass, the officiating priest's hair

Reading Medieval Images

16.5. Second Seal of Christ Church, Canterbury. London, British Library, Add. Charter, 67,123. Reproduced by permission of the British Library.

would be combed by the deacon in order to remove any "superfluous thoughts" (*cogitationes superfluas*)—an act of symbolic cleansing.[12] Bishops used combs in the ceremonies at the time of their installation as well as before their approach to the altar during mass. A prayer in the pontifical of Paris was to be recited by the celebrating bishop at the moment of the combing: "O Lord, may your benevolent spirit purify and cleanse our head and body and mind inside and out" (*Intus exteriusque caput nostrum totumque corpus et mentem meam tuus, Domine, purget et mundet Spiritus almus)*.[13] In the course of the liturgical day the comb could be used several times: the thirteenth-century "Evesham Book," containing general directions for abbots of the monastery of Evesham, says that as part of the ritual the abbot's hair was combed in the sacristy before Vespers and before the solemn chanting of the Gospels at Matins; there was also a combing before mass.[14] In the ritual at the church at Viviers (1360) the combing of hair was performed three times during the mass. The celebrant sat during the Kyrie, the Gloria, and the Credo, "and as many times as he rose, the deacon, having removed his headdress and amice, combed his hair" (*unde quoties assurgebat; ipsi capillos pectebat Diaconus amoto ejus capello seu almucio*).[15] At least from the time of Edward the Confessor the comb formed part of the coronation ceremonial.[16] Thus, aside from their purely utilitarian function in lay society, combs played an important role in church ceremonial.

16

Medieval church treasuries were repositories of these liturgical combs, many of which were presented by kings, queens, and bishops. Royal gifts include the so-called comb of Theodolinda, by legend given to Monza cathedral in the sixth century but first recorded in the 1275 inventory, and the ivory comb of Henry I, mounted with gold and gems, probably presented to the Quedlinburg treasury at the end of the tenth century.[17] At Canterbury cathedral six ivory combs were inventoried, along with two of special note: a gift of Henry III made of gold with gems and another of ivory with silver-gilt plates on the sides.[18]

By far the largest category of combs are those associated with saints. As secondary relics they form a significant body of material. Historically combs were deposited in the graves of their owners; many have been found in Frankish and Anglo-Saxon cemeteries. In monastic settings they were important personal belongings, buried with the dead because they were given at the time of the taking of vows and the first tonsure. The seventh- or eighth-century comb of St. Lupus, archbishop of Sens (died 623), shows rampant lions; cut à jour, the comb looks purely secular, but the saint's name is prominently inscribed on it (PECTEN S. LVPI).[19] Other combs with no particular religious imagery but associated by tradition with saints are known, for example, the comb in the treasury of the cathedral at Nancy, which belonged to St. Gauzelin, Bishop of Toul, or that found in the shrine of St. Anno in Siegburg, made in 1183.[20] One of the humblest of surviving combs, devoid of decoration and probably of Egyptian origin, comes from the tomb of St. Cuthbert (d. 687) at Durham cathedral; it was recorded in the saint's translation in 1104.[21]

The personal comb of Becket is presumed to have been lost, since it was not among the items—including his vestments, a chalice, gloves, ring, sandals, and pastoral staff—that were placed in his new shrine in Trinity Chapel in 1220. But, surprisingly, the 1432 register of Glasgow cathedral mentions "a precious burse with the combs of St. Kentigern and St. Thomas of Canterbury."[22] What became of Thomas's comb? During the Reformation the last Roman Catholic archbishop of Glasgow, James Beaton (1517–1603), fled to France in 1560 with the treasures and records of the see. Deposited in the Scots College in Paris, they were sent to St. Omer at the outbreak of the Revolution but never recovered. Could the Metropolitan Museum's ivory comb, which surfaced in France in the nineteenth century, be the reputed comb of Thomas Becket and, therefore, be a vestige of the peregrination of the Glasgow cathedral treasury? According to this scenario, the narrative decoration on the comb would be explained as a later embellishment in order to secure the identity of the original owner. This hypothesis would help to account for the comb's unusual iconography. There is only one other comb known to display scenes of a saint's life: an early thirteenth-century ivory fragment in Berlin showing the miraculous discovery of the bones of St. Clement, the first-century pope, by Cornelius and Phoebus and identified by the inscription CLEMENS E TVMVLO.[23]

16

It is equally possible that the comb was commissioned by a succeeding archbishop of Canterbury who wanted to emulate Becket's stand against the king and protection of the church. The patron of the comb's decorative program, then, would have wanted these key themes depicted because they exemplified not only the virtues of the office of the archbishop but also the Christ-like nature of Thomas's martyrdom: it was recognized in the eyewitness accounts that Becket's return to Canterbury and death manifested a clear desire to follow the path of Christ.

But this, too, is speculative, and perhaps it is best to consider the comb, commemorative of Thomas's life and death, as forming part of the vast quantity of memorabilia produced at Canterbury for the pilgrims thronging there to witness the miracles performed at his tomb and wishing to carry away an image of the most celebrated martyr of Christianity in the later Middle Ages. Evidence of this production is provided by the numerous reliquary caskets and other objects made after Thomas's canonization in 1174. Some of these pieces were luxury objects produced for persons of wealth and power, such as the gold relic locket pendant made for Reginald FitzJocelin, bishop of Bath (1174–91), for presentation to Margaret, dowager queen of Sicily who died in 1183.[24] The fact that the comb is a specifically liturgical object, possibly used by an archbishop or bishop, reinforces its status as a commemorative work. Other liturgical works were made for a similar purpose. Several late twelfth- and thirteenth-century bishops' miters survive on which scenes of the martyrdom are prominently displayed. One now in the Bavarian National Museum, Munich, shows the martyrdom of Becket on one side and that of St. Lawrence on the other.[25] This object, and others like it, were probably produced in an embroidery workshop connected to Christ Church cathedral. Like the comb, such objects were part of an extensive serial production intended for distribution as propaganda for the cult of St. Thomas.

The comb therefore adds a new dimension to the works probably made at Canterbury to perpetuate the memory of St. Thomas. The imagery selected for its decoration condenses on a single object the causes for which he fought. More than local or national concerns, they took on an international character, being integral to the conflict between papacy and empire. Thomas's instant veneration as a martyr reverberated throughout Europe, and a comb whose function was both practical and symbolic could become an emblem of his cause.

1 1988.279. Purchase, Rogers Fund and Schimmel Foundation, Inc., Mr. and Mrs. Maxime Hermanos, Lila Acheson Wallace, Nathaniel Spear Jr., Mrs. Katherine Rorimer, William Kelly Simpson, Alastair B. Martin, and Anonymous Gifts, 1988. H. 3 3/8 in. (8.6 cm); W. 3 3/8 in. (8.6 cm). Formerly in the collection of Marquis de Ganay; Martine, Comtesse de Béhague, Paris. Published: Sotheby's, Monaco, Antiquités et Objets d'Art, December 5, 1987, lot 166 (called North Italian, 12th/13th century with an Old Testament scene and a martyrdom of a saint); *Metropolitan Museum of Art Bulletin, Recent Acquisitions*, n.s. 47/2 (Fall 1989), 16.

2 George Warner, *Queen Mary's Psalter* (London, 1912), pl. 284. Tancred Borenius, *St. Thomas Becket in Art* (London, 1932), 54–55, suggests that a cycle of scenes in the choir of the cathedral of Trier, which existed until the 1860s, began with the scene of Henry II appointing Thomas archbishop. See Paul Clemen, *Die romanische Monumentalmalerei in den Rheinlanden* (Düsseldorf, 1916), 621–23, fig. 433.

3 Currently on loan to the British Library. See Janet Backhouse and Christopher de Hamel, *The Becket Leaves* (London, 1988), fol. 4v.

4 The fire and repair of Christ Church are described in considerable detail by the monk Gervase in his *Tractatus de combustione et reparatione Cantuariensis ecclesiae*, ed. William Stubbs, *The Historical Works of Gervase of Canterbury*, vol. 1, Rolls Series, no. 73/1 (London, 1879), 3–29. See especially Francis Woodman, *The Architectural History of Canterbury Cathedral* (London, 1981), 24–86; and his "Lanfranc's Cathedral at Canterbury," *Canterbury Cathedral Chronicle* 71 (1977), 11–16.

5 T. A. Heslop, "The Conventual Seals of Canterbury Cathedral, 1066–1232," in *Medieval Art and Architecture at Canterbury before 1220*, The British Archaeological Association Conference, Transactions for the Year 1979 (Leeds, 1982), 94–100. According to Buckler's nineteenth-century measured drawings, the west façade towers were much like the transept façade. See Woodman, *Architectural History*, 35 and fig. 20.

6 Cambridge, Trinity College, MS. R.17.1, fols. 284v–285r. Francis Woodman, "The Waterworks Drawings of the Eadwine Psalter," in *The Eadwine Psalter: Text, Image, and Monastic Culture in Twelfth-Century Canterbury*, ed. Margaret Gibson et al. (London and University Park, PA, 1992), 168–77. Illustrated in color in Deborah Kahn, *Canterbury Cathedral and Its Romanesque Sculpture* (London, 1991), pl. VII.

7 The various accounts are collected in *Materials for the History of Thomas Becket, Archbishop of Canterbury*, ed. J. C. Robertson (I–VI), with J. B. Sheppard (VII), Rolls Series, no. 67 (London, 1875–85). Several recent biographies carefully reconstruct the sequence of events; see Frank Barlow, *Thomas Becket* (Berkeley, 1986), 225–50, and Richard Winston, *Thomas Becket* (New York, 1970), 351–66. See also John Butler, *The Quest*

for Becket's Bones (New Haven, 1995), 1–14. Most representations depict Thomas in pontifical vestments preparing for mass near an altar. See Ursula Nilgen, "La 'tunicella' di Tommaso Becket in S. Maria Maggiore a Roma: Culto e arte intorno a un santo 'politico,'" *Arte medievale* 9/1 (1995), 105–20; and her "The Manipulated Memory: Thomas Becket in Legend and Art," in *Memory and Oblivion*, ed. W. Reinink and J. Stumpel, Proceedings of the XXIXth International Congress of the History of Art held in Amsterdam, 1–7 September 1996 (Dordrecht, 1999), 765–72.

8 For the casket see *English Romanesque Art, 1066–1200*, exh. cat. (London, 1984), no. 302, and Neil Stratford, "Niello in England in the Twelfth Century," in *Art and Patronage in the English Romanesque*, ed. Sarah Macready and F. H. Thompson, The Society of Antiquaries, Occasional Papers, n.s. 8 (London, 1986), 28–49, esp. 43–44; for John of Salisbury's *Life of St. Thomas Becket* (British Library, MS Cotton Claudius B.II), C. M. Kauffmann, *Romanesque Manuscripts, 1066–1190* (London, 1975), no. 93.

9 Especially close are the patterns on North 2, 8, and 11. See Roslin Mair, "The Choir Capitals of Canterbury Cathedral, 1174–84," in *Medieval Art and Architecture at Canterbury before 1220* (as n. 5), 56–66, pls. VIIa, VIIIc, IXc.

10 *English Romanesque Art*, no. 82, and George Zarnecki, "The Transition from Romanesque to Gothic in English Sculpture," in *Studies in Romanesque Sculpture* (London, 1979), IV 152–58, esp. 57–58. See also Daniel Thurre, *L'atelier roman d'orfèvrerie de l'Abbaye de Saint-Maurice* (Sierre, 1992), 237–42.

11 Paul Williamson, *Northern Gothic Sculpture, 1200–1450* (London, 1988), no. 1.

12 Durandus, *Rationale Divinorum Officiorum*, 4.3; ed. A. Davril and T. M. Thibodeau, CCCM 140 (Turnhout, 1995), 259–62. See, in general, Henry John Feasey, "The Use of the Comb in Church Ceremonies," *The Antiquary* 32 (1896), 312–16, and Rohault de Fleury, *La messe*, vol. 8 (Paris, 1889), 167–73.

13 Cited by M. Bretagne, "Recherches sur les peignes liturgiques," *Bulletin monumental* 27 (1861), 273–83, esp. 275.

14 *Officium ecclesiasticum abbatum secundum usum Eveshamensis monasterii*, ed. H. A. Wilson, Henry Bradshaw Society, vol. 6 (London, 1893), 1, 7.

15 Du Cange, *Glossarium Mediae et Infimae Latinitatis*, s.v. "Sedes majestatis."

16 Feasey, "The Use of the Comb," 312.

17 *Il Duomo di Monza: I tesori*, ed. Roberto Conti (Milan, 1989), 40–41. See Dietrich Kötzsche, "Der sogenannte Kamm Heinrichs I. in Quedlinburg," *Festschrift*

für Hermann Fillitz zum 70. Geburtstag = Aachener Kunstblätter 60 (1994), 97–104. For a general survey see Franz Swoboda, "Die liturgischen Kämme" (Ph.D. diss., Universität Tübingen, 1963).

18 J. Wickham Legg and W. H. St. John Hope, *Inventories of Christchurch Canterbury* (Westminster, 1902), 24, 74.

19 *Les trésors des églises de France*, exh. cat. (Paris, 1965), no. 813.

20 Ibid., no. 834. *Monumenta Annonis: Köln und Siegburg. Weltbild und Kunst im hohen Mittelalter*, exh. cat. (Cologne, 1975), no. D11.

21 See Peter Lasko, "The Comb of St. Cuthbert," in *The Relics of Saint Cuthbert*, ed. C. F. Battiscombe (Oxford, 1956), 336–49.

22 *Registrum Episcopatus Glasguensis*, vol. 2 (Edinburgh, 1843), 330, no. 339: "Item una bursa preciosa cum pectinibus sanctorum Kentigerni et thome cantuariensis." Cited by Feasey, "Use of the Comb," 315.

23 Charles Little, "An Ivory Tree of Jesse from Bamberg," *Pantheon* 32 (1975), 292–300, fig. 7.

24 Thomas P. F. Hoving, "A Newly Discovered Reliquary of St. Thomas Becket," *Gesta* 4 (1965), 28–30. An important fourteenth-century pewter pilgrim's badge depicting the now destroyed shrine of St. Thomas has been given to the Metropolitan Museum of Art (2001.310). See "Recent Acquisitions: A Selection, 2000–2001," *Metropolitan Museum of Art Bulletin* (Fall 2001), 19.

25 Agnes Geijer, "Engelska broderier av romansk typ," *Nordenfjeldske Kunstindustrimuseum Årbok* (1956), 43–69, repr. p. 49.

16

Sacred Images

The special category of images called sacred designates those images deemed worthy of veneration, those that elicited devotion and became objects of cult. Indeed the origin of the Christian veneration of sacred images has often been sought in pilgrimage devotion and the cult of relics promoted at saints' shrines.[1] Attitudes toward sacred images developed along different tracks in the Byzantine East and Latin West. In the West, for example, the emphasis on the instructional role and didactic capacity of religious imagery was stronger and longer lived than in Byzantium. And, decisively important, Byzantium, unlike the West, experienced an Iconoclastic Controversy in the eighth and ninth centuries: the need to mount a defense against those who would destroy all images of God and his saints, on the grounds that they were idolatrous, led to the articulation of an orthodox theology of sacred images.[2]

In the Byzantine tradition, veneration was given not to the image but to the model or archetype represented by that image: not to the image of Christ but to Christ himself. Iconic representations were believed to have the ability to direct a viewer's prayer to the archetype, focusing the viewer's attention and potentially triggering an intense spiritual encounter.[3] The tenth-century story of a sick man who prayed while gazing up at the icon of Christ Pantokrator (Christ as "all-ruler") in the central dome of the Holy Apostles in Constantinople shows how such an exchange might occur.

> "Lord, if I tremble from fear at the sight of your icon which has been produced by human hands, how will I, wretch that I am, be able to look upon you, the fearsome Judge, when you come to judge the universe? I have sinned, Lord. Forgive me, for I have not kept your commandments." Having said this, he started to confess his sins, all except for one that he was too ashamed to admit. Whereupon a voice came to him from the image, saying: "Speak!" As soon as the man had declared his remaining sin, another fearsome voice was heard: "Your sins are forgiven."[4]

Such stories reflect popular attitudes toward sacred images, but they are kin to more sophisticated understandings of the affective power of icons.

At around the turn of the thirteenth century, Nicholas Mesarites ruminated upon the effect of another iconic representation of Christ Pantokrator in these words: "His eyes, to those who have achieved a clean understanding, are gentle and friendly and instill the joy of contrition in the souls of the pure in heart, ... to those, however, who are condemned by their own judgment, they are scornful and hostile

and boding of ill."[5] Mesarites, too, speaks of an image of Christ, but he directs his analysis of its power to the viewer rather than to the image, locating the figure's transformative force in the viewer's faith rather than the icon's form. Modern historians have by and large followed Mesarites' lead, especially when confronted with the formulaic repetitiveness of key iconic themes.

Byzantine icons, especially icons of Christ and the Virgin, often adhered to recognizable types: Christ as Pantokrator carries a book in his left hand and makes a gesture of blessing with his right; the Virgin Hodegetria ("pointing the way") supports the Christ child with her left hand and gestures toward him with her right. The temptation in art-historical scholarship has been to name and classify these types rather than to explore the distinctive affective characteristics of each or to investigate the ramifications of replication and its role in heightening spiritual affect.[6] In the following essay, Annemarie Weyl Carr examines a miracle-working icon of the Virgin in the shrine of Panagia Theoskepaste on Cyprus that replicates a much replicated icon of a particular type. The name given to the type, "Kykkotissa," refers not to an aspect of the mother of God but to another powerful Cypriote icon, this one in a shrine at Kykkos. Carr shows how the power of each reproduction was enhanced by association and how the type came to be "validated by an implicit history of effective Marian interventions." Her analysis of the presentational character of the Kykkotissa type and her discussion of how the devout viewer *sees* significance in the physical, tangible icon add a new dimension to our understanding of how sacred images worked in the Byzantine East.

T. K. T

1 Hans Belting, *Likeness and Presence: A History of the Image before the Era of Art*, trans. E. Jephcott (Chicago, 1994), esp. 59–62. See also Thomas F. Mathews, "Pagan Icons," in *Ancient Faces: Mummy Portraits from Roman Egypt*, ed. Susan Walker (New York, 2000), 124–27.

2 *The Sacred Image East and West*, ed. Robert Ousterhout and Leslie Brubaker (Urbana, 1995), esp. 1–24 ("Introduction: The Sacred Image"); Celia Chazelle, "Memory, Instruction, Worship: 'Gregory's' Influence on Early Medieval Doctrines of the Artistic Image," in *Gregory the Great: A Symposium*, ed. John C. Cavadini (Notre Dame, 1995), 181–215. For instances of the interpenetration of eastern and western attitudes, see Kurt Weitzmann, "Crusader Icons and *Maniera Greca*," in *Byzanz und der Westen: Studien zur Kunst des europäischen Mittelalters*, ed. Irmgard Hutter (Vienna, 1984), 143–70.

3 Gilbert Dagron, "Holy Images and Likeness," *Dumbarton Oaks Papers* 45 (1991), 23–44. See also Henry Maguire, *The Icons of Their Bodies: Saints and Their Images in Byzantium* (Princeton, 1996), esp. 16.

4 As paraphrased by Henry Maguire, "*Abaton* and *Oikonomia*: St. Neophytos and the Iconography of the Presentation of the Virgin," in *Medieval Cyprus: Studies in Art, Architecture, and History in Memory of Doula Mouriki*, ed. Nancy Patterson Ševčenko and Christopher Moss (Princeton, 1999), 95–105, at 103.

5 Maguire, *The Icons of Their Bodies*, 116–17, citing the translation of Glanville Downey.

6 Victor Lasareff, in "Studies in the Iconography of the Virgin," *Art Bulletin* 20 (1938), 26–65, provides an early critique of the scholarly emphasis on "main" icon types and an "underestimation of the emotional element and its meaning in art" (26).

17.1. Kalopanagiotis, Shrine of the Panagia Theoskepaste showing the icon. Photo: author.

17 The "Virgin Veiled by God": The Presentation of an Icon on Cyprus

Annemarie Weyl Carr

Few representational genres pose the challenge of reading images so clearly as do the holy images of the Orthodox Church, known literally as "images": icons.[1] Icons have been made for many centuries and continue to be made today. But they have been the object of art-historical inquiry largely for students of Byzantium, who examine them at long chronological remove as works designed to function in a culture far distanced from our own. Any assessment of how icons might have looked to Byzantine viewers raises at once the question of how they were supposed to work. Appreciative of their stylistic abstraction, we approach the question of their function in a manner akin to Alice in Wonderland's looking glass. Either they are mirrors in which we contemplate our own anxious gaze in the hope of gaining methodological insight, or they vanish altogether, becoming transparent upon another world. We have found it hard to fix our attention on the surfaces themselves and their modes of effectiveness. Given the ease with which their images migrate from one medium, one size, one level of aesthetic sophistication to another, it has been simpler for us to reduce them to the status of signs—of logos, even—and so to evade the issues of their physical presence altogether. We have preferred to invoke "real presence" rather than the literal presence of the painted panels themselves. Not without a degree of relief, for instance, Byzantinists have exposed the volatility of designations like "Blachernitissa," "Eleousa," and even "Hodegetria." That these epithets were affixed to varying images of Mary seemed to prove that the names did not invoke specific charismatic paintings but instead were ways of characterizing Mary herself. Most icons, moreover, are not furnished with qualifying nicknames at all. They simply label the subject in a way that invites us to bypass the specific, physical icon and focus on the sacred original.

Yet it is clear that how images "mean" as messages must in some fundamental way coincide with the way in which they "work" as objects. Orthodoxy's holy icons, no less than our works of "art," have their hierarchy of more and less effective examples. Some icons are greater and more holy than others. And the more holy icons maintain a strong objective existence. This was made clear to me by an

investigation of one particularly famous icon: the miracle-working icon of the Mother of God at Kykkos Monastery on Cyprus.[2] The Kykkotissa—as the icon is known today—has been fully veiled from sight since at least the seventeenth century and remains hidden from view today. Pilgrims are admonished to honor it more as an object than an image. "Virgin Mary held this in her hands," they are told. The icon's legend dwells upon the heavenly origin of the panel's wood: brought by the archangel Gabriel from the tree of knowledge in Paradise, it was painted by St. Luke the Evangelist, blessed by the Virgin Mary, and greeted on its arrival in Cyprus by the island's trees, which bent their tips to the ground in its honor.[3] The Kykkotissa's myriad replicas—as much as they offer a vision of Mary—offer a recognizable replica of that miracle-working panel. They re-present not simply Mary but the icon of Kykkos, a place at which Mary's power has been known to be active. As such they offer a site for veneration; at the same time, they proffer proof that icons (like the Kykkotissa and—indeed—like themselves) can provide an avenue of special access to Mary. Olga Gratziou has shown how the printed engravings of the Kykkotissa that the monastery sold by the thousands in the eighteenth and nineteenth centuries embedded the icon's image in an elaborate staffage—images of the icon's miracles, figures of God the Father and angels hovering over it, or St. Luke painting with his brush the figure of Mary herself—that proclaimed the print's authenticity as a replica of the great icon in a way that was accomplished more directly in painting through the use of the traditional tempera medium.[4]

The Kykkotissa is a great icon. But all icons play upon their membership in the class of holy image. They adhere to familiar styles and types, and they repeat with particular frequency those types that have become the sites of miraculous occurrences.[5] More than the names, it is the images themselves, recurrently quoting miracle-working icons, that affirm the special potency of icons as replicable sites of sanctity. Reflecting a site one comes to—as much as an image one sees through—they offer themselves for scrutiny by those seeking authenticity and the access it affords. We can, then, ask about this scrutiny.

It is in the spirit of this conception of the icon—as the re-presentation of a holy object—that the ensuing study approaches the interpretation of one particular panel. This panel repeats the iconography of the icon at Kykkos, showing the Virgin gazing over the averted head of a bare-legged Child, who twists kicking in her arms, a scroll in his right hand and his left in the folds of a scarlet veil that falls over his mother's traditional maphorion. The painting is of high quality, but its original setting is unknown. It offers us, in short, an icon of the type of the Kykkotissa whose excellence warrants it a place in the history of art but whose original context is lost, forcing us to confront the object itself for interpretive insight.

The icon in question resides in a tiny chapel outside the village of Kalopanagiotis in Cyprus's Marathasa Valley (Fig. 17.1).[6] Quite hidden by two

17

216　　　　　　　　　　　　　　　　*Reading Medieval Images*

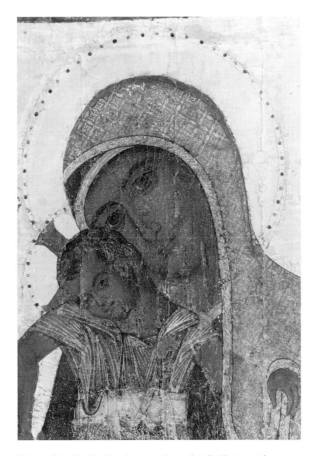

17.2. Kalopanagiotis, Shrine of the Virgin Theoskepaste, icon: detail. Photo: author.

huge live oak trees that are often aflutter with prayer cloths, the chapel is signaled by a rickety electric sign that gives its name, Panagia Theoskepaste: the "Virgin Veiled by God." The name could readily be linked with the icon, which dominates the building's little interior by its large size and fine quality, but in fact the icon's connection with the chapel is unclear. Older than the present chapel, it is not noted by any of the ethnographers who recorded the chapel's many legends, and it seems to have attracted no attention until it was relieved of thick soot and a silver cover twenty years ago.[7] At 113 cm in height, it is the second largest medieval panel of the Kykkotissa's type that is known in Cyprus (Figs. 17.2, 17.3; Color Plate 6). Its style resembles closely that of a well-known icon of the archangel Michael from the Chrysaliniotissa Church in Nicosia, assigned to the end of the fourteenth century.[8] The smooth, pale golden ground, the distinctive configuration of the halo with its red and green jewels and finely incised tracery, and above all Mary's face with its long, firm nose, finely modeled incarnadine, and large, graceful eyes, link it closely

17

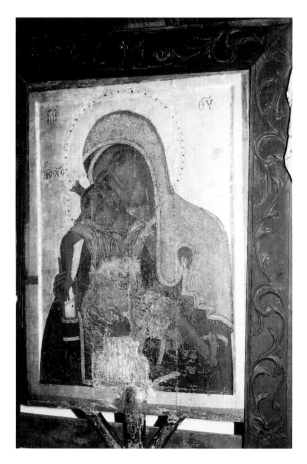

17.3. Kalopanagiotis, Shrine of the Virgin Theoskepaste, icon. Photo: author.

with the Michael. It may be contemporary with the icon in Nicosia, but it is safer to place it somewhat later, in the fifteenth century. This dating is indicated by the shape of the Christ Child's boyish face, in which the chin is set off by a sweet curve from the baby fat of the cheeks (Fig. 17.2). This is a facial type that seems to appear in the late fourteenth century in Italy and to migrate from there into other Mediterranean regions in the fifteenth.[9]

The icon's date is significant, for it places the panel among the earliest paintings of the Kykkotissa's type that are known to survive on Cyprus. These early examples are concentrated in the Marathasa Valley, where the shrine of the Theoskepaste is located.[10] They may be replicas of Kykkos's icon; on the other hand, the truth may be just the opposite: the icon of Kykkos may echo a type with earlier roots in Marathasa. Certainly, the type was already old and widespread by the time it became prominent on Cyprus. Its earliest known occurrence is on an

17
––––

Reading Medieval Images

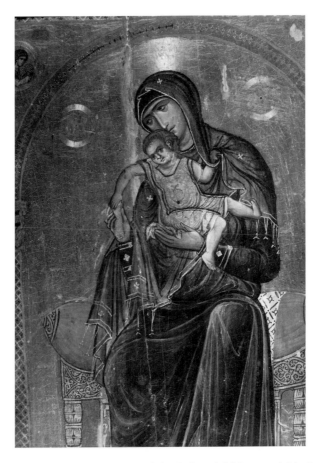

17.4. Mount Sinai, Monastery of St. Catherine. Icon of the Virgin and Child surrounded by Prophets: detail. Reproduced through the courtesy of the Michigan-Princeton-Alexandria Expedition to Mount Sinai.

early twelfth-century panel of truly courtly excellence preserved at St. Catherine's Monastery, Mount Sinai (Fig. 17.4).[11] The image seems to have been known but not in any way notable on Cyprus from the twelfth century onward;[12] it assumed greater prominence in Sicily and southern Italy, where a cluster of impressive miracle-working examples is preserved from the late thirteenth and fourteenth centuries.[13] Surviving examples from Marathasa begin to appear at much the same time that Marathasa's Lusignan lord, Queen Eleanor of Aragon, helped rebuild Kykkos in the wake of the devastating fire of 1365 to which later legend assigned the icon's signature miracle.[14] The far-flung recurrence of the Kykkotissa's type in places as distant as Sinai and Sicily tells us that the image made famous by Kykkos was familiar already at the time of the Kykkotissa's first miracle: more than Mary merely, the image presented a recognized type, an icon validated by an implicit history of effective Marian interventions. The name "Kykkotissa," then, is an accretion; it masks

17

rather than explains the image's appeal.

Having a large icon of the Kykkos type so radiantly available to the eye is wholly exceptional—most of Cyprus's major examples are veiled, like their model at Kykkos. Of all Cypriot examples, the Theoskepaste is the most visible: the one that most invites speculation about its image.[15] It repeats, as noted, the image that had been used three centuries earlier in the famous twelfth-century icon at Sinai (Fig. 17.4). It has been the contention of this article that icons were *seen* as much as seen through: that the very physical objects themselves were of focal significance. But how one sees significance in an object remains very complicated. In the case of the Sinai icon, our image of the Virgin appears surrounded by prophets, apostles, Mary's parents Joachim and Anna, the protoparents Adam and Eve, and God himself in a richly elaborated composition. The mating of this particular image of Mary to the frame of prophecy that surrounds it can hardly be casual and has begged explanation.[16] The key seems to lie in the posture of the Christ child. It echoes closely his posture in twelfth-century images of the Presentation in the Temple—exemplified by the tetraptych on Mount Sinai, where one sees the same kicking pose of the bare legs and the twisting posture (Fig. 17.5).[17] This accords with the way the gaze

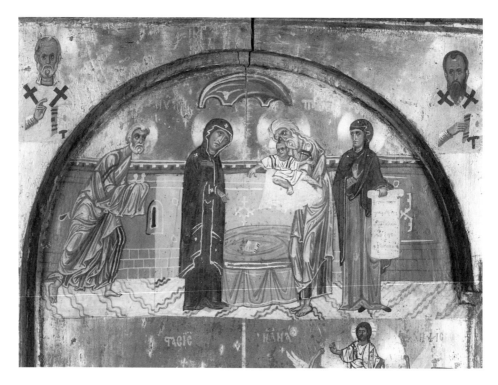

17.5. Mount Sinai, Monastery of Saint Catherine. Tetraptych with feast scenes: detail, Presentation of Christ. Reproduced through the courtesy of the Michigan-Princeton-Alexandria Expedition to Mount Sinai.

Reading Medieval Images

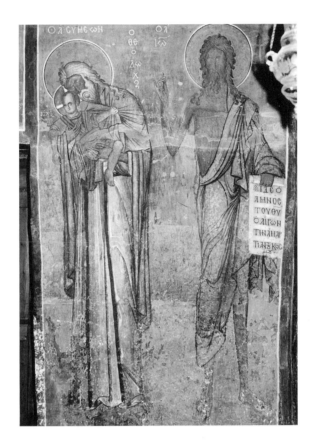

17.6. Lagoudera, Church of the Panagia tou Arakos. Symeon Christodochos. Photo: author.

of Mary meets, among all the prophets, the figure of Symeon, "last dying voice of the Old Testament." Symeon bears on his scroll his prophecy of the sword that would pierce Mary's heart, interpreted throughout the Middle Byzantine period as a reference to her sorrow at the Crucifixion. These suggest that we see Mary here as the Virgin of the Presentation, who fulfills not only the prophecies of the Incarnation but the terrible promise of the Passion as well.

The linkage of the Child's pose with the Presentation seems confirmed by its recurrence in the earliest witness we have to the posture's use on Cyprus. It appears here in the person not of Mary but of Symeon, in the mural cycle of 1192 at Lagoudera (Fig. 17.6).[18] Symeon is not actually shown in a scene of the Presentation. But his placement is striking. Located below the scene of Mary's own Presentation in the Temple, with the inscription of the donor's presentation of the church just over his head, he stands directly across the naos from the Virgin, shown bearing the Child and flanked by angels who respond to Symeon's prophecy by displaying the instruments of the Passion. Thus, Symeon seems to function in a whole web of "presentational"

17

imagery. This suggests that this strikingly physical image of the Child, with his kicking legs and twisting pose, is linked in content, too, to themes of Christ's corporeality. This is a Christ whose significance lies in his being flesh, and mortal. It yields one of a range of Marian images with very active, bare-limbed children that became prominent from the late eleventh century on. We link these images—I believe correctly— with the cultural and theological shift that emphasized the fleshly and Eucharistic aspects of Christology. But they exhibit a shift in the imagery of Mary, too. Mary does not simply present what comes from the Father; she offers what she authors, which is the flesh. With this, she acquires a sharper centrality that affects not just the iconographic but the charismatic character of the image.

The scholarly literature that speculates upon the way in which Byzantium's iconic images worked has become very ramified and represents by now a wide range of theoretical opinion. It is, however, characteristically theological and focused largely on images not of Mary but of Christ. Gary Vikan's delectable article on edible icons, for instance, argues the use of iconic images in terms of the Eucharistic bread: the image is consumed in the act of response.[19] Vikan builds here upon the image of the icon as a window upon its original, becoming virtually transparent in the viewer's eyes. Robert Nelson's article on the discourse of icons "then and now" offers a more opaque view of the icon, in which the immediacy invoked is less that of image and

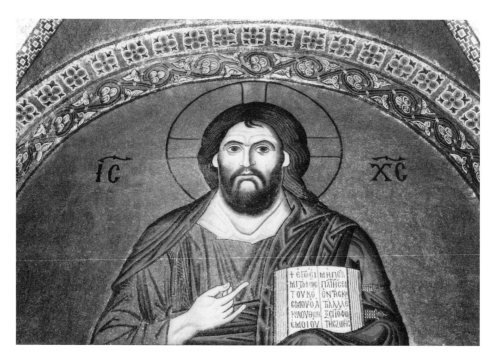

17.7. Monastery of Hosios Loukas, narthex: Pantokrator. Photo: courtesy of Gerald L. Carr.

original than of image and viewer.[20] He examines images of the type known nowadays as the Pantokrator (Fig. 17.7). Focal for him is the image of the Word: the open book. The book is the image of the Logos, and God's portrait frames this central image, giving it immediacy by directing his word to *us*. Visionary for Vikan, the image becomes acoustic for Nelson. But for both, the image of Christ is central.

Now, the images of Mary also carry the Logos. In the pose known nowadays as the Hodegetria, her image is strikingly similar to that of the Pantokrator, the upright Child in her arms resembling the Pantokrator's book (Fig. 17.8). Both images are Logo-centric. But here the word-image dynamic cannot work the same way. Mary does not speak the Word; the Logos is not the voice of her image. Mary cannot speak the Word; she can only present it. This is apparent in the gesture of her hand, pointing toward the Child and not, as in the image of the Pantokrator, raised in speech. Only very rarely can Mary present her own word in the direct posture that we know from Christ: the famous image of the Magnificat in the Dumbarton Oaks Psalter is the clearest instance.[21] Here the word *is* her own—the Magnificat itself (Luke 1:46–55). In the Hodegetria, she offers not her own word but the word of the Father in her flesh. From this image, then, we may turn to the icon on Sinai (Fig. 17.4). Once again, it is Christ who is central to our way of interpreting the image because he is the unexpected element. Instead of sitting

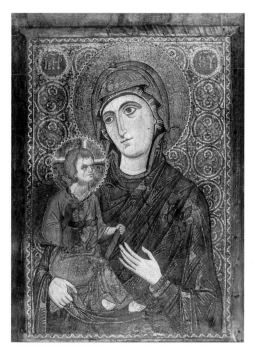

17.8. Mount Sinai, Monastery of St. Catherine. Mosaic icon of the Virgin. Reproduced through the courtesy of the Michigan-Princeton-Alexandria Expedition to Mount Sinai.

17

"Virgin Veiled by God"

Logos-like and behaving like a book, he has wriggled into a canted, diagonal position that displays to greatest advantage his bare legs, plump belly, and squirming energy. It is not his role as a manifestation of the Word, but his role as a body that is engaging. As such, he emphasizes not the presentational aspects of the Hodegetria but representational aspects of physical life.

This fundamentally physical Christ challenges the economy of the icon that Nelson represents—one that sees the icon functioning in verbal terms, as a statement of a text. The Sinai icon is, moreover, not alone in doing so. It offers just one of a number of variants of the Virgin with a bare-legged, twisting Child that became current in the late eleventh and twelfth centuries. To Hans Belting, who did most to heighten our awareness of this development, these images stand at the threshold of the shift from presence to representation, from icon to art.[22] As such, these images seem—again—to inch away from the essence of the icon as a charismatic form. Yet these analyses run almost head on into the fact that it is precisely these images, one after another, that go on to become the great miraculous images of the late and post-Byzantine centuries: the Kykkotissa, the Pelagonitissa, the Kardiotissa are among the truly great iconic archetypes of later and post-Byzantium—they cannot represent a departure from the icon. What I think they do represent, however, is a shift in what Lynn Hunt might call the "family romance" of Christological imagery, as the Mother of God takes a focal role in the economy of the sacred image.[23]

With this shift we encounter an irony in our manner of approach, for our approach has been Christocentric: we developed it through the figure of Christ. But are these icons images of Christ in the first order? Or are they images of his mother? This brings out another intriguing aspect of the Presentation that comes out in the Sinai icon—namely, the centrality of Mary. For although the Presentation was classed as a Marian feast, it was not Mary who dominated either its literary tradition or its representation in art.[24] The festival of the Presentation is known in Greek as the Hypapante, that is, the meeting. The meeting in question was the meeting of Symeon and Christ, of Old Law and New. Though Mary facilitated the meeting by bearing Christ, she was herself no more than accessory to the action, and she remains secondary to its interpretation through much of its history. Even in the twelfth-century images like that in the Sinai tetraptych (Fig. 17.5), where Symeon bears the Child and Mary can gesture, her role is essentially passive, for she assumes the mourning posture of the Crucifixion and so plays the role of an onlooker. And with the condensation of this expressive variant of the Presentation into the icon of the Symeon Christodochos, the entire scene is collapsed into the two figures of Symeon and the Child, without Mary at all—the very image used at Lagoudera.

In view of this history, the imagery of the Sinai icon becomes striking for summing up the Presentation in the figures not of Symeon and Christ but of Mary and her Child. There exists a late twelfth-century homily on the Presentation by

17

—

Reading Medieval Images

Cyprus's own St. Neophytos, however, in which the entire feast is presented in terms of the Virgin herself and her advent bearing the Sun of Righteousness in her arms.[25] The homilist and his audience are cast in the role of Symeon and Anna, receiving the vision of Mary's arrival. The centrality of Mary in this conception of the Presentation is novel. In assessing our images, we, too, need to make a shift akin to that in the sermon, to see more clearly the Virgin in the image.

This shift is greatly facilitated by a shift in the image itself. For where the Virgin and Christ of the Sinai icon looked toward Symeon and Anna, they both look out at us in the icons of the Kykkotissa's type (Figs. 17.2, 17.3). This change fundamentally alters the image. For what had been a presentation to Symeon becomes instead a presentation to us. The composition across the surface seen in the icon of the Virgin and Prophets at Sinai becomes instead a layered one in three dimensions in which the Mother of God looks out at us and places her Son in between. There is no question of speaking. She does not so much present the Word as proffer the image.

Our approach to icons hitherto has been very logocentric. It has been so visually: we have focused on the Child. And it has been so theoretically: we have focused on linguistic theory. I wonder if this is a valid approach to an image like this: if the strongly fleshly Christ does not bring with it a stronger focus upon his Mother and with this a performance that is neither acoustic, as it was for Nelson, nor transubstantial, as it was for Vikan, but presentational: a quiet offering of what can only be seen. This is not to say that the icons of the Kykkos type represent the Presentation but rather that presentation is as basic a matrix for them as speaking is for images of the Pantokrator.

These images suggest that we have seen icons too much as if they were "Theoskepaste," that is, veiled by God. We have not seen the centrality of his Mother. Instead, with Cyprus's St. Neophytos, we might say in the face of these: "she comes." It has been noted often and with a kaleidoscope of explanations that by far the greatest number of miracle-working images in Byzantium were images of the Mother of God. In the presentational mode, in which Mary brings to our eyes the image of God, the figure of Mary seems to have evolved a form especially effective at generating a sense of place, inviting one less to see through the icon than to receive its vision. This may help to explain the unreasonable success as charismatic images of the particular icons of Mary disseminated in the twelfth century—the types of the Vladimirskaya, the Pelagonitissa, the Kykkotissa. This is not to say that these icons functioned differently from other icons but to suggest that their physical form was configured to suit their function in a distinctive way that we are bound to miss if we see the icon purely as a transparent screen. Both the icon itself and the image it bears constitute the presentation of a holy thing.

17

1 Aspects of this article were included in lectures read in Ann Arbor, Michigan, on 10 October 1997, in Marburg, Germany, on 27 June 1997, and in Princeton, New Jersey, on 6 March 1997. I owe sincere thanks to Dr. Athanasios Papageorgiou, to the Holy Archbishopric of Cyprus, and to the Cyprus American Archaeological Research Institute for help with research materials.

2 This is part of the work on a book entitled *Pursuing the Life of an Icon: The Virgin of Kykkos*. The idea emerged in a very fundamental way from Ilene Forsyth's own book, *The Throne of Wisdom: Wood Sculptures of the Madonna in Romanesque France* (Princeton, 1972), as an effort to do for a Byzantine image something comparable to what she had done so beautifully for the Romanesque statues of the Virgin. On the icon of Kykkos Monastery, see Ephraim the Athenian, *A Narrative of the Founding of the Holy Monastery of Kykkos and the History of the Miraculous Icon of the Mother of God. Διήγηση για την Ίδρυση της Ιεράς Μονής Κύκκου και την Ιστορία της Θαυματουργικής Εικόνας της Θεοτόκου*, ed. N. Christodoulou, trans. A. Jakovljević (Nicosia, 1996); Stylianos K. Perdikes, "Η Περιγραφή της Ιεράς Μονής Κύκκου σε μία Χαλκογραφία του 1778," in *Επετηρίδα Κέντρου Μελετών Ιεράς Μονής Κύκκου* 1 (1990), 31–50; Georgios A. Soteriou, "Η Κυκκιώτισσα," *Νέα Εστία* (Christmas 1939), 3–6.

3 Ephraim the Athenian, *Narrative*, 23.

4 Olga Gratziou, "Μεταμορφώσεις μίας Θαυματουργής Εικόνας: Σημειώσεις στις όψιμες Παραλλαγές της Παναγίας του Κύκκου. Transformations of a Miraculous Icon: Observations on Some Late Variants of the Kykkos Virgin," *Δελτίον της Χριστιανικής Αρχαιολογικής Εταιρείας*, ser. 4, 17 (1993–94) = Memorial volume for Doula Mouriki, 317–30.

5 On the relation of icons to miracle-working models see in particular Gordana Babić, "Il modello e la replica nell'arte bizantina delle icone," *Arte cristiana* 76, fasc. 724 (1988), 61–78; Pina Belli d'Elia, ed., *Icone di Puglia e Basilicata dal medioevo al settecento*, exh. cat. (Milan, 1988), 24–26; and also the Poganovo icon of the "Miracle of Latomos" in Gordana Babić, "Sur l'icône de Poganovo et la Vasilissa Hélène," in *L'art de Thessalonique et des pays balkaniques et les courants spirituels au XIVe siècle* (Belgrade, 1987), 57–65, with earlier bibliography.

6 Reproduced in Annemarie Weyl Carr, "Popular Imagery," in *The Glory of Byzantium: Art and Culture of the Middle Byzantine Era, A. D. 843–1261*, ed. Helen C. Evans and William D. Wixom, exh. cat. (New York, 1997), 114; and in Athanasios Papageorgiou, *Η Αυτοκέφαλος Εκκλησία της Κύπρου: Κατάλογος της Έκθεσης. The Autocephalous Church of Cyprus: A Catalogue of the Exhibition* (Nicosia, 1995), pl. p. 143. The significance of the Virgin's red veil is not pursued here but will figure in other studies.

7 The shrine and its legends are discussed in Athanasios Papageorgiou, "Καλοπαναγιώτης," *Μεγάλη Κυπριακή Εγκυκλοπαίδεια*, vol. 6 (Nicosia, 1982), 215; Rupert Gunnis, *Historic Cyprus* (Nicosia, 1936), 367; N. G. Kyriazes, "Μοναστήρια ἐν Κύπρῳ," *Κυπριακὰ Χρονικά* 12 (1936), 242–43.

8 Athanasios Papageorgiou, *Icons of Cyprus* (Nicosia, 1992), pl. 46.

9 Seen also in the Cypriot Eleousa from Ktima, now in the Byzantine Museum, Nicosia (Athanasios Papageorgiou, *Icons of Cyprus* [Geneva, 1969], pl. p. 65), the facial type is associated with Italianizing paintings of the Cretan School from the fifteenth century onward: see the beautiful fifteenth-century icon from the Stathatos Collection in the Benaki Museum (Manolis Chatzidakis, "Les débuts de l'école crétoise et la question de l'école dite italogrecque," in *Μνημόσυνον Σοφίας Αντωνιάδη* [Venice, 1974], pl. 10, 1; rpt. in his *Études sur la peinture postbyzantine* [London, 1976], article IV), and the icons of the Madonna della Consolazione from the second half of the century associated with Nicola Tzafouris (Nano Chatzidakis, *Venetiae quasi alterum Byzantium: From Candia to Venice. Greek Icons in Italy, 15th–16th Centuries*, exhib. cat. [Venice, 1993], fig. 12, and no. 24). An Italian example is seen in Taddeo di Bartolo's Madonna and Child with a Goldfinch in Colle Val d'Elsa from the late fourteenth century (Bernard Berenson, *Italian Pictures of the Renaissance: Central Italian and North Italian Schools*, vol. 2 [London, 1968], 470).

10 Of the eight paintings on Cyprus from the late fourteenth and fifteenth centuries that exhibit—or are known to have exhibited—the iconographic type of the Kykkotissa unequivocally, six are from Marathasa: 1) the icon at the Panagia Theoskepaste itself; 2) the badly damaged late fourteenth-century Athanasiotissa now in the Byzantine Museum, Nicosia (*Byzantine Icons from Cyprus*, exh. cat. [Athens, 1976], 84–87, no. 30); 3 and 4) the unpublished icons at the church of St. Sergios and the church of the Panagia in Kalopanagiotis; 5) the icon labeled *Η Κυκηότισσα* from the church of Hagia Paraskeve in Moutoullas, now at the Museum of Kykkos Monastery (Papageorgiou, *The Autocephalous Church*, pl. p. 144); and 6) the now-vanished icon from the iconostasis of the Archangel Church in Pedoulas (Georgios A. Soteriou, *Τα Βυζαντινά Μνημεία της Κύπρου* [Athens, 1935], pl. 148). The two that are not from Marathasa are the small icon from the Chrysaliniotissa Church in Nicosia, now in the Byzantine Museum in Nicosia (Papageorgiou, *Icons of Cyprus* [1969], pl. p. 48), and the fragmentary Virgin labeled *Η Κυκιότισσα* in the church of Saints Kyrikos and Ioulitta in Letympou (Sophocles Sophocleous, "Η Εικόνα της Κυκκώτισσας στον Άγιο Θεόδωρο του Αγρού," in *Επετηρίδα Κέντρου Μελετών Ιεράς Μονής Κύκκου* 2 [1993], pl. 9). Two large icons have been attributed to the thirteenth century, but I now believe on iconographic grounds that they must be later: the icon at Hagios Theodoros (Sophocleous, "Η Εικόνα," 329–37, pls. 1–6) and the fresco icon at the Chryseleousa Church in Lysos

17

(Annemarie Weyl Carr, "Byzantines and Italians on Cyprus: Images from Art," *Dumbarton Oaks Papers* 49 [1995], 348–52, pl. 20; Sophocleous, "Η Εικόνα," pl. 13).

11 On this famous icon see Doula Mouriki, "Icons from the 12th to the 15th Century," in *Sinai: Treasures of the Monastery of Saint Catherine*, ed. Konstantinos A. Manafis (Athens, 1990), 105, 385 nn. 26–28; Annemarie Weyl Carr, "The Presentation of an Icon at Mount Sinai," Δελτίον της Χριστιανικής Αρχαιολογικής Εταιρείας, ser. 4, 17 (1993–94) = Memorial volume for Doula Mouriki, 239–48, with earlier bibliography.

12 The pose of the Child is seen in the Symeon Christodochos at Lagoudera, reproduced here (Fig. 17.6), and the pose of Mother and Child is approximated in the beautiful thirteenth-century icon from Asinou, now in the Byzantine Museum at Nicosia (Papageorgiou, *Icons of Cyprus* [1992], pl. 35).

13 Paola Santa Maria Mannino, "La Vergine 'Kykkiotissa' in due icone Laziali del Duecento," in *Roma anno 1300*, Atti del IV settimana di studi di storia dell'arte medievale dell'Università di Roma "La Sapienza" (Rome, 1983), 487–96; Belli d'Elia, *Icone de Puglia e Basilicata*, nos. 30 and 31.

14 Ephraim the Athenian, *Narrative* (as n. 2), 51. It is impossible to know whether the Sicilian background of Eleanor's family had anything to do with the emergence of the Kykkotissa's type on Cyprus or with the queen's interest in Kykkos.

15 A second, somewhat smaller icon of the type will soon be visible when the icon from Hagia Paraskeve at Moutoullas is installed, as planned, in the museum at Kykkos.

16 See Carr, "The Presentation of an Icon"; Olga E. Etinhof, "Ermitazn'i Pamiatnik Vizantiiskoi Zivopisi kontsa XII Veka. A Byzantine Painting of the Late Twelfth Century in the Hermitage (Style and Iconography)," in *Vostochnoe Sredizemnomor'e i Kavkaz IV-XVI Vv.* (Leningrad, 1988), 141–59.

17 Mouriki, "Icons from the 12th to the 15th Century," 158–59, pl. 28.

18 Andreas Stylianou and Judith A. Stylianou, *The Painted Churches of Cyprus: Treasures of Byzantine Art* (London, 1985), elevation drawings, figs. 100 and 102.

19 Gary Vikan, "Ruminations on Edible Icons: Originals and Copies in the Art of Byzantium," in *Retaining the Original: Multiple Originals, Copies, and Reproductions = Studies in the History of Art* 20 (1989), 47–59.

20 Robert S. Nelson, "The Discourse of Icons, Then and Now," *Art History* 12 (1989), 144–57.

21 Fol. 80v: see Sirarpie Der Nersessian, "A Psalter and New Testament Manuscript at Dumbarton Oaks," *Dumbarton Oaks Papers* 19 (1965), pl. opposite p. 155. See also the images of Mary holding a book in the twelfth-century miniatures in Vatican, Vat. gr. 1162, fols. 90r, 92r, 139r, 164v, and 166r.

22 See the powerful ch. 13, "Living Painting," in Hans Belting, *Likeness and Presence: A History of the Image before the Era of Art*, trans. Edmund Jephcott (Chicago, 1994), 261–96.

23 Lynn Avery Hunt, *The Family Romance of the French Revolution* (Berkeley, 1992).

24 On the shifting imagery of the Presentation, see Henry Maguire, "The Iconography of Symeon with the Christ Child in Byzantine Art," *Dumbarton Oaks Papers* 34–35 (1980–81), 261–69; Carr, "The Presentation of an Icon," 242–45.

25 Ermanno M. Toniolo, "Omelie e catechesi mariane inedite di Neofito il Recluso (1134–1200c)," *Marianum* 36 (1974), 305–7; trans. in Carr, "The Presentation of an Icon," 245–46.

Mimesis

"Shadow," says Michael Baxandall, "originates in a local and relative deficiency of visible light." A cast shadow is a kind of shadow "caused by a solid intervening between a surface and a light source."[1] The pictorial rendering of shadow contributes to the illusion that a painting reproduces the visible world—things that actually exist or could exist—in two dimensions; it lends force to the conviction that depicted things occupy a coherent pictorial space seen from a particular vantage point and, because light conditions are fleeting, at a particular moment in time. The device is employed in certain pictorial idioms, not others; it came into play in the fourteenth century, that is, early in the period designated by contemporaries as the "Renaissance."

In the western critical tradition, the capacity of painters to imitate natural appearances has been held up as an ideal. Ancient Roman writers, including Pliny (who located the origin of all painting in the outlining of a man's shadow), looked back and told the history of Greek painting in terms of a collective conquest of illusionism.[2] In the mid-sixteenth century, Giorgio Vasari, sometimes called the first modern art historian, recorded the accomplishments of Italian artists in the three centuries preceding Michelangelo and composed a history of the perfection of skills for imitating nature.[3] Vasari found little to admire in Italian art produced between Roman late antiquity and the Trecento—a millennium when aesthetic, religious, and ideological requirements encouraged artists to no more than a tempered *mimesis* (and when cast shadows were rarely depicted). Particularly corrupting, in Vasari's view, was the influence of the Byzantine style—*maniera greca*—felt in Italy especially in the twelfth and thirteenth centuries. Roman mosaics like those discussed by Dale Kinney at the beginning of this volume (Figs. 1.1–2) Vasari viewed as "works that have more of the monstrous in their lineaments than of likeness to whatsoever they represent."[4] It was Giotto who rescued art from this impasse: "That very obligation which the craftsmen of painting owe to nature, who serves continually as model to those who are ever wresting the good from her best and most beautiful features and striving to counterfeit and to imitate her, should be owed, in my belief, to Giotto, painter of Florence."[5]

There are many ways to complicate Vasari's story, apart from demonstrating the sophistication of medieval pictorial idioms. One is to focus on the ways in which Italian painters of the Trecento and Quattrocento would forgo or undermine naturalistic effects, and their reasons for doing so. The work of Giotto can be admired for its departures from as well as its imitation of nature. Richard Offner (1889–1965), in a classic article of 1939, "Giotto, non-Giotto," gives this analysis of Giotto's Arena Chapel frescoes, painted ca. 1305:

The composition being conceived as a system of interdependent elements, each figure is accommodated to the whole by being contoured and modelled large in order not to draw too much attention to itself by individualization or description of its physical character. ...The composition thus subjugates the individual form to a corporate order and equilibrium, which it brings into predominating evidence. This implies a non-naturalistic treatment of the figure.

As there is no naturalism in the representation, so there is no effort to catch the action on the wing. . . . Thus the recognizable units and limits of time tend to fade, and the latent drama emerges in its spiritual implications.

In the following essay, Marvin Eisenberg calls attention to a deliberately inconsistent use of the device of the cast shadow in a predella painted by Mariotto di Nardo, a Florentine painter active a century after Giotto. In this panel, showing a martyrdom, a sharp-edged shadow calls attention to a single and significant motif in the composition. Mariotto, Eisenberg suggests, introduces a moment of illusionism—catching "the action on the wing"—for the paradoxical reason of heightening an impalpable mystery.[6]

E. S.

1 *Shadows and Enlightenment* (New Haven, 1995), 1, 4.

2 *Natural History*, 35.15. See *The Elder Pliny's Chapters on the History of Art*, trans. K. Jex-Blake with commentary by E. Sellers (London, 1896; rpt. Chicago, 1968).

3 In our own time Sir Ernst Gombrich has examined the same histories in relation to theories of perception, seeking to demonstrate the naturalness of western pictorial conventions developed over time to imitate things seen. See especially his *Art and Illusion: A Study in the Psychology of Pictorial Representation* (Princeton, 1960; 2d ed., 1961). For commentary, see W. J. T. Mitchell, *Iconology: Image, Text, Ideology* (Chicago, 1986), 75–94.

4 *Lives of the Painters, Sculptors and Architects*, trans. Gaston du C. de Vere (1912; rpt. New York, 1996), preface, 46. Cf. Gombrich, *The Story of Art* (1st ed., London, 1950; 16th ed., 1995), 136: "The power of observation of nature, which we saw awakening in Greece about 500 BC, was put to sleep again about 500 AD."

5 *Lives*, 96.

6 *Burlington Magazine* 74 (1939), 259–68; 75 (1939), 96–113; rpt. in *A Discerning Eye: Essays on Early Italian Painting by Richard Offner*, ed. Andrew Ladis (University Park, PA, 1998), 61–88. Georges Didi-Huberman writes that his encounter with Fra Angelico caused him to "give up the idea of understanding the history of Renaissance painting as the history of the conquest of resemblances." See *Fra Angelico: Dissemblance and Figuration*, trans. Jane Marie Todd (Chicago, 1995), 3.

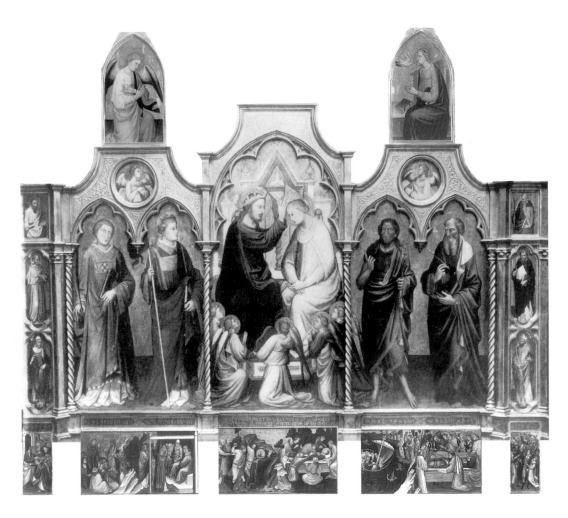

18.1. Mariotto di Nardo, "Confraternity Altarpiece." Photomontage courtesy of The National Museum of Western Art, Tokyo.

18 The Stoning of St. Stephen in an Altarpiece by Mariotto di Nardo: Again the Cast Shadow

Marvin Eisenberg

> There does indeed run through his life a sort of double meaning,
> like his shadow thrown upon the wall.
>
> G. K. Chesterton, *St. Francis of Assisi* (1924)

Three previously unknown predella panels, depicting six episodes from the life of St. Stephen, were sent from a British private collection to the London art market in 1989.[1] Each of the wide rectangular panels contains two scenes from the legends of the first Christian martyr, ranging from his preaching and conflict with the Sanhedrin, to his stoning and burial and the translation of his relics from Jerusalem to Constantinople, to his entombment with St. Lawrence in the Roman church of San Lorenzo fuori le Mura (Fig. 18.1). It was immediately recognized that the three newly revealed panels, acquired in 1993 by the National Museum of Western Art in Tokyo, had once been part of the same predella as two narrower panels formerly in the collection of the Munich antiquarian, Jacques Rosenthal, their whereabouts unknown since the late 1920s. Rediscovered in a European collection in 1998, these two panels, which had at one time been framed erroneously to form a diptych, would have been located beneath the pilasters framing the main register of an altarpiece and would thus originally have bracketed the three double scenes of the panels now in Tokyo. The full sequence of eight scenes, as reconstructed in figure 18.1, would have begun with Stephen's ordination and ended with the posthumous miracle of the curing of the sick woman, Petronia.[2]

The five sequential panels, it could be determined, had originally formed the complete predella of a now dismembered altarpiece, dated 1408, by the Florentine painter Mariotto di Nardo, who ran a prolific workshop from the last decade of the Trecento until 1424—the year of his final major work and of his will, drawn up during a serious illness.[3] Mariotto had received the commission for the polyptych from the allied Confraternities of the Virgin and of St. Stephen for their chapel/meeting hall, which adjoined the Pieve di Santo Stefano in Pane at Rifredi, then a village, now a suburb northwest of Florence.[4] The eight episodes spread over

Mariotto's five predella panels and the eight-part predella by Bernardo Daddi in the Vatican Pinacoteca comprise the two most comprehensive recitations of the life of St. Stephen in earlier Italian painting.[5]

The concentration on the events in the life of a single saint both in Mariotto's and in Daddi's predellas is a departure from normal practice, in which individual narrative scenes are allied with the various saintly effigies represented above them in the main register of a polyptych.[6] Moreover, the central narrative panel of a predella typically gives resonance to the focal imagery of an altarpiece—most frequently an enthroned Madonna and Child, amplified below by such "Joys of the Virgin" as the Nativity and the Adoration of the Magi, or by her "Sorrows," most commonly in the iconic *imago pietatis*.[7] In contrast, the central panel of Mariotto's predella, though originally located below a scene of the *Coronation of the Virgin*, was occupied by St. Stephen's execution and burial, events that comprise by analogy to Christ the protomartyr's own passion.

A vertical axis of concerted symbolism runs through the center of the "Confraternity Altarpiece," encompassing ancient and fundamental theological doctrine.[8] In the *Coronation of the Virgin*, the principal image of Mariotto's reconstructed altarpiece, the usual honorific placement of the Virgin to the proper right of her Son is reversed, thereby endowing Christ with the primary role in the mystery. This implied dominance of Christ and his act of crowning Mary clearly mirror the *Sponsus-Sponsa* relationship rhapsodized in the Solomonic Song of Songs.[9] The allegorized relation between the bridegroom and bride as the love between Christ and his Church, and the allied paralleling of the Virgin with the Church, are reinforced by the architecture of the throne that provides a churchly backdrop for the celebratory rite of the Coronation.[10] The ecclesiastical aspect of the setting is enhanced by the axial trumeau between the two figures, which takes the form of a salomonic spiral column; this feature would have had an even greater prominence if Mariotto had fulfilled his original design, as is revealed by the spiral underdrawing visible through the undecorated sill that forms a visual link between the mantles of Christ and the Virgin.[11]

At the crest of the "Confraternity Altarpiece" there would have been a central pinnacle, thus far an unidentified element of the dispersed polyptych. By analogy with contemporary altarpieces, the image would most likely have been a Blessing Redeemer, an apt counterpart to the Christ of the *Coronation* and also to the depiction of St. Stephen as the first Christian martyr in the predella.[12] More specifically, the two central episodes of the predella—the Stoning and Burial of St. Stephen—materialized the conception of the protomartyr's life and death as an *imitatio Christi*. Not by chance was the principal feast of St. Stephen celebrated on December 26th; his transcendental existence—his birth into sainthood—thus emerged in the liturgical calendar immediately in the wake of the birth of Christ.[13]

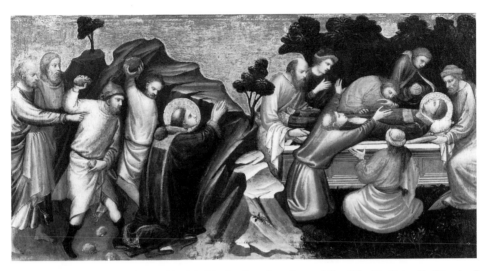

18.2. Mariotto di Nardo, Stoning and Burial of St. Stephen, from the predella of the "Confraternity Altarpiece" (P. 1993–2). Tokyo, The National Museum of Western Art. Photo: The National Museum of Western Art.

18.3. Mariotto di Nardo, Stoning and Burial of St. Stephen: detail. Tokyo, The National Museum of Western Art. Photo: The National Museum of Western Art.

Completing this "spine" of symbolic allusions is the isolated and highlighted boulder at the base of the rocky declivity that shapes the enclave of Stephen's execution. This pictorial passage, located exactly at the center of the predella and aligned with the axis of the main register, embodies a fervent moment within St. Augustine's long series of Sermons on St. Stephen, where he concentrates on the stoning and its analogies with the martyrdom of Christ: "He was being stoned with rocks, as he was dying for the Rock...*But the rock was Christ*" (1 Corinthians 10:4).[14] The parallel is reinforced in Stephen's last words, recorded in Acts 7:59–60: "Lord Jesus, receive my spirit.... Lord, lay not this sin to their charge." Finally, Stephen may be linked with the spiral trumeau of the main register through his characterization in the *Golden Legend* as "this strong column of God" (*fortis columna Dei*), a quotation purported to come from St. Augustine.[15]

Within the scene of Stephen's execution, an episode lodged in the richly symbolic core of the altarpiece, the varying depictions of the stones hurled at him lead to the central issue of this brief study (Fig. 18.2; Color Plate 7). Scattered over the ground are the numerous stones thrown by the two executioners. A single stone, however, remains poised at Stephen's shoulders, imbedded like a cabochon in the gilded ornamentation of the saint's dalmatic (Fig. 18.3). In later retouchings of the

18
———

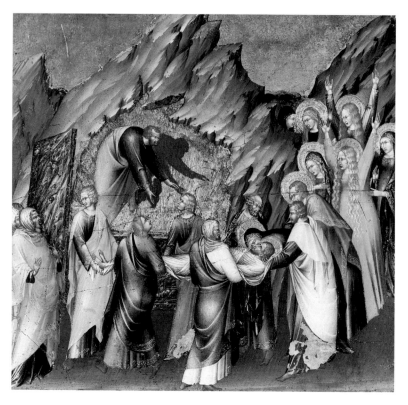

18.4. Giovanni di Paolo, Entombment of Christ. Baltimore, The Walters Art Museum (37.483).
Photo: The Walters Art Museum.

panel that were recently removed by the conservator at the museum in Tokyo, the stones on the ground cast long shadows, in contradiction to the frontal lighting found throughout the predella.[16] But a single stone—the focal one poised at Stephen's shoulders—does cast a crescent-shaped shadow, which technical analysis has proved to be original. The potency of this stone and its incisive shadow were diluted by the false shadows cast by the stones on the ground, but with their recent removal the fatal stone has regained its force as the symbolic crux of the narrative. The intensity of physical presence conveyed by the optical effects of sharply focused light and cast shadow isolates the mortal blow that transformed Stephen into a sanctified immortal. Within the passion of St. Stephen, the quality of real presence in the instrument of his death is thereby given vivid emphasis, with the resultant paradox of a theological mystery confirmed by material palpability.[17]

This paradoxical device has a long history and is variously observed in scenes of the passion of Christ within Italian painting of the fourteenth and early fifteenth centuries. Some years ago, Hayden Maginnis noted that the cast shadows in the Passion cycle by Pietro Lorenzetti in the Lower Church at Assisi are rendered

18

Reading Medieval Images

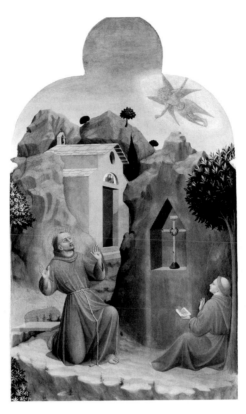

18.5. Sassetta, Stigmatization of St. Francis. London, National Gallery (4760). Photo: National Gallery.

with a newly incisive clarity in contrast to a more diffused rendering in prior painting of the later Duecento and Trecento.[18] Previously, Millard Meiss had focused on the looming shadow cast by the mourning St. John the Evangelist in an *Entombment of Christ* by Giovanni di Paolo in the Walters Art Museum, a work of 1426 by an artist who in other works of this decade eschewed the cast shadow (Fig. 18.4).[19] Here, as in Mariotto's predella panel, the lighting system is neutrally frontal, underscoring the isolation of the Evangelist's spectral shadow and its power to amplify the mystery of the tragic event.

That the implication of Christian mystery in the cast shadow is not reserved for scenes of Christ's Passion is demonstrated by Sassetta's *Stigmatization of St. Francis* (Fig. 18.5), a work of ca. 1440. This picture held a place in the recent exhibition on the cast shadow at the National Gallery in London and in Ernst Gombrich's lapidary monograph on the theme of the show.[20] In Sassetta's panel, the insistently limned shadow cast by the kneeling Francis has its source in the light emanating from the radiant seraphic vision of Christ. The force of this cast shadow is strengthened by contrast with the fainter shadow that falls on the church, both

18

―

produced by the same supernatural light. Again the cast shadow is employed to convey a moment of transcendence and again that moment is one of impassioned revelation. As Victor Stoichita observed in his recent study of the cast shadow, this physical phenomenon may be utilized to depict "not the fathomable, but its absolute opposite: the mystery."[21] Or, as Meiss noted in connection with the Baltimore Giovanni di Paolo, such works "tend to divert the [new pictorial] discoveries to expressive purposes."[22]

In the first decade of the Quattrocento, Mariotto di Nardo had rendered the cast shadow as a vehicle of mystical meaning in a minute and isolated passage of a vast polyptych, thereby adding a further element to the dense axis of doctrinal symbolism that courses through the "Confraternity Altarpiece" (Fig. 18.1). By the 1420s, Gentile da Fabriano and Masaccio would give a more prominent place to the cast shadow, utilizing it to reinforce physical presence but also endowing it with the power to enhance the mystery of a sacred event or to function as a thaumaturgic force. In Gentile's *Nativity* in the predella of the Strozzi *Adoration of the Magi* of 1423, the radiance of the newborn child generates the source of light that forms the cast shadows splayed over the manger shed, just as the supernal rays incised into the gold ground etch the procession of shadows cast by the cortege of the Magi in the upper right lobe of the main panel.[23] With Masaccio's *St. Peter Healing with His Shadow* in the Brancacci Chapel, the advancing curative shadow cast by St. Peter sequentially over the two cripples has a double genesis: a natural source from the lancet window to the right and a mystical emanation from the altar backed by that window.[24] In the ensuing decades, as inquiry into the physical world came to preoccupy the Quattrocento painter, the cast shadow as a means to materialize and amplify Christian mysteries largely gave way to its function within an ever-expanding repertoire of devices to depict the illusions of an objective reality.[25]

1 This study enlarges on an aspect of my investigations of the three predella panels and their integration into a reconstructed altarpiece by Mariotto di Nardo, dated 1408, which had suffered dismemberment and wide dispersion beginning in the seventeenth century. See Marvin Eisenberg, "*The Coronation of the Virgin* by Mariotto di Nardo," *The Minneapolis Institute of Arts Bulletin* 55 (1966), 9–24; Eisenberg, Michiaki Koshikawa, and Kimio Kawaguchi, with the assistance of T. Yoshikawa, *The "Confraternity Altarpiece" by Mariotto di Nardo: The Coronation of the Virgin and the Life of St. Stephen* (Tokyo, 1998); Eisenberg, "Postscript to '*The Confraternity Altarpiece*,'" *Journal of the National Museum of Western Art, Tokyo* 3 (1999), 61–63. The extensive literature on the numerous elements of the altarpiece and their present locations may be found in the 1998 publication. I am grateful to the National Museum of Western Art, Tokyo, for permission to publish Figures 18.1, 2, and 3 and Color Plate 7, all of which appear in that collaborative monograph of 1998.

2 Miklós Boskovits (*Pittura fiorentina alla vigilia del Rinascimento, 1370–1400* [Florence, 1975], 397, 398) tentatively proposed the function of the two panels as elements of a predella and their alliance with the dispersed altarpiece by Mariotto di Nardo. For illustrations of the two panels both in their fictive pairing and as individual elements of the predella, see Eisenberg et al., "*Confraternity Altarpiece*," fig. 4 and pl. XV. The principal textual sources for the life of St. Stephen and the diffusion of his cult are in Acts, the writings of St. Augustine, and the *Golden Legend*. See ibid., passim.

3 For the stylistic development of Mariotto di Nardo's work, see Miklós Boskovits, "Sull'attività giovanile di Mariotto di Nardo," *Antichità viva* 7/5 (1968), 3–13; and "Mariotto di Nardo e la formazione del linguaggio tardo-gotico a Firenze negli anni intorno al 1400," *Antichità viva* 7/6 (1968), 21–31.

4 For the two confraternities at Santo Stefano in Pane, see Bruno P. F. Wanrooij, *Storia della Venerabile Confraternita della Misericordia di Santo Stefano in Pane, Rifredi* (Florence, 1995).

5 For the panels by Bernardo Daddi, see Richard Offner and Klara Steinweg, *A Critical and Historical Corpus of Florentine Painting*, ed. M. Boskovits and E. N. Lusanna, vol. 3/3 (Florence, 1989), pl. XVI.

6 See, for example, Richard Fremantle, *Florentine Gothic Painters* (London, 1975), figs. 380, 488, 565, 806, and 807.

7 See, for example, ibid., figs. 334, 487, 488, 565, 686, 807, 856, and 991. The classic study of this devotional image showing Christ as a Man of Sorrows displaying his wounds, sometimes embraced and supported by the grieving Virgin or flanked by the Virgin and St. John the Evangelist, remains Erwin Panofsky's "*Imago Pietatis*," in *Festschrift für Max J. Friedländer zum 60. Geburtstage* (Leipzig, 1927), 261–308.

8 The "Feast of the Queenship of the Blessed Virgin" entered the canonical Roman liturgy only in 1954. Within the liturgy of this Marian feast, there is no specific reference to the act of Christ crowning his mother.

9 Song of Songs 4:8–10, 12; 5:1. See Gertrud Schiller, *Ikonographie der christlichen Kunst*, vol. 4/2 (Gütersloh, 1980), 103ff. and 116ff.

10 For these Marian symbolic metaphors, see Ilene H. Forsyth, *The Throne of Wisdom: Wood Sculptures of the Madonna in Romanesque France* (Princeton, 1972), 22ff. For Mary as Ecclesia, see also Schiller, *Ikonographie*, 4/2:103ff., 114, 116ff.

11 Popular lore regarding the spiral column is approached by J. M. C. Toynbee and J. B. Ward-Perkins, *The Shrine of St. Peter and the Vatican Excavations* (London, 1956), 247ff. In Mariotto di Nardo's *Annunciation* altarpiece in the Museo Civico, Pistoia, the left side of the churchly structure housing the seated Virgin is supported by three spiral columns, while only one of the three columns implied in the balancing right side of the structure is depicted; see Bernard Berenson, *Italian Pictures of the Renaisssance: Florentine School*, vol. 1 (London, 1963), pl. 532.

12 See, for example, Fremantle, *Florentine Gothic Painters*, figs. 436, 485, 491, 506, and 526.

13 A second Feast of St. Stephen on August 3rd, commemorating the discovery of the saint's relics, was removed from the official Roman liturgy in 1960.

14 St. Augustine, Sermon 317, part 5; trans. Edmund Hill, in *The Works of St. Augustine: A Translation for the 21st Century*, vol. III/9 (Hyde Park, NY), 144.

15 Jacobus de Voragine, *The Golden Legend: Readings on the Saints*, trans. William Granger Ryan, 2 vols. (Princeton, 1993), 2:43.

16 The technical examination of the Tokyo predella panels was performed by Kimio Kawaguchi, Conservator at the National Museum of Western Art. For his report on the false and original cast shadows, see the technical section of Eisenberg et al., "*Confraternity Altarpiece*," 75, and pls. XII–2 and XIV–2, 3; for the added shadows, see also pl. VIII.

17 In the scene of the *Stoning* in the Vatican frescoes, Fra Angelico lent an apparitional presence to the stone that strikes Stephen by poising it on a vertical axis, so that it appears to hover rather than directly strike him. See John Pope-Hennessy, *Fra Angelico*, 2d ed. (Ithaca, 1974), pl. 110.

18 Hayden B. J. Maginnis, "Cast Shadow in the Passion Cycle at San Francesco, Assisi: A Note," *Gazette des Beaux-Arts* 77 (1971), 63–64.

18

—

19 Millard Meiss, "Some Remarkable Early Shadows in a Rare Type of Threnos," in *Festschrift Ulrich Middeldorf* (Berlin, 1968), 112ff. Meiss also cites an *Entombment* (fig. 2), ascribed to Arcangelo di Cola da Camerino, in a Florentine private collection, in which the three empty crosses on Calvary cast sharply defined shadows over the hilly landscape; see also Keith Christiansen, *Gentile da Fabriano* (Ithaca, 1982), fig. 51. Christiansen, 50, proposes that the light effects in the two panels by Giovanni di Paolo and Arcangelo reflect a prototype by Gentile da Fabriano.

20 E. H. Gombrich, *Shadows: The Depiction of Cast Shadows in Western Art* (London, 1995), 47–49. Within Sassetta's series of eight panels depicting the *Life of St. Francis*, only the *Stigmatization* contains cast shadows.

21 Victor I. Stoichita, *A Short History of the Shadow* (London, 1997), 82.

22 Meiss, "Some Remarkable Early Shadows," 117.

23 Andrea De Marchi, *Gentile da Fabriano* (Milan, 1992), pls. 42 and 50. The lone cast shadow found in the work of Lorenzo Monaco has proved to be a later addition. In an attempt to endow a supernatural event with physical presence, a salient shadow was inserted at an unknown date below the shroud draped over the sarcophagus in the *Holy Women at the Tomb* of 1408 in the Louvre. See Eisenberg, *Lorenzo Monaco* (Princeton, 1989), 156–57, fig. 33. Without the knowledge that it is a later addition, Keith Christiansen understandably found the cast shadow in the Louvre panel "puzzling" (*Gentile da Fabriano*, 72 n. 21).

24 Umberto Baldini and Ornella Casazza, *The Brancacci Chapel* (New York, 1992), plate opposite p. 171.

25 Stoichita (*Short History of the Shadow*, 82, fig. 15) notes, however, that as late as ca. 1440, in Fra Filippo Lippi's San Lorenzo *Annunciation*, the shadow cast by the neck of the glass decanter in the foreground marks "the 'spot' where the incarnation takes place." Lippi's panel is contemporary with Sassetta's *Stigmatization*, cited earlier in this essay (Fig. 18.5).

18

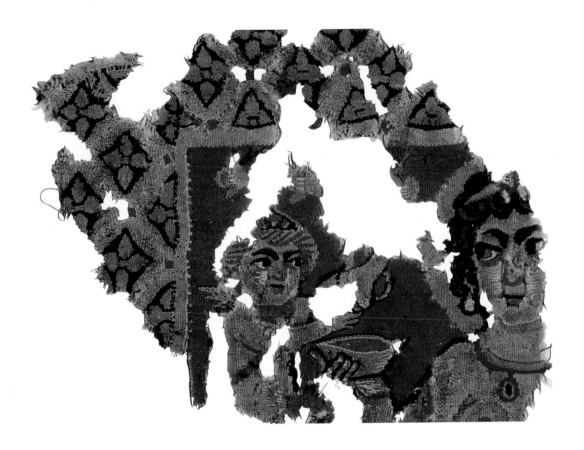

Plate 1. Tapestry-woven woolen fragment. Ann Arbor, University of Michigan, Kelsey Museum of
 Archaeology (22710). Photo: Kelsey Museum of Archaeology.

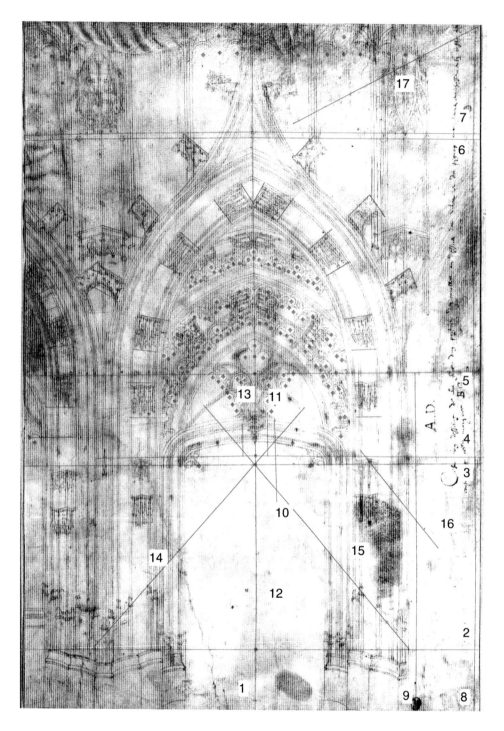

Plate 2. Computer-generated image after drawing in The Metropolitan Museum of Art, The Cloisters Collection (68.49): drawing grid and pinpricks of compass points emphasized. Diagrammatic overlay by author.

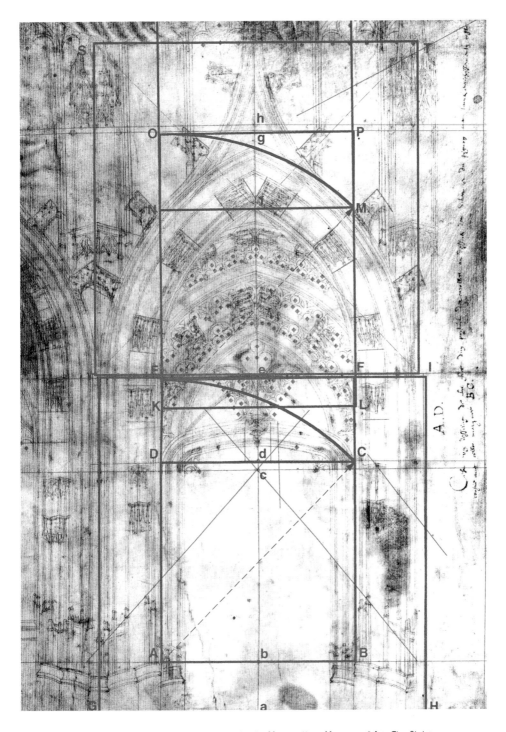

Plate 3. Computer-generated image after drawing in the Metropolitan Museum of Art, The Cloisters Collection (68.49): proposed proportional relationships. Diagrammatic overlay by author.

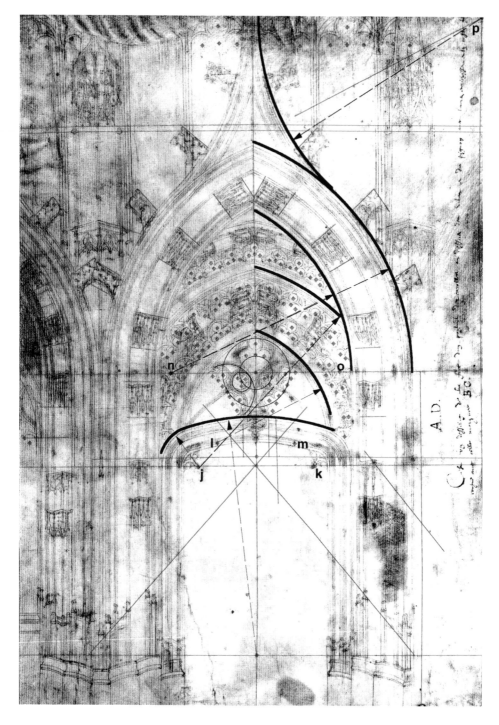

Plate 4. Computer-generated image after drawing in The Metropolitan Museum of Art, The Cloisters Collection (68.49): construction of porch and portal arches. Diagrammatic overlay by author.

Plate 5. Musical performers. London, British Library, Add. MS 11695 (Beatus of Liébana, *In Apocalypsim*), fol. 86r. Reproduced by permission of the British Library.

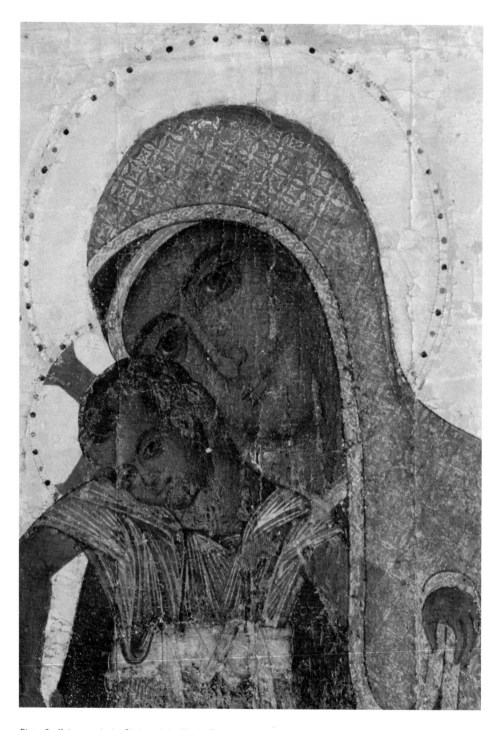

Plate 6. Kalopanagiotis, Shrine of the Virgin Theoskepaste, icon: detail. Photo: author.

Plate 7. Mariotto di Nardo, Stoning and Burial of St. Stephen, from the predella of the "Confraternity Altarpiece." Tokyo, The National Museum of Western Art. Photo: The National Museum of Western Art.

Suggestions for Further Reading

Listed below are recent art-historical studies in English, produced since ca. 1985, that the editors of the volume and contributors to it have found suggestive in relation to the theory and practice of "reading" medieval works of art. The first section collects investigations into medieval art theory. The second assembles studies in which authors think about or demonstrate what it is to read a medieval image or object.

A. Medieval Attitudes toward the Image and Image-Making

Belting, Hans. *Likeness and Presence: A History of the Image before the Era of Art*. Trans. Edmund Jephcott. Chicago, 1994.

Brubaker, Leslie. *Vision and Meaning in Ninth-Century Byzantium: Image as Exegesis in the Homilies of Gregory of Nazianzus*. Cambridge, 1999.

Buettner, Brigitte. "Profane Illuminations, Secular Illusions: Manuscripts in Late Medieval Courtly Society." *Art Bulletin* 74 (1992), 75–90.

Byrne, Donal. "An Early French Humanist and Sallust: Jean Lebègue and the Iconographical Programme for the *Catiline* and *Jugurtha*." *Journal of the Warburg and Courtauld Institutes* 49 (1986), 41–65.

Camille, Michael. *The Gothic Idol: Ideology and Image-Making in Medieval Art*. Cambridge, 1989.

Carr, Annemarie Weyl. "Leo of Chalcedon and the Icons." In *Byzantine East, Latin West: Art-Historical Studies in Honor of Kurt Weitzmann*, 579–84. Ed. Christopher Moss and Katherine Kiefer. Princeton, 1995.

Caviness, Madeline H. "Images of Divine Order and the Third Mode of Seeing." *Gesta* 22 (1983), 99–120.

———. "'The Simple Perception of Matter' and the Representation of Narrative, ca. 1180–1280." *Gesta* 30 (1991), 48–64.

Chazelle, Celia. "Images, Scripture, the Church, and the Libri Carolini." *Proceedings of the Patristic, Mediaeval, and Renaissance Conference* 16/17 (1993), 53–76.

———. "Pictures, Books and the Illiterate: Pope Gregory I's Letter to Serenus of Marseilles." *Word & Image* 6 (1990), 138–53.

Cutler, Anthony. "From Loot to Scholarship: Changing Modes in the Italian Response to Byzantine Artifacts, ca. 1200–1750." *Dumbarton Oaks Papers* 49 (1995), 237–67.

Dagron, Gilbert. "Holy Images and Likeness." *Dumbarton Oaks Papers* 45 (1991), 23–44.

Deshman, Robert. "Another Look at the Disappearing Christ: Corporeal and Spiritual Vision in Early Medieval Images." *Art Bulletin* 79 (1997), 518–46.

Duggan, Lawrence G. "Was Art Really the 'Book of the Illiterate'?" *Word & Image* 5 (1989), 227–51.

Grant, Lindy. "Naming of Parts: Describing Architecture in the High Middle Ages." In *Architecture and Language: Constructing Identity in European Architecture, c. 1000 – c. 1650*, 46–57. Ed. Georgia Clarke and Paul Crossley. Cambridge, 2000.

Heslop, T. A. "Attitudes to the Visual Arts: The Evidence from Written Sources." In *Age of Chivalry: Art in Plantagenet England, 1200–1400*, 26–32. Ed. Jonathan Alexander and Paul Binski. London, 1987.

James, Liz, and Ruth Webb. "'To Understand Ultimate Things and Enter Secret Places': Ekphrasis and Art in Byzantium." *Art History* 14 (1991), 1–17.

Kessler, Herbert L. *Spiritual Seeing: Picturing God's Invisibility in Medieval Art*. Philadelphia, 2000.

Maguire, Henry. "Magic and the Christian Image." In *Byzantine Magic*, 51–71. Ed. Henry Maguire. Washington, DC, 1995.

———. "The Profane Aesthetic in Byzantine Art and Literature." *Dumbarton Oaks Papers* 53 (1999), 189–205.

Martindale, Andrew. "'There is neither speech nor language but their voices are heard among them': The Enigma of Discourse concerning Art and Artists in the 12th and 13th Centuries." In *Studien zur Geschichte der europäischen Skulptur im 12./13. Jahrhundert*, 205–17. Ed. Herbert Beck and Kerstin Hengevoss-Dürkop. Frankfurt am Main, 1994.

Pelikan, Jaroslav. *Imago Dei: The Byzantine Apologia for Icons*. Princeton, 1990.

Rudolph, Conrad. *The "Things of Greater Importance": Bernard of Clairvaux's Apologia and the Medieval Attitude Toward Art*. Philadelphia, 1990.

Sandler, Lucy Freeman. "Jean Pucelle and the Lost Miniatures of the Belleville Breviary." *Art Bulletin* 66 (1984), 73–96.

Webb, Ruth. "The Aesthetics of Sacred Space: Narrative, Metaphor, and Motion in *Ekphraseis* of Church Building." *Dumbarton Oaks Papers* 53 (1999), 59–74.

B. Modern Theory, Critical Approaches, and Case Studies

Abou-El-Haj, Barbara. *The Medieval Cult of Saints: Formations and Transformations*. Cambridge, 1994.

Alexander, Jonathan J. G. "Facsimiles, Copies, and Variations: The Relationship to the Model in Medieval and Renaissance European Illuminated Manuscripts." In *Retaining the Original: Multiple Originals, Copies, and Reproductions = Studies in the History of Art* 20 (1989), 61–72.

———. "Iconography and Ideology: Uncovering Social Meanings in Western Medieval Christian Art." *Studies in Iconography* 15 (1993), 1–44.

Binski, Paul. "The Angel Choir at Lincoln and the Poetics of the Gothic Smile." *Art History* 20 (1997), 350–74.

Bonne, Jean-Claude. "Depicted Gesture, Named Gesture: Postures of the Christ on the Autun Tympanum." *History and Anthropology* 1 (1984), 77–95.

Brown, Elizabeth A. R., and Michael W. Cothren. "The Twelfth-Century Crusading Window of the Abbey of Saint-Denis: *Praeteritorum enim recordatio futurorum est exhibitio*." *Journal of the Warburg and Courtauld Institutes* 49 (1986), 1–40.

Buettner, Brigitte. *Boccaccio's Des cleres et nobles femmes: Systems of Signification in an Illuminated Manuscript*. Seattle, 1996.

Cahn, Walter. "Heresy and the Interpretation of Romanesque Art." In *Romanesque and Gothic: Essays for George Zarnecki*, 27–33. Woodbridge, Suffolk, 1987.

———. "Romanesque Sculpture and the Spectator." In *The Romanesque Frieze and its Spectator*, 45–60. Ed. Deborah Kahn. London, 1992.

Camille, Michael. *Master of Death: The Lifeless Art of Pierre Remiet, Illuminator*. New Haven, 1996.

———. *Mirror in Parchment: The Luttrell Psalter and the Making of Medieval England*. Chicago, 1998.

———. "Seeing and Reading: Some Visual Implications of Medieval Literacy and Illiteracy." *Art History* 8 (1985), 26–49.

Carr, Annemarie Weyl. "Court Culture and Cult Icons in Middle Byzantine Constantinople." In *Byzantine Court Culture from 829 to 1204*, 81–99. Ed. Henry Maguire. Washington, DC, 1997.

———. "Thoughts on the Economy of the Image of Mary." *Theology Today* 56 (1999), 359–78.

———. "Thoughts on Seeing Christ Helkomenos: An Icon from Pelendri." In *Byzantinische Malerei: Bildprogramme – Ikonographie – Stil*, 405–20. Ed. Guntram Koch. Wiesbaden, 2000.

Carrasco, Magdalena Elizabeth. "Spirituality in Context: The Romanesque Illustrated Life of St. Radegund of Poitiers (Poitiers, Bibl. Mun., MS 250)." *Art Bulletin* 72 (1990), 414–35.

———. "The Construction of Sanctity: Pictorial Hagiography and Monastic Reform in the First Illustrated *Life of St. Cuthbert* (Oxford, University College MS 165)." *Studies in Iconography* 21 (2000), 47–89.

Caviness, Madeline H. "Patron or Matron? A Capetian Bride and a Vade Mecum for Her Marriage Bed." *Speculum* 68 (1993), 333–62.

Clark, William W. "Merovingian Revival Acanthus Capitals at Saint-Denis." In *L'acanthe dans la sculpture monumentale de l'Antiquité à la Renaissance*, 345–56. Paris, 1993.

Cohen, Adam S. *The Uta Codex: Art, Philosophy, and Reform in Eleventh-Century Germany*. University Park, PA, 2000.

Corrigan, Kathleen A. *Visual Polemics in the Ninth-Century Byzantine Psalters*. Cambridge, 1992.

Cormack, Robin. "Women and Icons, and Women in Icons." In *Women, Men and Eunuchs: Gender in Byzantium*," 24–51. Ed. Liz James. London, 1997.

Curschmann, Michael. "Marcolf or Aesop? The Question of Identity in Visio-Verbal Contexts." *Studies in Iconography* 21 (2000), 1–45.

Cutler, Anthony. *The Hand of the Master: Craftsmanship, Ivory, and Society in Byzantium (9th–11th Centuries)*. Princeton, 1994.

Diebold, William J. "Verbal, Visual, and Cultural Literacy in Medieval Art: Word and Image in the Psalter of Charles the Bald." *Word & Image* 8 (1992), 89–99.

Crossley, Paul. "Medieval Architecture and Meaning: The Limits of Iconography." *Burlington Magazine* 130 (1988), 116–21.

Dale, Thomas E. A. *Relics, Prayer, and Politics in Medieval Venetia: Romanesque Painting in the Crypt of Aquileia Cathedral*. Princeton, 1997.

Davis, Michael T. "Splendor and Peril: The Cathedral of Paris, 1290–1350." *Art Bulletin* 80 (1998), 34–66.

Derbes, Anne. *Picturing the Passion in Late Medieval Italy: Narrative Painting, Franciscan Ideologies, and the Levant*. Cambridge, 1996.

Deshman, Robert. *The Benedictional of Aethelwold*. Princeton, 1995.

Elsner, Jaš. *Art and the Roman Viewer: The Transformation of Art from the Pagan World to Christianity*. Cambridge, 1995.

Emmerson, Richard K. "*Figura* and the Medieval Typological Imagination." In *Typology and English Medieval Literature*, 7–34. Ed. Hugh T. Keenan. New York, 1992.

Grabar, Oleg. *The Mediation of Ornament*. Princeton, 1992.

Gerstel, Sharon E. J. *Beholding the Sacred Mysteries: Programs of the Byzantine Sanctuary*. Seattle, 1999.

Hahn, Cynthia J. *Portrayed on the Heart: Narrative Effect in Pictorial Lives of Saints from the Tenth through the Thirteenth Century*. Berkeley, 2001.

———. "Speaking without Tongues: The Martyr Romanus and Augustine's Theory of Language in Illustrations of Bern Burgerbibliothek Codex 264." In *Images of Sainthood in Medieval Europe*, 161–80. Ed. Renate Blumenfeld-Kosinski and Timea Szell. Ithaca, 1991.

Hamburger, Jeffrey F. *Nuns as Artists: The Visual Culture of a Medieval Convent*. Berkeley, 1997.

———. *The Rothschild Canticles: Art and Mysticism in Flanders and the Rhineland circa 1300*. New Haven, 1990.

———. *The Visual and the Visionary: Art and Female Spirituality in Late Medieval Germany*. New York, 1998.

Hedeman, Anne D. *Of Counselors and Kings: The Three Versions of Pierre Salmon's Dialogues*. Urbana, 2001.

Heslop, T. A. "'Brief in words but heavy in the weight of its mysteries.'" *Art History* 9 (1986), 1–11.

Hindman, Sandra. *Sealed in Parchment: Rereadings of Knighthood in the Illuminated Manuscripts of Chrétien de Troyes*. Chicago, 1994.

Holladay, Joan A. "Relics, Reliquaries, and Religious Women: Visualizing the Holy Virgins of Cologne." *Studies in Iconography* 18 (1997), 67–118.

Hughes, Christopher. "Visual Typology: An Ottonian Example." *Word & Image* 17 (2001), 185–98.

Huot, Sylvia. *From Song to Book: The Poetics of Writing in Old French Lyric and Lyrical Narrative Poetry*. Ithaca, 1987.

Jacoff, Michael. *The Horses of San Marco and the Quadriga of the Lord*. Princeton, 1993.

James, Liz. *Light and Colour in Byzantine Art*. Oxford, 1996.

Kartsonis, Anna D. *Anastasis: The Making of an Image*. Princeton, 1986.

Kemp, Wolfgang. *The Narratives of Gothic Stained Glass*. Trans. Caroline Dobson Saltzwedel. Cambridge, 1997.

———. "Visual Narratives, Memory, and the Medieval *Esprit du System*. In *Images of Memory: On Remembering and Representation*, 87–108. Ed. Susanne Küchler and Walter Melion. Washington, DC, 1991.

Kessler, Herbert L., ed. *Reading Ancient and Medieval Art* = *Word & Image* 5 (1989).

———. *Studies in Pictorial Narrative*. London, 1994.

——— and Marianna Shreve Simpson, eds. *Pictorial Narrative in Antiquity and the Middle Ages* = *Studies in the History of Art* 16 (1985).

Kinney, Dale. "Rape or Restitution of the Past?: Interpreting *Spolia*." In *The Art of Interpreting*, 52–67. Ed. Susan C. Scott. University Park, PA, 1995.

———. "Spolia from the Baths of Caracalla in Sta. Maria in Trastevere." *Art Bulletin* 68 (1986), 379–97.

Kornbluth, Genevra. "Susanna and Saint Eligius: Romanesque Reception of a Carolingian Jewel." *Studies in Iconography* 16 (1994), 37–51.

Kupfer, Marcia. "Medieval World Maps: Embedded Images, Interpretive Frames." *Word & Image* 10 (1994), 262–88.

———. *Romanesque Wall Painting in Central France: The Politics of Narrative*. New Haven, 1993.

———. "Spiritual Passage and Pictorial Strategy in the Romanesque Frescoes at Vicq." *Art Bulletin* 68 (1986), 35–53.

Lewis, Suzanne. *Reading Images: Narrative Discourse and Reception in the Thirteenth-Century Illuminated Apocalypse*. Cambridge, 1995.

Lowden, John. *The Making of the* Bibles Moralisées. University Park, PA, 2000.

Maguire, Henry. "The Art of Comparing in Byzantium." *Art Bulletin* 50 (1988), 83–103.

———. *The Icons of their Bodies: Saints and their Images in Byzantium*. Princeton, 1999.

Mathews, Thomas F. *The Clash of Gods: A Reinterpretation of Early Christian Art*. Princeton, 1993.

Maxwell, Robert A. "Sealing Signs and the Art of Transcribing in the Vierzon Cartulary." *Art Bulletin* 81 (1999), 576–97.

Melikian-Chirvani, A. S. "State Inkwells in Islamic Iran." *Journal of the Walters Art Gallery* 44 (1986), 70–94.

Murray, Stephen. *Notre-Dame, Cathedral of Amiens: The Power of Change in Gothic*. Cambridge, 1996.

Neagley, Linda E. "Elegant Simplicity: The Late Gothic Plan Design of St.-Maclou in Rouen." *Art Bulletin* 74 (1992), 395–422.

Necipoğlu, Gülru. *Architecture, Ceremonial, and Power: The Topkapi Palace in the Fifteenth and Sixteenth Centuries*. New York, 1991.

———. *The Topkapi Scroll—Geometry and Ornament in Islamic Architecture: Topkapi Palace Museum Library MS H. 1956*. Santa Monica, 1995.

Nees, Lawrence. "Theodulf's Mythical Silver Hercules Vase, *Poetica vanitas*, and the Augustinian Critique of the Roman Heritage." *Dumbarton Oaks Papers* 41 (1987), 443–51.

Nelson, Robert S. "The Chora and the Great Church: Intervisuality in Fourteenth-Century Constantinople." *Byzantine and Modern Greek Studies* 23 (1999), 67–101.

————. The Discourse of Icons, Then and Now," *Art History* 12 (1989), 144–57.

————. "Taxation with Representation: Visual Narrative and the Political Field of the Kariye Camii." *Art History* 22 (1999), 56–82.

————, ed. *Visuality before and beyond the Renaissance: Seeing as Others Saw*. Cambridge, 2000.

Neuman de Vegvar, Carol. "The Echternach Lion: A Leap of Faith." In *The Insular Tradition*, 167–88. Ed. Catherine E. Karkov et al. Albany, 1997.

Nolan, Kathleen. "Ritual and Visual Experience in the Capital Frieze at Chartres." *Gazette des Beaux-Arts* 123 (1994), 53–72.

O'Kane, Bernard. "Monumentality in Mamluk and Mongol Art and Architecture." *Art History* 19 (1996), 499–522.

O'Reilly, Jennifer. "Early Medieval Text and Image: The Wounded and Exalted Christ." *Peritia* 6–7 (1987–88), 72–118.

Ousterhout, Robert, and Leslie Brubaker, eds. *The Sacred Image East and West*. Urbana, 1995.

Parker, Elizabeth C., and Charles T. Little. *The Cloisters Cross: Its Art and Meaning*. New York, 1994.

Radding, Charles M., and William W. Clark, eds. *Medieval Architecture, Medieval Learning: Builders and Masters in the Age of Romanesque and Gothic*. New Haven, 1992.

Raguin, Virginia Chieffo, Kathryn Brush, and Peter Draper, eds. *Artistic Integration in Gothic Buildings*. Toronto, 1995.

Raw, Barbara. "What Do We Mean by the Source of a Picture?" In *England in the Eleventh Century: Proceedings of the 1990 Harlaxton Symposium*, 285–300. Ed. Carola Hicks. Stamford, 1992.

Roxburgh, David J. "Kamil al-Din Bihzad and Authorship in Persianate Painting." *Muqarnas* 17 (2000), 119–46.

Rudolph, Conrad. *Violence and Daily Life: Reading, Art, and Polemics in the Cîteaux Moralia in Job*. Princeton, 1997.

Sandler, Lucy Freeman. "A Bawdy Betrothal in the Ormesby Psalter." In *Tribute to Lotte Brand Philip: Art Historian and Detective*, 155–59. Ed. William W. Clark et al. New York, 1985.

————. "The Study of Marginal Imagery: Past, Present, and Future." *Studies in Iconography* 18 (1997), 1–49.

Sauerländer, Willibald. "Romanesque Sculpture in its Architectural Context." In *The Romanesque Frieze and its Spectator*, 16–43. Ed. Deborah Kahn. London, 1992.

————. "Style or Transition? The Fallacies of Classification Discussed in Light of German Architecture, 1190–1260." *Architectural History* 30 (1987), 1–29.

Schleif, Corine. "Hands that Appoint, Anoint and Ally: Late Medieval Donor Strategies for Appropriating Approbation through Painting." *Art History* 16 (1993), 1–32.

Schmitt, Jean-Claude. "The Ethics of Gesture." In *Fragments for a History of the Human Body*, Part 2, 129–47. Ed. Michel Feher. New York, 1989.

Sears, Elizabeth. "Louis the Pious as *Miles Christi*: The Dedicatory Image in Hrabanus Maurus's *De laudibus sanctae crucis*." In *Charlemagne's Heir: New Perspectives on the Reign of Louis the Pious*, 605–28. Ed. Peter Godman and Roger Collins. Oxford, 1990.

————. "The Iconography of Auditory Perception in the Early Middle Ages: On Psalm Illustration and Psalm Exegesis." In *The Second Sense: Studies in Hearing and Musical Judgement from Antiquity to the Seventeenth Century*, 19–38. Ed. Charles Burnett et al. London, 1991.

Seidel, Linda. "Medieval Cloister Carving and Monastic Mentalité." *The Medieval Monastery*, 1–16. Ed. Andrew Macleish. St. Cloud, MN, 1988.

————. "Salome and the Canons." *Women's Studies* 11 (1984), 29–66.

Ševčenko, Nancy Patterson. "Icons in the Liturgy." *Dumbarton Oaks Papers* 45 (1991), 45–57.

———. "The *Vita* Icon and the Painter as Hagiographer." *Dumbarton Oaks Papers* 53 (1999), 149-65.

Sheingorn, Pamela. "For God is such a Doomsman." In *Homo, memento finis: The Iconography of Just Judgment in Medieval Art and Drama*, 15–58. Kalamazoo, 1985.

Shelton, Kathleen J. "Roman Aristocrats, Christian Commissions: The Carrand Diptych." *Jahrbuch für Antike und Christentum* 29 (1986), 166–80.

Sherman, Claire Richter. *Imaging Aristotle: Verbal and Visual Representation in Fourteenth-Century France*. Berkeley, 1995.

Simpson, Marianna Shreve. "Narrative Allusion and Metaphor in the Decoration of Medieval Islamic Objects." *Studies in the History of Art* 16 (1985), 131–49.

Stahl, Harvey. "Narrative Structure and Content in some Gothic Ivories of the Life of Christ." In *Images in Ivory: Precious Objects of the Gothic Age*, 95–114. Ed. Peter Barnet. Detroit, 1997.

Tabbaa, Yasser. *Constructions of Power and Piety in Medieval Aleppo*. University Park, PA, 1997.

Thomas, Thelma K. *Late Antique Egyptian Funerary Sculpture: Images for this World and for the Next*. Princeton, 2000.

Valdez del Alamo, Elizabeth. "Lament for a Lost Queen: The Sarcophagus of Doña Blanca in Nájera." *Art Bulletin* 78 (1996), 311–33.

Wharton, Annabel Jane. *Refiguring the Post Classical City: Dura Europos, Jerash, Jerusalem and Ravenna*. Cambridge, 1995.

Vikan, Gary. "Pilgrims in Magi's Clothing: The Impact of Mimesis on Early Byzantine Pilgrimage Art." In *The Blessings of Pilgrimage*, 97–107. Ed. Robert Ousterhout. Urbana, 1990.

———. "Ruminations on Edible Icons: Originals and Copies in the Art of Byzantium." In *Retaining the Original: Multiple Originals, Copies, and Reproductions = Studies in the History of Art* 20 (1989), 47–59.

Ziegler, Joanna E. *Sculpture of Compassion: The Pietà and the Beguines in the Southern Low Countries, c. 1300 – c. 1600*. Brussels, 1992.

Zwirn, Stephen R. "The Intention of Biographical Narration on Mithraic Cult Images." *Word & Image* 5 (1989), 2–18.

Abbreviations

AASS — Acta Sanctorum. Antwerp, 1643ff.

CCCM — Corpus Christianorum, Continuatio Medievalis. Turnhout, 1966ff.

CCSL — Corpus Christianorum, Series Latina. Turnhout, 1954ff.

CSEL — Corpus Scriptorum Ecclesiasticorum Latinorum. Vienna, 1866ff.

DACL — *Dictionnaire d'archéologie chrétienne et de liturgie.* Ed. Fernand Cabrol and Henri Leclercq. Paris, 1903–53.

LCL — Loeb Classical Library

MGH — Monumenta Germaniae Historica

PL — Patrologiae cursus completus, Series Latina. Ed. J.-P. Migne. Paris, 1841–61.

Contributors

Walter B. Cahn is the Carnegie Professor of the History of Art at Yale University. He has been a Fulbright and a Guggenheim Fellow. His principal publications are *The Romanesque Wooden Doors of Auvergne* (1974); *Masterpieces: Chapters on the History of an Idea* (1979); *Romanesque Bible Illumination* (1982); and *A Survey of Manuscripts Illuminated in France: Romanesque Manuscripts, 1100–1200* (1996).

Michael Camille is Professor of Art History at the University of Chicago. His many publications include *The Gothic Idol: Ideology and Image-making in Medieval France* (1989); *Image on the Edge: The Margins of Medieval Art* (1992); *Master of Death: The Lifeless Art of Pierre Remiet, Illuminator* (1996); *Mirror in Parchment: The Luttrell Psalter and the Making of Medieval England* (1998). He has recently completed a book entitled *The Gargoyles of Notre-Dame: Medievalism and the Monsters of Modernity* to be published by the University of Chicago Press.

Annemarie Weyl Carr is a University Distinguished Professor of Art History at Southern Methodist University. She wrote her dissertation under Professor Ilene Forsyth at the University of Michigan. Author of *Byzantine Illumination, 1150–1250: The Study of a Provincial Tradition* (1987) and *A Byzantine Masterpiece Recovered: The Thirteenth-Century Murals of Lysi, Cyprus* (1991), she works especially on Byzantine art in the eastern Levant during the period of the Crusades. She is preparing a book on the icon of the Mother of God of Kykkos Monastery on Cyprus.

Celia Chazelle is Associate Professor in the Department of History at the College of New Jersey. She has held fellowships at the Zentralinstitut für Kunstgeschichte in Munich (Samuel Kress Foundation Fellowship) and at Bryn Mawr College (J. Paul Getty Fellowship and Andrew Mellon Fellowship). Her publications examine early medieval doctrines of the artistic image and issues in Carolingian theology and iconography. She has recently completed a book, *The Crucified God in the Carolingian Era: Theology and Art of Christ's Passion* (2001).

Michael T. Davis, Professor of Art at Mount Holyoke College, received his Ph.D. from the University of Michigan in 1979. His publications on French Gothic architecture include studies on the cathedrals of Clermont-Ferrand and Limoges and the church of Saint-Urbain, Troyes. Currently he is preparing a book on the career of

the master mason Jean des Champs and continuing research on the architectural history of Paris, 1250–1350.

Lois Drewer is a Reader at the Index of Christian Art, Princeton University. She prepared her dissertation under Professor Ilene Forsyth at the University of Michigan. Her many studies, on a range of iconographic questions in early Christian and Byzantine art, include articles treating medieval women and saints.

Marvin Eisenberg is Professor Emeritus of the History of Art at the University of Michigan. His publications on early Tuscan painting include monographs on Lorenzo Monaco (1989) and the reconstructed "Confraternity Altarpiece" by Mariotto di Nardo (1998) as well as articles in American, British, and Italian periodicals. He has been a Guggenheim fellow, a fellow at the Institute for Advanced Study, Princeton, and the Benjamin Franklin Fellow of the Royal Society of Arts, London.

Dorothy F. Glass is Professor of the History of Art at the State University of New York at Buffalo, where she has received a Chancellor's Award for Excellence in Teaching. Her work has been supported by the American Council of Learned Societies, the American Philosophical Society, the Fulbright Commission, the American Academy in Rome, and the Metropolitan Museum of Art. Among her publications are: *Studies on Cosmatesque Pavements* (1980); *Italian Romanesque Sculpture: An Annotated Bibliography* (1983); *Romanesque Sculpture in Campania: Patrons, Programs and Style* (1992); and *Portals, Pilgrimage and Crusade in Western Tuscany* (1997).

Oleg Grabar is Professor Emeritus in the School of Historical Studies at the Institute for Advanced Study in Princeton. He taught at the University of Michigan between 1954 and 1969 and then at Harvard University from 1969 until 1990, when he was the first Aga Khan Professor of Islamic Art. The most recent of his fifteen books is *Mostly Miniatures: An Introduction to Persian Painting* (2000).

Cynthia Hahn is Gulnar K. Bosch Professor of Art History at Florida State University. She is the author of two books on illustrated narratives of saints' lives, as well as *Portrayed on the Heart: Narrative Effect in the Pictorial Lives of Saints from the Tenth through the Thirteenth Century* (2001). Her numerous articles, ranging in subject from early Christian ampullae to fifteenth-century panel painting, have appeared in the *Art Bulletin, Art History, Gesta, Speculum*, and other journals and collections. She is currently working on representational issues raised by reliquaries and their presentation.

Reading Medieval Images

Dale Kinney is Professor of the History of Art and Dean of the Graduate School of Arts and Sciences at Bryn Mawr College. Her recent publications treat a variety of topics, including late antique ivories and architecture, spolia, and art historiography. She is a Fellow of the American Academy in Rome and a recent editor of *Gesta*. Santa Maria in Trastevere was the subject of her doctoral dissertation.

Charles T. Little is Curator of Medieval Art at the Metropolitan Museum of Art. His research interests lie especially in the areas of monumental sculpture and ivory carving, and he has published, with Elizabeth C. Parker, *The Cloisters Cross: Its Art and Meaning* (1994) and is co-author of *Europe in the Middle Ages: The Metropolitan Museum of Art* (1998). Co-director of the Limestone Sculpture Provenance Project and a recent president of the International Center of Medieval Art, he has taught as adjunct professor at New York University, both in the Department of Fine Arts and at the Institute of Fine Arts.

Linda Neagley is Associate Professor in the Department of Art and Art History and Director of the Medieval Studies Program at Rice University. She previously taught at the University of Michigan and at the University of California at Los Angeles and Berkeley. She has recently been the Samuel H. Kress Senior Fellow at the Center for Advanced Study in the Visual Arts at the National Gallery of Art. Her publications include *Disciplined Exuberance: Saint-Maclou and the Late Gothic Architecture of Rouen* (1998) and articles on French Flamboyant architecture and Late Gothic sculpture.

Elizabeth C. Parker is Professor in the Department of Art and Music History at Fordham College at Lincoln Center and in the Graduate Program in Medieval Studies of Fordham University. She has edited various publications and journals, most recently *Traditio: Studies in Ancient and Medieval History, Thought, and Religion*, published by Fordham University. Her publications include *The Cloisters Cross: Its Art and Meaning* (1994), co-authored with Charles T. Little, and articles on art and liturgy.

Elizabeth Sears is Professor in the Department of the History of Art at the University of Michigan. She previously taught at Princeton University and has been a visiting professor at the University of Hamburg. She has held fellowships at the Warburg Institute and the Wellcome Institute for the History of Medicine in London, at the Zentralinstitut für Kunstgeschichte in Munich, at Magdalen College and All Souls College in Oxford, and at the Getty Research Institute in Los Angeles. Her publications include *The Ages of Man: Medieval Interpretations of the Life Cycle* (1986), an edition of the writings of Edgar Wind on Michelangelo (2000), and articles on a wide range of iconographical and historiographical topics.

Harvey Stahl is Associate Professor of Medieval Art at the University of California at Berkeley. He has been an Assistant Curator of Medieval Art at the Metropolitan Museum of Art and has taught at Manhattanville College. He has lectured and published on topics pertaining to manuscript painting, gothic ivories, medieval sculpture, and reliquaries and is currently completing a publication on the Psalter of Saint Louis.

Thelma K. Thomas is Associate Professor in the Department of the History of Art at the University of Michigan and Associate Curator at the Kelsey Museum of Archaeology. She has held fellowships at the Metropolitan Museum of Art, the Brooklyn Museum of Art, and the Center for Advanced Study in the Visual Arts at the National Gallery of Art. Her publications, including *Textiles from Karanis, Egypt in the Kelsey Museum of Archaeology: Artifacts of Everyday Life* (2001), explore issues of collecting, historiography, and materials and techniques in the arts of late antique Egypt and in the Christian arts of the medieval Near East.

O. K. Werckmeister is Professor Emeritus of Art History at Northwestern University, previous holder of a Mary Jane Crowe Distinguished Professorship. He earlier taught at the University of California at Los Angeles and has held visiting appointments at the University of Marburg, Texas at Austin, and Hamburg. He has been a John Simon Guggenheim Memorial Fellow and a Fellow at the Wissenschaftskolleg, Berlin, and was a founding member of the Caucus for Marxism and Art within the College Art Association of America. His most recent books are *The Making of Paul Klee's Career* (1989), *Citadel Culture* (1991), and *Icons of the Left* (1999).